DARK
ODYSSEY

For Fanny and Katherine, may their paths be full of light.

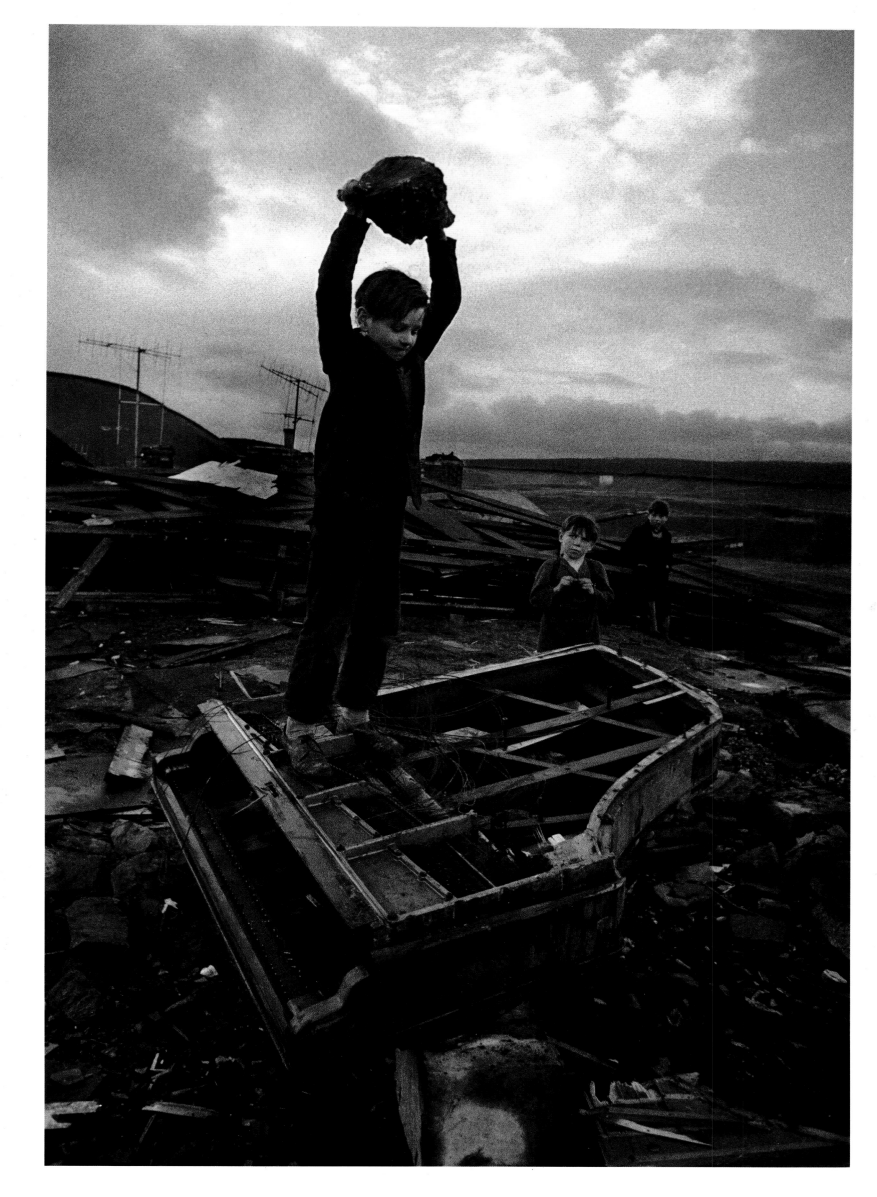

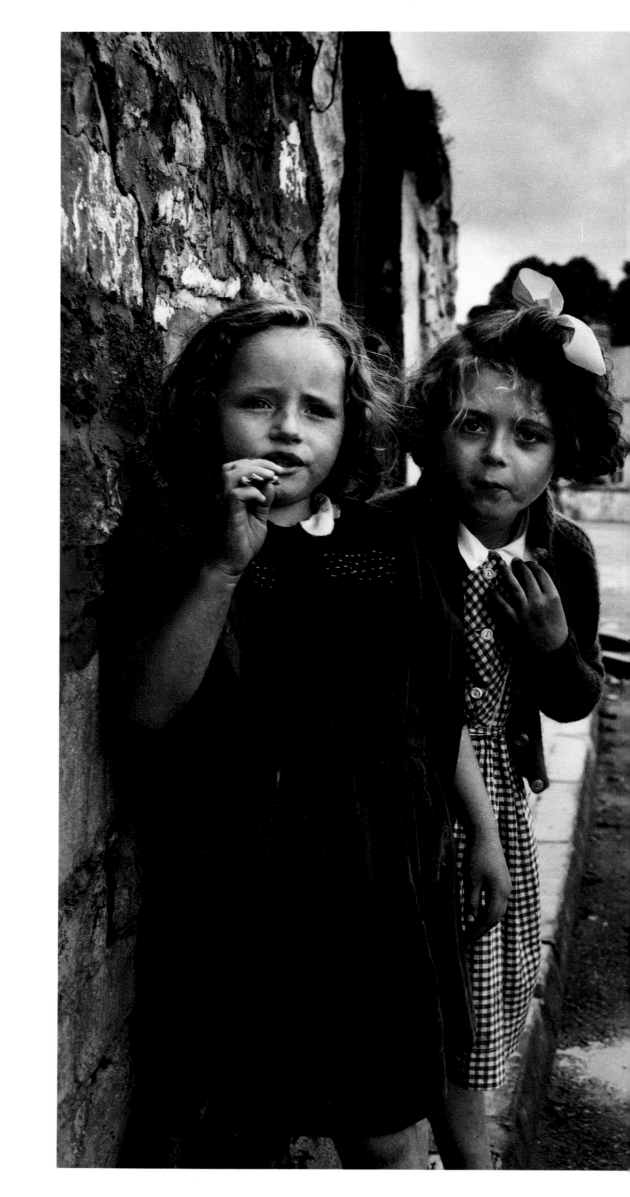

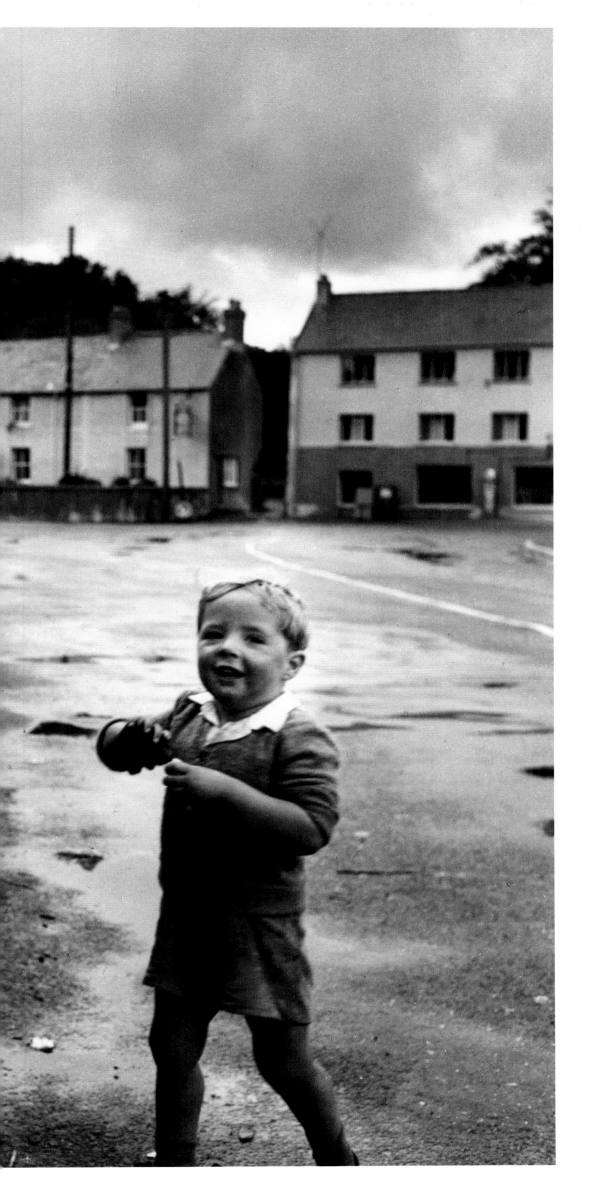

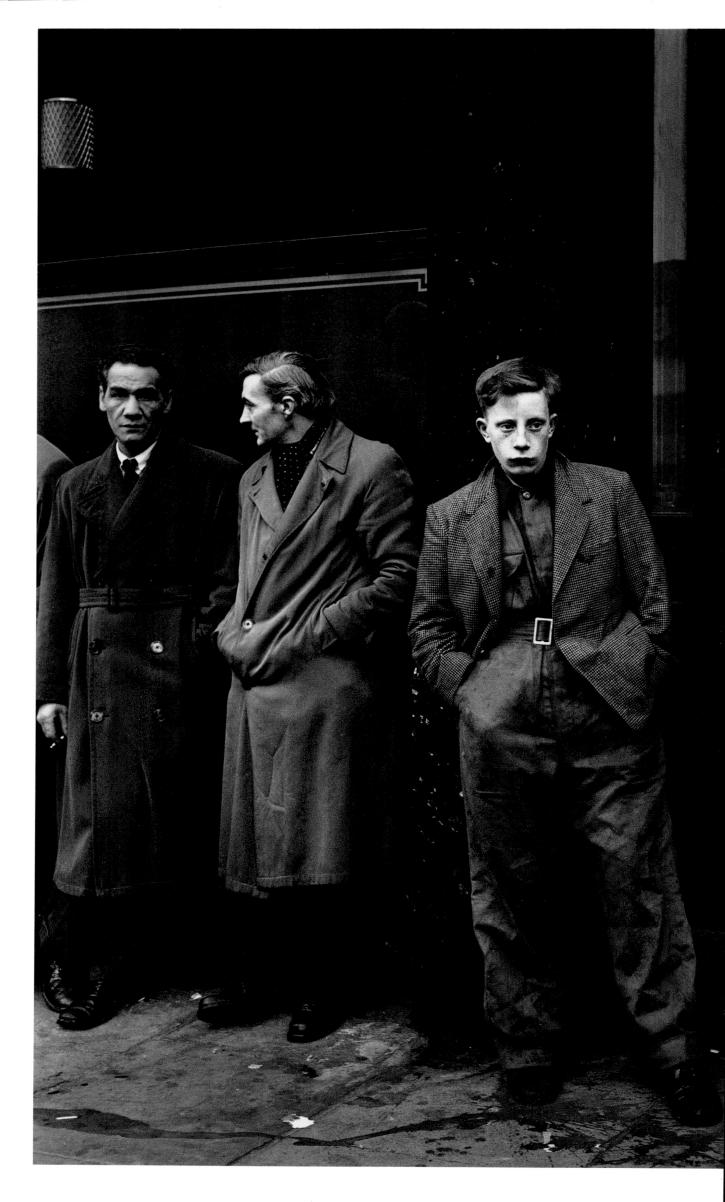

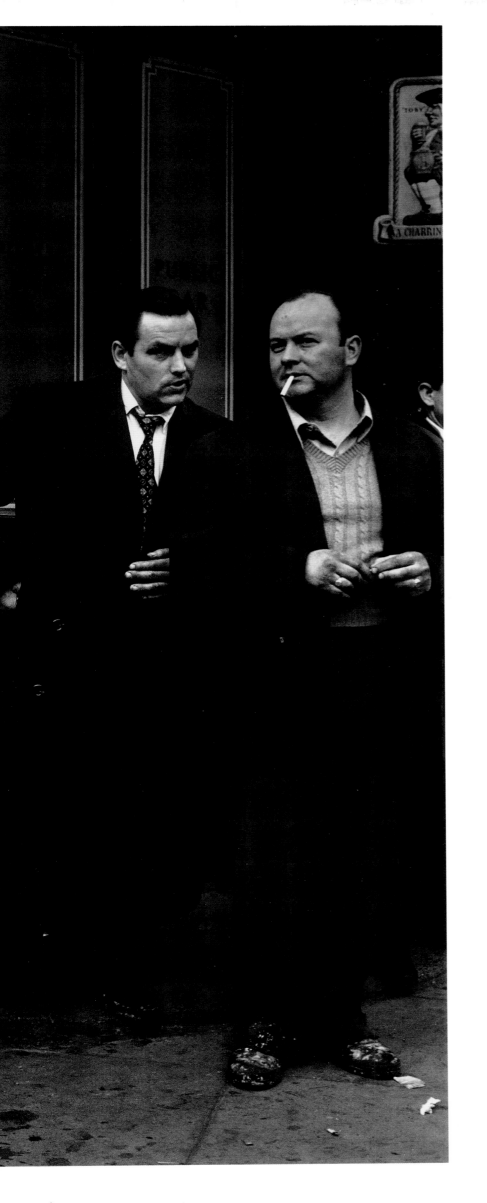

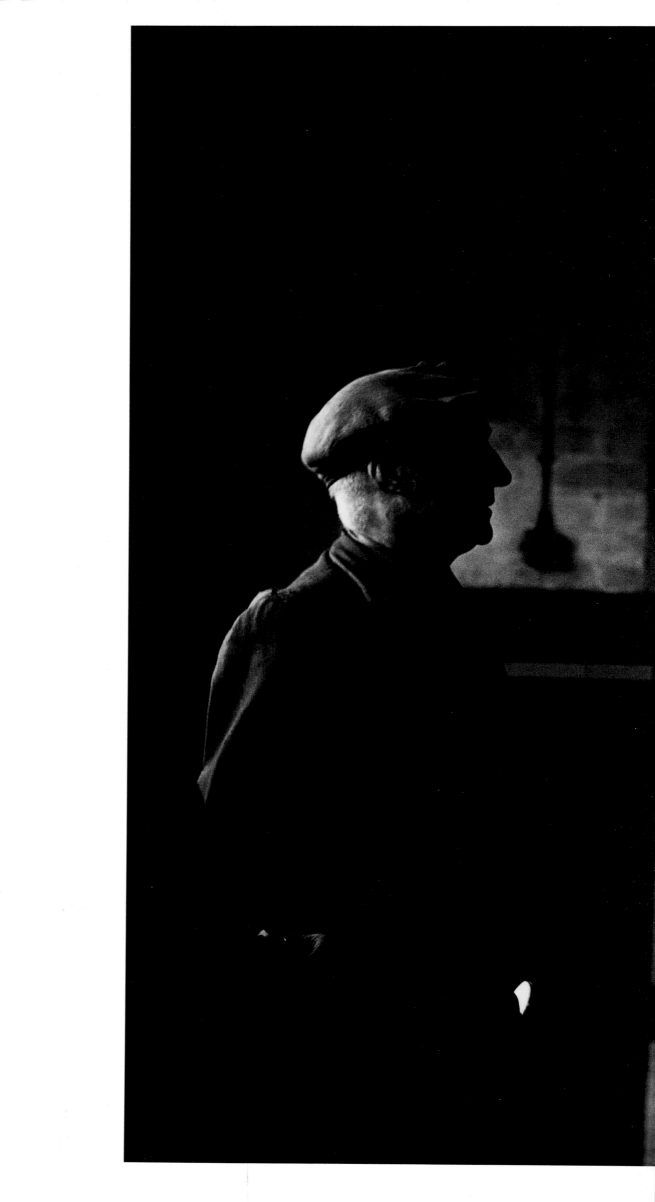

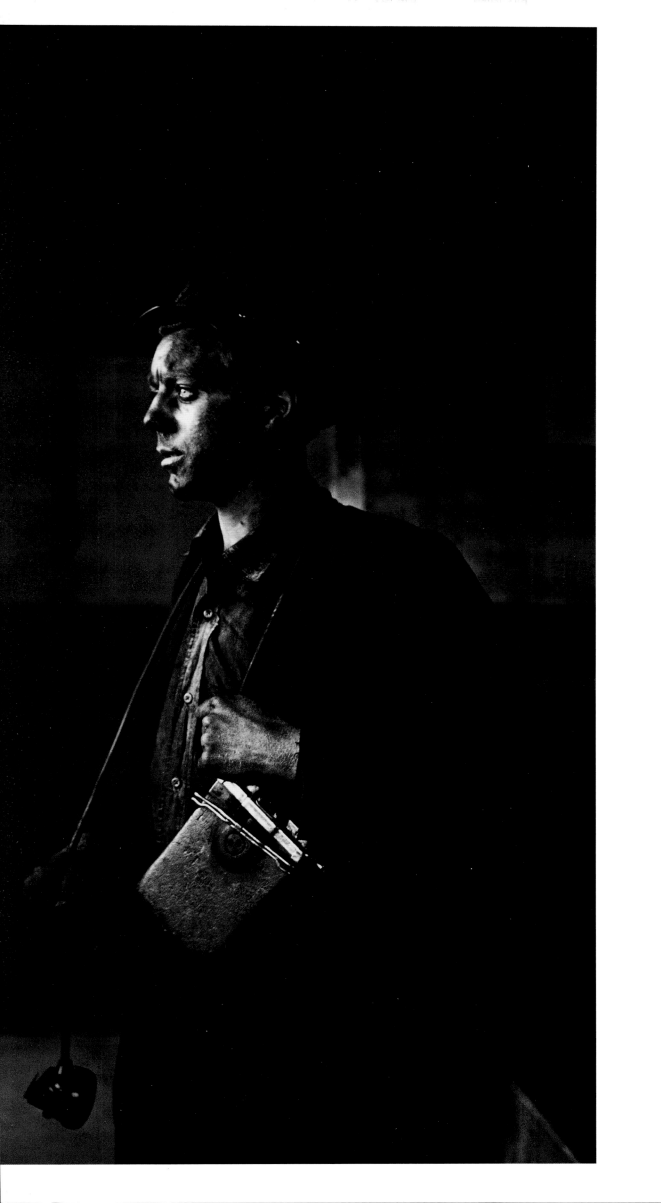

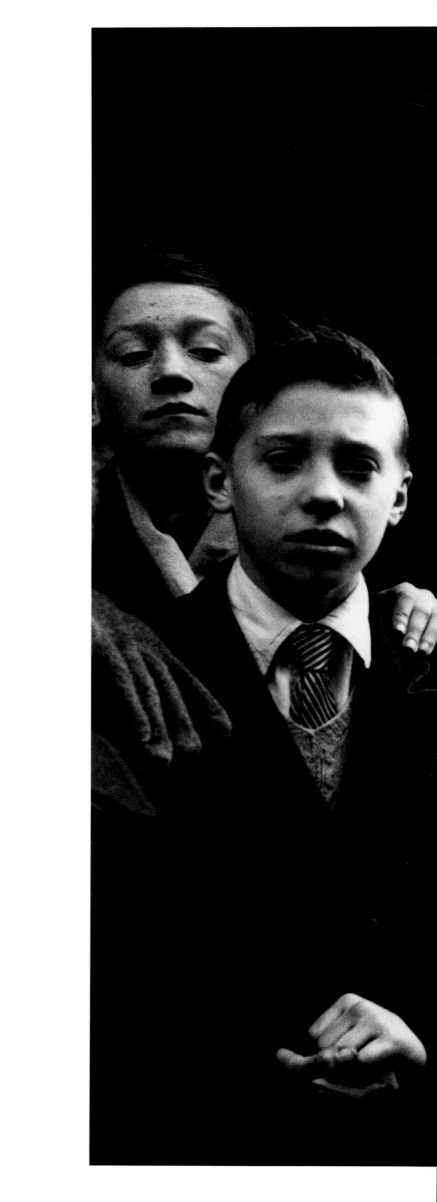

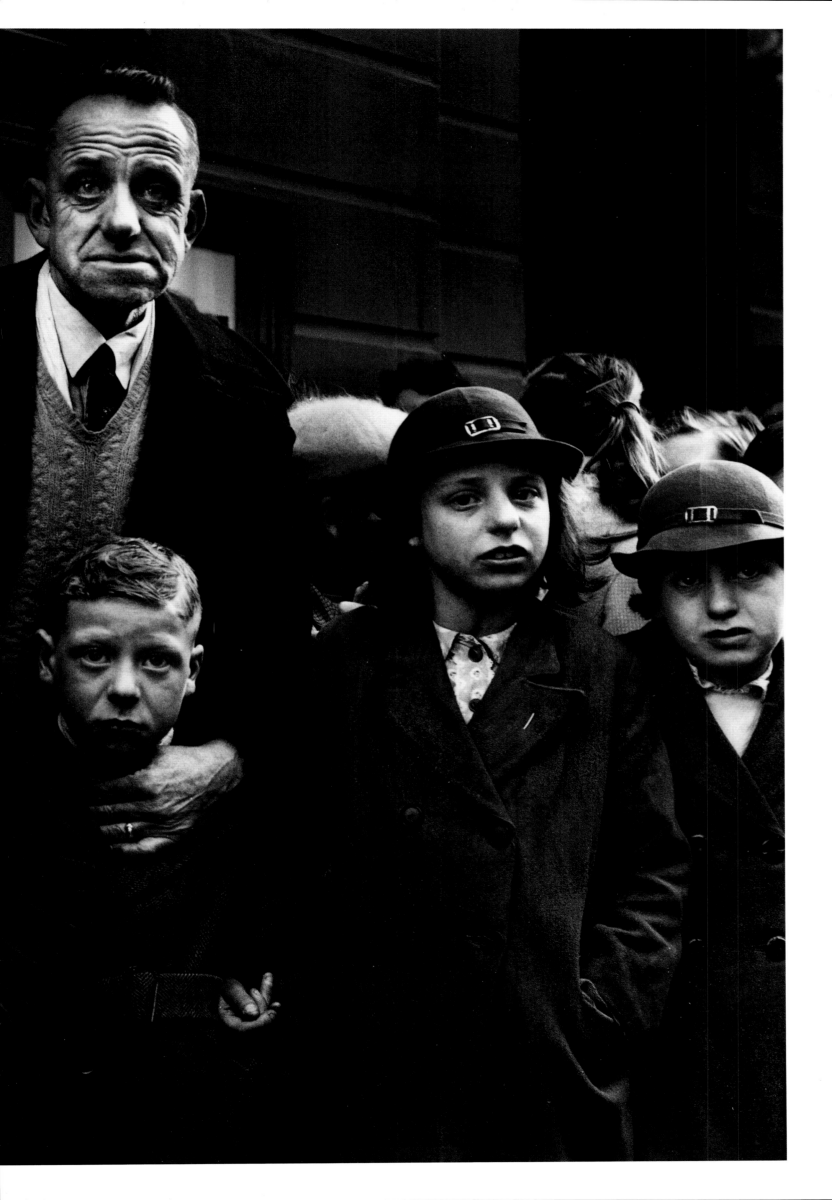

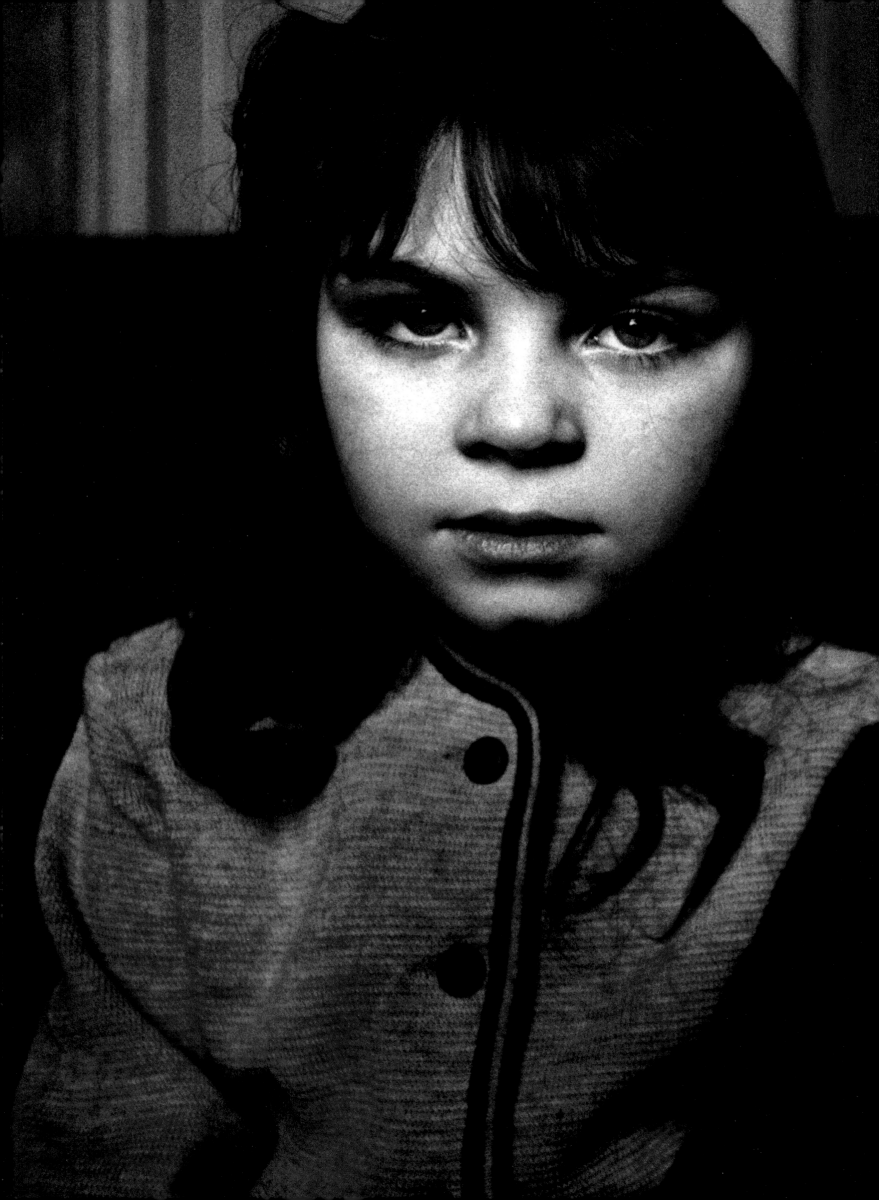

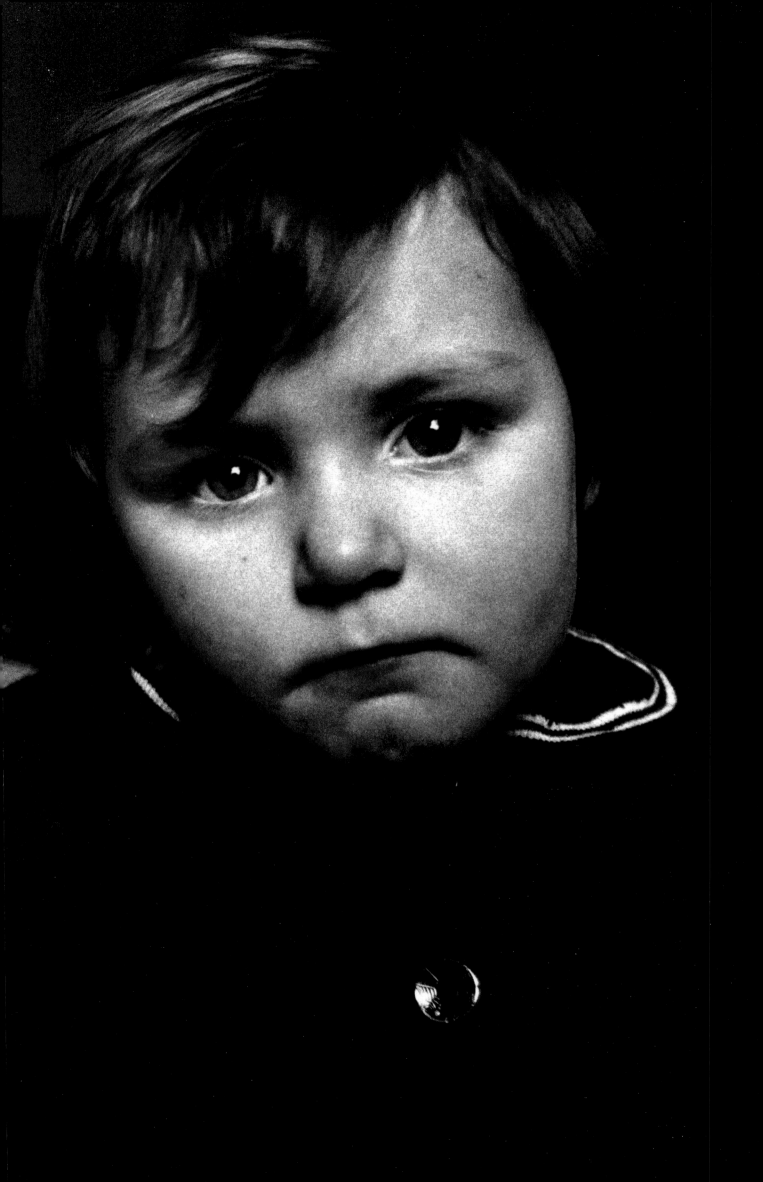

photographs and commentary by Philip Jones Griffiths

introduction by Murray Sayle

DARK
ODYSSEY

PHILIP JONES GRIFFITHS

APERTURE

introduction

this

book is, of its kind, a masterpiece. That's a bold claim, I realize. True, the Welsh photographer Philip Jones Griffiths has been a friend of mine for more than thirty years, and we have worked together in many parts of the world, especially in Vietnam. Wartime buddies? I suppose we are. Prejudiced? Perhaps I am. At least I can tell you what kind of man Philip is, what kind of life he has led, to produce this body of work. His photographs tell much the same story; I offer a personal interpretation.

Many of these images, particularly of Vietnam, will seem familiar. Some *are* familiar; they were published around the world during the Vietnam War, and others—of American soldiers water-skiing, for instance, farmers' huts burning, Vietnamese civilians running in terror—inspired much of Francis Ford Coppola's film fantasy *Apocalypse Now*, which in turn has, for better or for worse, influenced the way a whole generation of people who were not there visualize that sad war. Philip's 1971 book *Vietnam Inc.* even contributed some lines of dialogue to Coppola's film, lifted without acknowledgment from the long captions Philip wrote to reinforce his photographs. Influencing, even shaping the way the world saw a war is quite a feat for one man. Only a photographer could have done it, one with a fiery, focused vision, a preacher's energy, and some luck. A Welsh photographer, in fact.

Philip looks Welsh. A big, genial man, he is built like a rugby forward. He talks (a lot) with a lilting accent, hinting that his first language was not English, but musical and emotional Welsh. His family names, Jones Griffiths, are aggres-

sively Welsh. His national allegiances (especially his view of Wales in relation to its powerful neighbor and overlord, England) are not, I think, incidental to his work. Philip has carried Wales with him to 140 countries, to wars, revolutions, and civil commotions beyond count. In this book the long thread connecting his childhood in Wales with the culmination in Vietnam and other violent parts of the world may not be obvious. Let us trace it.

Philip was born in the little town of Rhuddlan, in north Wales, in 1936. He spoke Welsh as a child (and he sometimes speaks it still); to Philip and his compatriots, Welsh resounds with affection, intimacy, neighborliness, the warmth of home. By contrast, English (which he learned at school) is the language of commerce, the coldest of all human relationships; the tongue of power and greed, of the raucous seaside huckstering of the English pitchmen down at the nearby holiday-resort, Rhyl, and of smoke-blackened, industry-scarred England, just over the border.

Philip's emotional landscape is not consistent. English has also been the language of opportunity for him, while Welsh was the vehicle of a stern, unforgiving Protestant religion—itself imported from England. In Philip's mind, Welsh puritanism and Welsh patriotism have joined to shape a powerful image: that of gentle village life crushed under the wheels of brutal, mechanized invaders. This vision is too elemental to be called politics or ideology; it belongs in a medieval passion play about the struggle of light against darkness. Philip carried it around the world, until he encountered a place it seemed to explain: Vietnam.

Philip did not have an unhappy childhood—far from it. His home town stands on the river Clwyd, winding from distant mountains through the farm landscape of North Wales to the sea. Philip's father, Joseph Griffiths, supervised the local trucking service of the London, Midland and Scottish Railway. Catherine Jones, Philip's mother, was Rhuddlan's district nurse, who ran a small maternity clinic at home. In the Welsh manner, Philip uses the names of both his parents, to distinguish himself from all the other Joneses and Griffithses of the neighborhood. He recalls an uneventful childhood, with World War II only a far-off, menacing rumble, brought nearer home by food rationing, the arrival of English children sent to the country ("they were tough and naughty—rather exciting, really") and a never-to-be forgotten air raid on Liverpool, on the day Philip, aged five, happened to be visiting there with his mother.

As in all Welsh villages, religion was important in the family's life. One of Philip's uncles is a preacher, and his father was

precentor at the local Wesleyan Methodist chapel. Philip recalls being punished for fidgeting during an interminable hellfire sermon, when he was, he says, actually moving his point of view the better to frame the preacher's head—an early interest in visual composition. He maintains that he is now antireligion, but concedes that, in at least one respect, early exposure to a stern faith has left a deep mark. Wesleyan Methodism teaches that the Lord has put us on earth to use our God-given talents to leave the world better than we found it. For Philip, the Lord's work has turned out to be crusading photojournalism.

Philip remembers that photography found him, rather than the other way around. As a child he was given a Kodak Brownie, "the magic box that makes pictures." At St. Astaph Grammar School near Rhuddlan he discovered chemistry, and touched off the traditional explosions in the garden shed. From there it was a short step to buy developer and hypo and process and print his films using the family bathroom as a makeshift darkroom. Still in high school, Philip started to earn a few shillings photographing weddings. He soon bought a better camera.

His parents, and perhaps Philip himself, completely misread these youthful enthusiasms. His mother saw a link between photographic chemistry and the pharmaceutical profession. To his father, pharmacy was a steady, respected line of work; to both parents, it was a chance that at least one of their three sons would settle down in Rhuddlan. In 1952, at sixteen, Philip was apprenticed to the local branch of Boots the Chemist in Rhyl, with the added chore of developing and printing black-and-white photographs. The following year he had his first news photograph, a portrait of the local Conservative member of Parliament, published in the *Rhyl Leader* newspaper for a reproduction fee of fifty pence. He kept taking photographs and sometimes selling them while he finished his pharmaceutical studies in Liverpool.

Boots, his employer, is a nationwide chain; by 1961, at twenty-five, the burly young Welshman had moved to London, and was holding down one of the toughest jobs in all pharmacy—as night manager of the Boots branch in Piccadilly Circus, just off the notorious Soho red-light district. One of only two all-night drugstores in the British capital, Boots was (in those innocent days) frequented by registered drug addicts picking up their prescriptions of free heroin, prostitutes purchasing the paraphernalia of their trade, drunks and bar brawlers buying bandages, and many more picturesque slices of low life. Philip was free to photograph them. The 1961 edition of *Photography Annual* carried five of his Piccadilly photographs. Dennis Hackett, picture editor of the long-established *Observer* Sunday newspaper, offered him free-lance work. Before long, the *Observer* was using photographs, credited to Philip Jones Griffiths, of the new war raging in Algeria. Boots had to find a new night manager.

How did an unknown, absurdly young man manage such a fast climb to a prestigious pinnacle of Fleet Street? Part of the explanation was, of course, natural talent: visual curiosity, an eye for the meaningfully incongruous, a fast finger on the shutter release as the desired composition flashes into frame. These are the basic skills, probably inborn. But just about anyone, by following a few simple rules, can take a publishable photograph. Some great photographs have been made by pure luck—then again, some people seem to be amazingly lucky.

Many nonphotographic skills are also asked of the outstanding photojournalist: stamina, robust physical and mental health, self-reliance, patience with endless delays and obstructions, the painstaking organizing of logistics, the knack of getting along with colleagues and competitors, which usually means much give-and-take (the loners don't seem to last long), luck in being in the right place, and the other kind of luck, in not getting aboard the wrong helicopter. Separately, these qualities are not uncommon. In combination with a visual gift they are rare. Philip the photographer has them, as his work here testifies. Philip the white-coated, businesslike night pharmacist laid some of the essential foundations.

His timing was excellent. He arrived in London, Leica in hand, at the beginning of the Swinging Sixties, just as the market was newly opened for photographers who could think beyond a single snapshot—for "photojournalists," as we started to call them. After the peaceful gap of the 1950s, there were new wars in Africa, Southeast Asia, China, the Middle East, and South America, needing coverage by a new generation of photographers. When I first met him, in 1964, Philip had worked in more than forty countries, lived with anti-French rebels in Algeria, toured Ethiopia, and even trailed the aging Duke of Windsor (the former King Edward VII) through Harley Street, the posh medical district of London. Not bad, for someone barely twenty-eight.

Up to that point, Philip's photographs are those of an intelligent, more-than-competent craftsman. Impeccably composed, striking and effective, his work shows not much individual style, and his subjects seem to have been dictated by the vagaries of editorial assignments. Many of the early images could have come out of *Picture Post*, where Bill Brandt, Bert Hardy, and George Rodger had taught a generation to see

a gritty, gloomy, far-from-Merrie England. Philip added post-Depression Wales. We can also see the clash of races (hard to avoid in Africa), hints of profeminism and antiexploitation—all lifelong themes for Philip. His promise was quickly recognized: on the proposal of his friend, Ian Berry, he was invited to apply to join Magnum, the famous co-operative photo agency. Philip submitted three photo essays in contact-sheet form. He was an entry-level Magnum nominee in May 1966, an associate a year later, a full member in 1970. Later he was Magnum's president for an unprecedented five-year term. He is a loyal member of Magnum to this day.

Magnum has been good to Philip, and vice-versa. He is not cut out by temperament to work for a boss. Individualistic reporting, visual or written, calls for hard choices that can really only be made individually: how long to follow a story, how much effort to put into it, what risks are worth running to get it.

Photojournalism is, among other things, a global logistical operation. Film has to be shipped, processed, circulated to editors before its news content goes cold. Magnum, which currently has only forty photographer members, gives them the back-up that normally only a wealthy newspaper or magazine can supply—but without the obedience exacted in return. Back in 1966 the agency's newest associate was thirty, unmarried, with a growing reputation and his new Magnum connection promising assignments with no need to haunt editors' offices in London or New York. He was as well placed as he ever would be to take on a big, challenging project. For a young man with war experience, that could only mean the story the world was already talking about.

The war in Vietnam was visually overwhelming. When Philip arrived in 1966, you could still make out the crumbling French observation towers of the previous war, overlooking enamelled green rice paddies, small boys and straw hats, city girls floating along in the exquisite *ao dzai*, that most ethereal of female garments. But by then, the landscape was already bomb-cratered and scarred at every crossroads with sandbags, bunkers, and barbed wire. Gigantic American trucks tore up fragile roads and scattered shoals of Vespa riders and the skinny, sweating drivers. The tree-shaded boulevards of French days were crowded with two seemingly different species of the human race; tiny brown Vietnamese and huge pink Americans, a daily visual reminder that a big, powerful country had come to make war in (or, as Philip said, on) a small, insignificant one.

Vietnam was the first and will almost certainly be the last war in which the correspondents of "allies" and neutrals could get accreditation (from one side only), and free military transportation, without being subject to any form of government censorship. This unheard-of freedom of the press came about by accident. Early on, when America was said to be only "assisting" the South Vietnamese government, officially there was no war, and therefore no legal basis for censoring news. By 1966, American domestic support, high at first, was flagging; Princeton students and faculty had marched against American intervention, Dan Rather had called Vietnam a "dirty little war," and Morley Safer had shown U.S. Marines setting fire with Zippo® lighters to thatched houses in the village of Can Ne. Washington's first priority then became rallying the home front, "selling" the war to increasingly disillusioned American voters. By that time, official censorship would have made Americans at home even more suspicious.

This freedom from censorship, in a way, made life for writing journalists more confusing. Readers, and therefore editors, wanted to know who was winning, but also what the war was about, who was in the right, whether America should be involved. Where to look for the answers? Basically there were two possibilities: either to report what we were told in Saigon, least reliably at the infamous "five o'clock follies," the daily military press briefings, or to go into "the field," the rest of South Vietnam. Writers could do either, but, until fighting came to Saigon in the Tet offensive of February 1968, photographers had no choice: it was either the field, or a blank day. Usually, the field won.

Philip and I put up at the same hotel in Saigon, Le Royale. Working from this base, we made a kind of informal two-man news team, one of many. Kitted out in jungle boots and green U.S. Army fatigues bought in the Saigon black market, loaded down with water bottles, wound dressings, combat rations, toothbrushes, spare underwear, cameras, film, and notebooks, we would set out from Le Royale by taxi, before dawn, past sentries dozing on street corners, to the Saigon airport, Tan Son Nhut—specifically to Aerial Port Nine, one of its many military subsections. Here we would check in, and arrange for a helicopter—"Limeys, huh? Sure, we'll get you to An Bang."

Then we were off to some planned operation, if we knew of one (Philip had excellent sources), or on a personal reconnaissance mission, looking for action. In this way, we covered search-and-destroy operations, Junction City in the Iron Triangle, north of Saigon, and Cedar Falls in War Zone C, in Tay Ninh province, to the west. It was all standard America-in-Vietnam: helicopter door-gunners banging away at targets glimpsed on the ground (basically, anything that moved),

tunnels emptied with tear gas, half-blinded men, women, and sometimes children stumbling out, and the tunnels then blown up with another gas, acetylene, peasant huts burned down, rice fields ploughed up by bulldozers armored against mines, occasional brief firefights, leaving dead Vietnamese clutching an assortment of rusty weapons, bits of webbing, water bottles, or, often, nothing at all. All the time Philip, who seemed to know what he was looking for, was taking photographs.

The meaning of all this was far from clear. It was hard to believe that the future of humanity really rested on the outcome of these obscure clashes. The real opponents were not even in South Vietnam, but in Washington, in Hanoi, in Beijing and Moscow. The Americans were ostensibly open, even garrulous, about what they were doing every day in Vietnam, but unable to describe their ultimate aim, if they had one. No reliable information was available from the other side—who (apart from being Vietnamese) they were, how much support they had, what their real war aims were.

The only way to get deeper into the story in words was to describe battles, which all sounded, after a while, pretty much the same. If America aimed at eliminating Communism from South Vietnam then the outlook was grim, considering that the borders could not be sealed, there seemed to be quite enough Communists inside them already, and there was another group of supporters in Berkeley, California. On the other hand, it seemed unlikely that a ragged army of peasant guerrillas could defeat the mechanized military juggernaut that had rolled over their country. With neither side able to win, it seemed the war would go on forever—a heartbreaking prospect, but there were no verifiable facts to support any other. Some excellent descriptive writing came out of Vietnam, but little insightful analysis until long after the war was over. Monotonous, pointless reports, the lack of a clear aim, or any way of measuring progress added to American frustration and boredom with Vietnam.

On the other hand, Vietnam was the greatest, and the last, photographers' war. Photographers were in their element. Presented with an opportunity that will never come again, they were not called on to document the tedious progress, or non-progress, of a war, to weigh the conflicting claims in search of an elusive truth. Photography's uniqueness is in isolating the here and now, time's river magically frozen for a hundredth of a second. Until electronic image manipulation came along, the camera was almost universally seen as a portable truth machine, its own verification built-in. But photography does not aim at objectivity, or seeing both sides: if there was such a

thing as an impartial photograph, it would be supremely dull, and unlikely to get past the first edit. "This is what was in front of the lens," is all that a photograph can actually say; but, in the hands of a master, this simple statement can have enormous resonance. The most effective Vietnam images, especially Philip's, are simple and succinct, the visual equivalent of the strongest antiwar slogans. Not surprisingly, armies the world over now reject the very idea of uncensored war photography. If the generals can help it, there will be "no more Vietnams."

We all, of course, brought our own Vietnam with us to Vietnam. Most Americans arrived with historic anticolonialism, directed at containing a supposed Communist empire directed from Moscow; they came with America's own racial conflicts (sadly, the first war to treat African-Americans as equals, in and out of combat, was not one in which anyone could earn much glory), they came with Confederate flags, peace symbols, the sixties' social ferment, and, of course, bulging shopping bags. French reporters used the vocabulary of partisan resistance; anticlerical Italians arrived sure that, with the Pope on one side, they were on the other. Philip brought the most original vision of any of us: Vietnam fused with images from his own childhood, of kindly, rural Wales threatened by soulless, materialistic, powerful England over the border. With it he produced, I believe, a body of work that will live long after the contentions over Vietnam have faded into history. As yet, no writing about Vietnam has been anywhere near that league.

Consider Philip's image of a bomb crater on pages 136–137. I instantly recognize that particular hole, because I was standing next to Philip when he took the photograph. It was made during Operation Delaware, an attempt by the First Cavalry Division (Airborne) to block the A Shau Valley, through which a branch of the Ho Chi Minh supply trail reputedly ran towards Hué, the ancient capital of Vietnam.

In April 1968 Philip and I had already covered, for the London Sunday Times, Operation Pegasus, the relief of Khe Sanh. In that operation, the same division had tried out a novel way of making war—using helicopters carrying infantrymen riding inside, and heavy artillery slung underneath. On that first trial, the new system seemed to work—the helicopters were used to establish fire bases on the hilltops, allowing the Americans to avoid the opposition and hold their ground. If this was a viable way for the South Vietnamese borders to be sealed without having the entire U.S. Army absorbed by the jungle—it was important news.

Two weeks later, Philip and I were on one of the heli-

copters headed west into the mountains from Camp Evans, an American base inland from Hué. A VC/NVA attack on Hué was reported to be imminent, with the A Shau Valley a vital link in their supply route. We went along to see whether the helicopters could prevent it.

It was a disaster. As we crossed the mountains, we were shot at. Below us in the valley, a duel was going on between VC/NVA artillery and American fighter-bombers trying to silence the guns with napalm. The helicopter ahead of us was hit, and crashed in flames. We were ordered back to Camp Evans. A half-hour later, our pilot told us we were going in again. This time the clouds had cleared, the flak had been silenced, and we were able to land. The first thing we saw on the ground was that huge bomb crater, made by a 1,000-pound "jungle buster" dropped in some earlier attempt to cut the trail. Such craters are all over Vietnam, but something about this one stuck in my memory—relief, perhaps, at getting my boots on solid ground, agreeably surprised to be alive.

The Air Cavalry lost seventeen of its two hundred helicopters in that one operation. Without fixed fire bases, the trail would have had to be cut afresh, the operation repeated over and over again. If there was a military key to Vietnam, helicopter mobility was not it.

As workmanlike journalism, addressing a current question, my report may be of passing interest to some future historian. But look at what Philip has made of A Shau. The bomb crater, the soldier, the tiny U.S. flag over the landing zone have come together in a powerful statement. The message is clear: a mechanized monster has despoiled an innocent landscape. The image still persuades, long after the event has become irrelevant. Freezing a passing moment into timeless truth is what artists do, not journalists. It is, I believe, as art, therefore, that we should assess Philip's best work.

This is why Philip's camera seems to take fire the moment he turns it to Vietnam. Some of his images may seem partisan to the point of parody, the work of an angry polemicist risking his credibility by relentlessly overstating his case. When we look more closely, however (although many of his images are painful to dwell on), a deeper message emerges. The players in Philip's photographs take on the symbolic weight of figures of good and evil in a medieval morality play: martyrs, monsters, the sacrifices and the sacrificed. The themes of defenseless innocence, suffering mother and child, grieving parents and mutilated grandparents figure in religious art because they speak to universal human emotions. Made in one war, only one of the many wars of this century,

these Vietnam photographs have lost none of their impact. They are so here-and-now they could have been made yesterday, yet we know they will seem that way a century from now. Whether they told "the central truth about Vietnam" is now irrelevant. They certainly tell one truth, one that has already echoed down the years: our infinite readiness to inflict suffering on one another, for reasons that seem to us wise, just, and worthy at the time. This is the central truth of war itself.

For me (and also, I am told, for Henri Cartier-Bresson) the artist who comes closest to prefiguring Philip's Vietnam photographs is Francisco de Goya, whose suite of etchings *Los Desastres de la Guerra* was first published long after Napoleon's invasion of Spain in 1808. Goya's images of Spanish partisans shot and bayoneted by French soldiers were based on drawings he made on the spot—the forerunner of photography. And, like Philip, Goya was a critic of the "follies and extravagances" of his time, a stern moralist who used his art to preach against the tyrants and oppressors of his day. Ironically, it is largely Goya's work that has kept the ugly memory of them alive.

I am confident that no photographer will, in a future war, equal, much less surpass Philip's visual account of America in Vietnam.

What has Philip Jones Griffiths been doing since Vietnam? A great deal. The credit "Philip Jones Griffiths—Magnum" has been carried on much distinguished photojournalism published over the years. Many of those images are in this book. He has done some polished noneditorial photography, and in fact he shot last year's Sayle New Year family photograph. He has a family—or rather two, with a daughter each in London and New York. He has made films, as writer, director, presenter, and cameraman, for the BBC and the British Fourth Channel, about postwar Vietnam, Thailand, Pitcairn Island, and other topics. He spent much time in Southeast Asia; but if he has found another Vietnam, he has not so far told anyone about it. His obsession is not with war itself. One country, and one war, gave Philip the chance to say something very profound, very important to him, about life as he sees and understands it. Like Goya, he has found neither the need nor the occasion to say it twice. Time, therefore, to turn to his images, the last of their kind we shall see, made in unrepeatable circumstances, by a rare talent—by my fearless friend Philip, a most original photographer with a very Welsh kind of genius.

Murray Sayle

edens

My photographs in this book record a journey that began forty-four years ago, in a small village in Wales.

I discovered photography among various youthful distractions. As I immersed myself in the subject, I came across a statement by Henri Cartier-Bresson, explaining that with a camera the discovery of the external world simultaneously reveals the internal world. I found this prospect electrifying: it had to be the key to a meaningful life!

Wales has a puritanical culture and a heritage of strict morality. While I had no difficulty rejecting mandates hurled from the pulpit, in ensuing arguments I found myself embracing the idea that life should have a purpose. I now felt lucky to have discovered one.

Reveling in my new-found calling, I set out to explore my own country. With my prophetically named Agiflex camera around my neck and Camus's *The Stranger* in my pocket, I took delight in being the silent observer in rowdy crowds, the all-too-visible invisible man.

Thus far, the journey has taken me to almost every country. I've seen the world evolving rapidly; my task has been to try to make sense of it all.

Most of us live in artificial, man-made worlds that limit our experiences. I was fortunate to be able to wander for months among the Stone Age tribes who inhabit the Central Highlands of New Guinea. Theirs was a society with a life-style beyond Rousseau's imagination: a highly complex structure with rules as strict as any found in the West. Often thought of as a belligerent, warring people, they have never sunk to the barbarity of Europeans. For instance, they settle many of their disputes by shaming their enemies, presenting them with gifts they cannot afford to reciprocate.

This Eden, like all the others, was doomed by the arrival of "civilizing" foreigners with their baggage of bourgeois morality—Christian missionaries leading the way with their cult of death. (Nevertheless, I once met a sceptical chief who explained that the communion bread and wine given him were definitely no one's flesh and blood. He declared that, while the missionaries might be deceived, *he* could tell the difference).

The industrialized nations are performing a slow genocide on the peoples of the world by the eviction of peasants from their land, the urbanization of society and the imposition of a uniform consumer culture. The transformation of Indian society is far advanced by Murdoch's satellite television. Brains are being electronically pickled—no need to weave, sing, dance or even talk when the latest soap hits the dish.

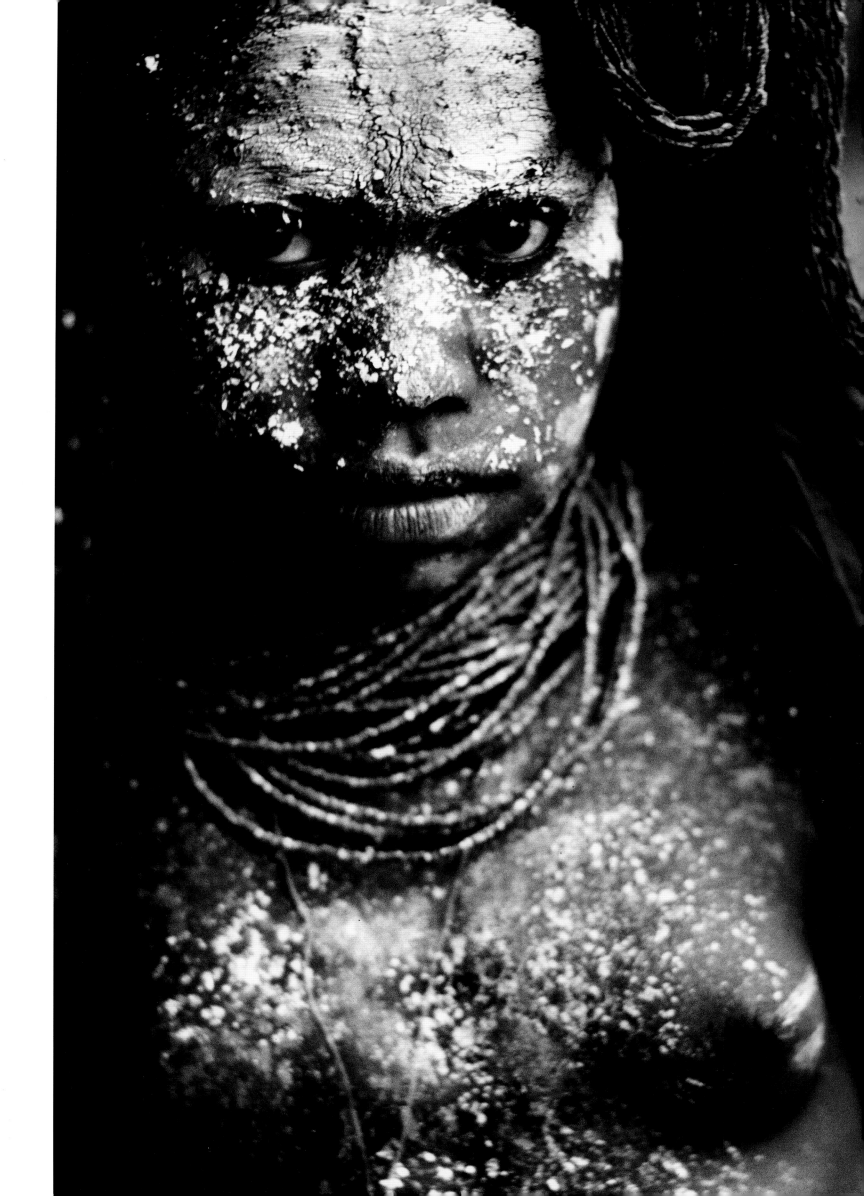

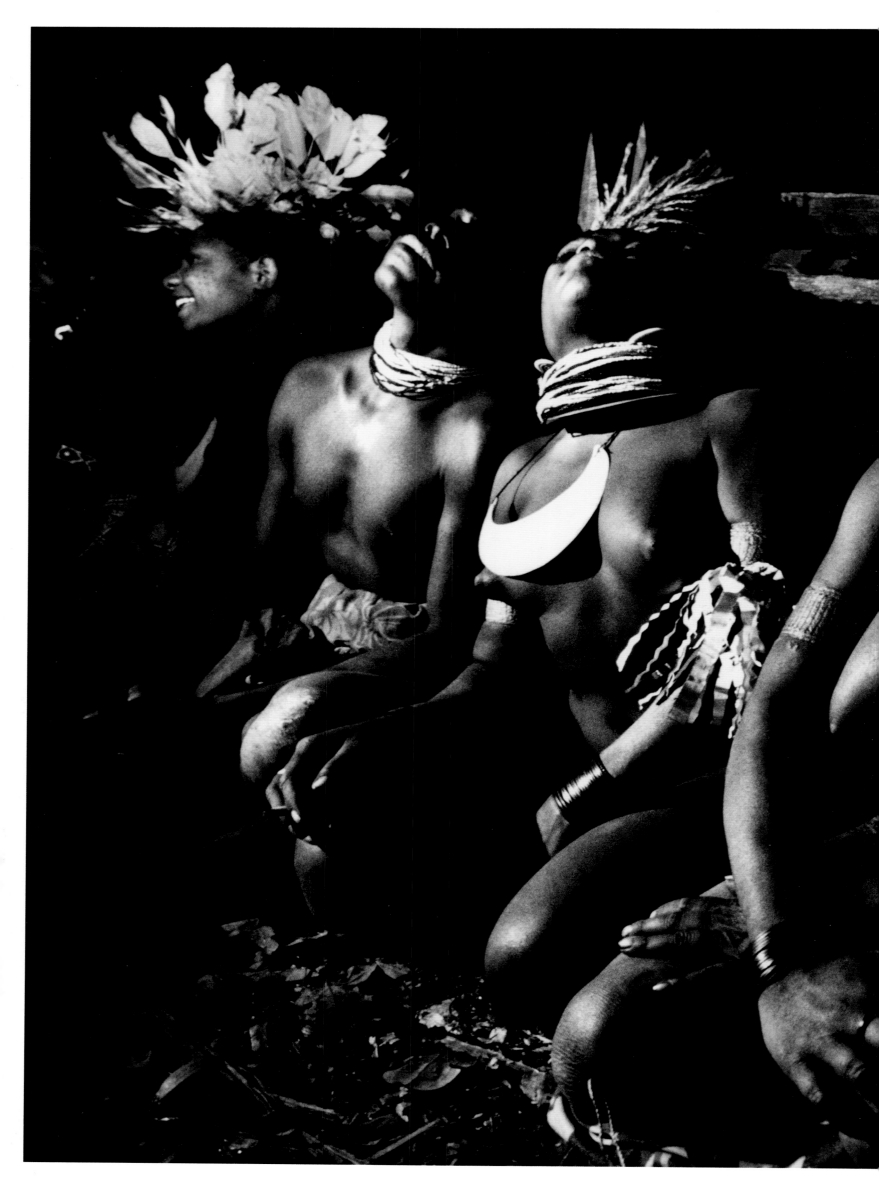

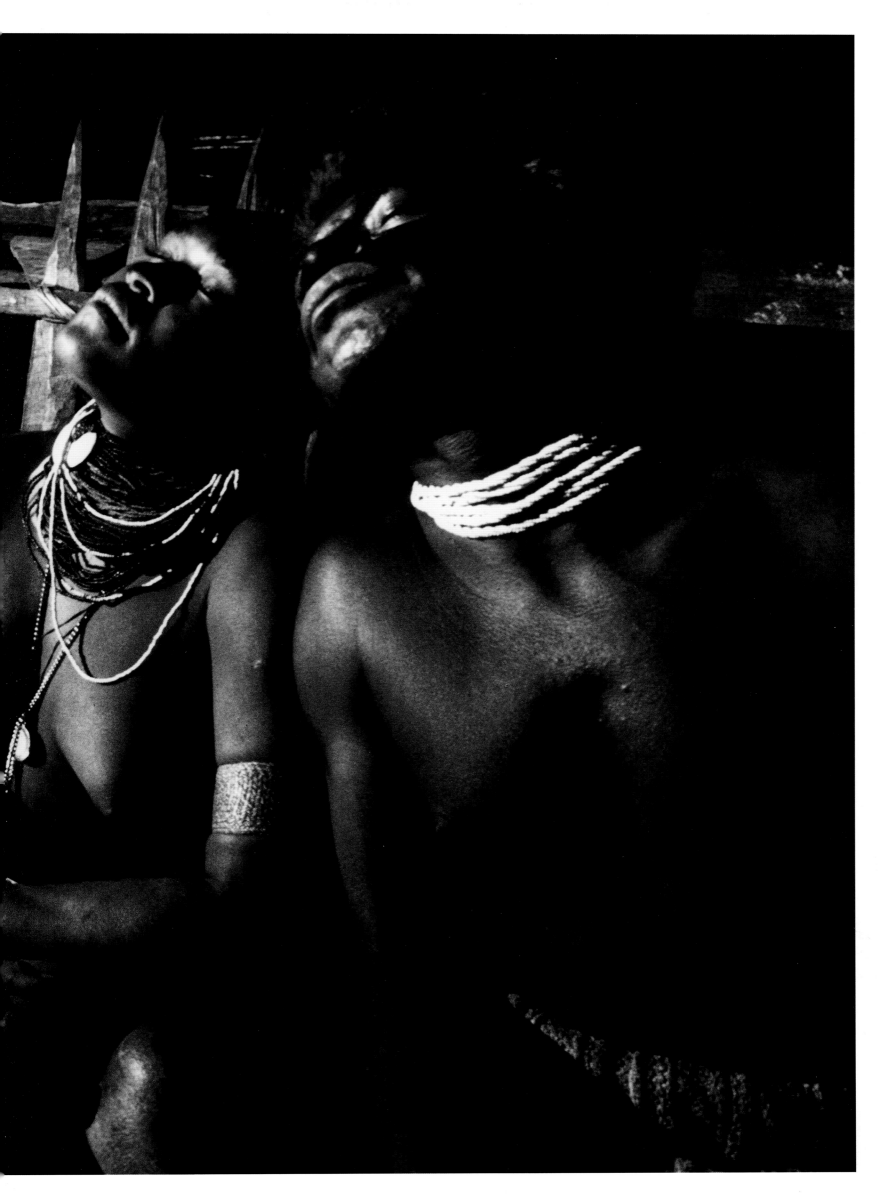

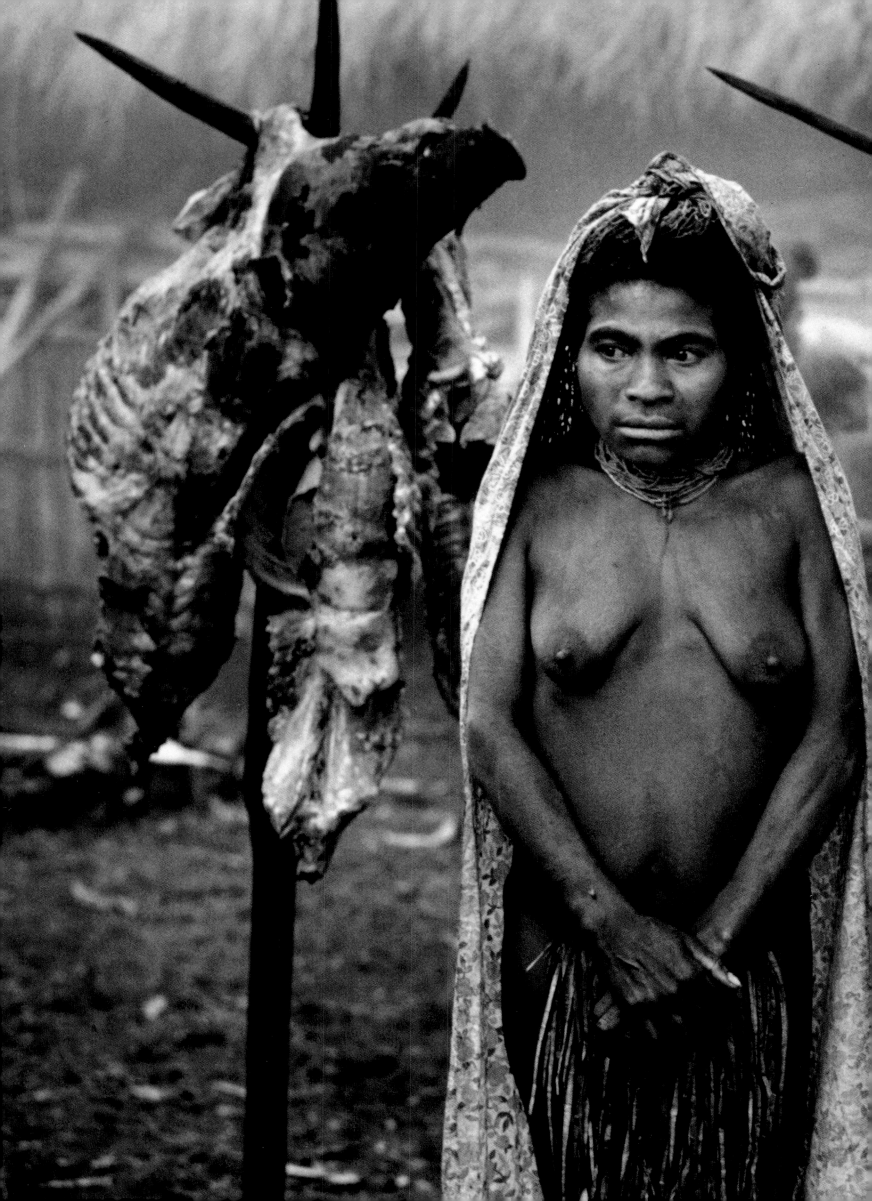

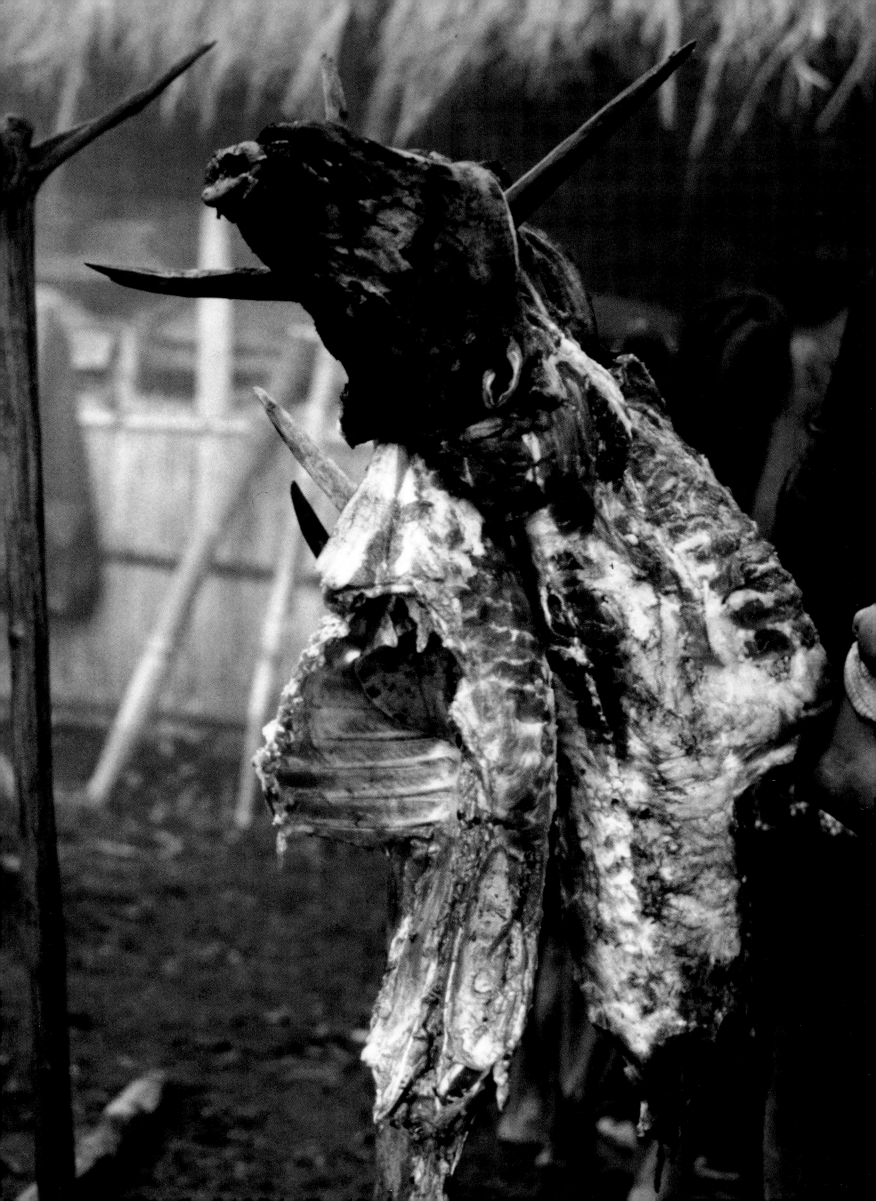

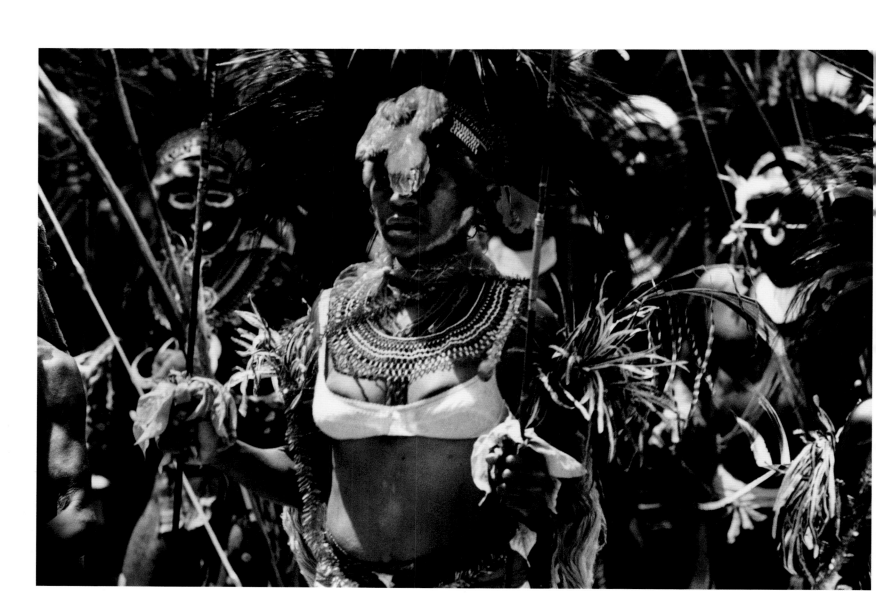

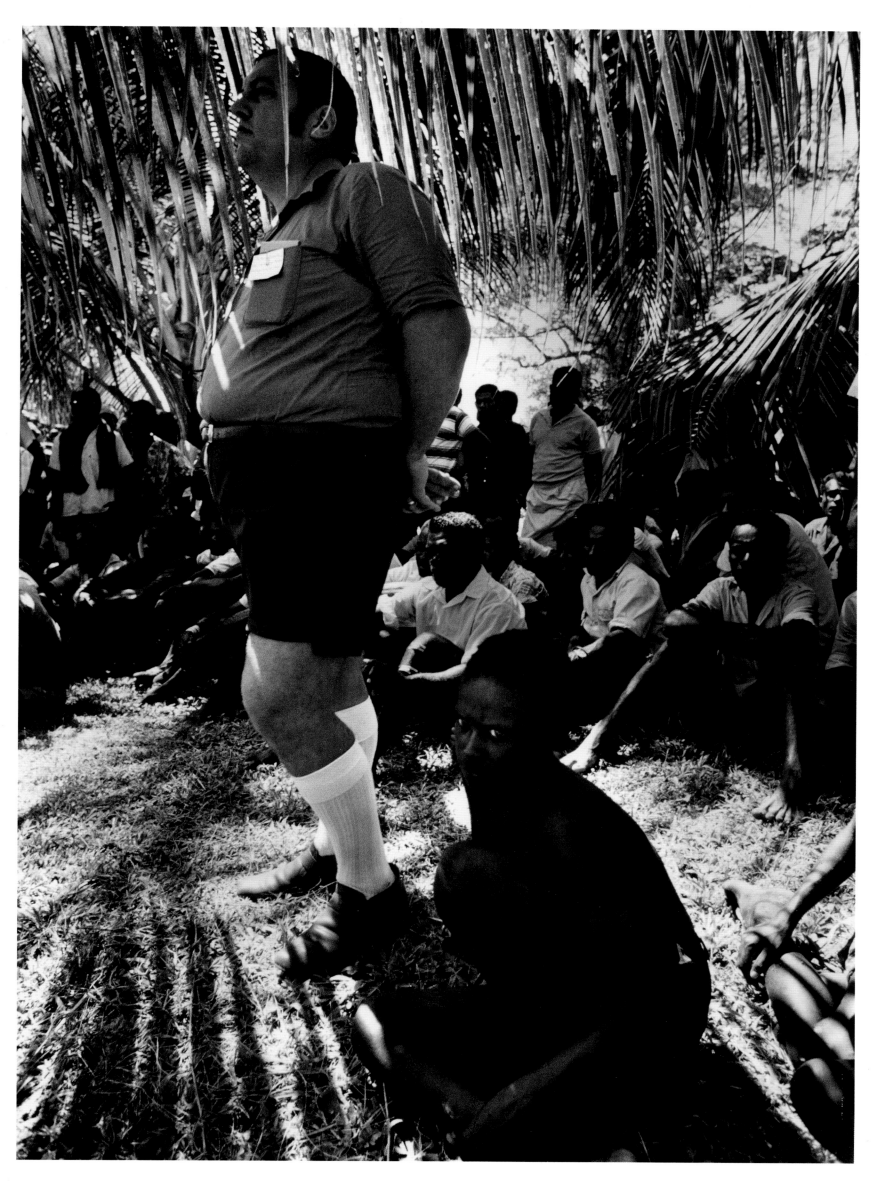

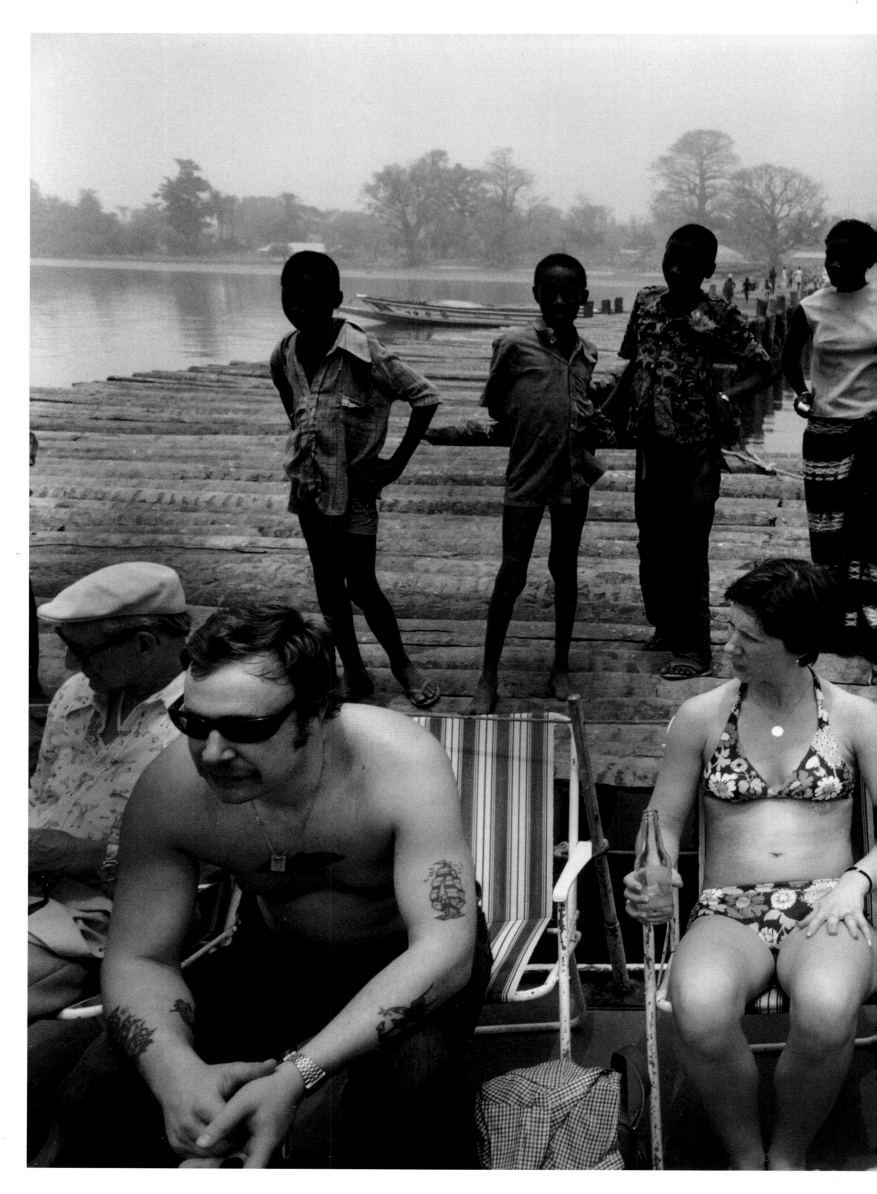

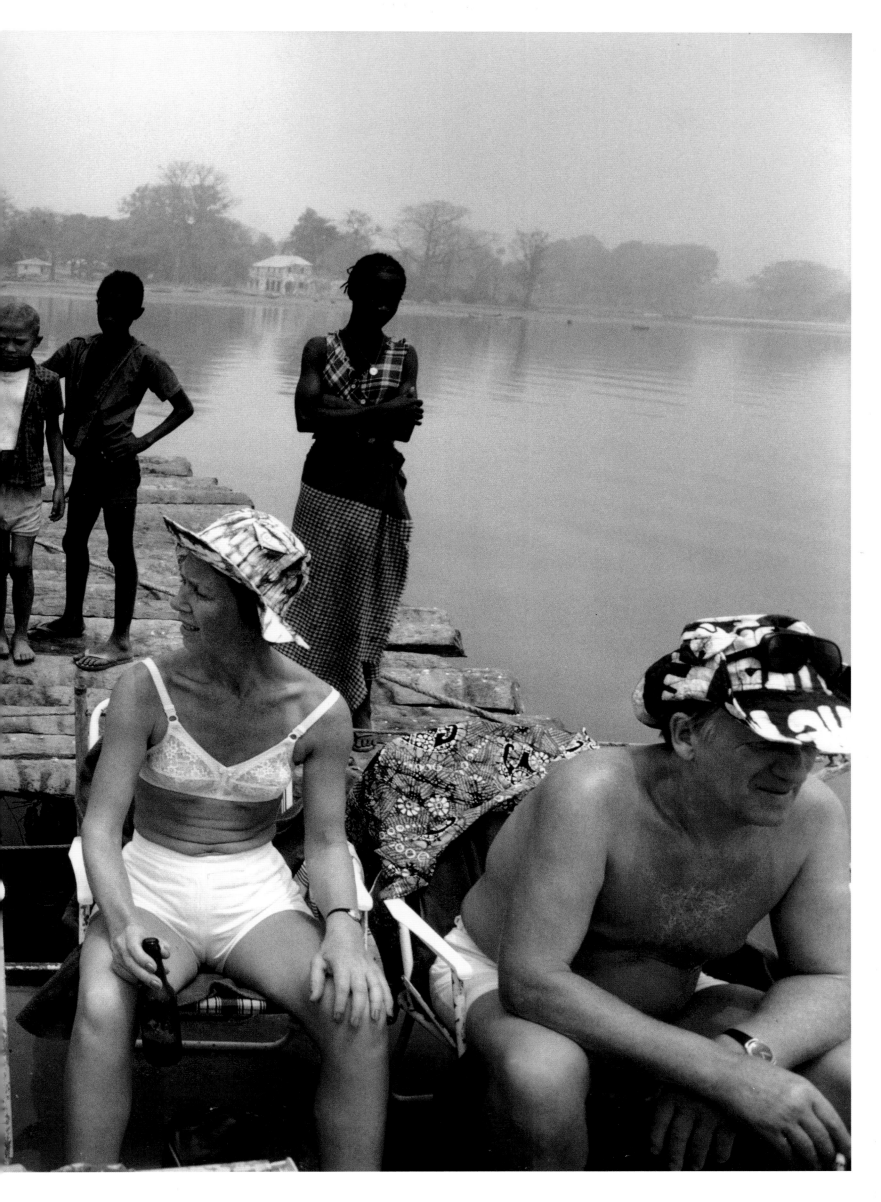

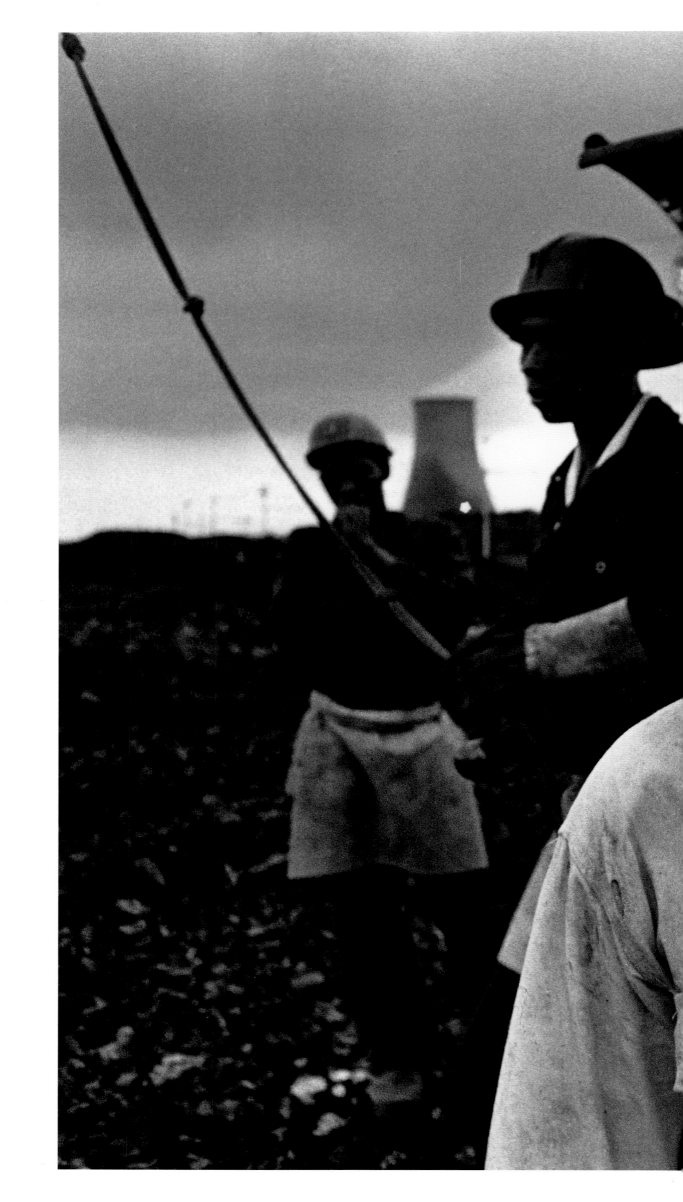

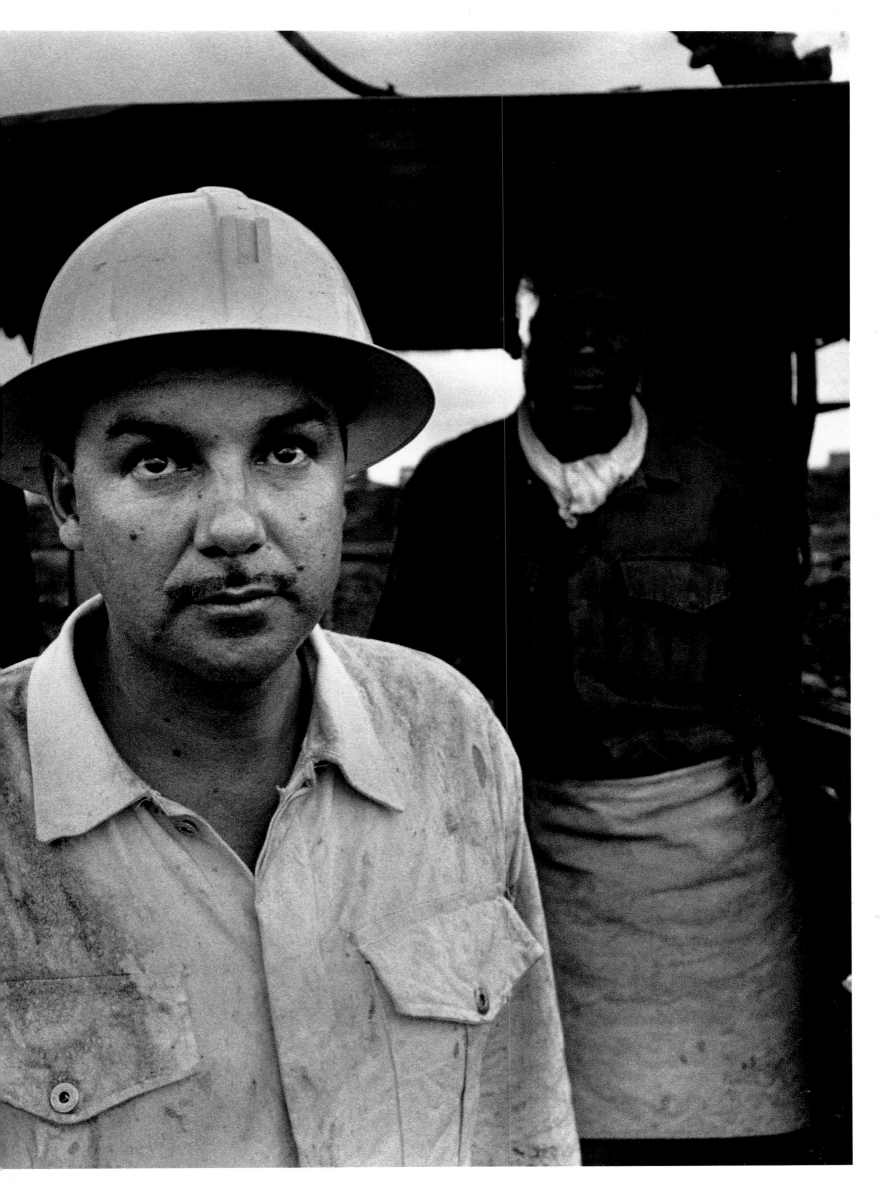

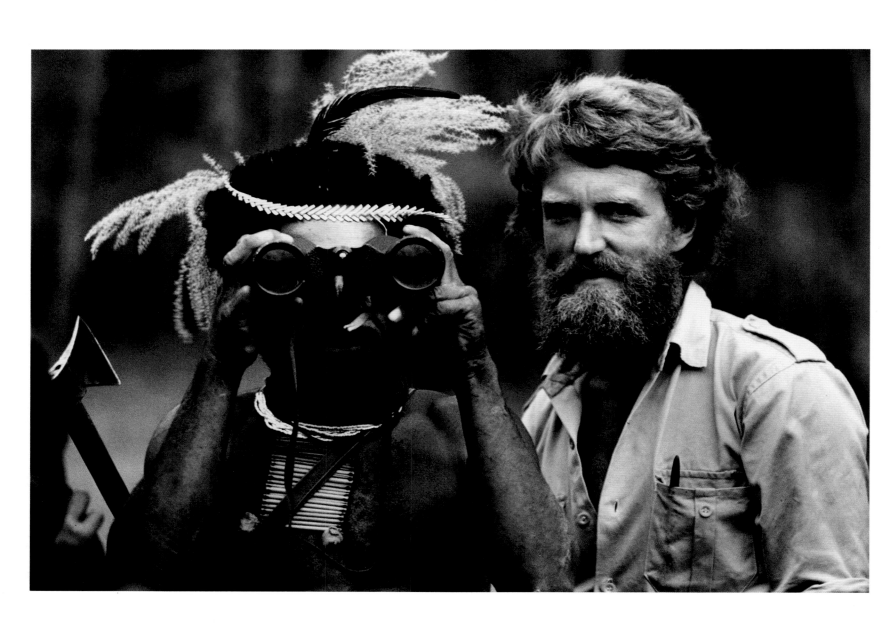

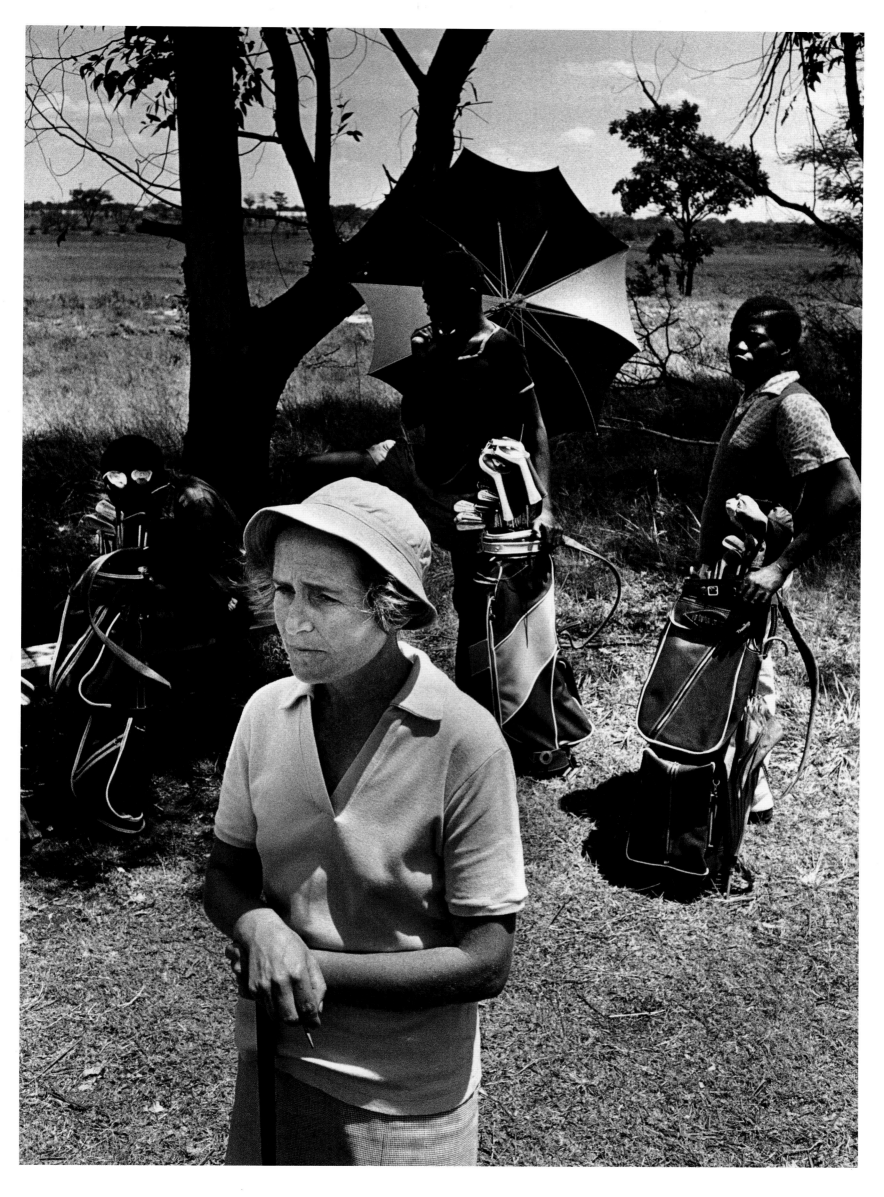

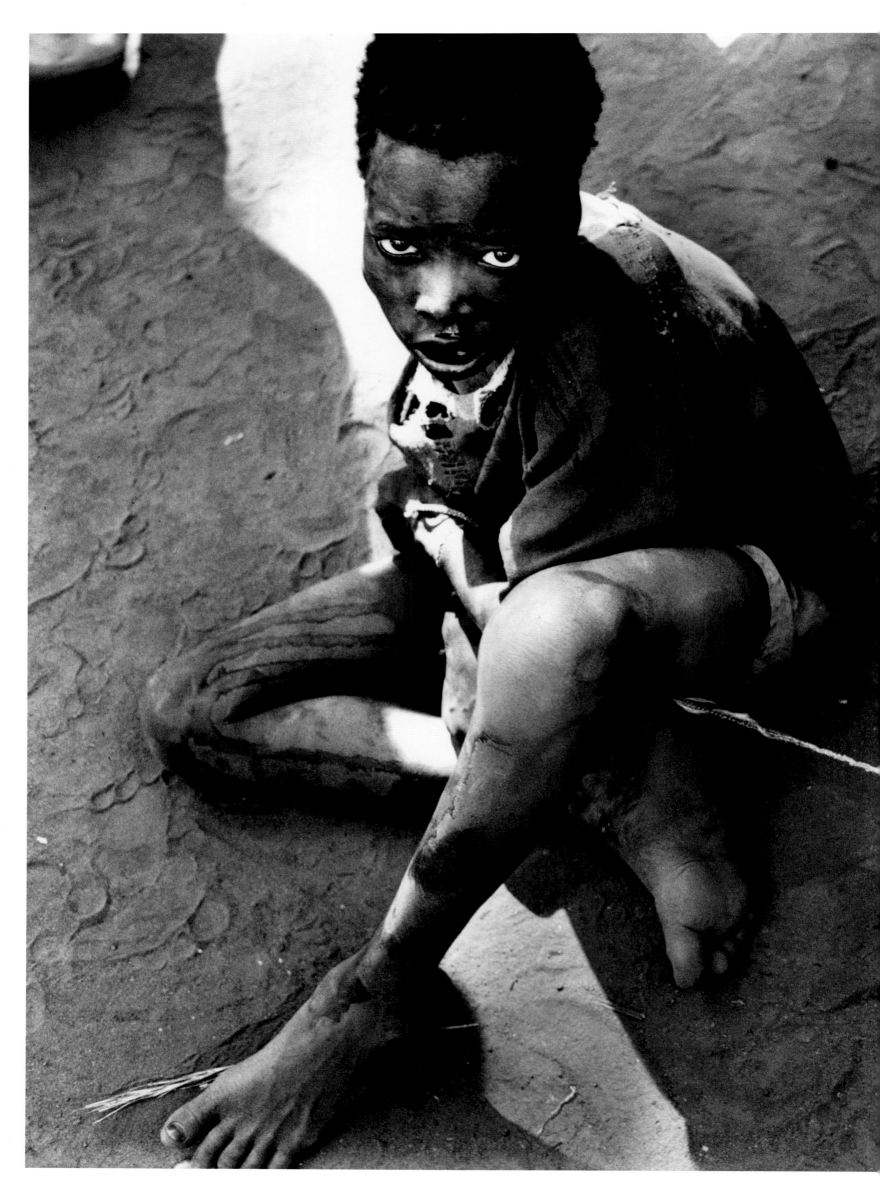

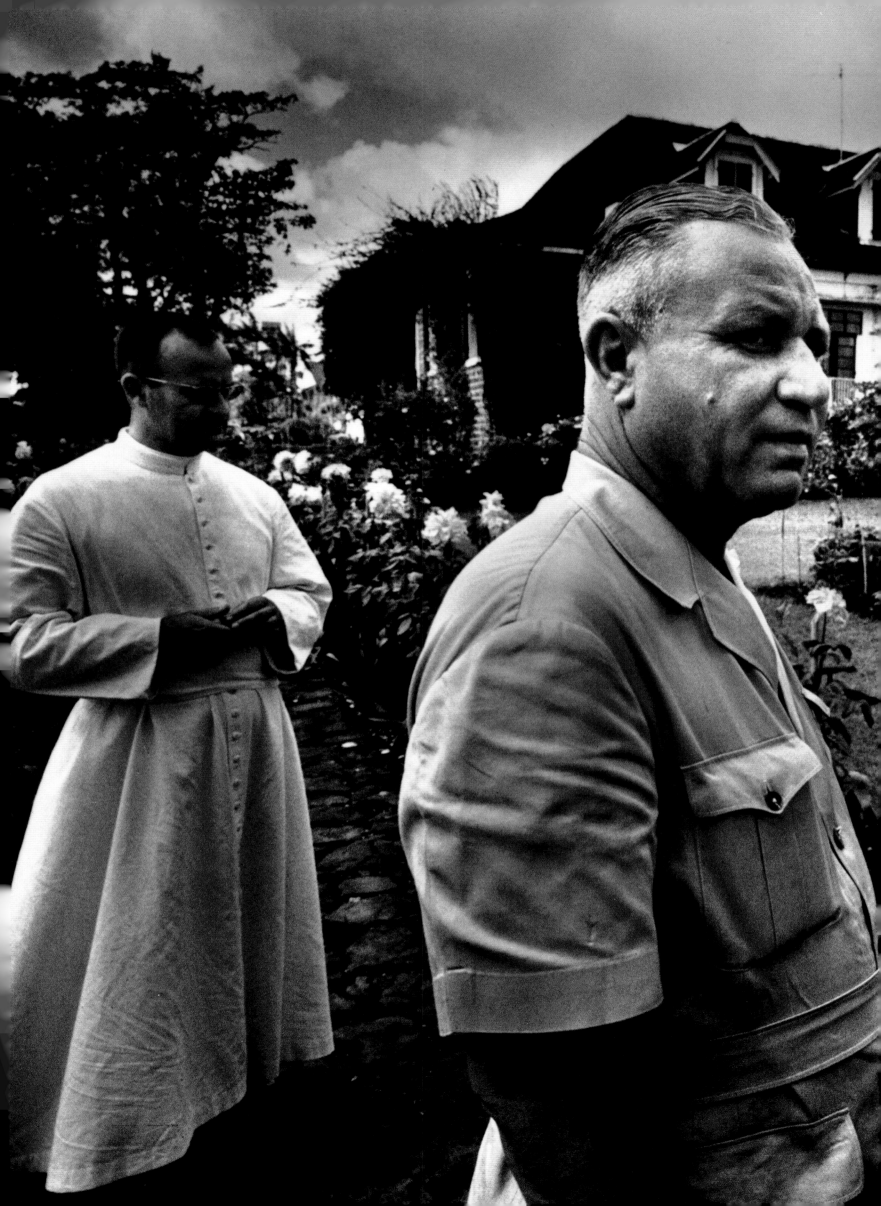

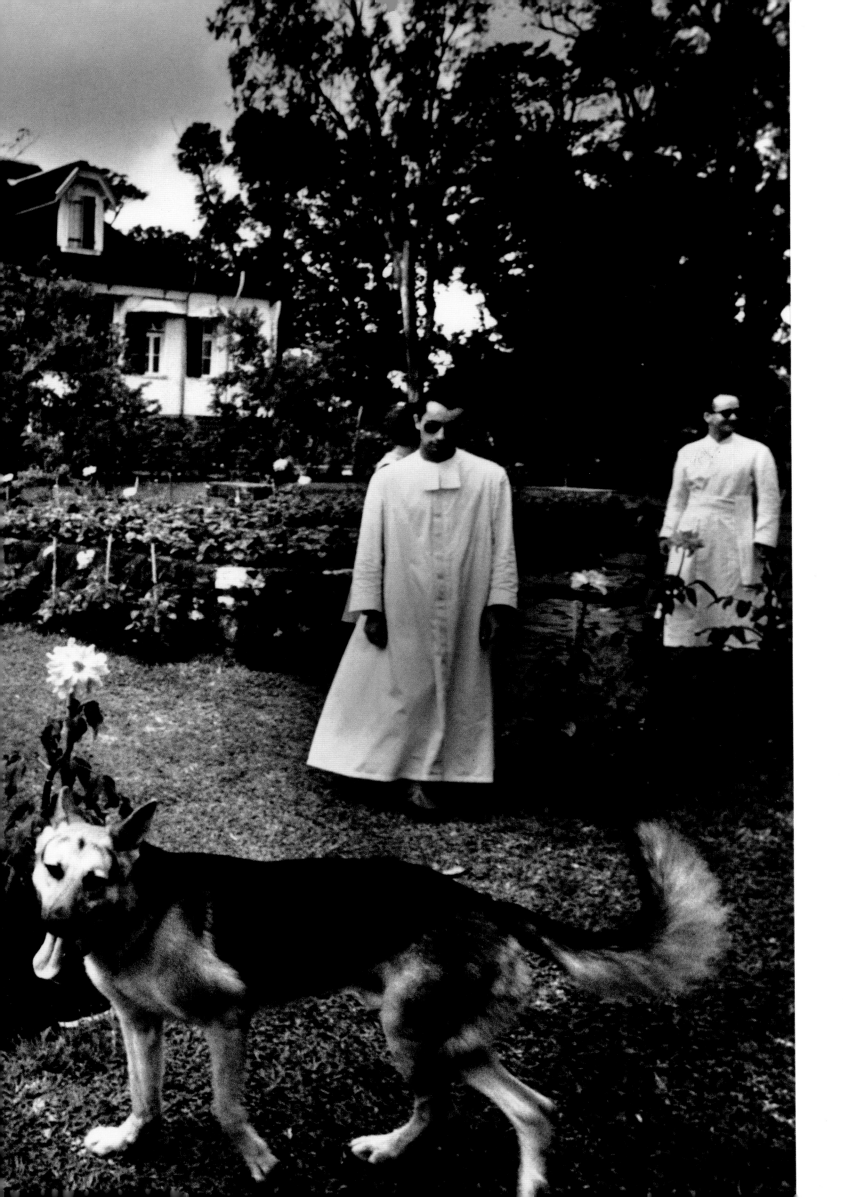

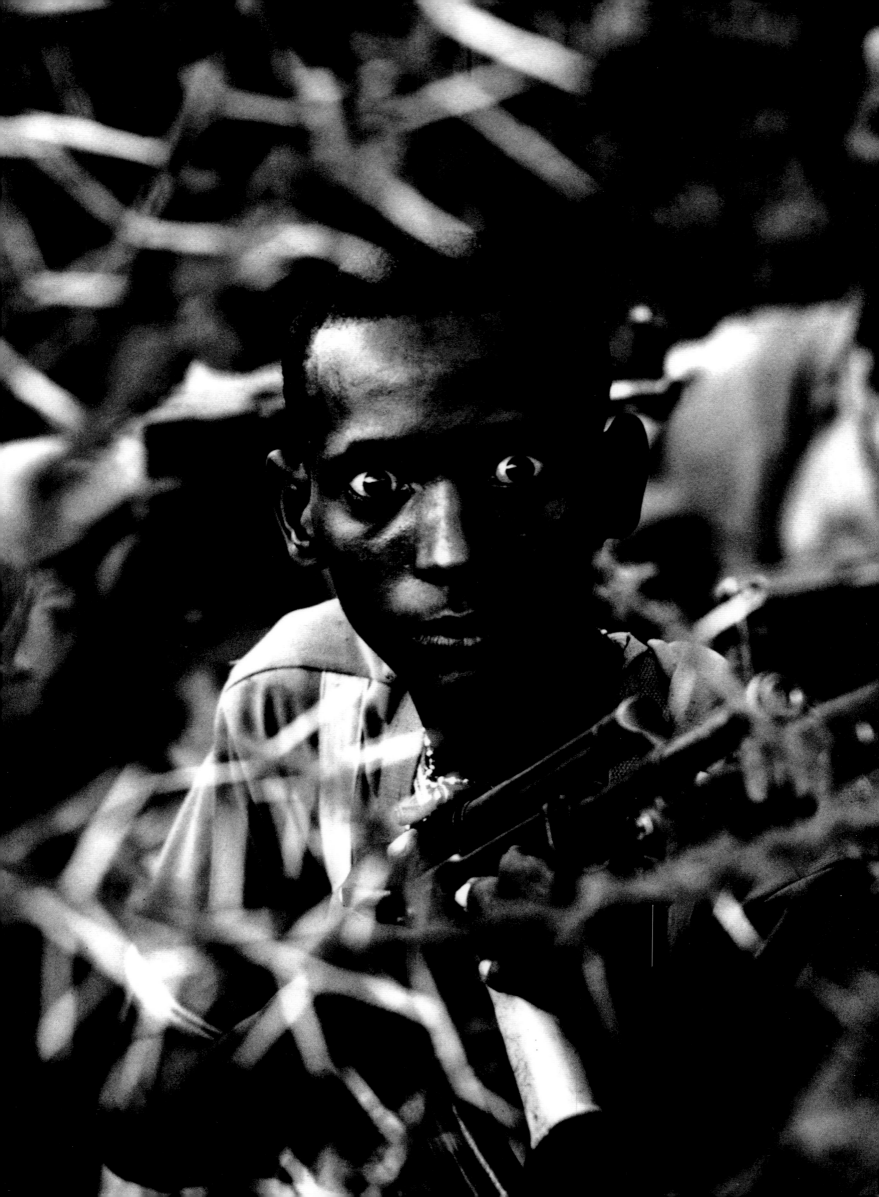

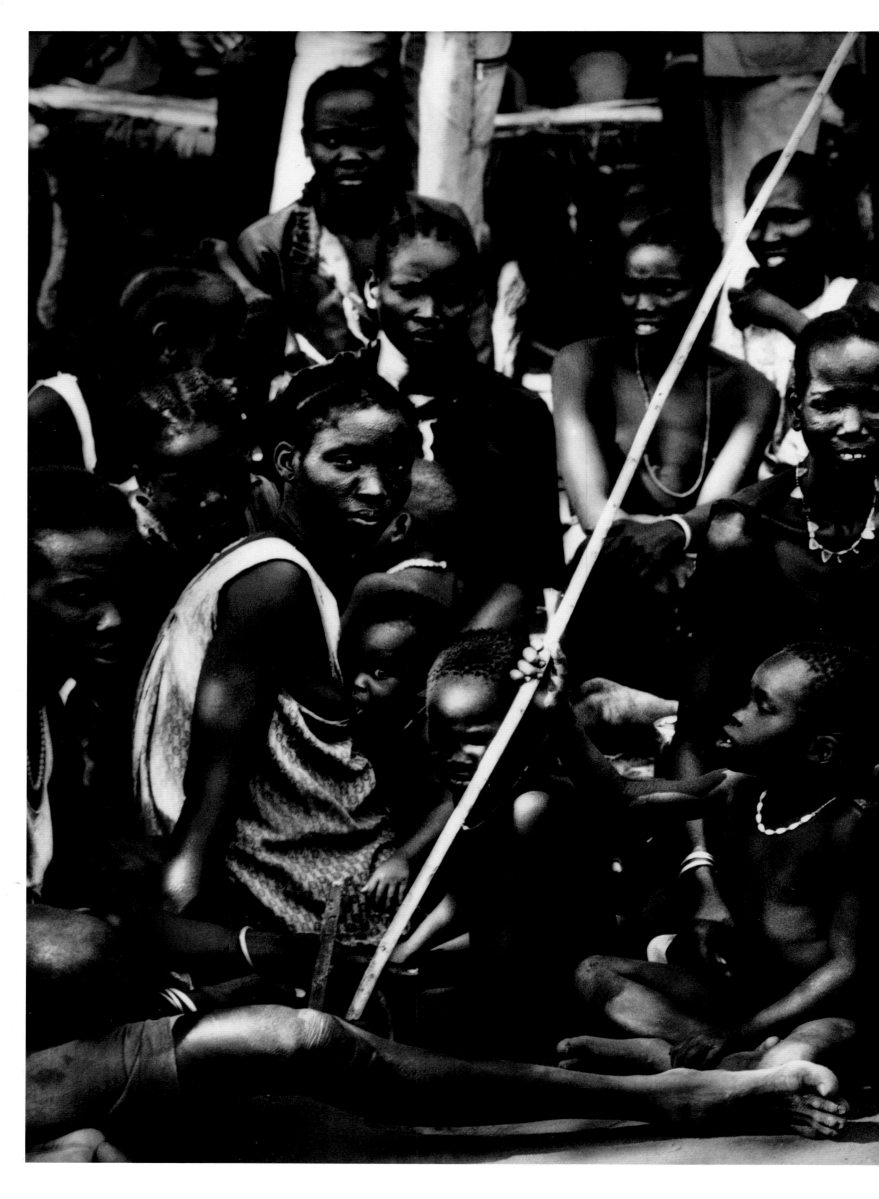

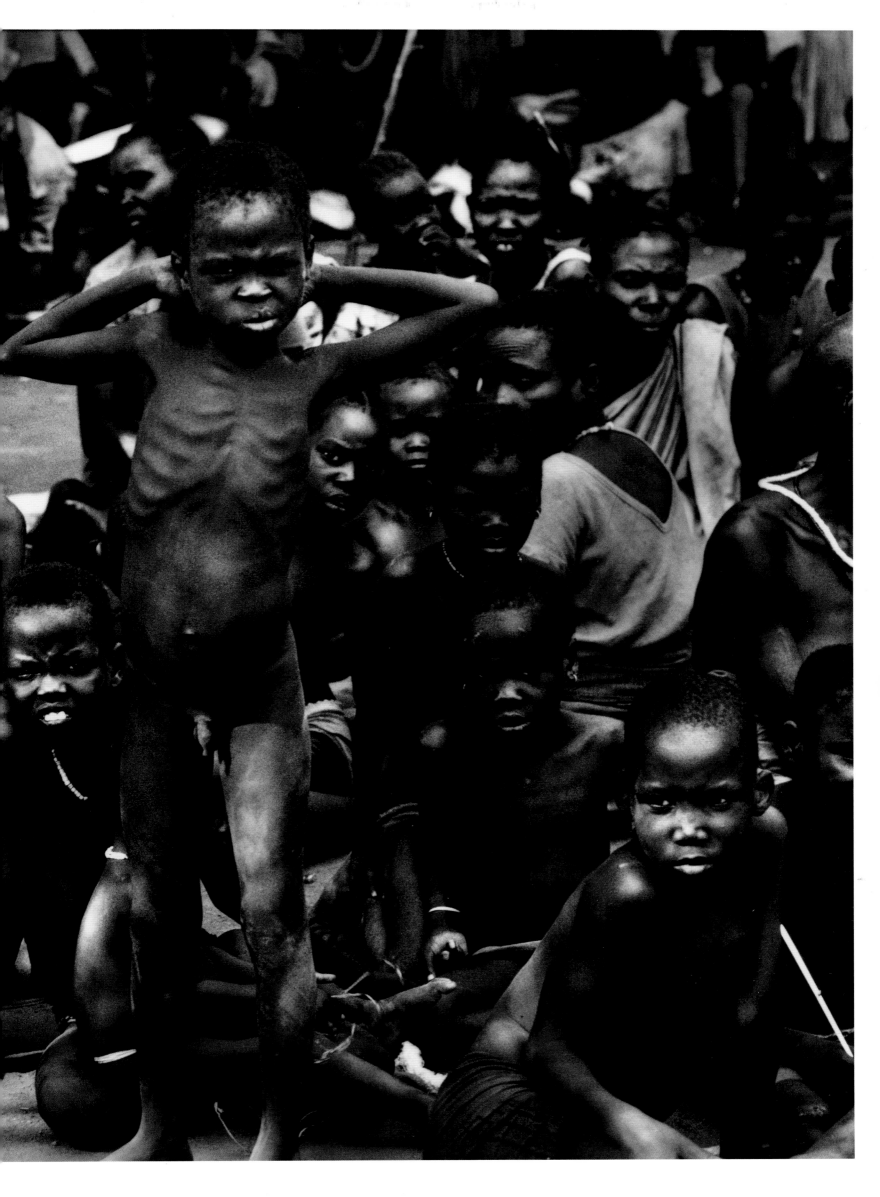

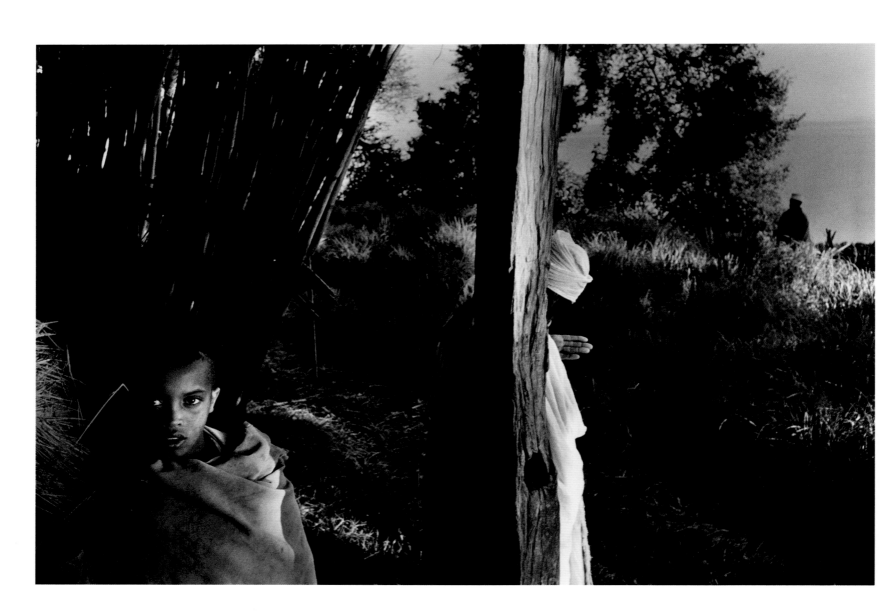

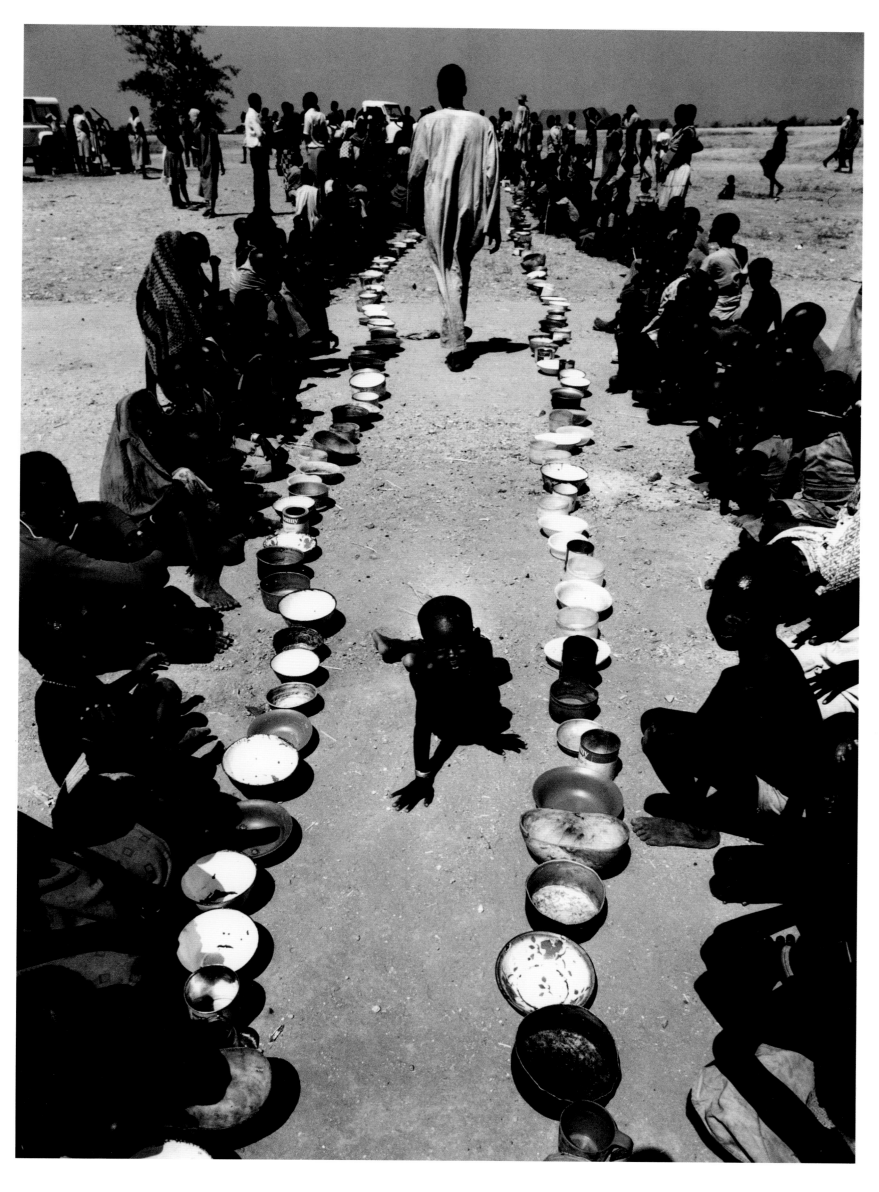

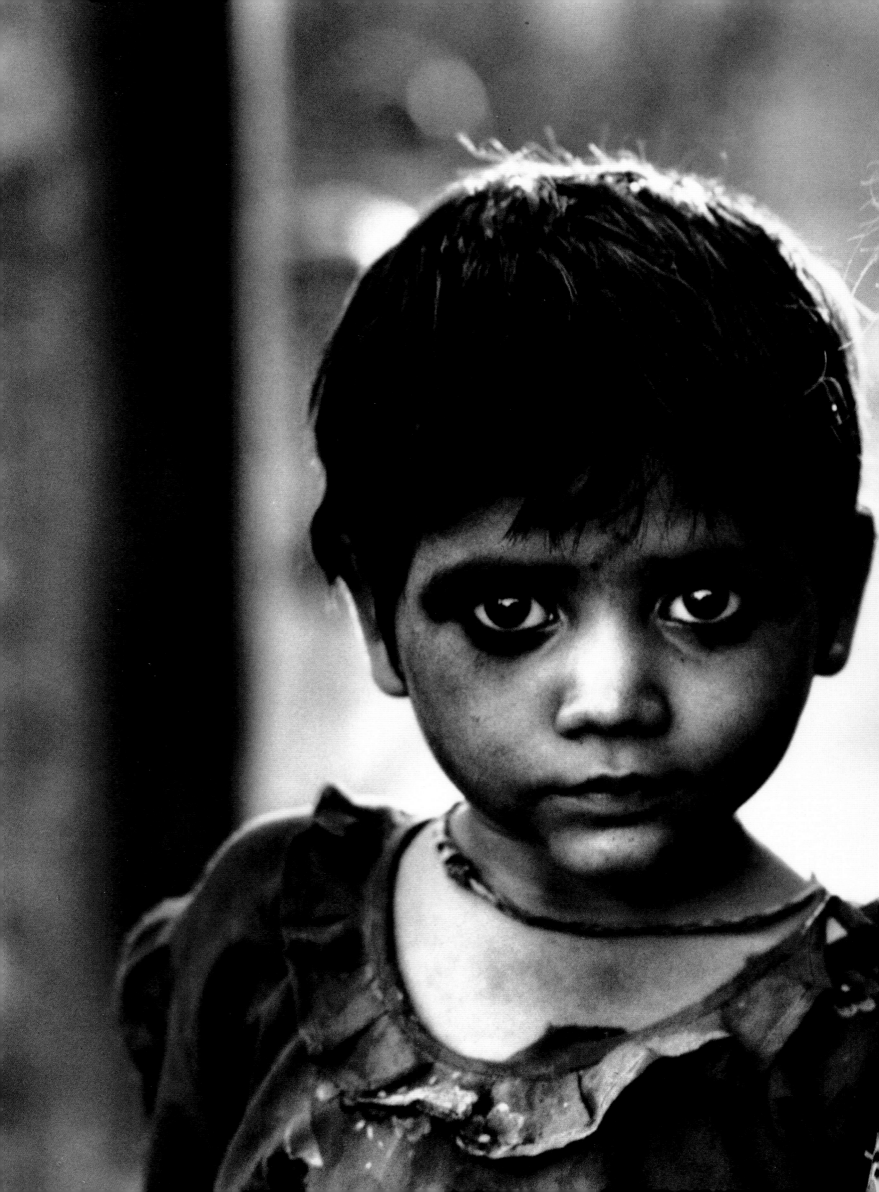

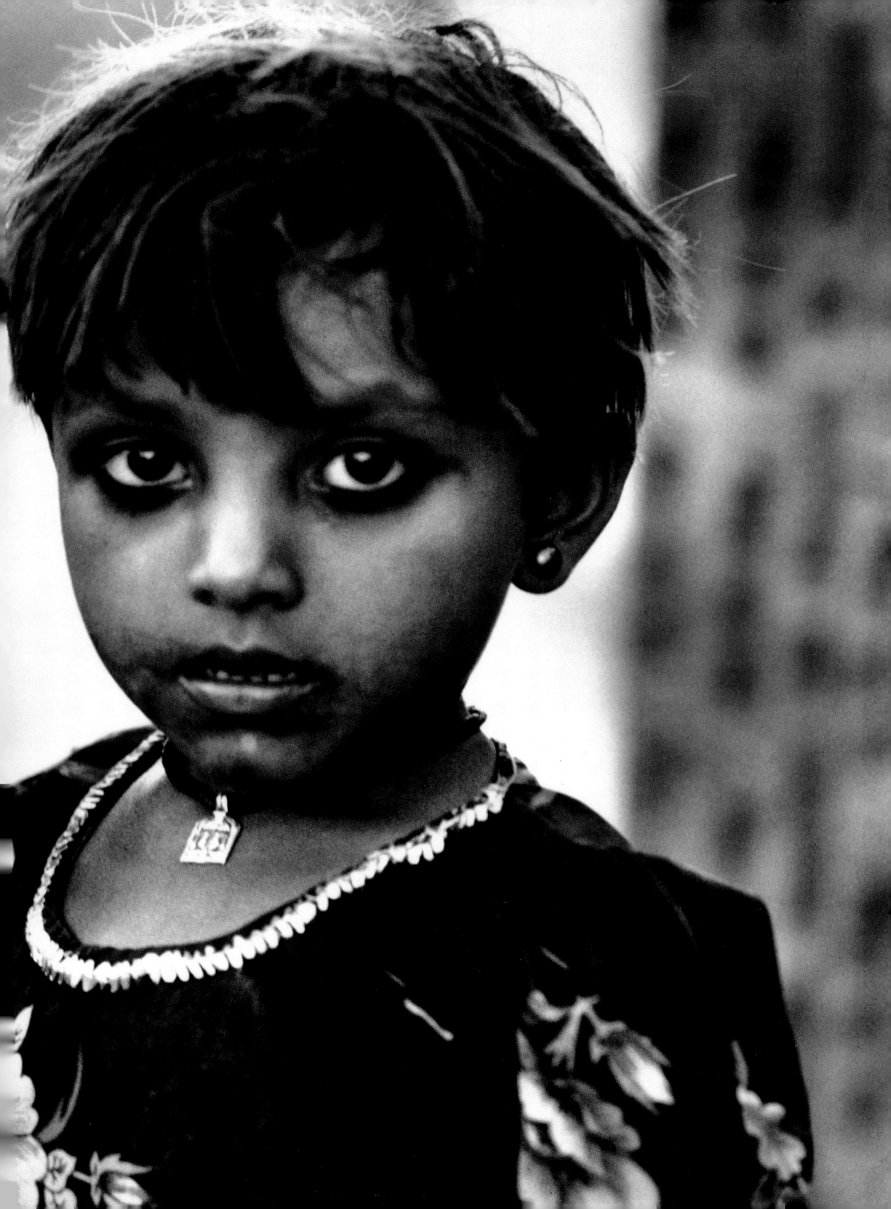

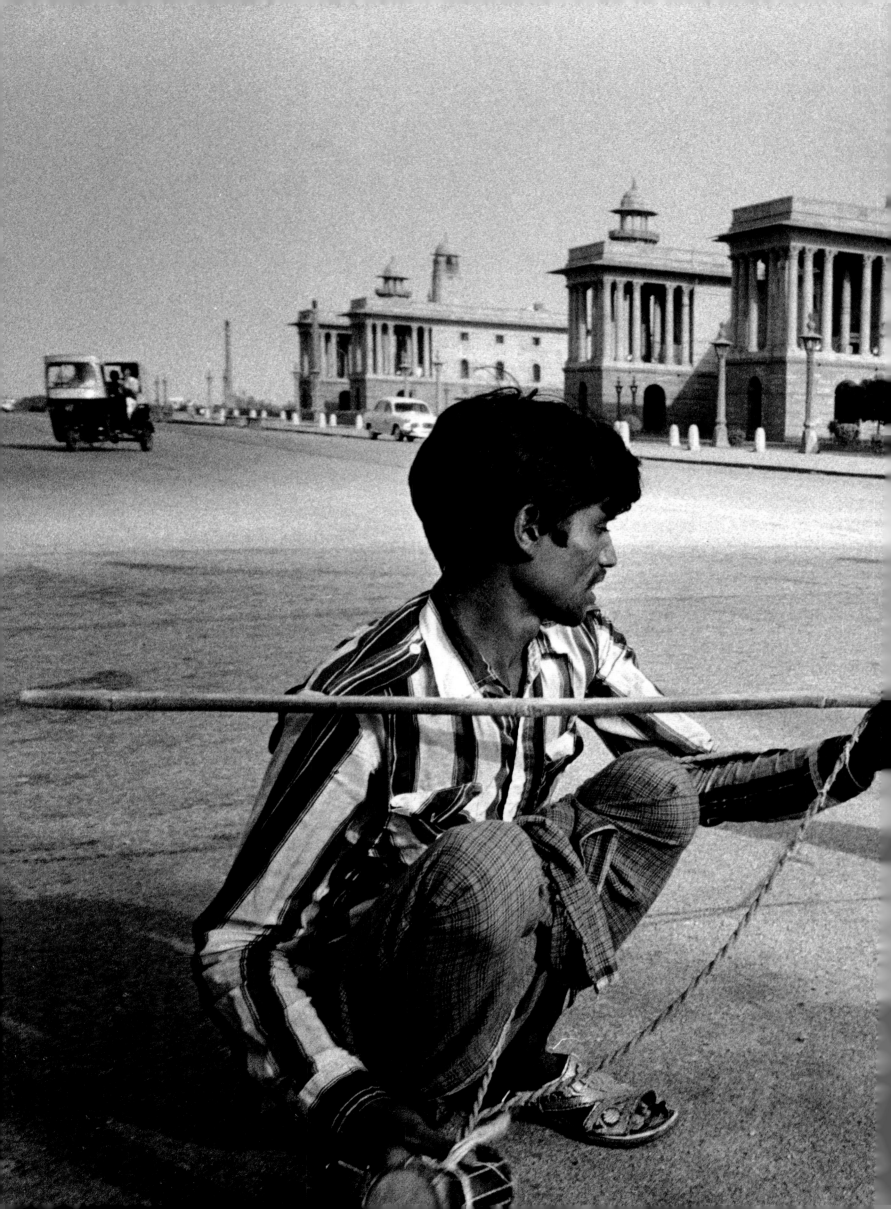

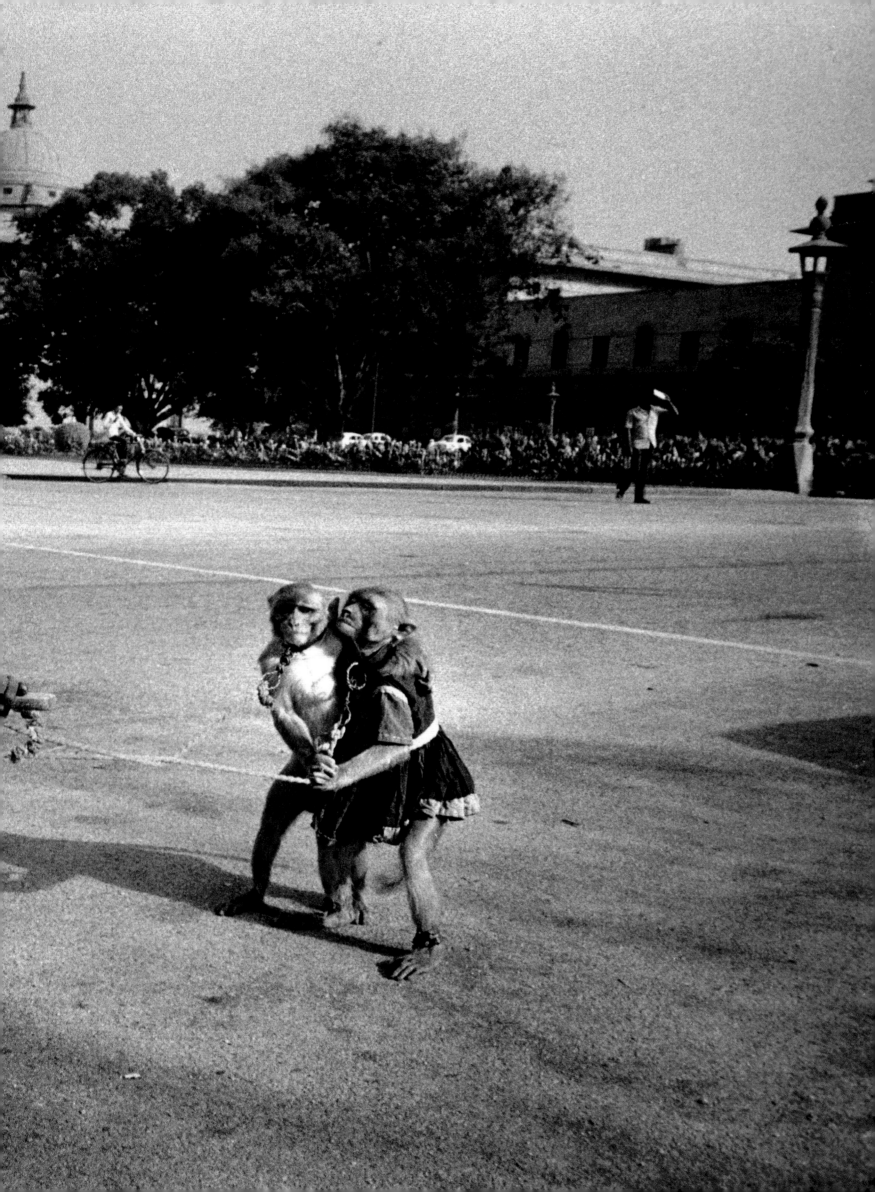

strife and alienation

Growing up in postwar Britain could be considered a privilege of sorts. As the country went through major upheavals, life was never boring. The colonies gained their independence and our power and wealth declined. Soon, the achievements of the Socialists came under attack from the Right—a new and wily Tory party. Arguments raged over the way to move forward. I became embroiled in the maelstrom of political debate. Working mostly on political stories, for the *Guardian* newspaper and later the *Observer*, I had an excellent opportunity to study developments firsthand.

Photographers in those days were not taken very seriously, so subjects would often drop their guard. I learned a lot as my camera provided an entrée into the world of political machinations. I had a grandstand view of most of the Deadly Sins—especially greed—and unbridled hypocrisy. Observing the symptoms so clearly, I eventually came to understand something of the nature of the underlying disease.

Class division flourished in Britain, and still does. The restless many struggle in imposed poverty while the opulent few are firmly in control of their own destinies. Everywhere, more wealth is now concentrated in fewer hands than ever, while the population is duped into believing the converse. The sight of people voting against their own interests is never uplifting—still, witnessing this process has led to my enduring fascination with the workings of control and persuasion. By now, I have a healthy contempt for all officialdom and a profound mistrust of everything they say.

The conflict in Northern Ireland has provided a revealing study of the way the British State deals with an urban uprising. It is an unsavory little war that seems to have more to do with providing basic training in counter-insurgency techniques for the British Army than with keeping the peace.

During the "Swinging Sixties"—a euphemism coined, I believe, to disguise the public's growing alienation in matters of sex and human relations—I watched as a society, increasingly bored with consumerism, embraced new diversionary spectacles to feed its fantasies. In my travels I've been appalled at the treatment meted out by one half of the human race to the other—to the detriment of both. But then, my Celtic ancestors traditionally worshiped women, so perhaps I was born biased.

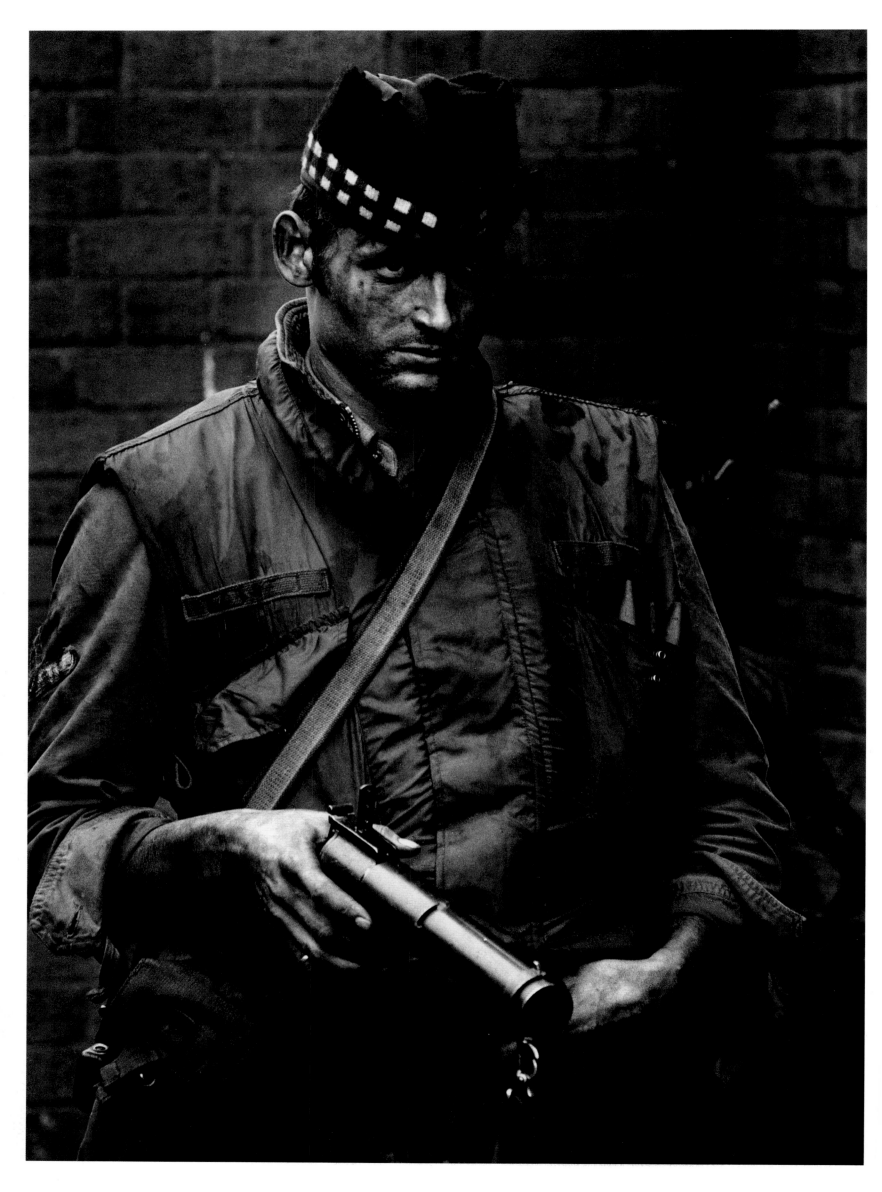

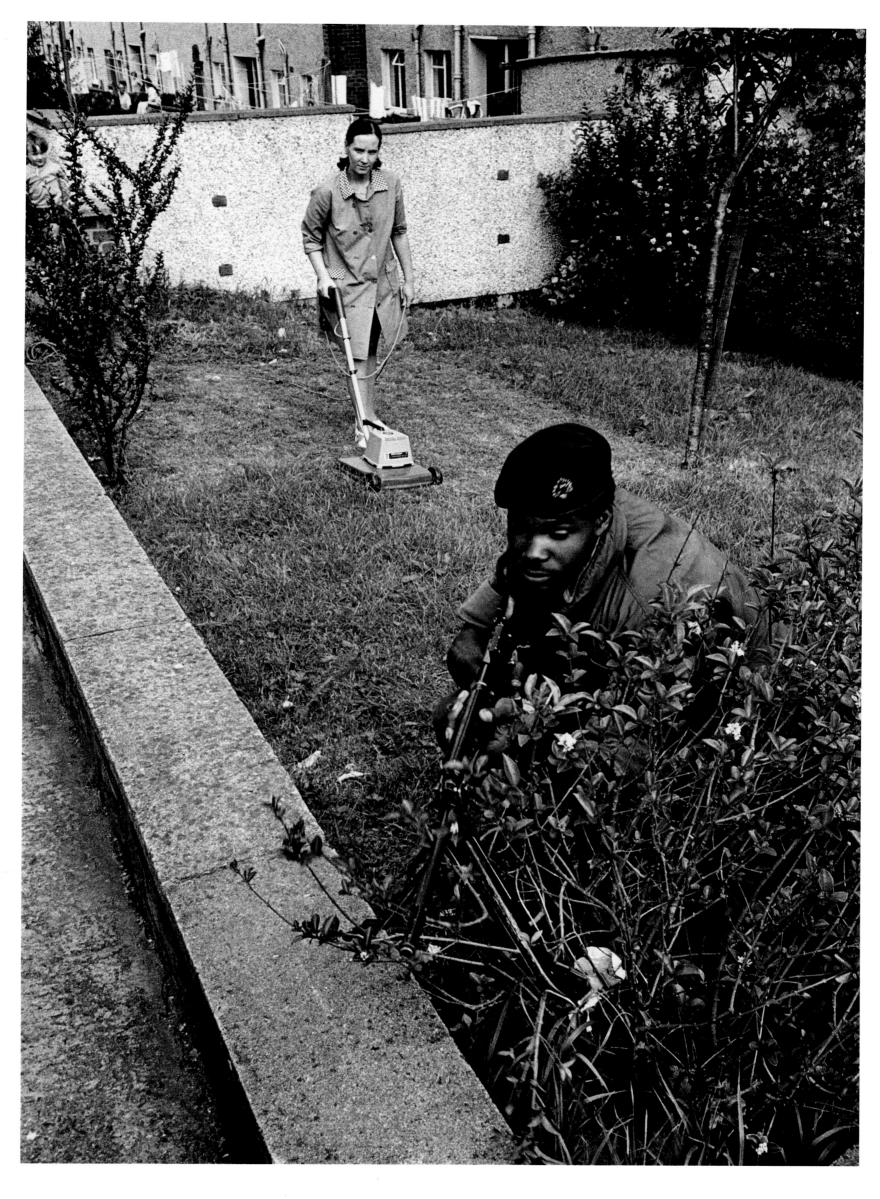

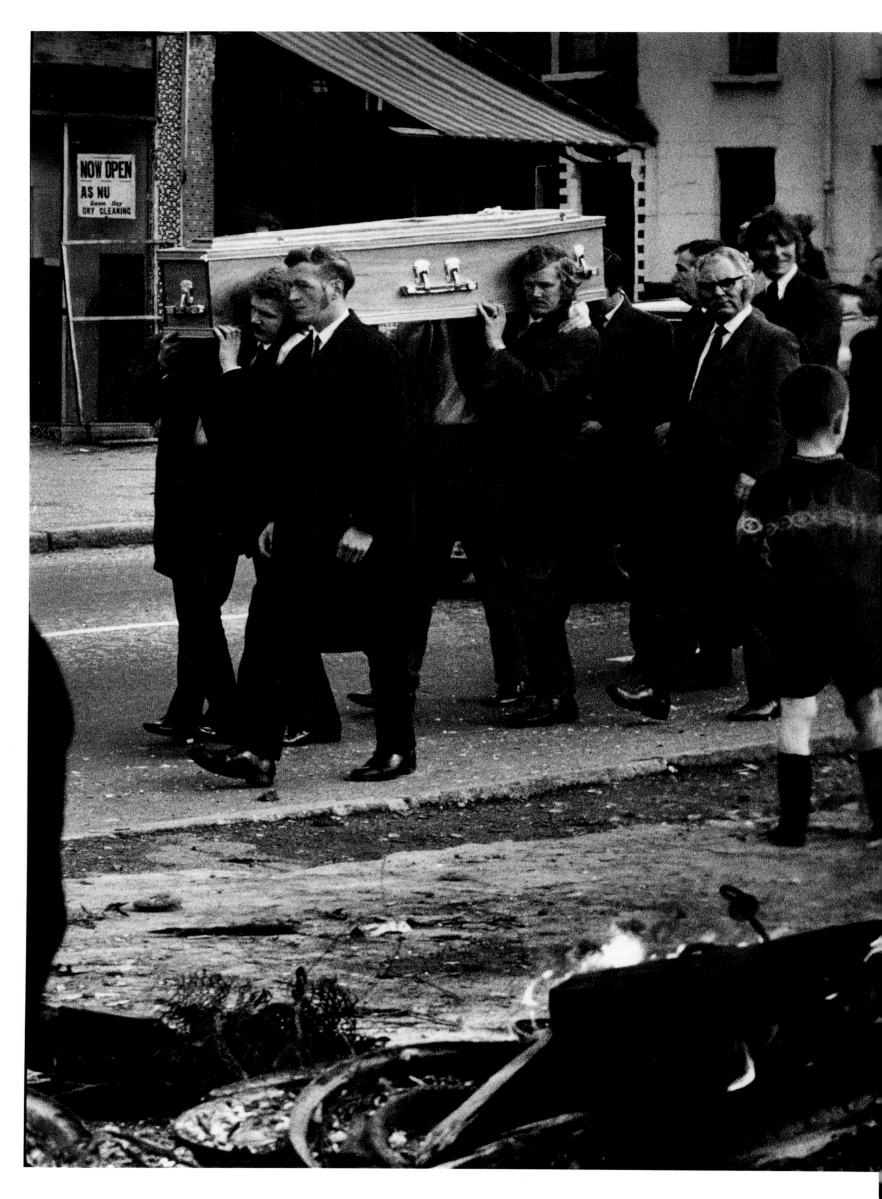

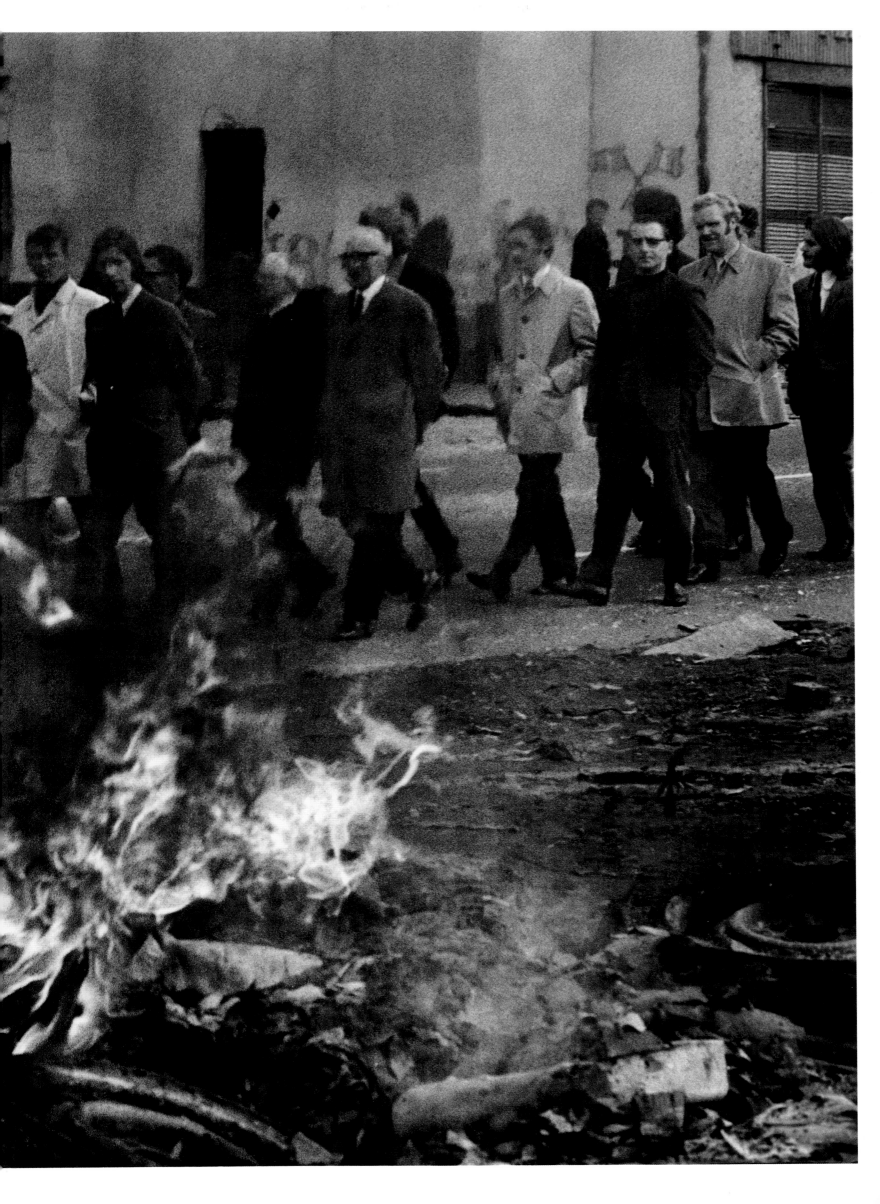

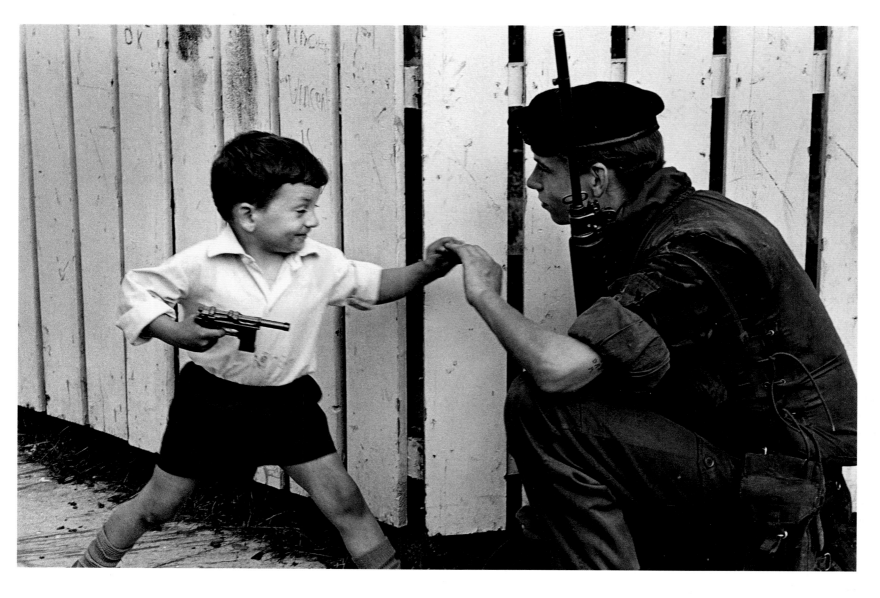
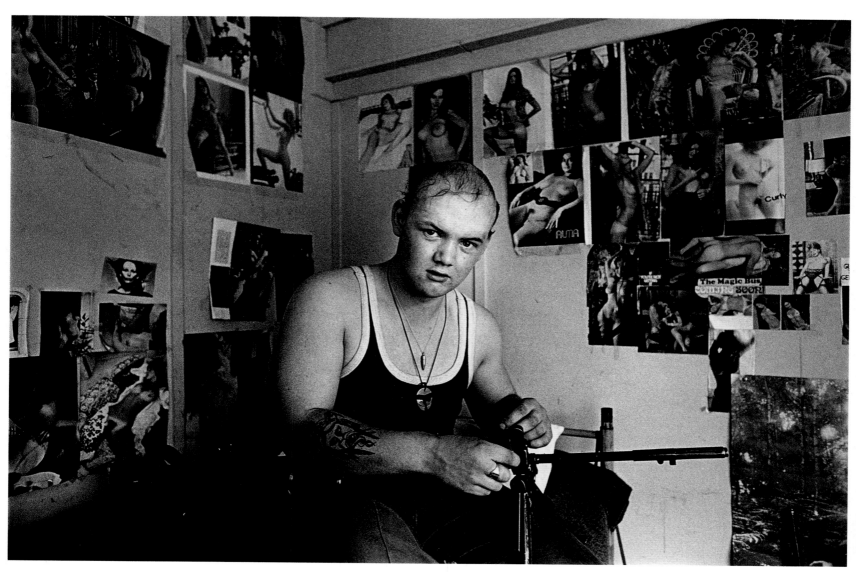

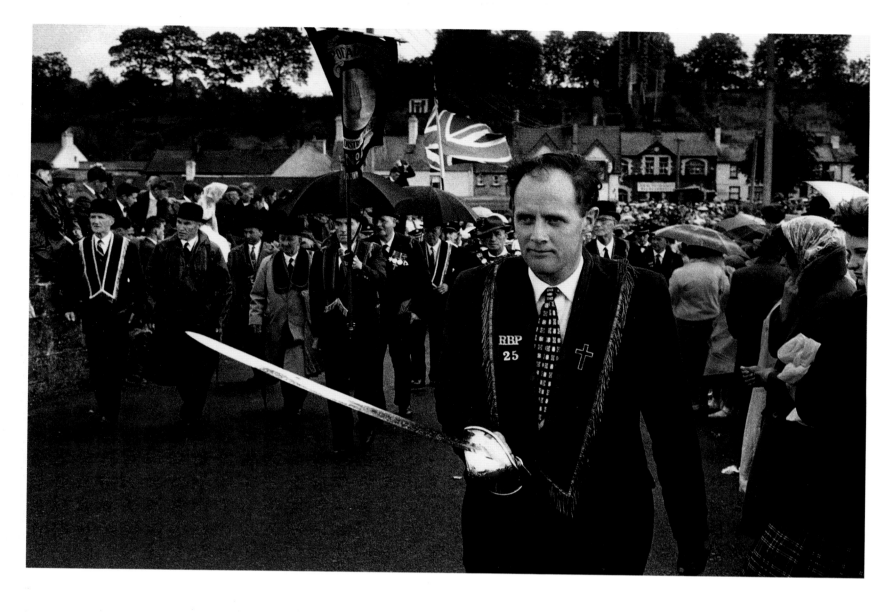

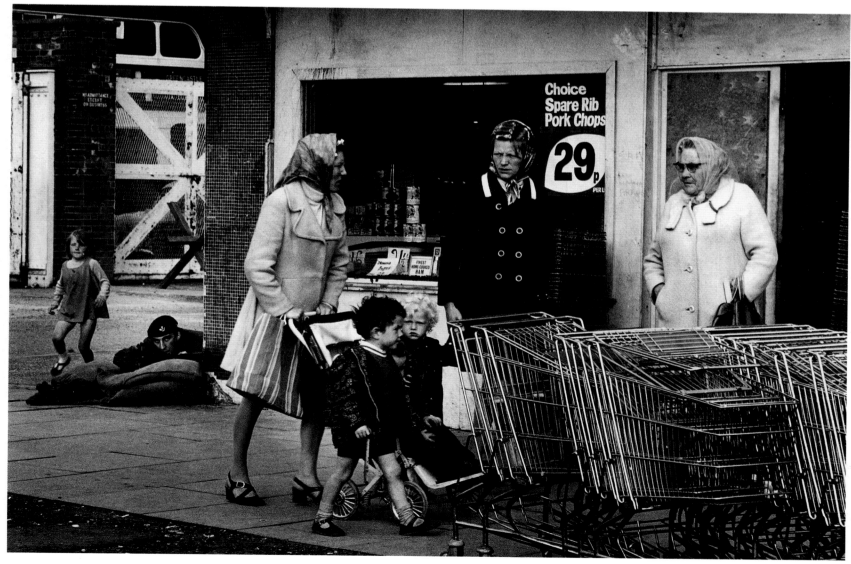

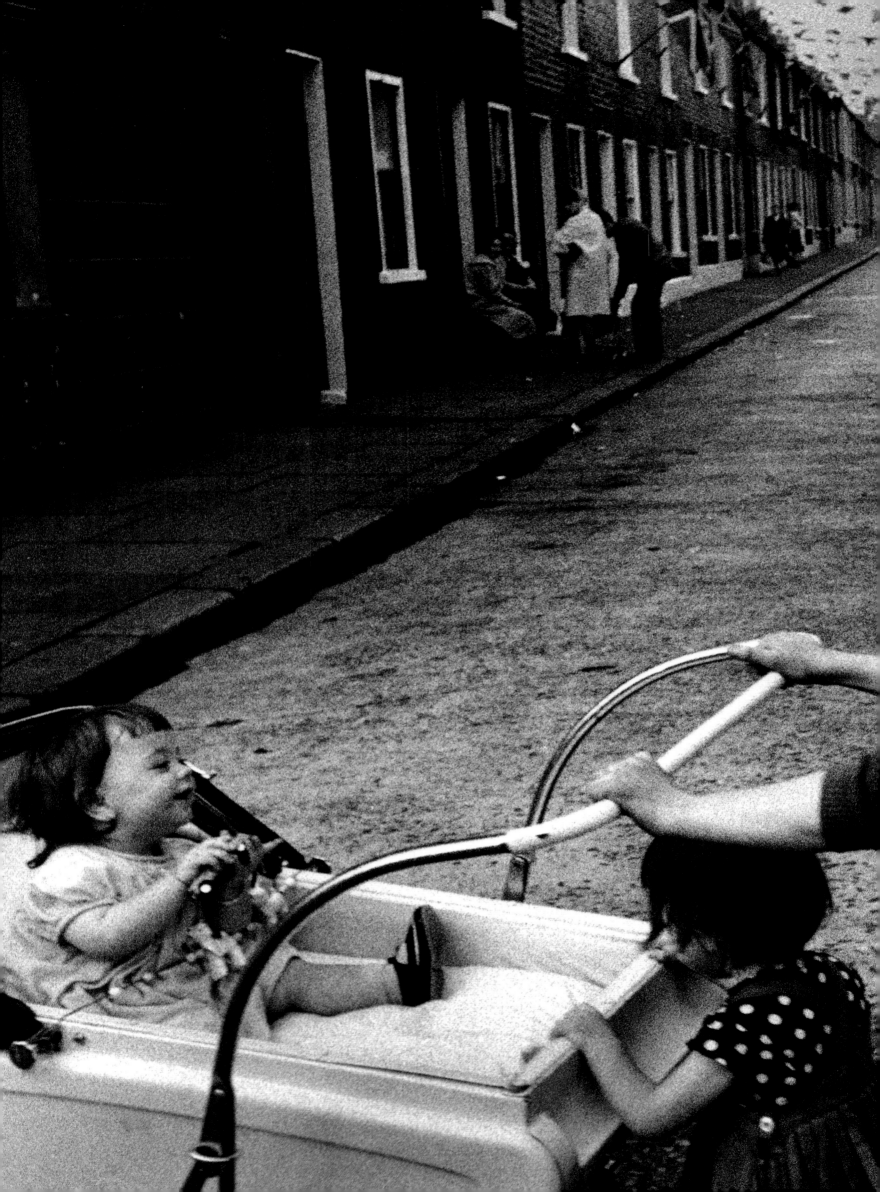

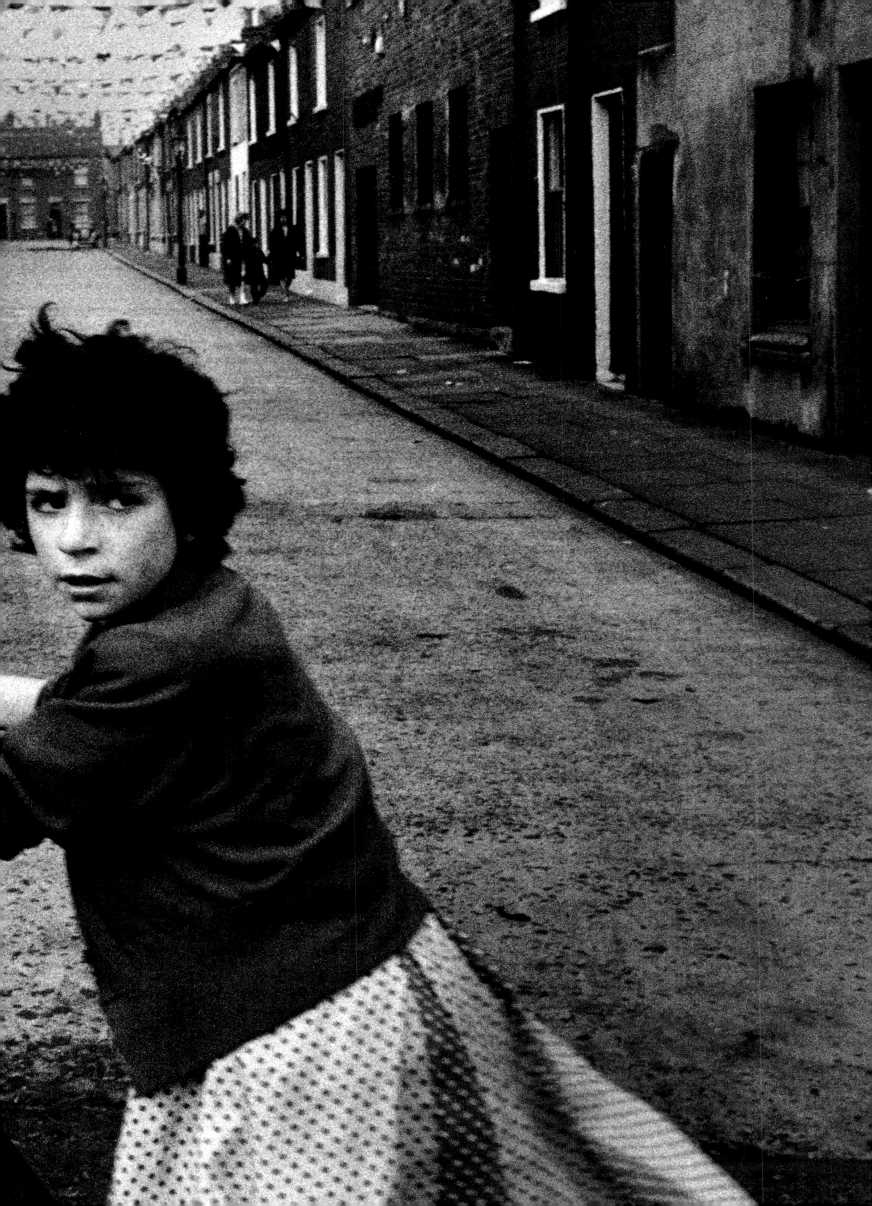

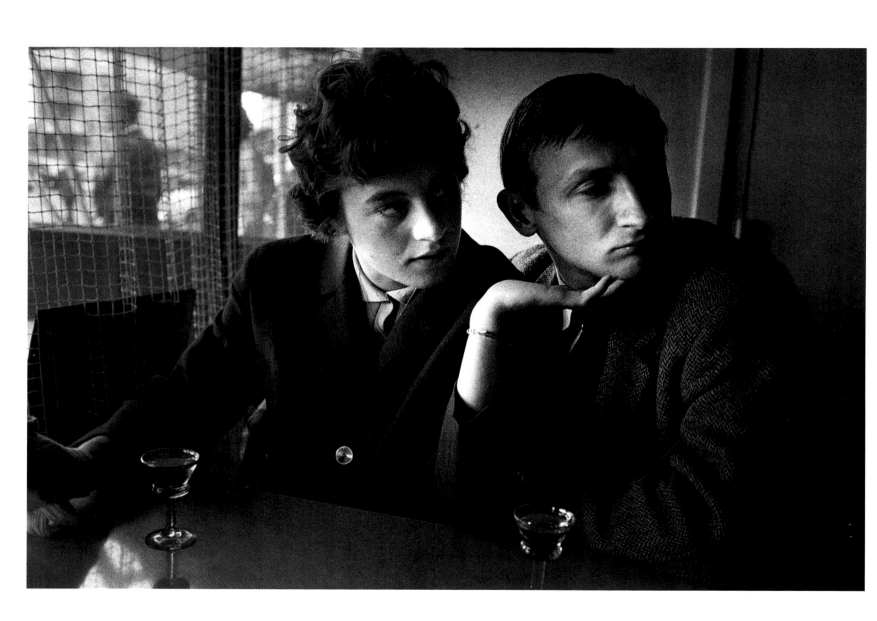

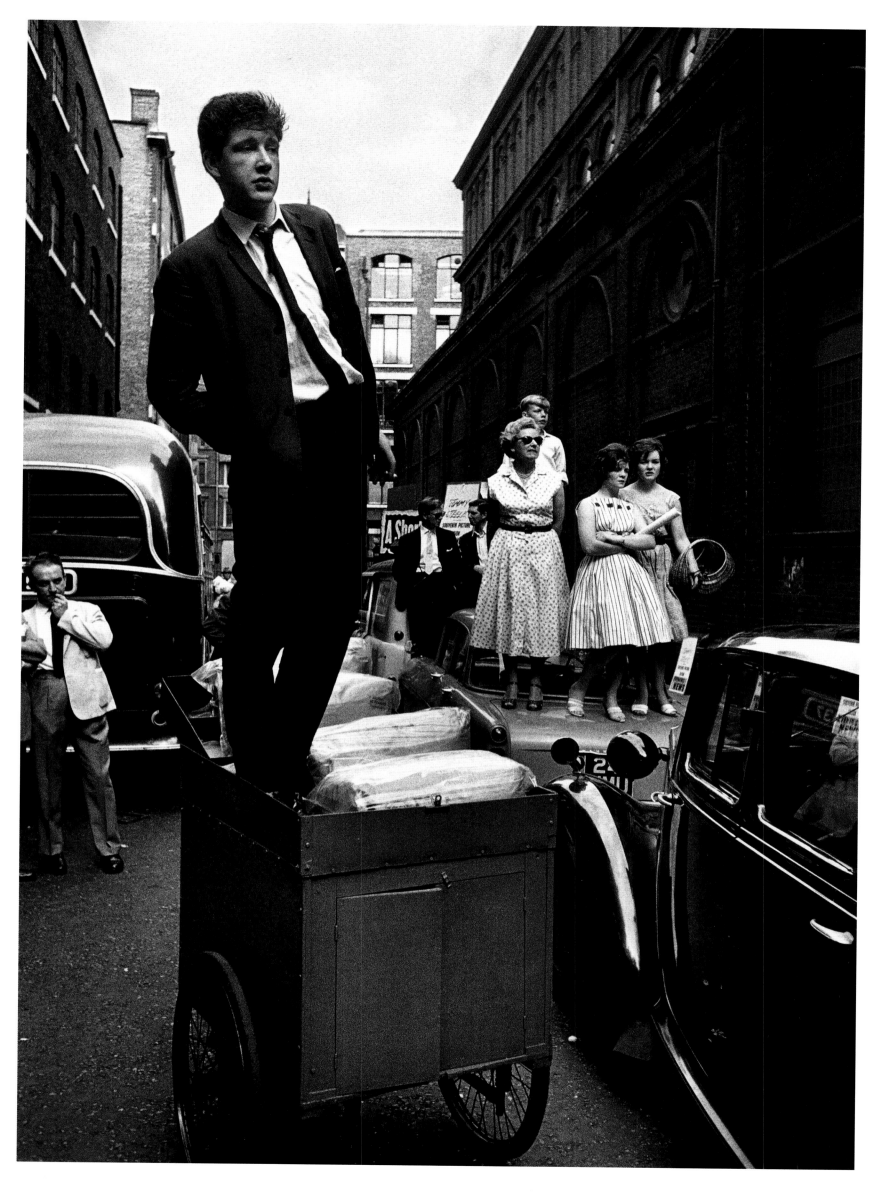

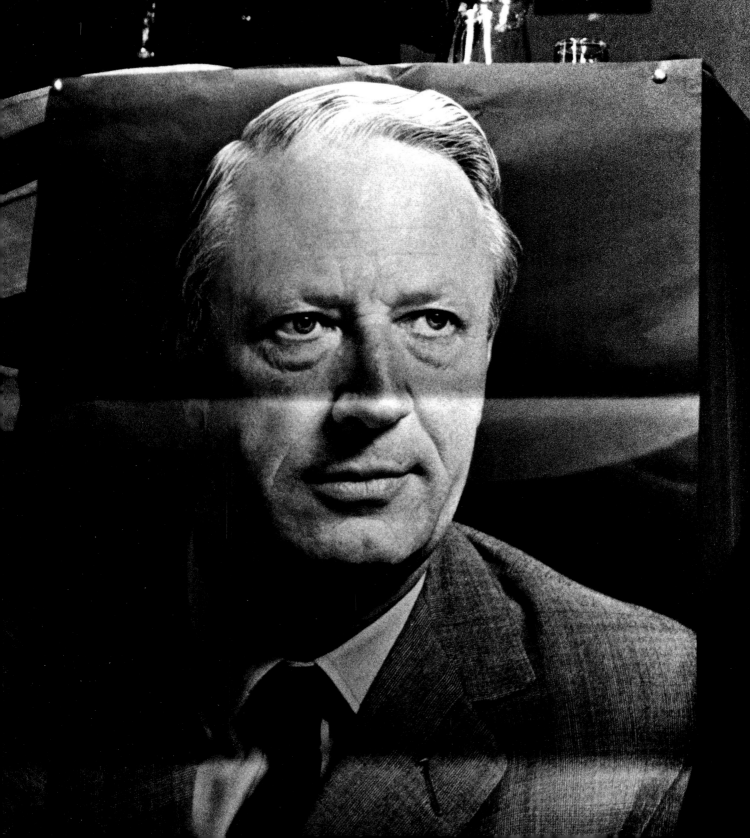

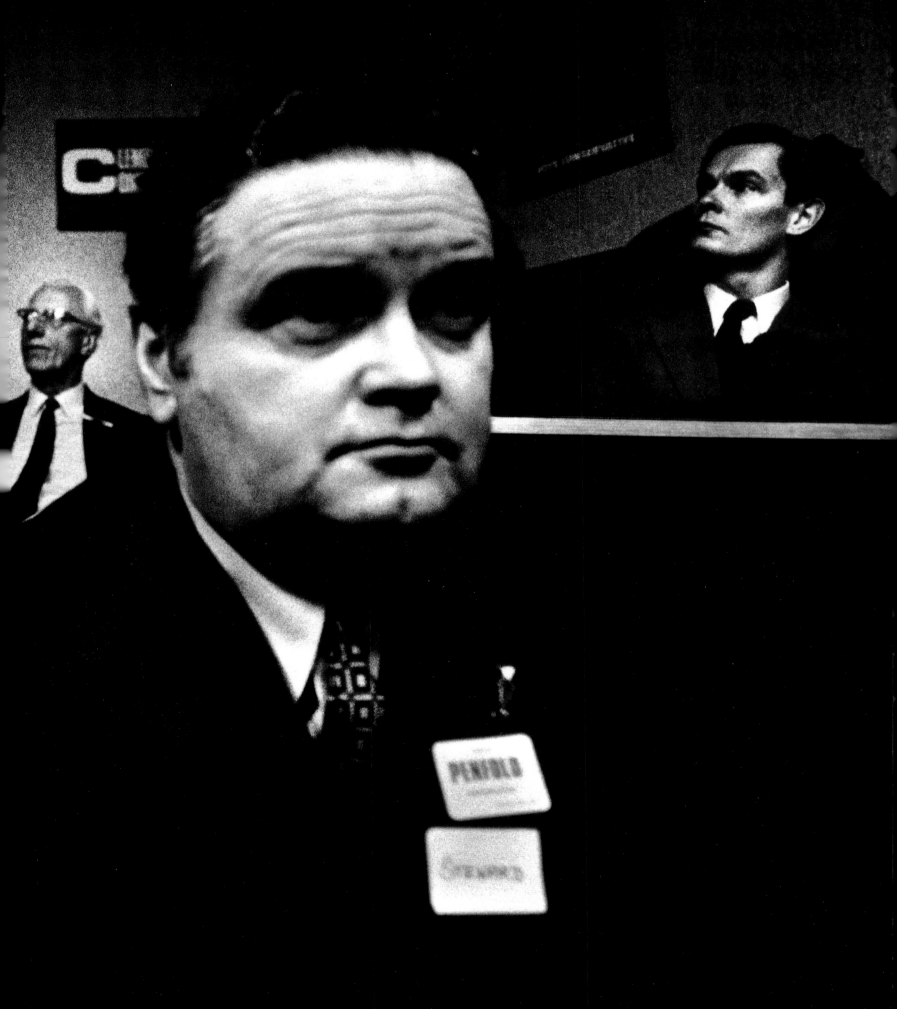

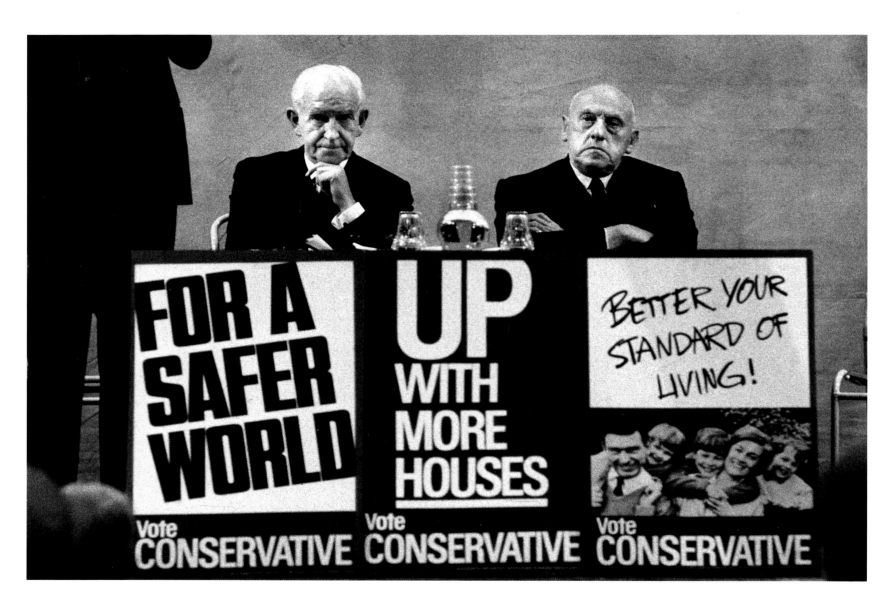

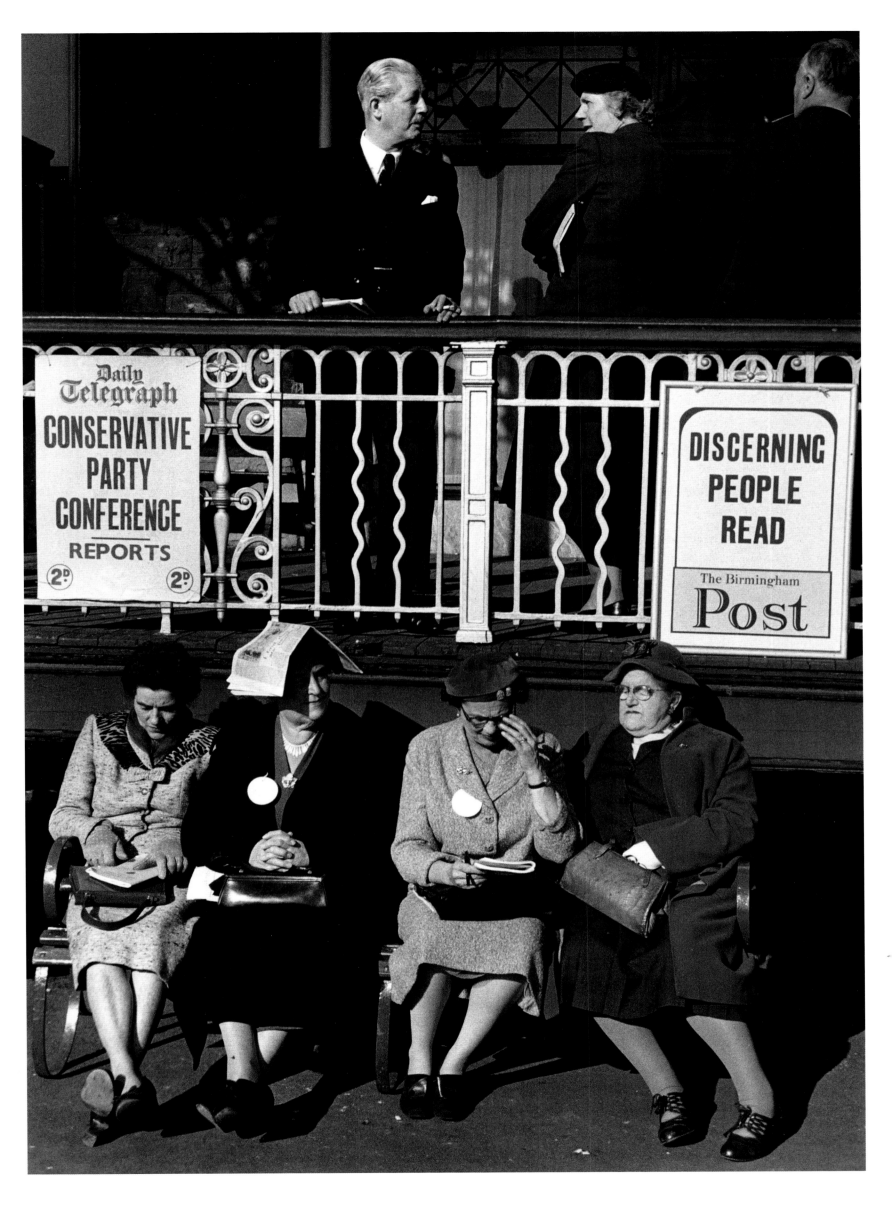

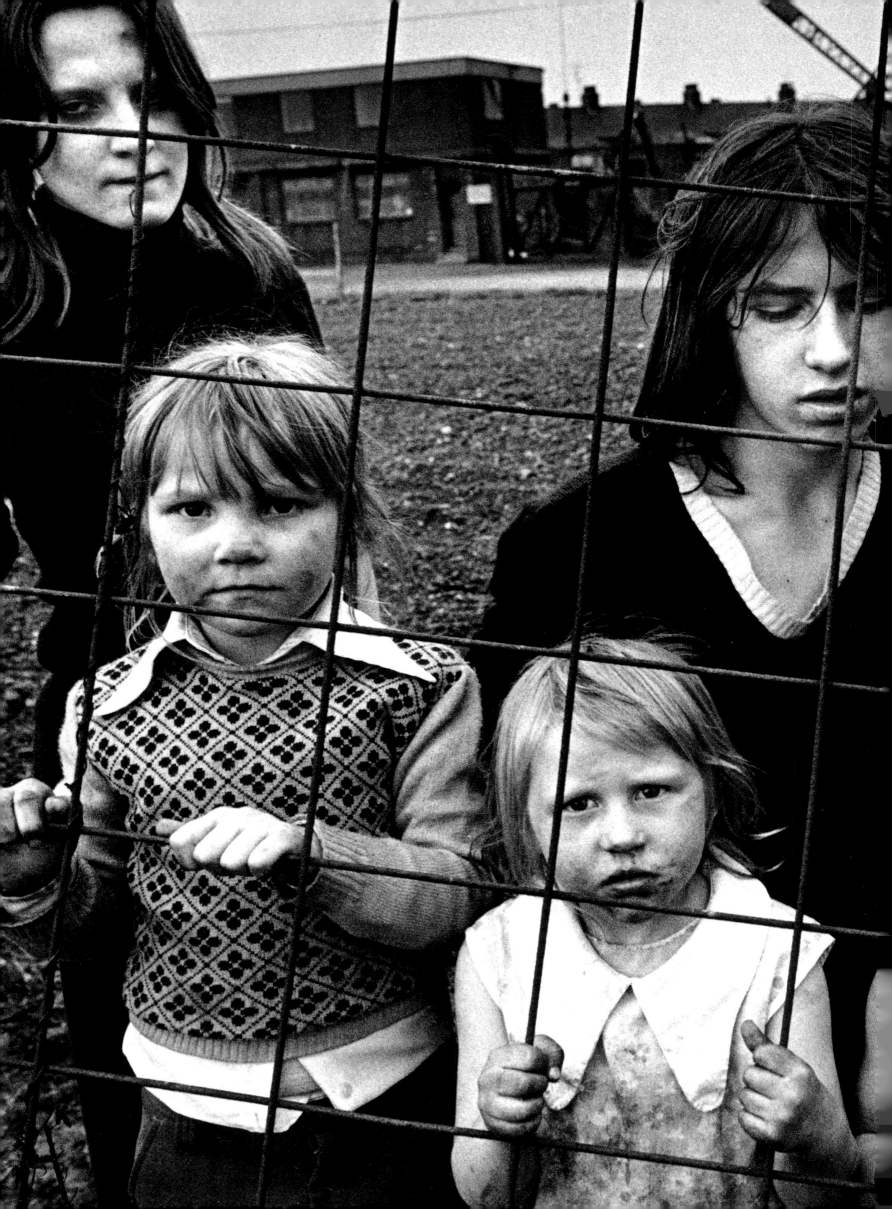

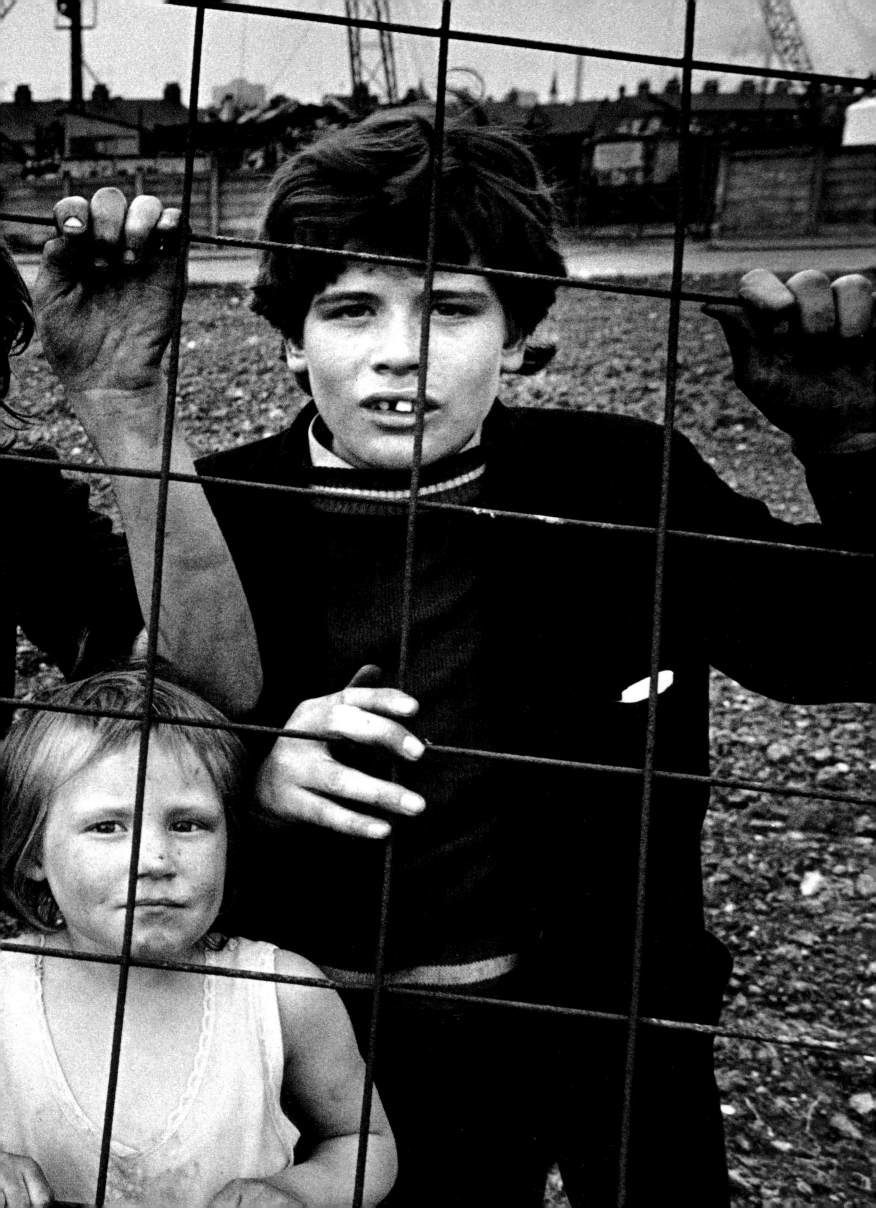

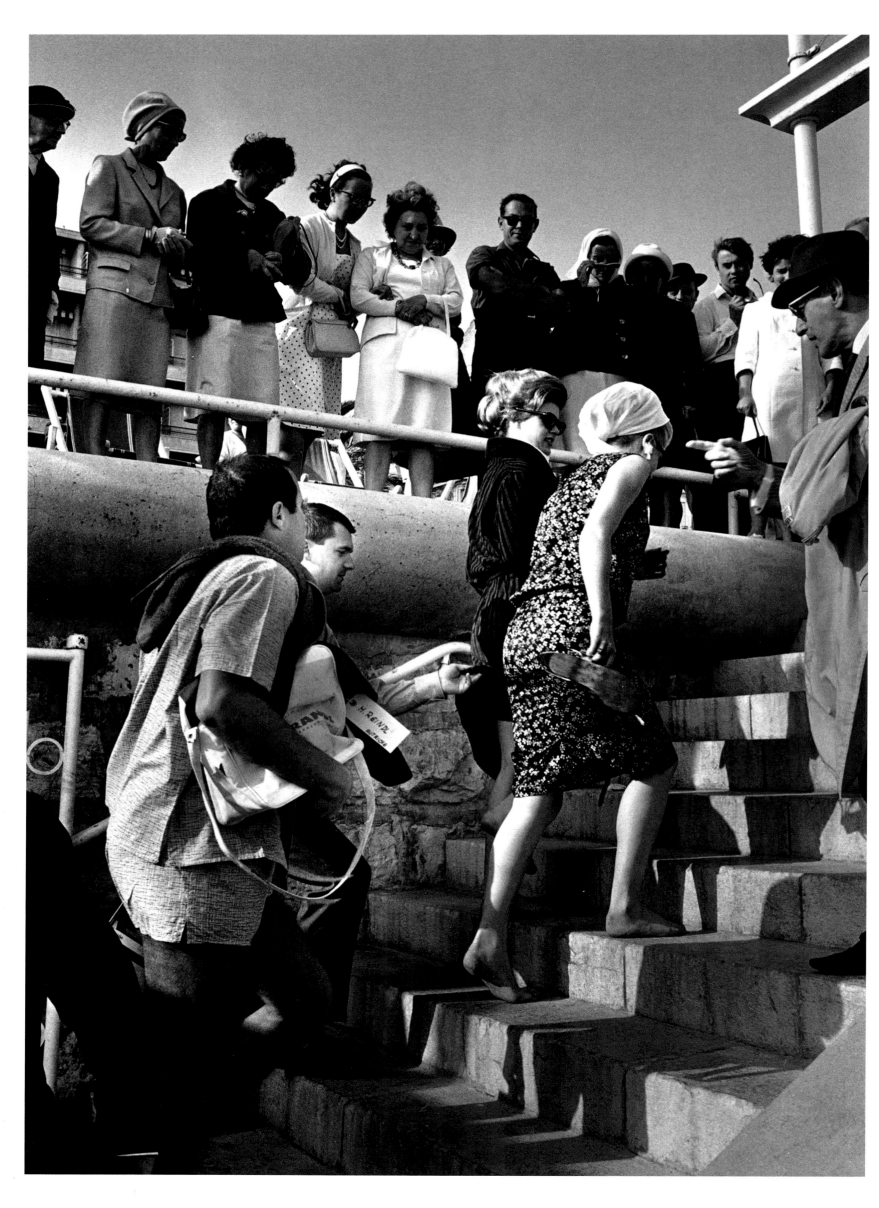

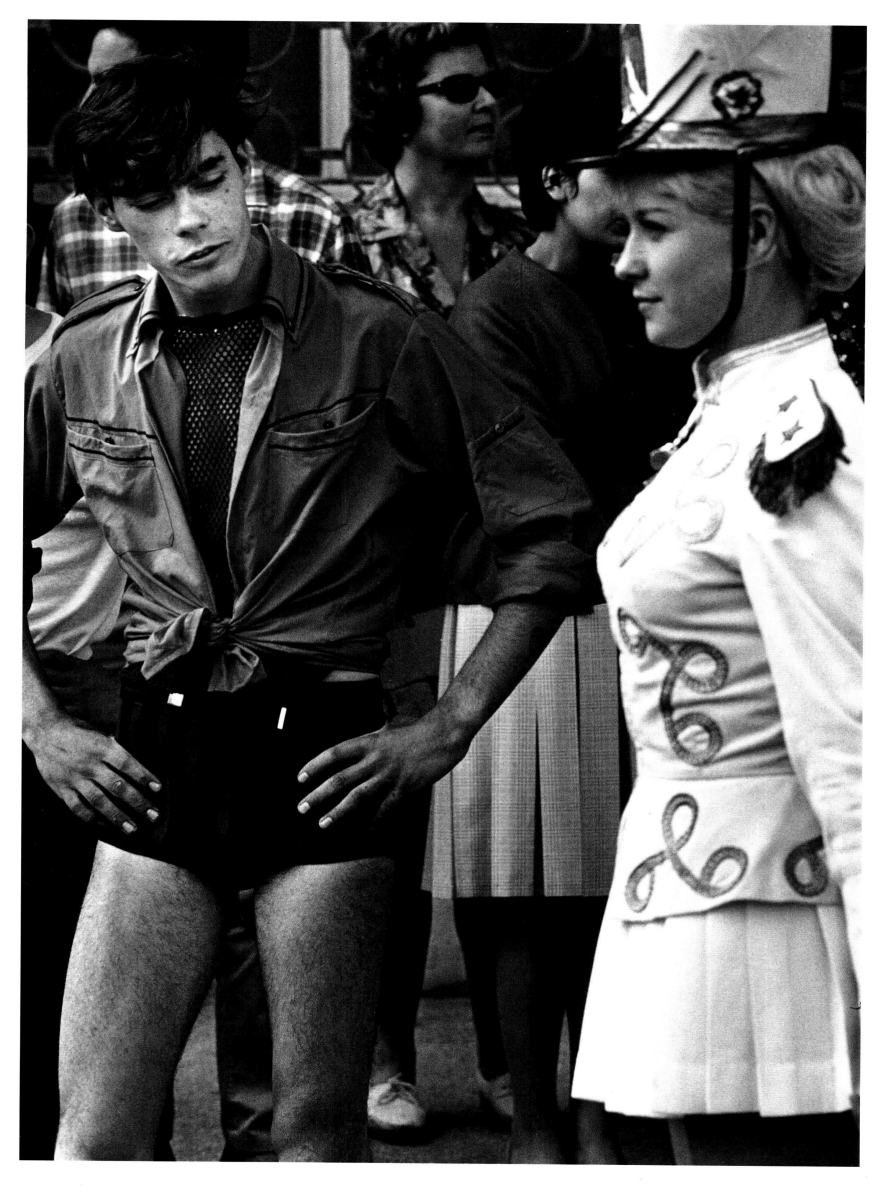

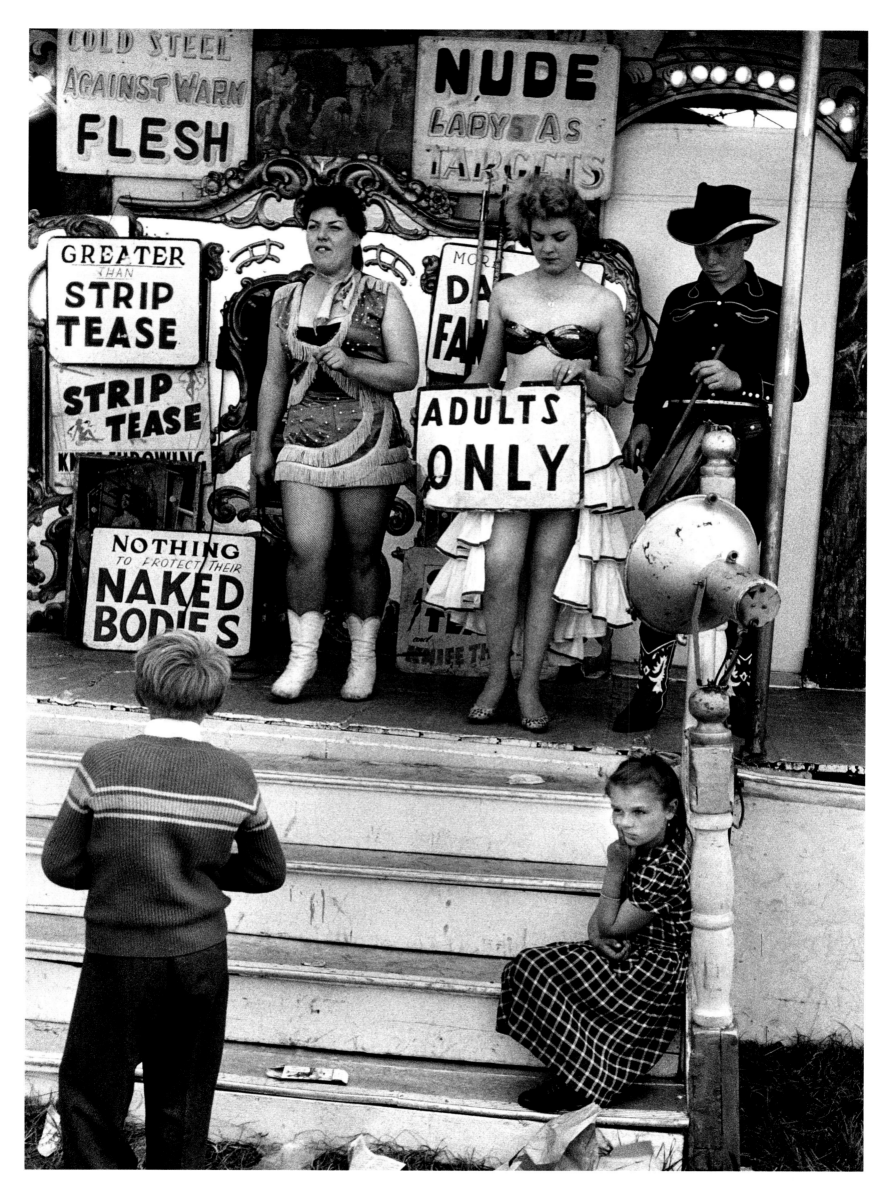

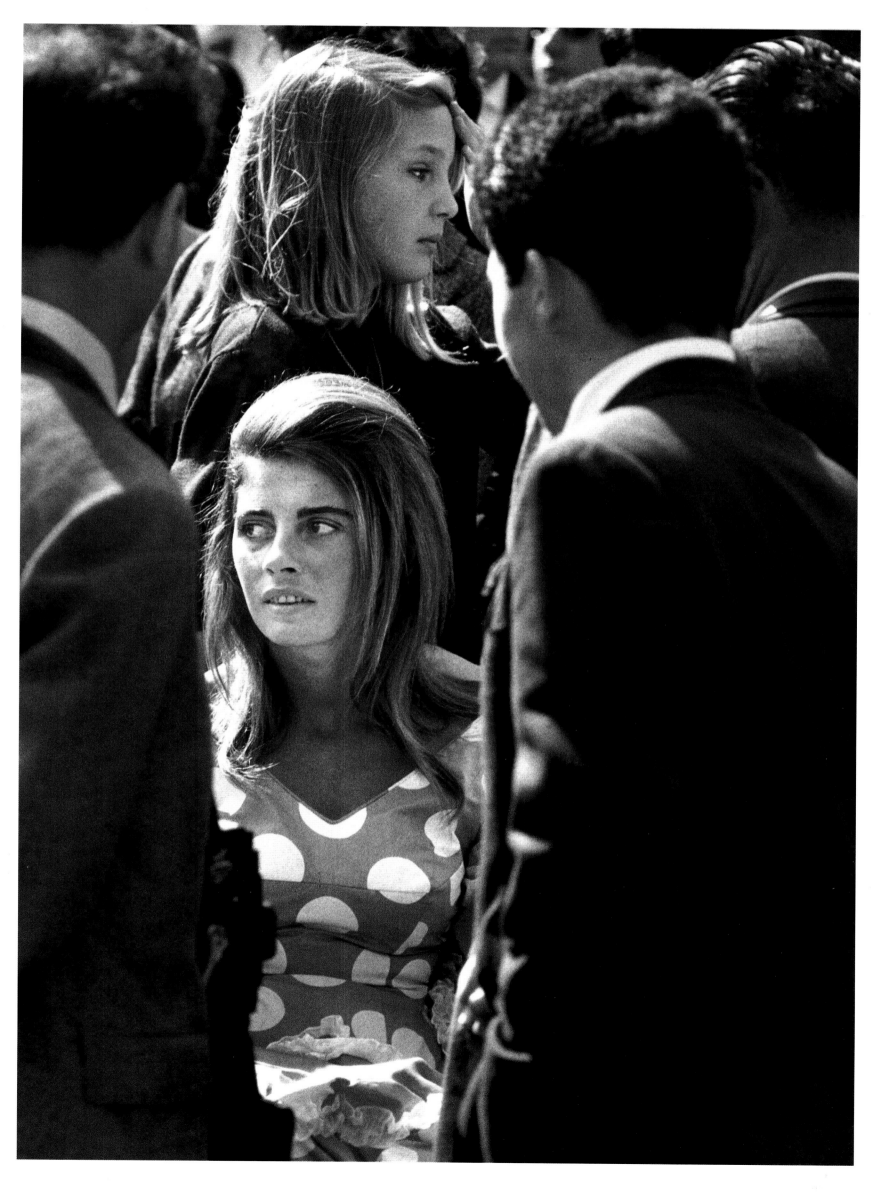

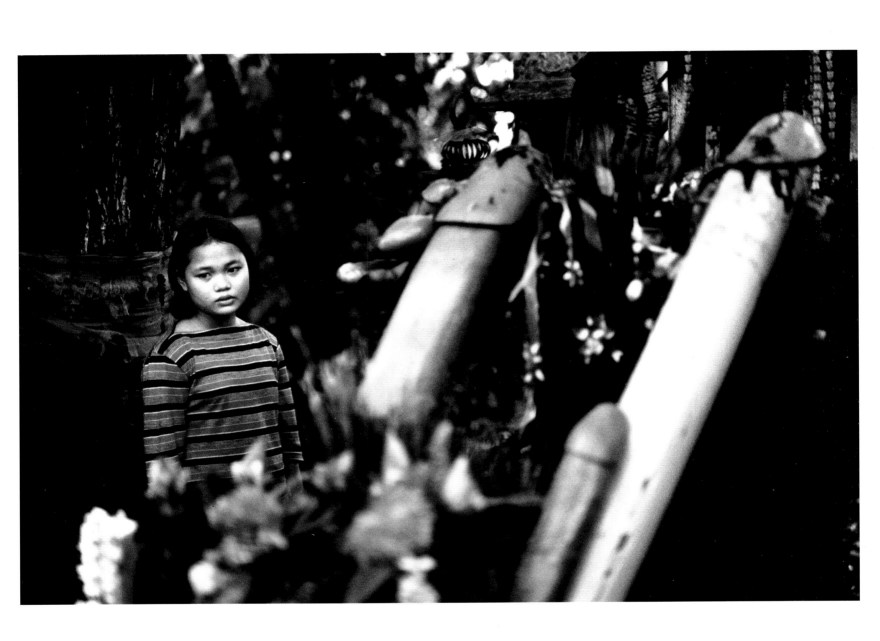

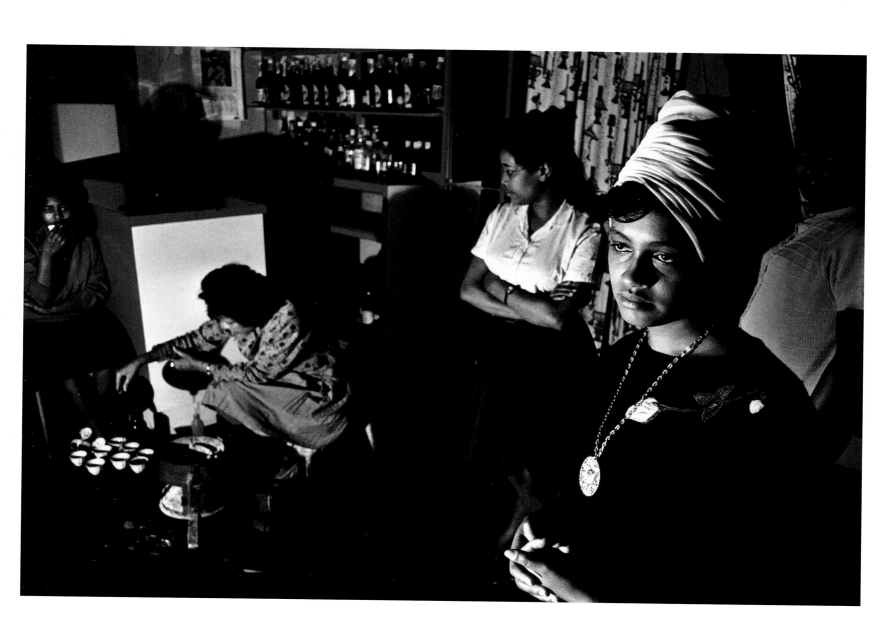

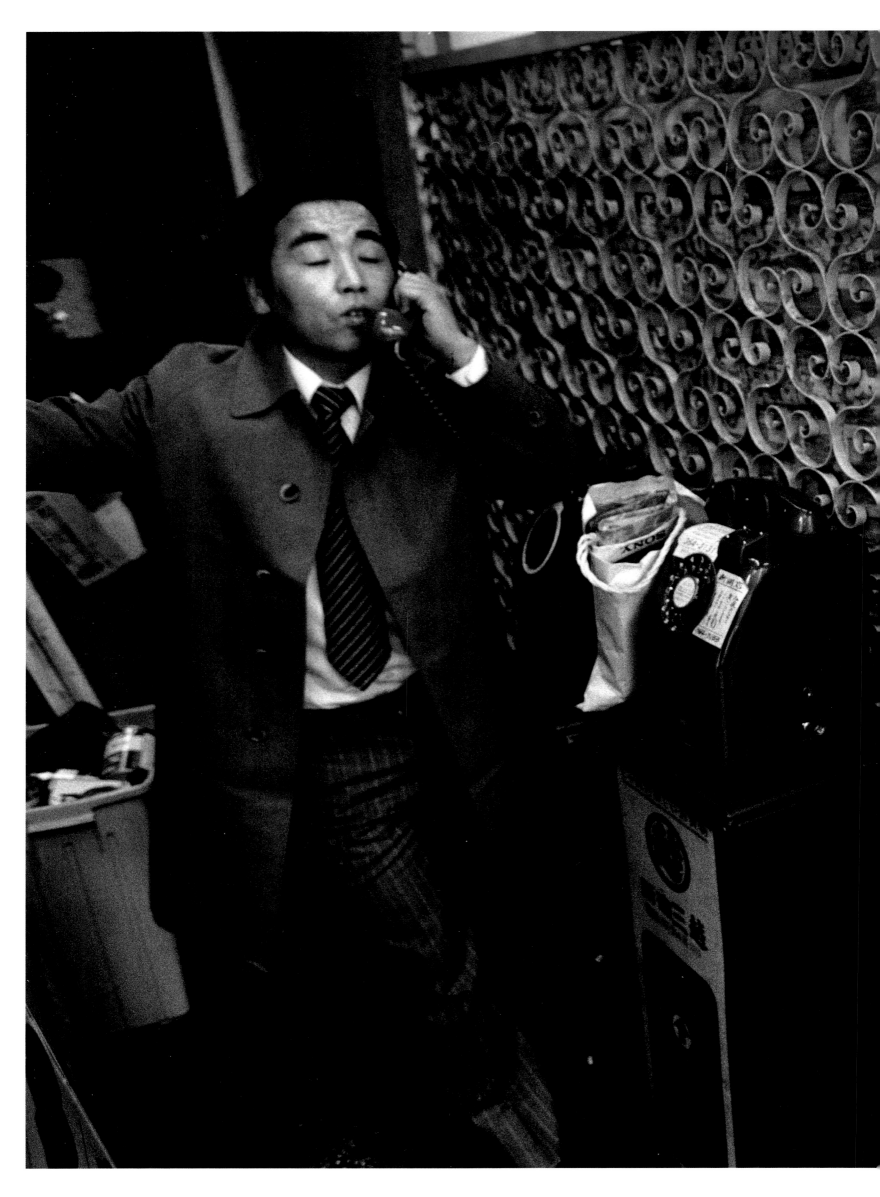

conflict

Today, the average American child is fed a daily diet of Rambo exterminating Sambo, and witnesses thirteen-thousand killings on TV before reaching the age of sixteen. Violence, in all its forms, is the most widely publicized human activity.

I grew up regarding war as an obscenity, but my interest in how societies endeavor to achieve their goals inevitably led to a fascination with conflict—as Clausewitz writes, "War is nothing more than the continuation of politics by other means." "Politics" is a polite term used to describe the process by which one group appropriates the wealth of another; most of the wars I've seen had economic gain as their purpose. True, there are religious wars but these are of little concern to those not involved. Wars of national liberation, like the one in Vietnam, are of more interest because they inflame colonialists with the fear that other colonies may follow suit.

In war, truth is almost inevitably the first casualty. Lies are as indispensable as ammunition—often they *are* the ammunition. My camera has given me opportunities to witness the deceit implicit in conflicts, and my goal is to see through the deceptions. The camera requires one to *be* there—a photographer is denied the luxury of philosophizing from afar.

There are photographers who are still hammering home simplistic maxims about "man's inhumanity to man." This affords little insight into the subject. What we need is to understand the reasons why men set out to kill one another—a good place to start would be the realm of economics. Then, perhaps, we will be able to find another way to solve our differences.

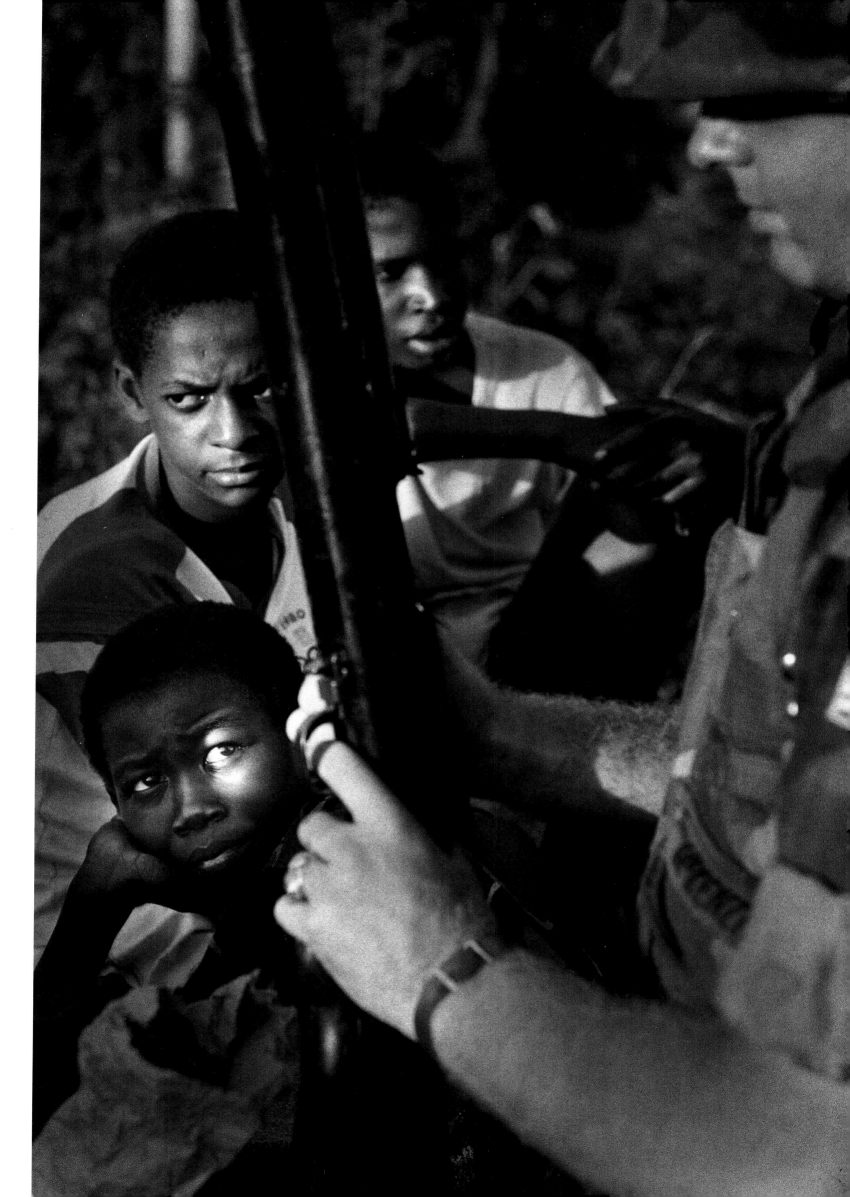

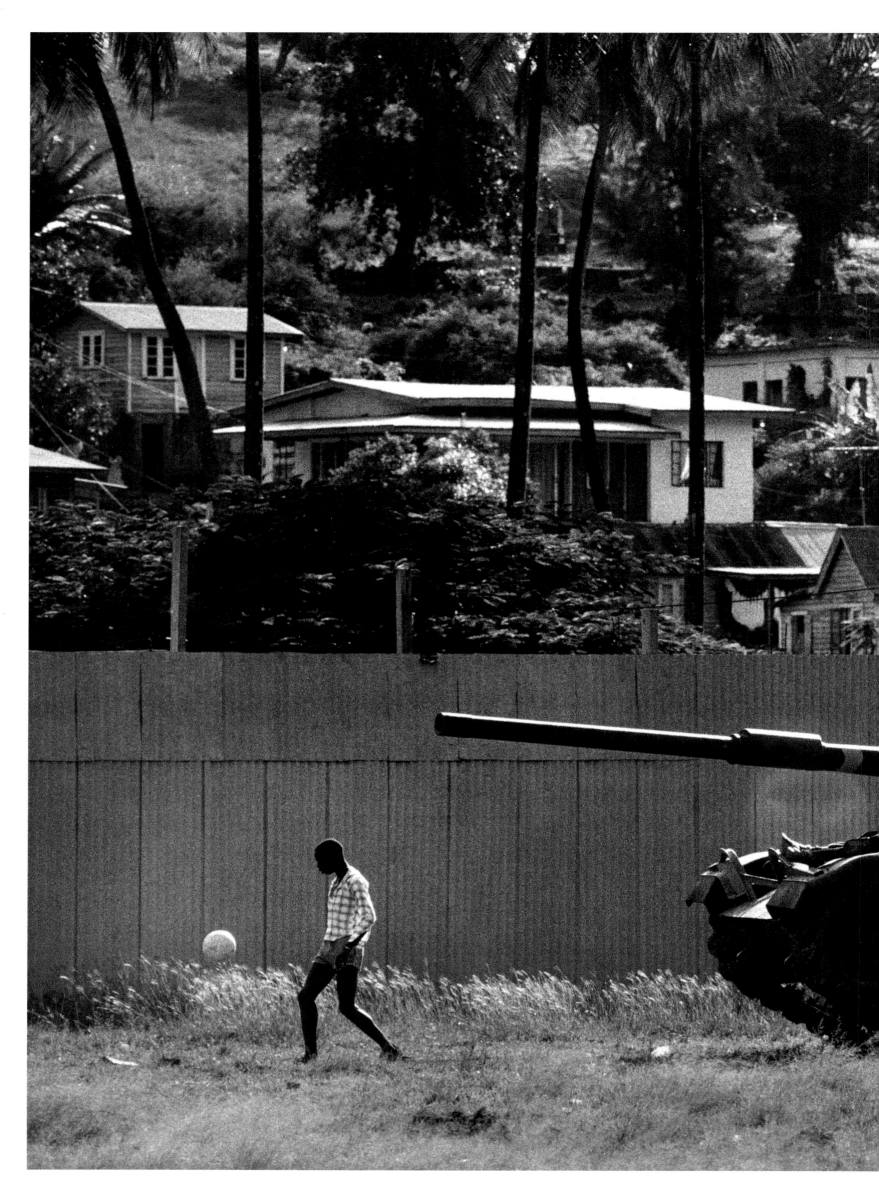

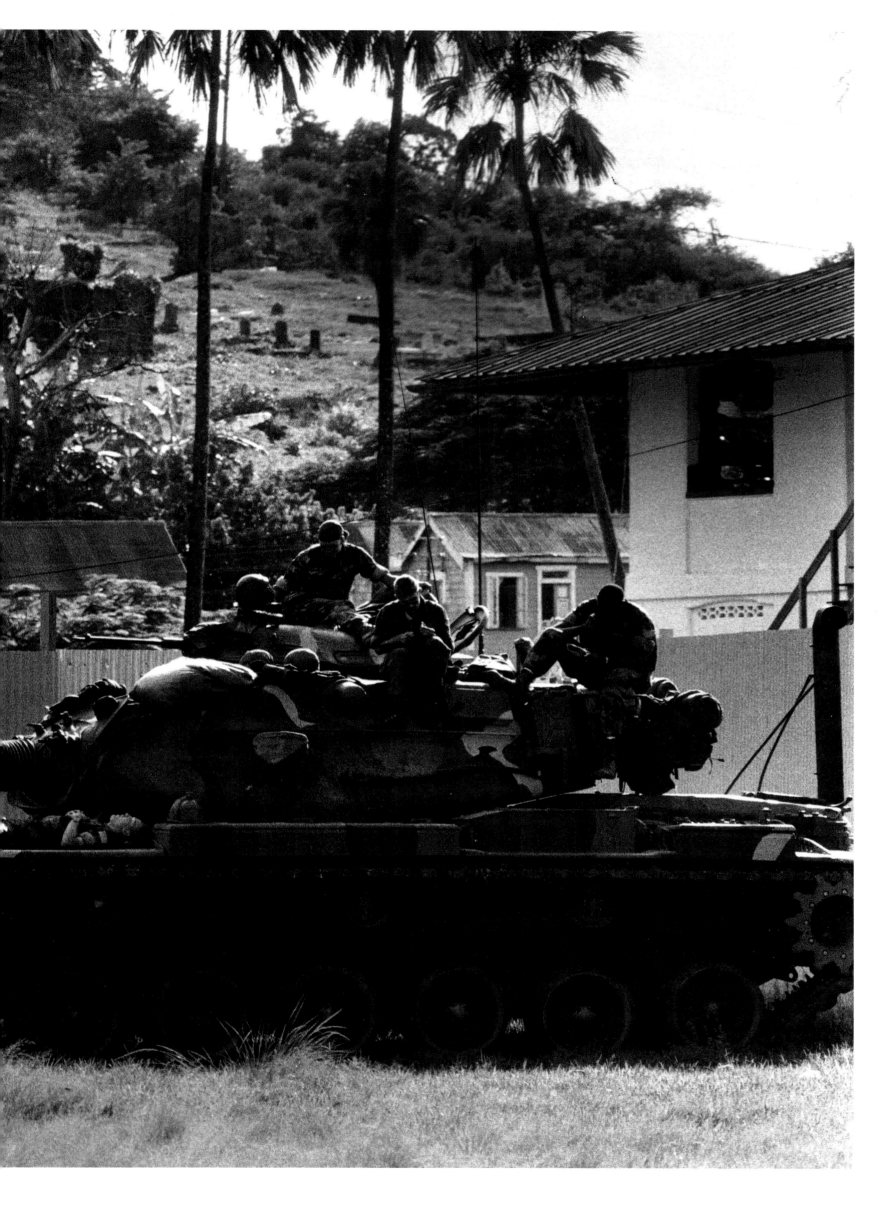

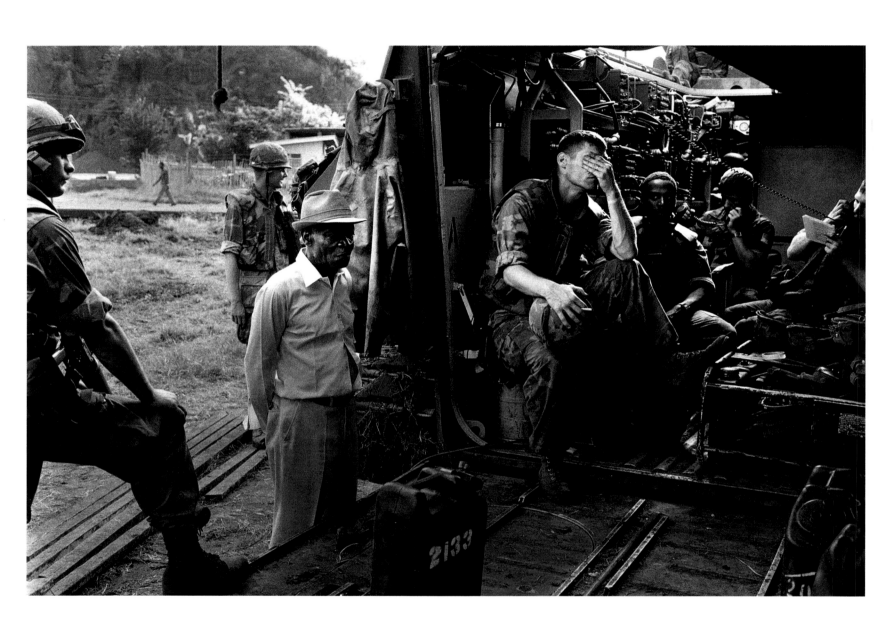

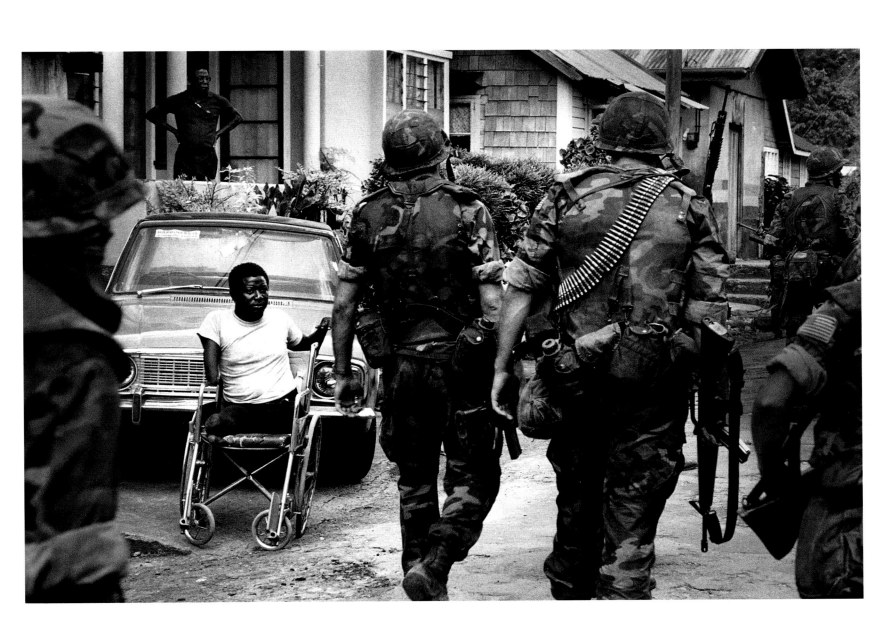

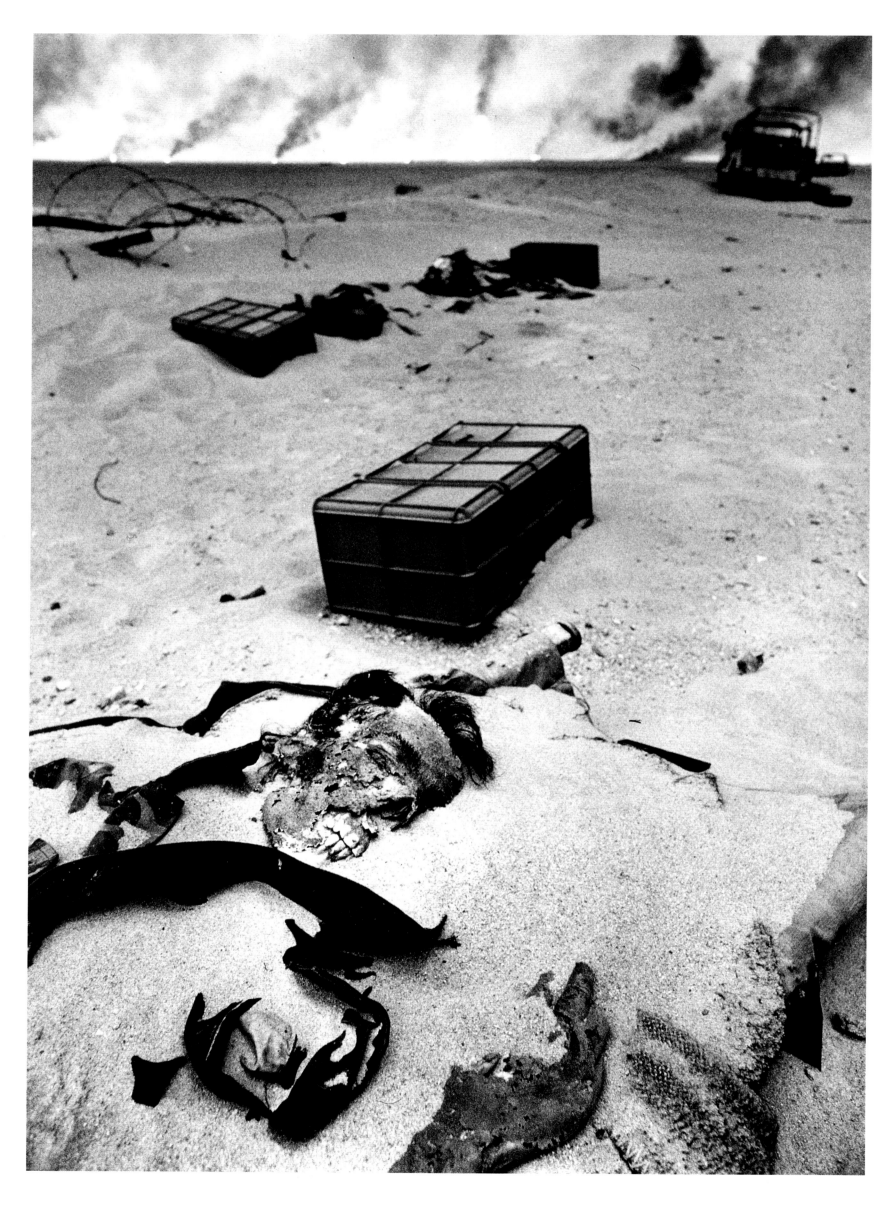

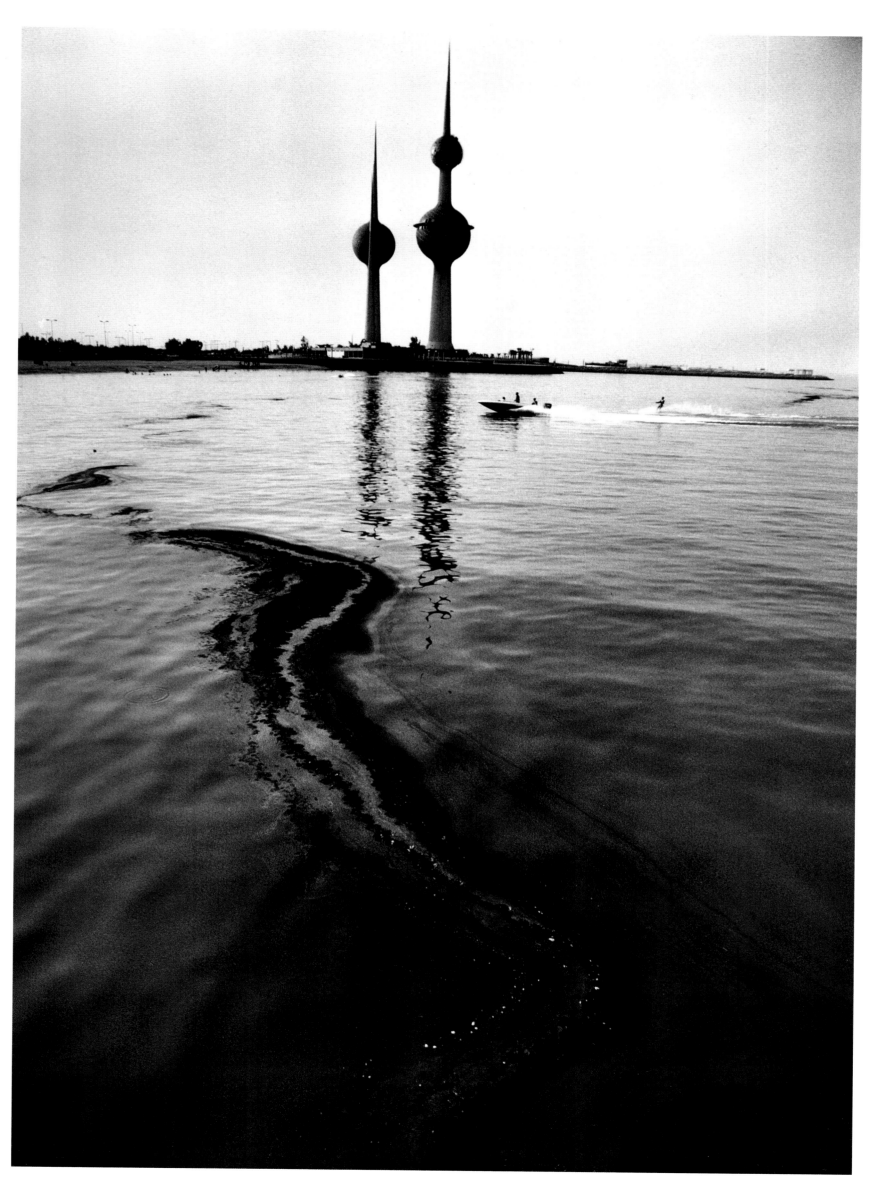

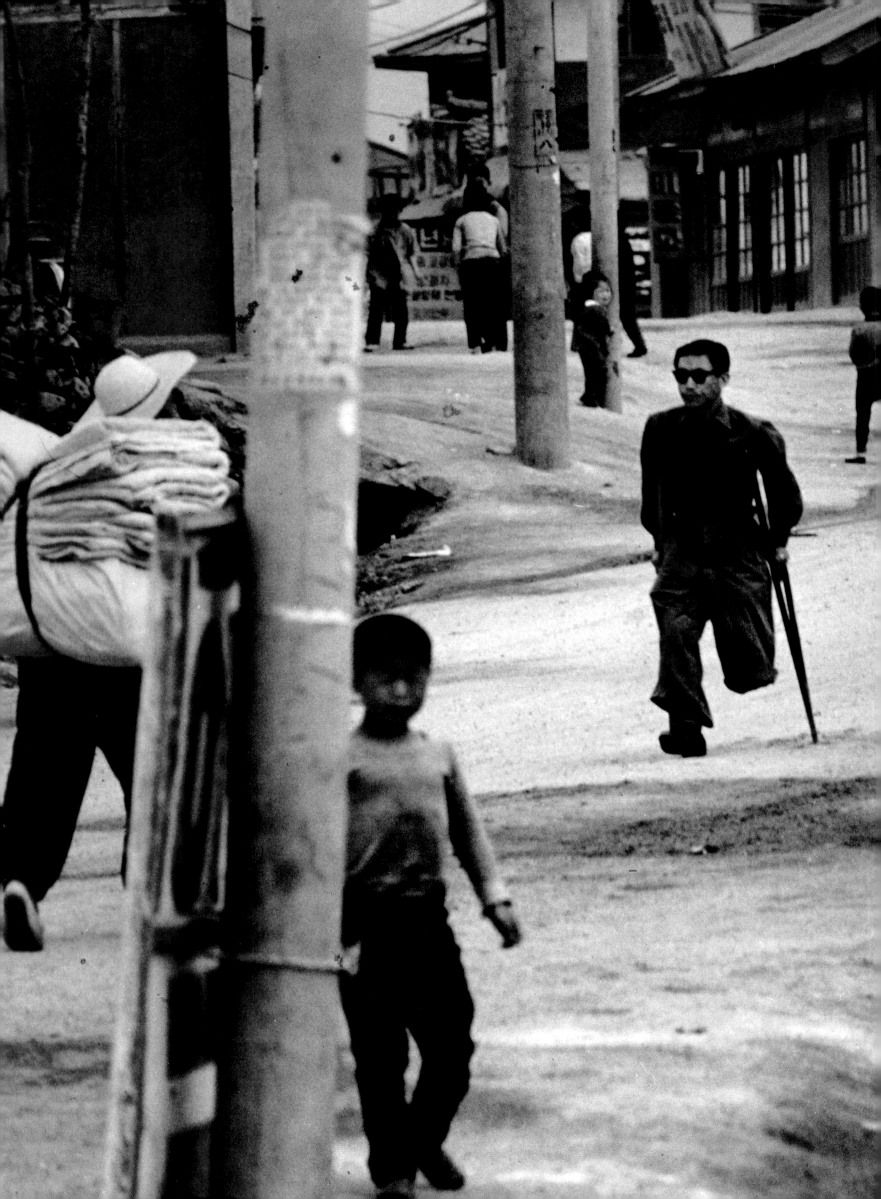

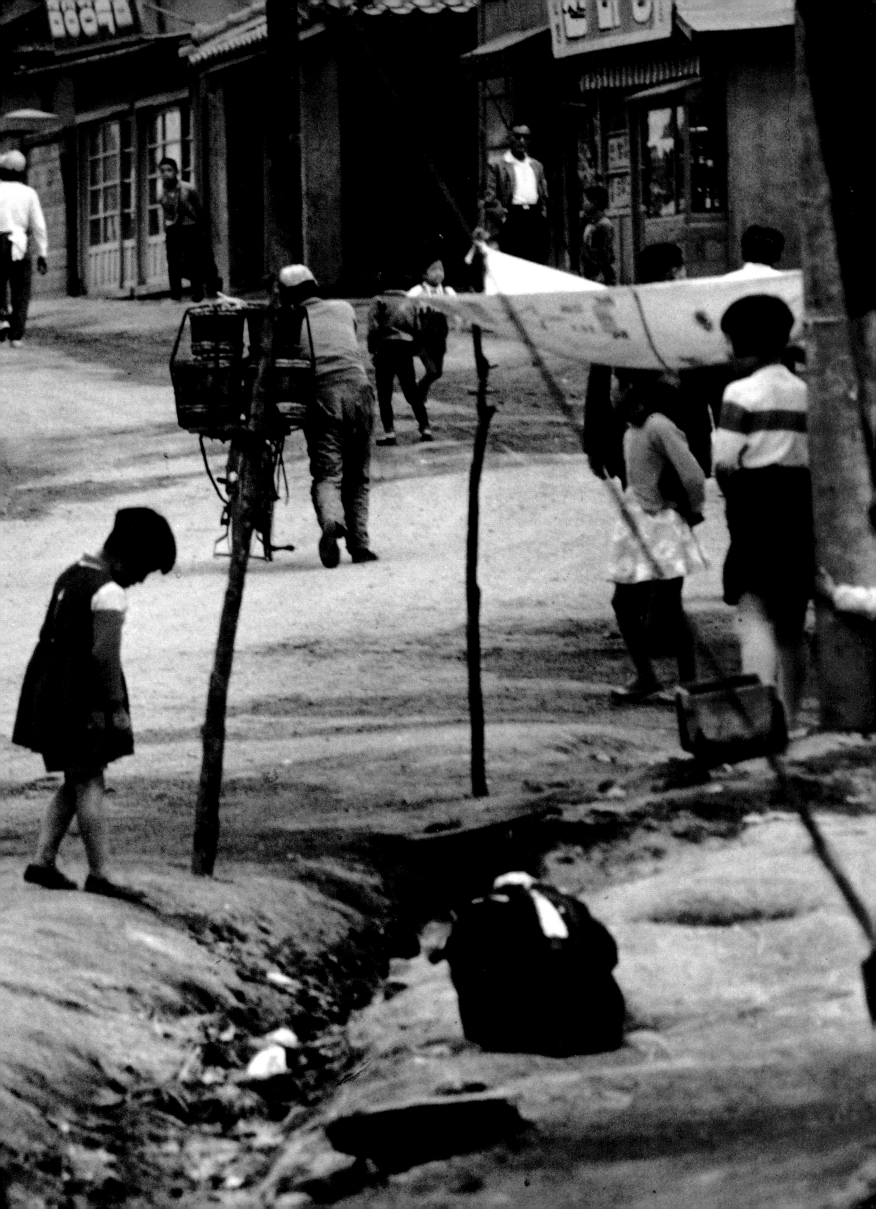

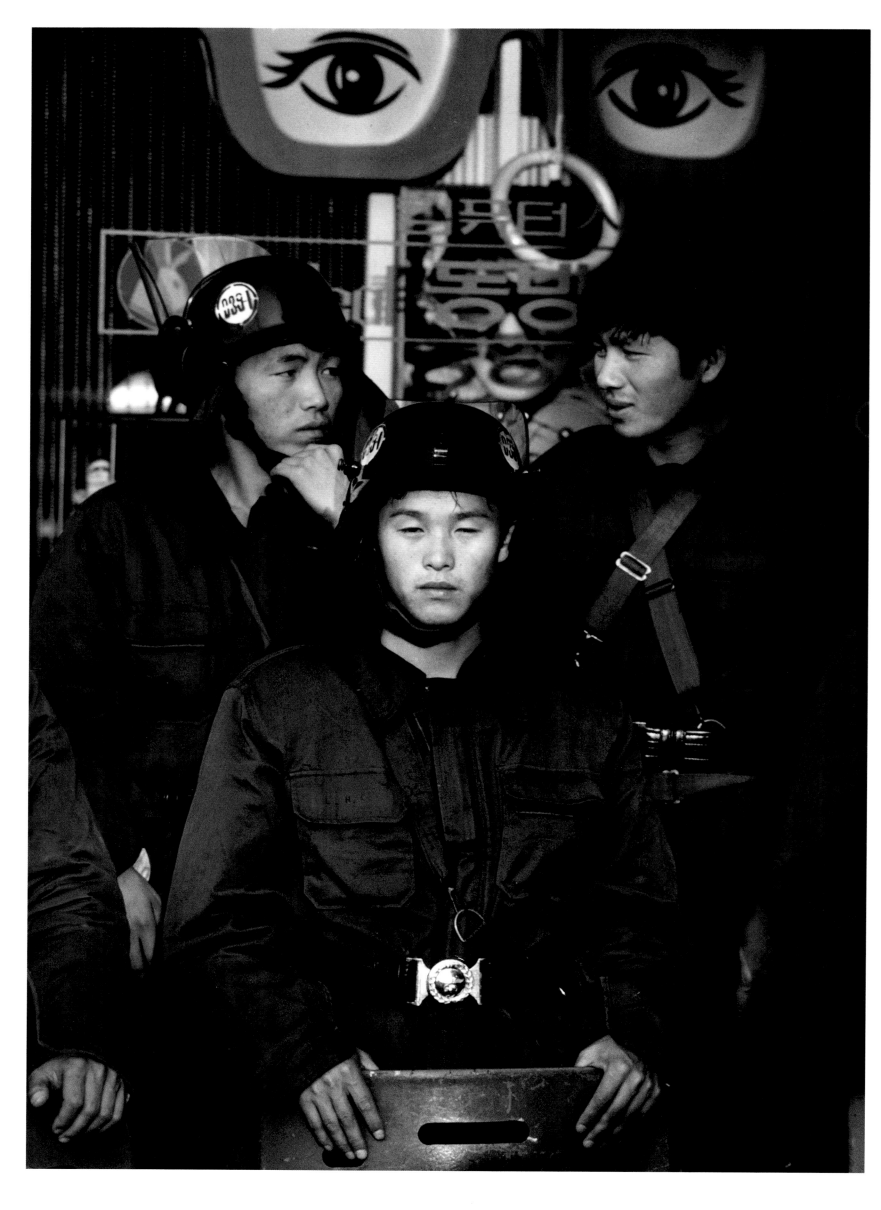

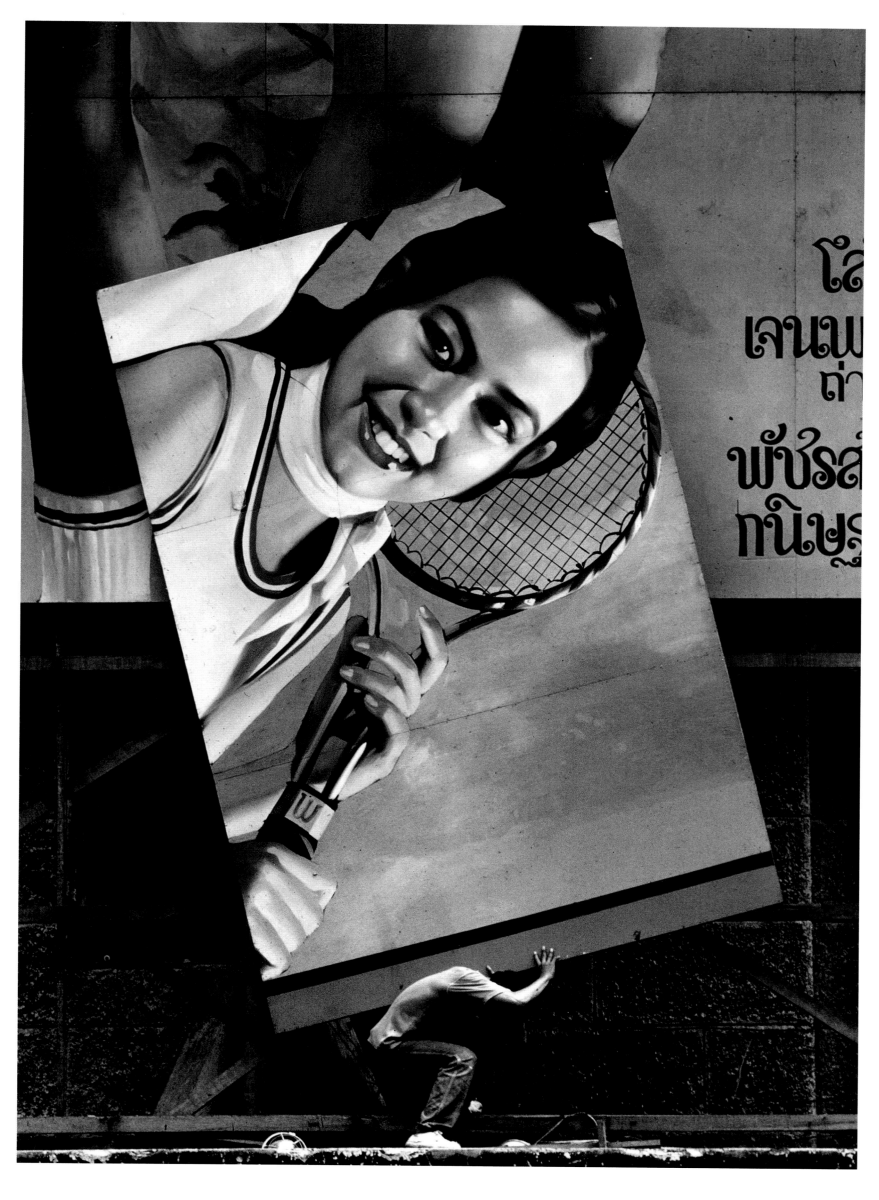

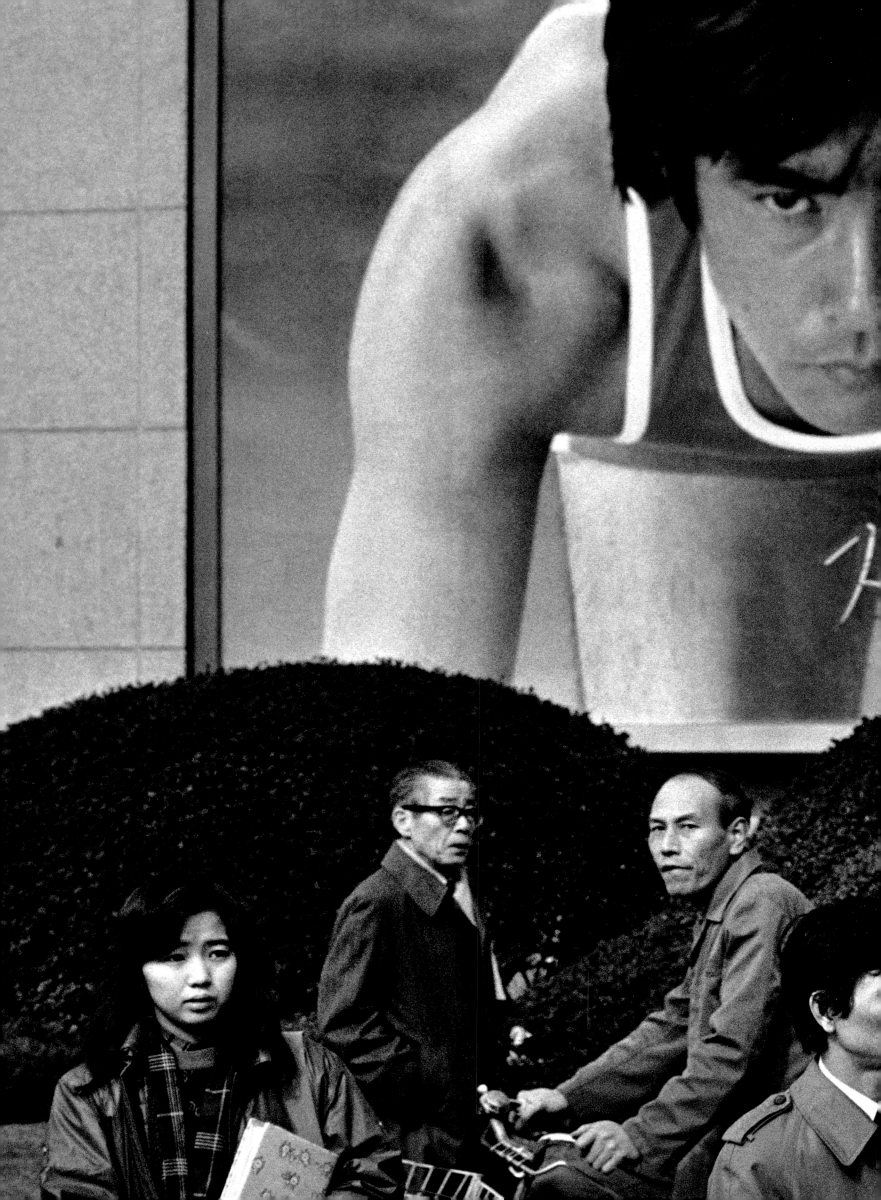

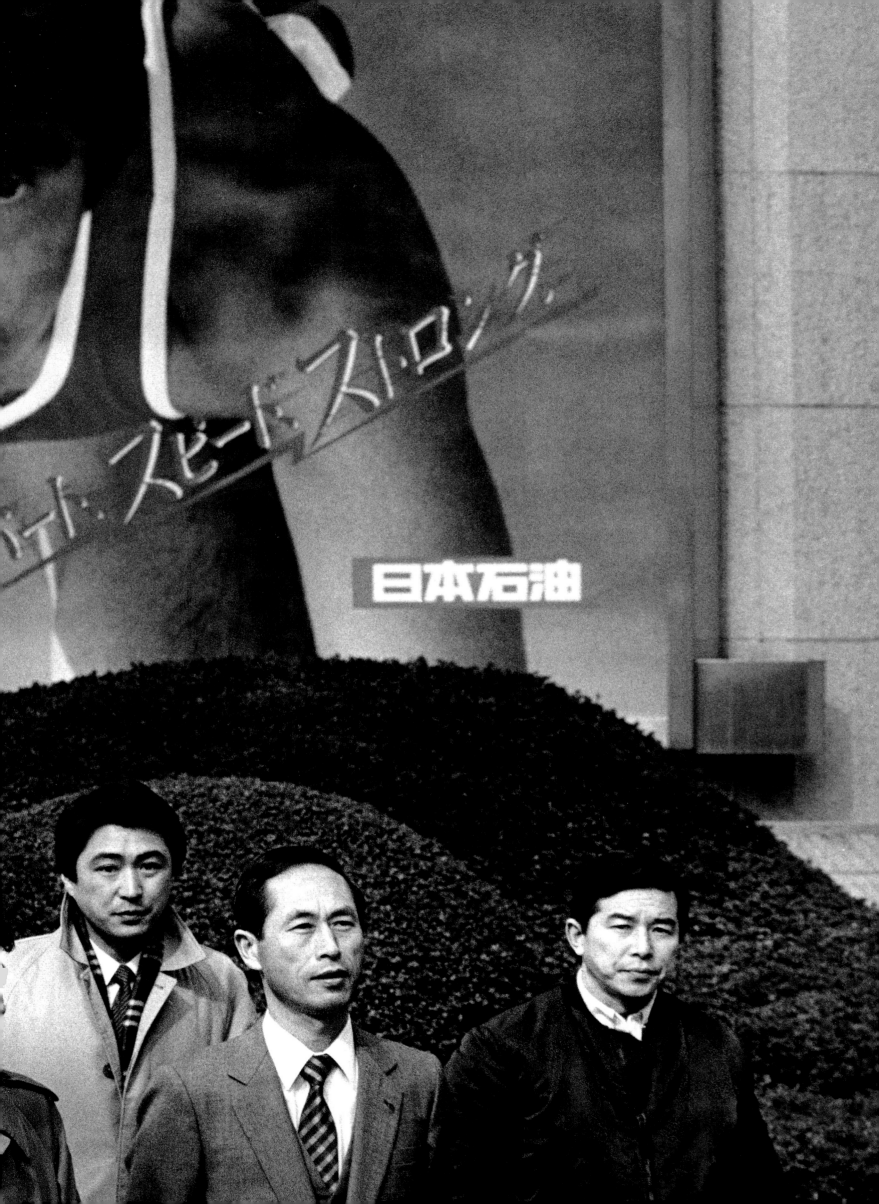

beliefs and moralities

Early in my travels it occurred to me that, with few exceptions, people's need for organized religion is inversely proportional to their self-confidence. Those with a measure of control over their lives seem to have little need to place their destinies in the hands of a deity. There are obviously occasions when people require succor—who would not offer a crutch to someone otherwise unable to walk? However, many religions, with misdirected fervor, are in the business of breaking legs.

Pharaohs, kings, despots, and tyrants throughout history have employed religion in their quest to safeguard their wealth, power, and privilege. Exhortations to commit life and soul to the will of God are the perfect device for disempowering people—they then become convinced they can make no contribution to their own future.

It has always been easy to find connections between immoral behavior and religion. The Christian church claims a monopoly on virtue, yet its role in the genocide of the inhabitants of the Americas required a suspension of moral values. I have noticed that most societies have a highly developed code of morality, quite independent of any religion. True, the code is often appropriated by or credited to a religion—if the mountain gorillas of Rwanda were a notch or two "higher" on the evolutionary tree, the American Republican party would no doubt attribute their harmonious life-style to the success of Christian family values.

In my youth, it was the debate over nuclear weapons that highlighted the gulf between religion and morality. The opposition to government policy was essentially secular. The prospect of instant death—we were assured we would have four minutes to say our good-byes before vaporization—concentrated the public mind on questioning the power structure that ruled us. Religion offered no answer other than the lame suggestion that if we were all to die in a man-made hellfire on earth, then we'd get preferential treatment on reaching the pearly gates.

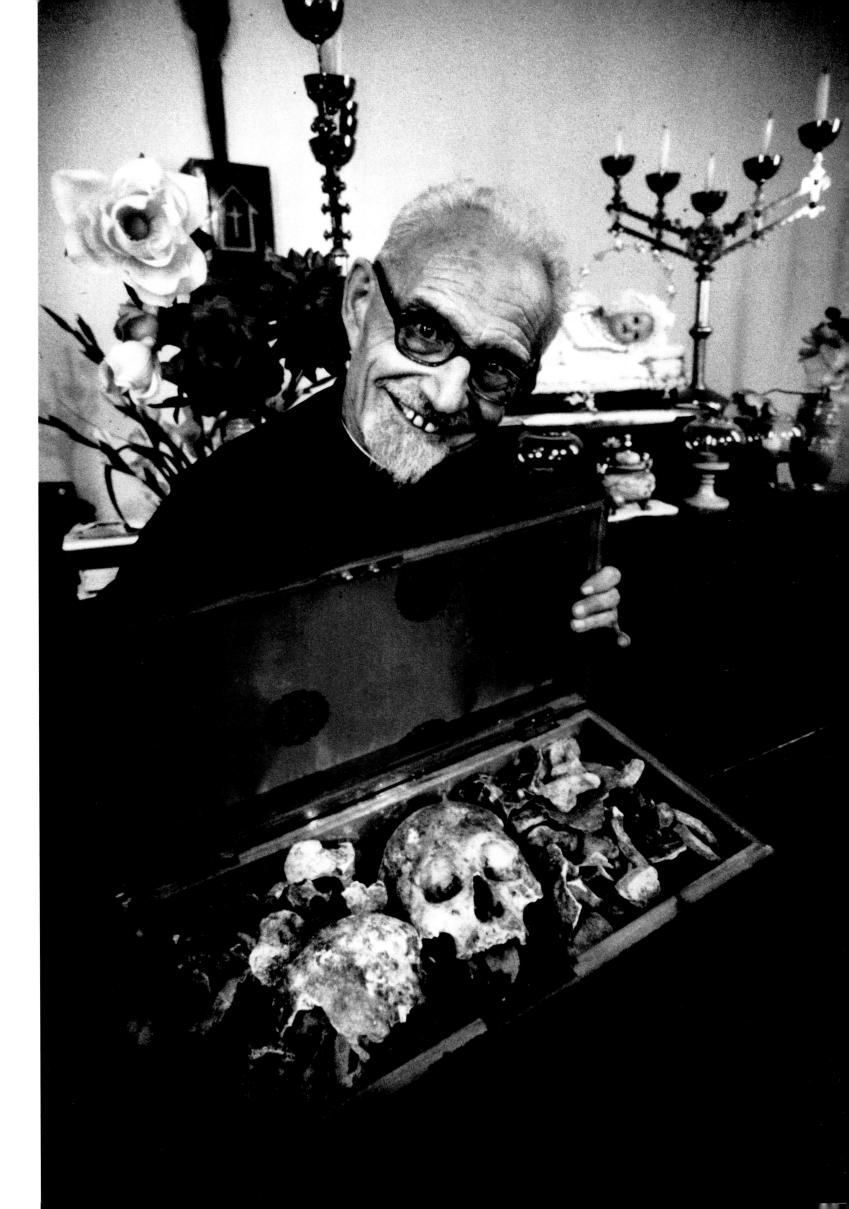

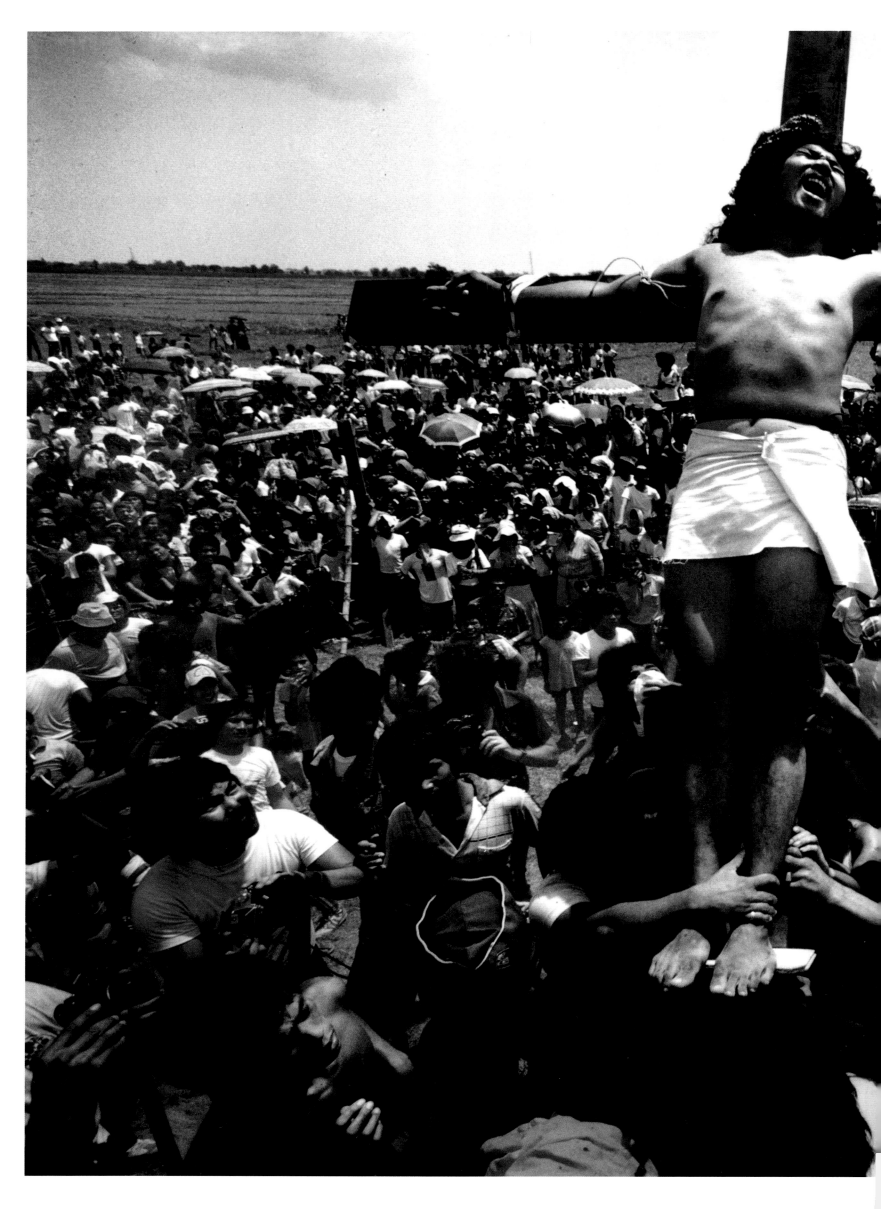

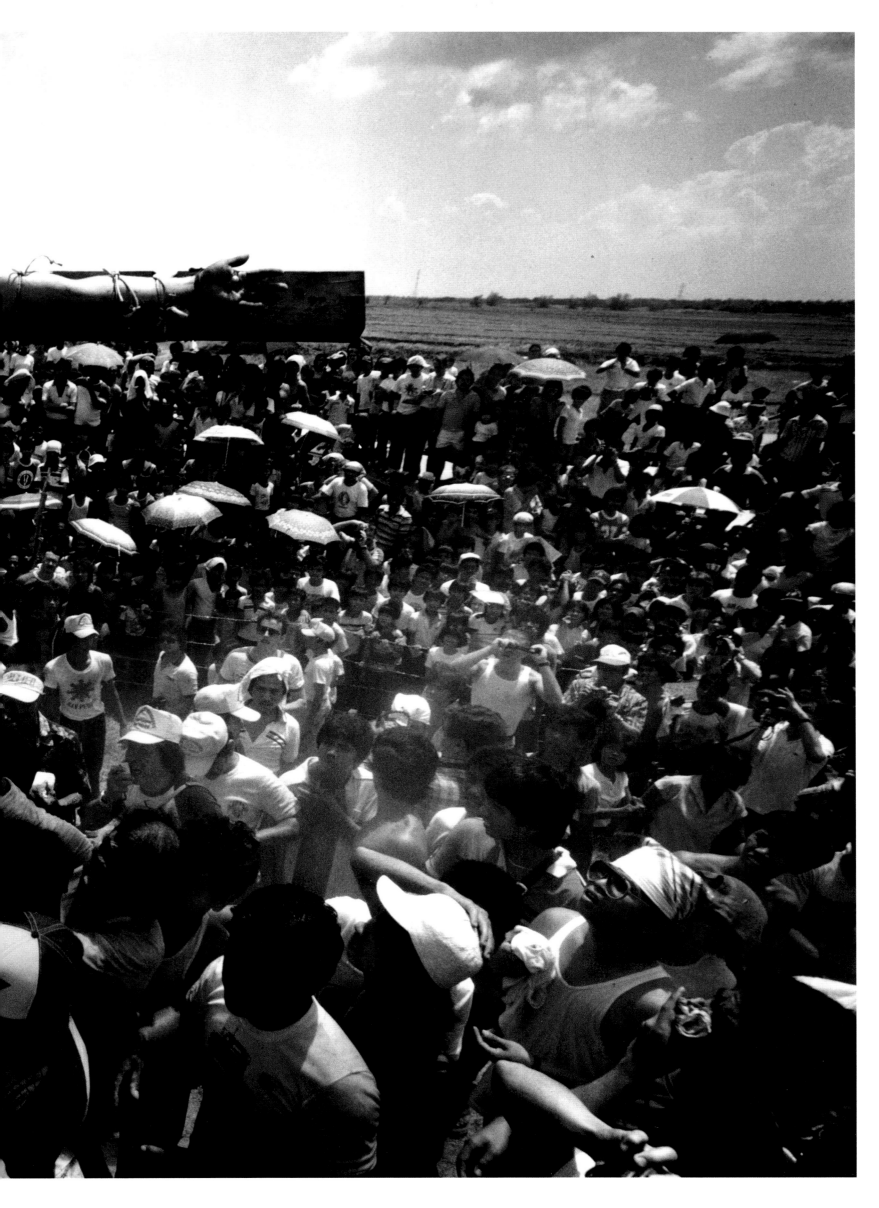

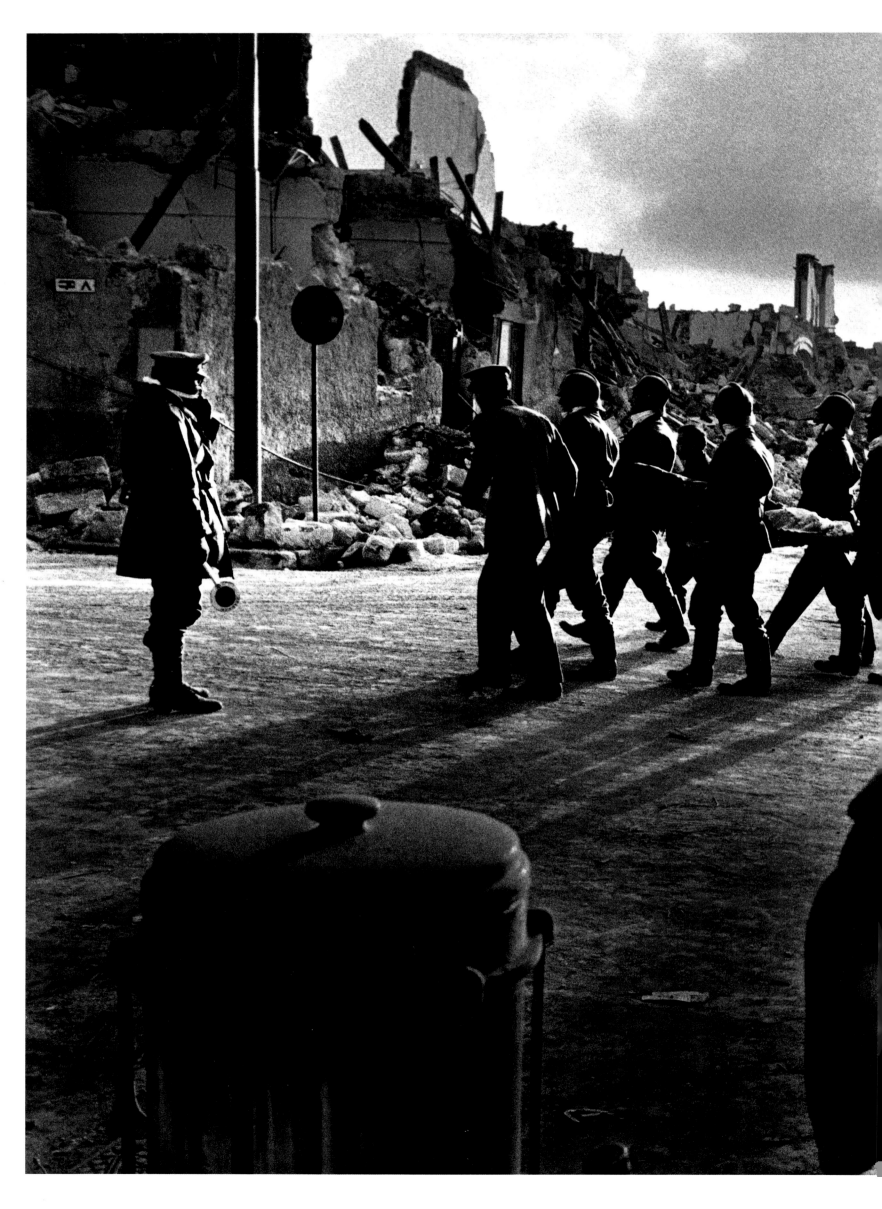

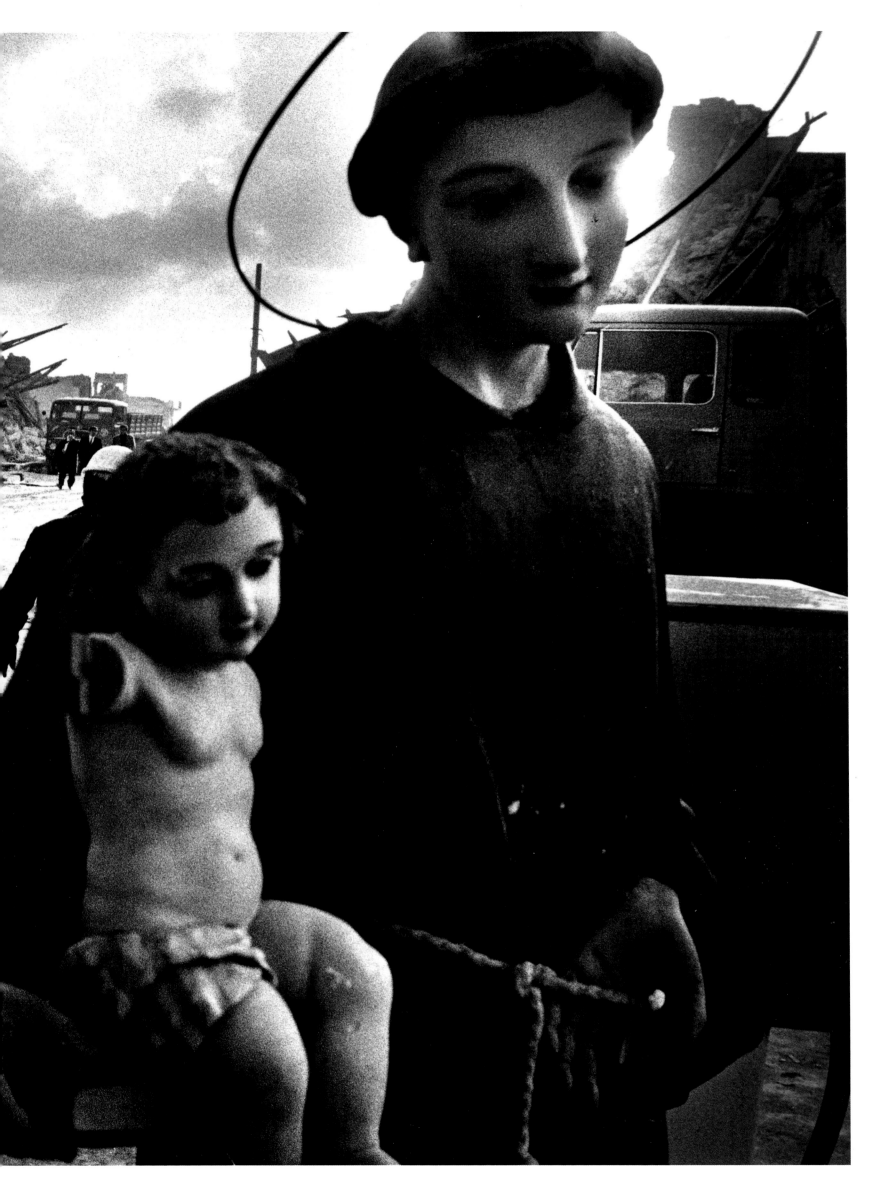

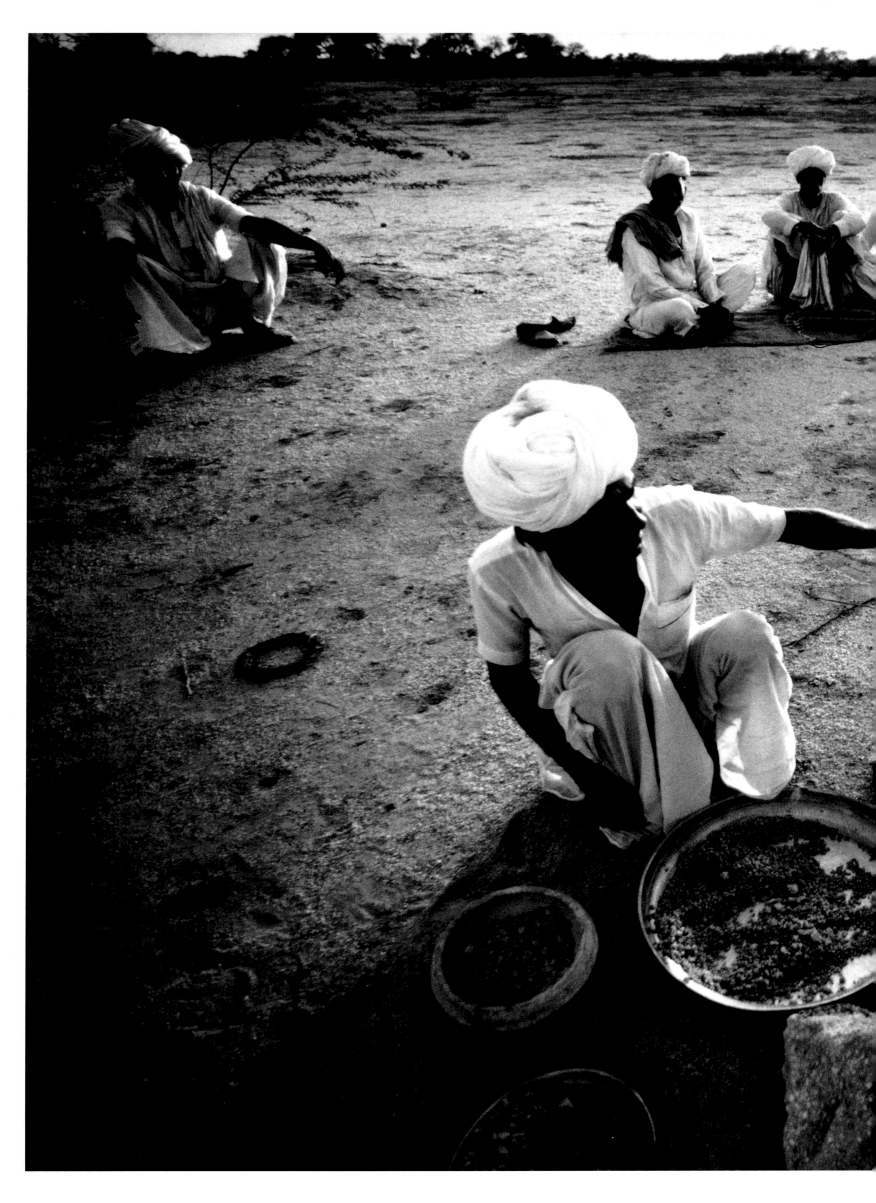

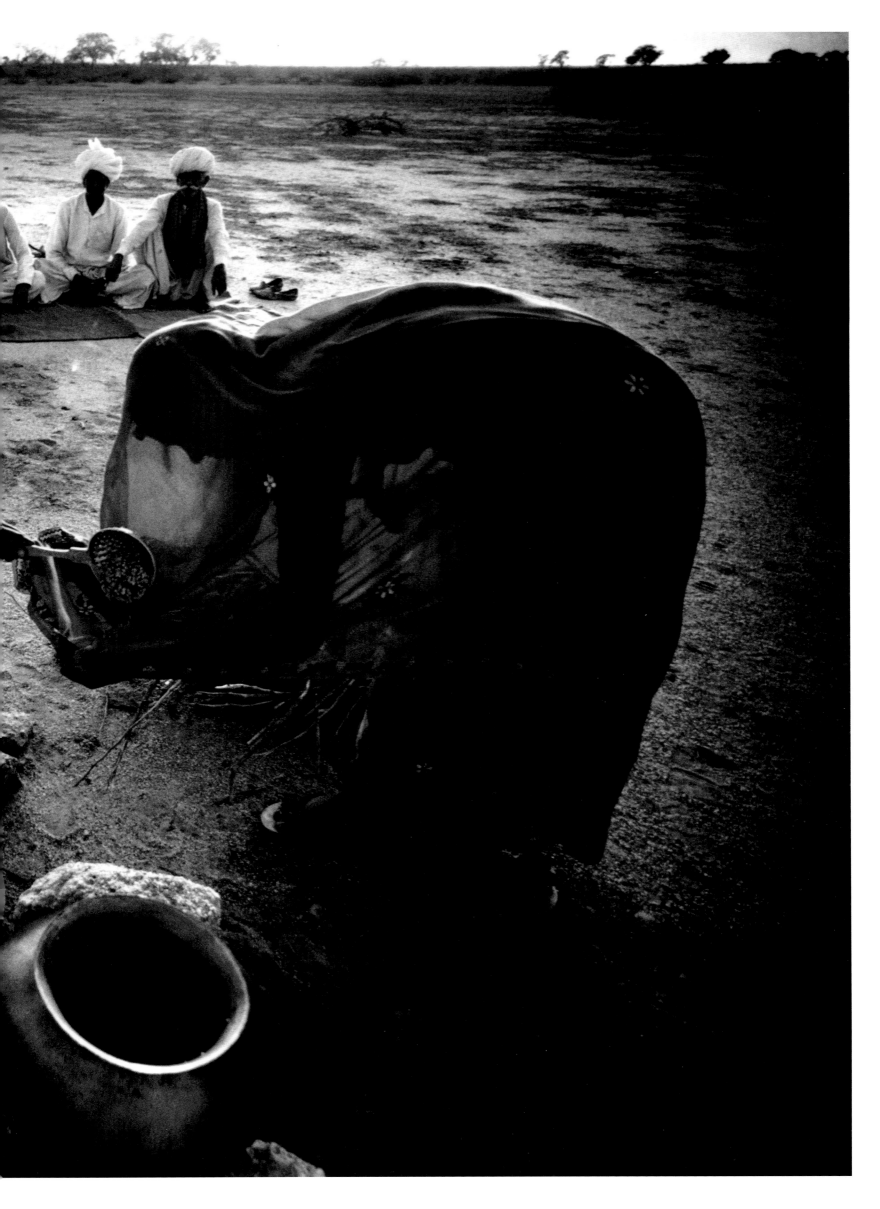

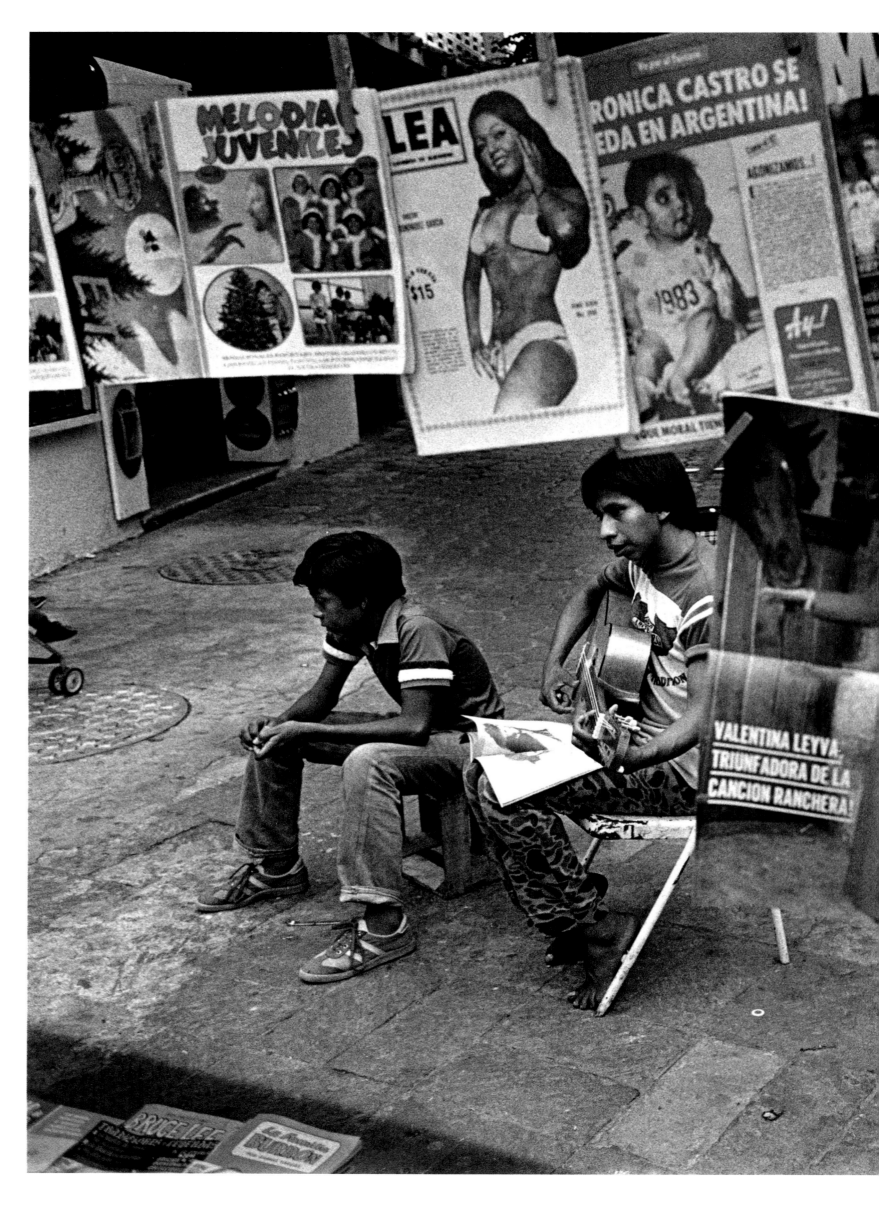

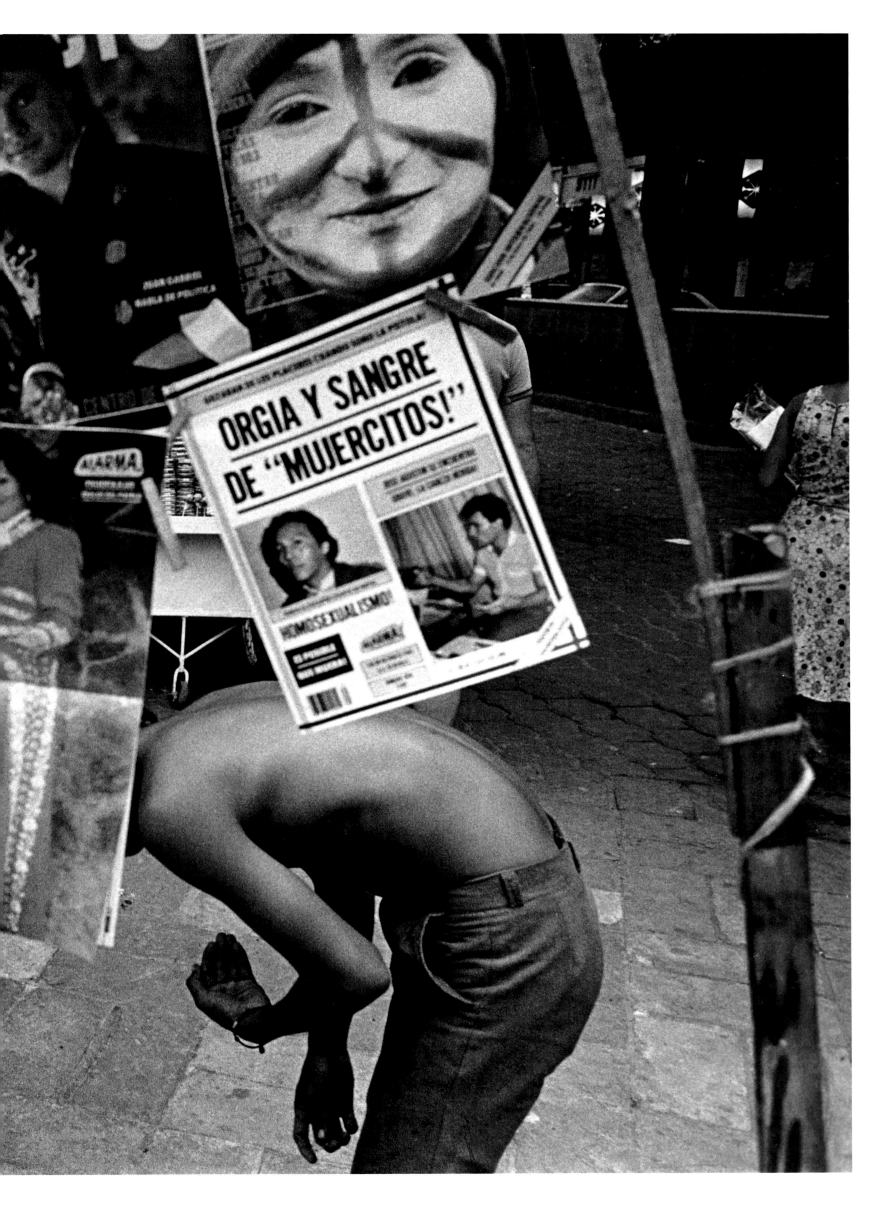

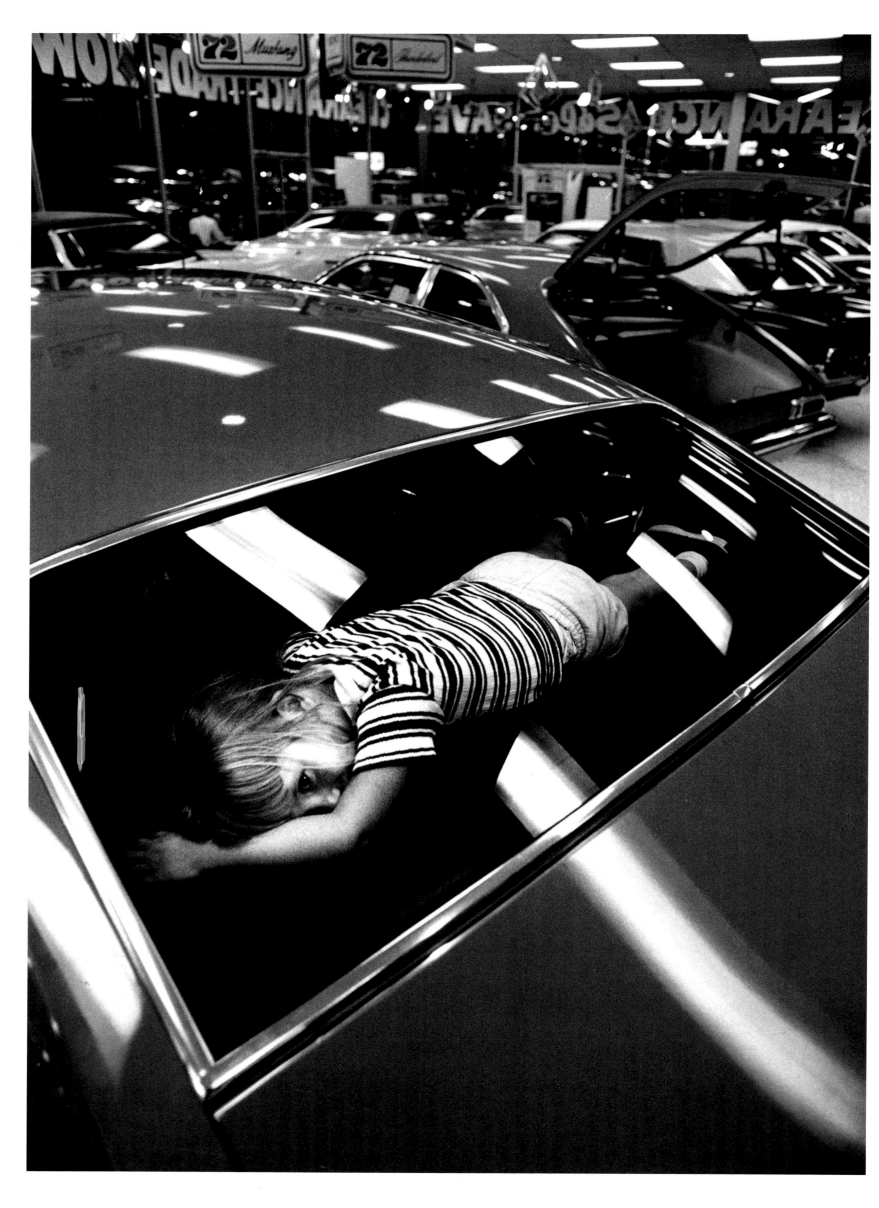

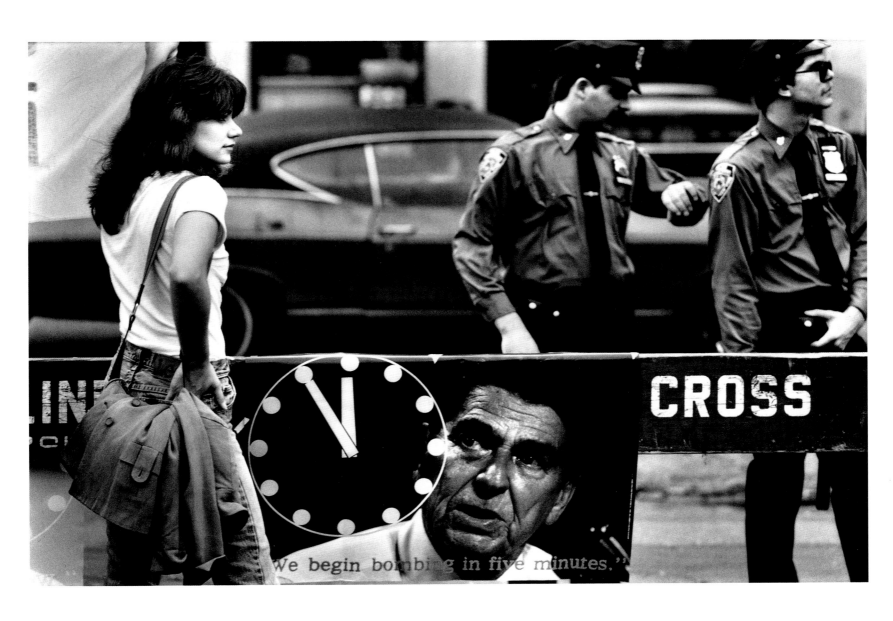

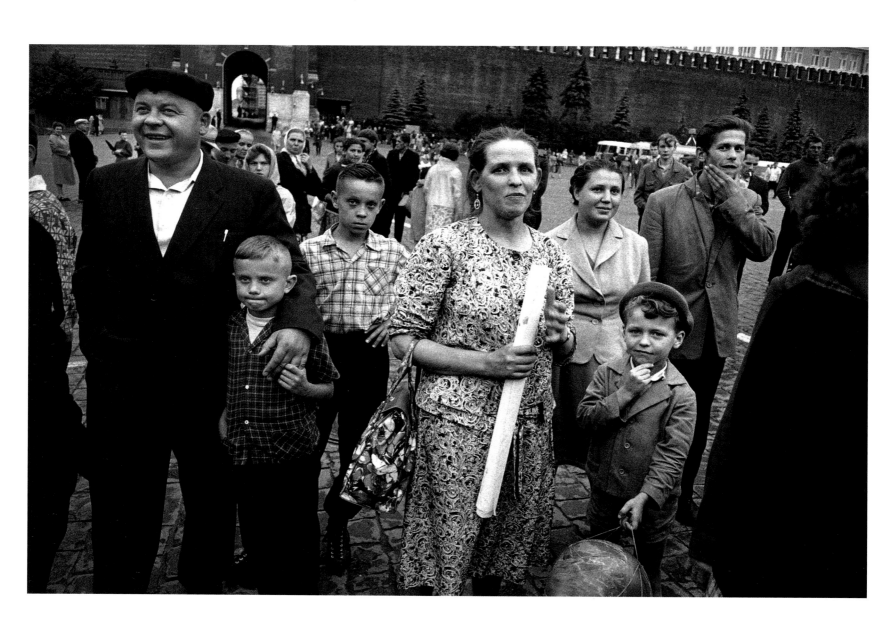

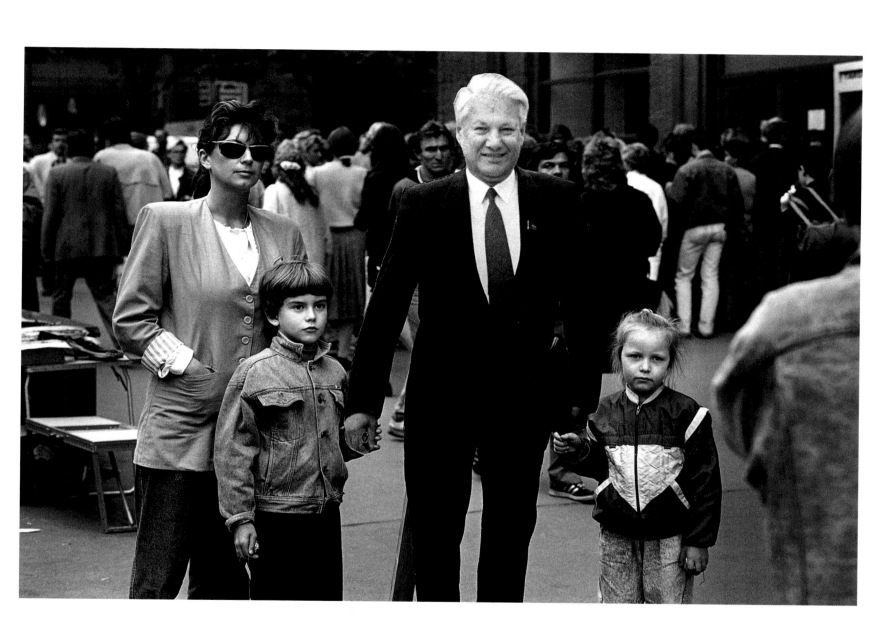

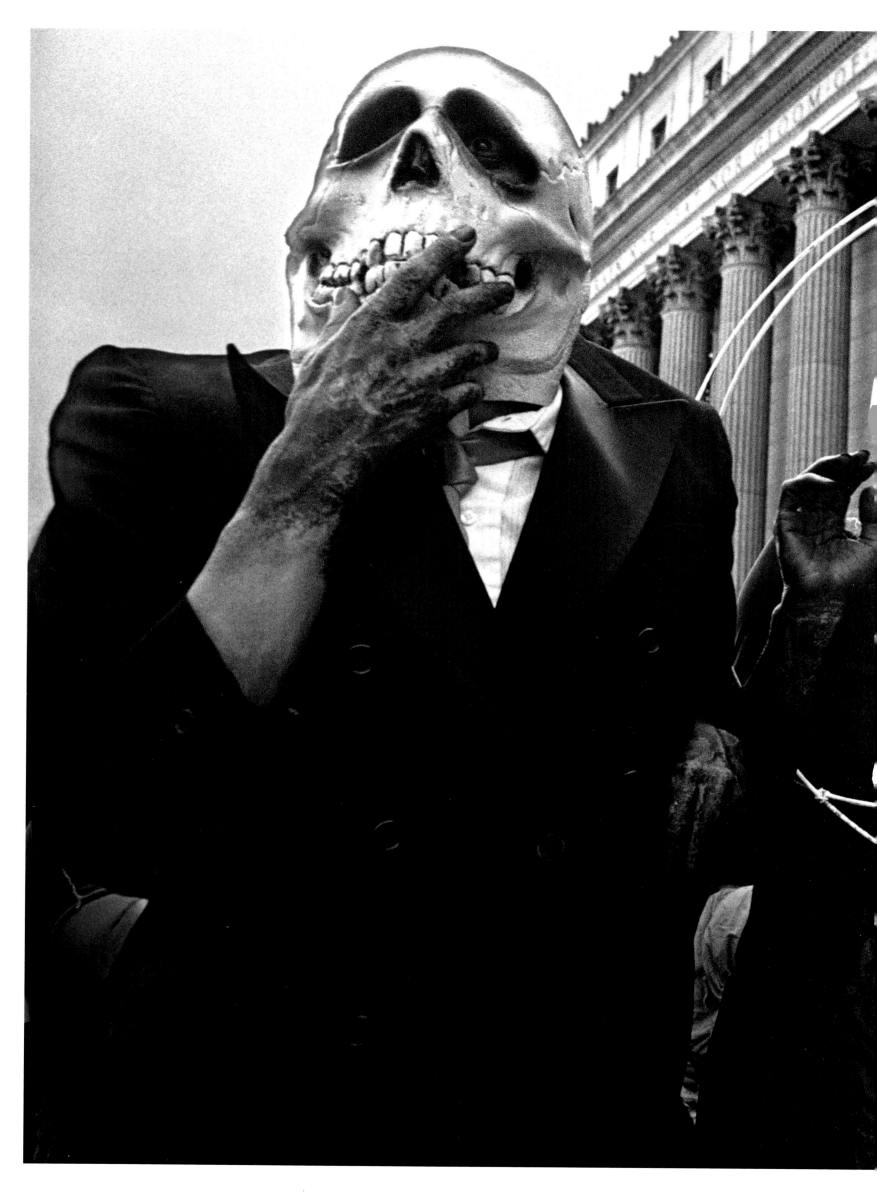

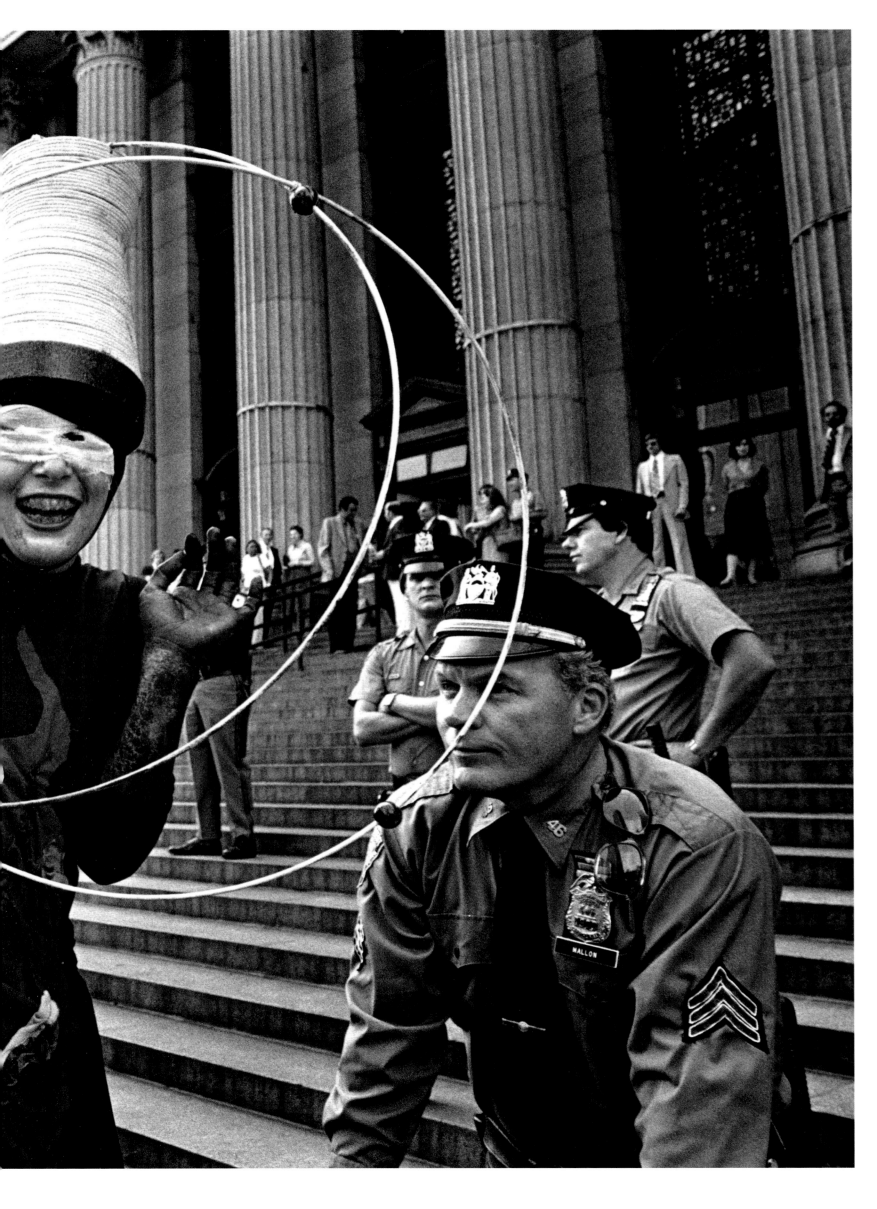

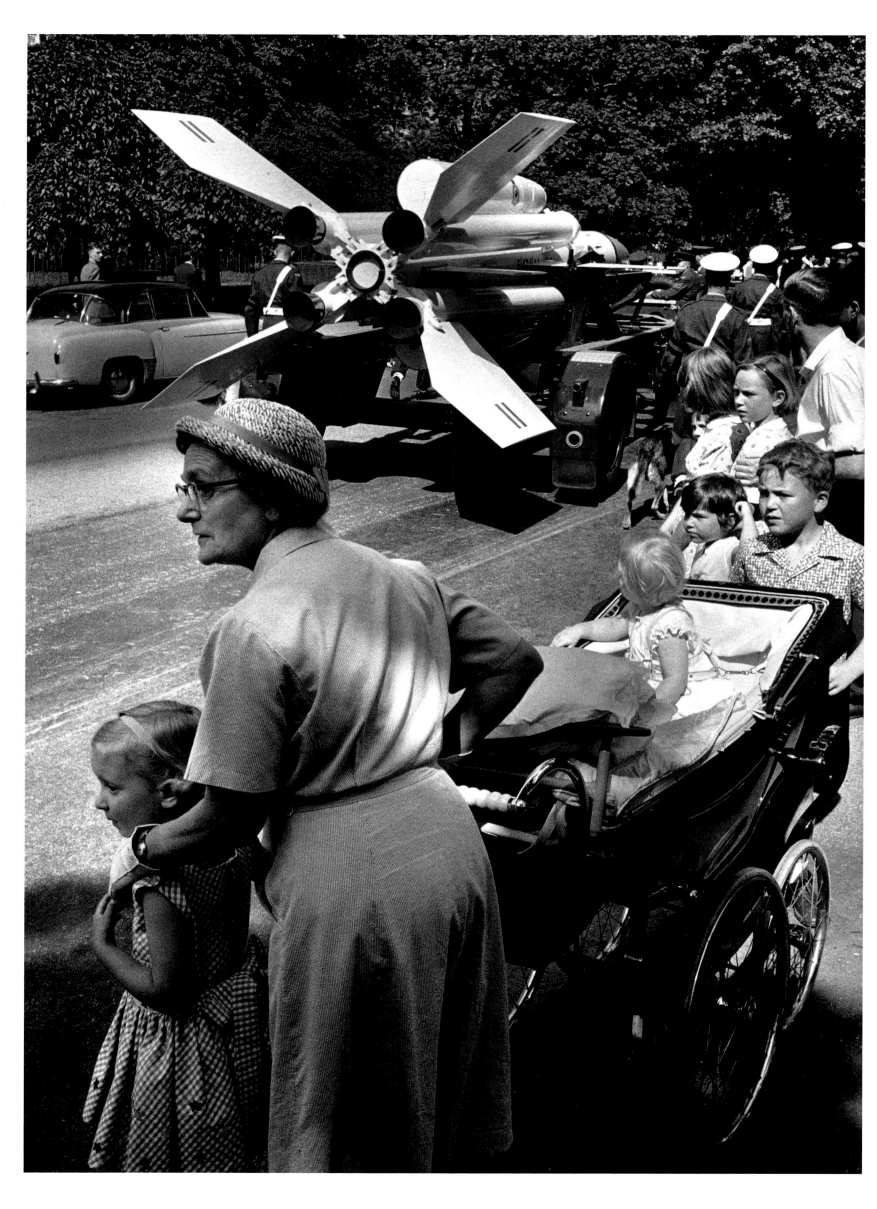

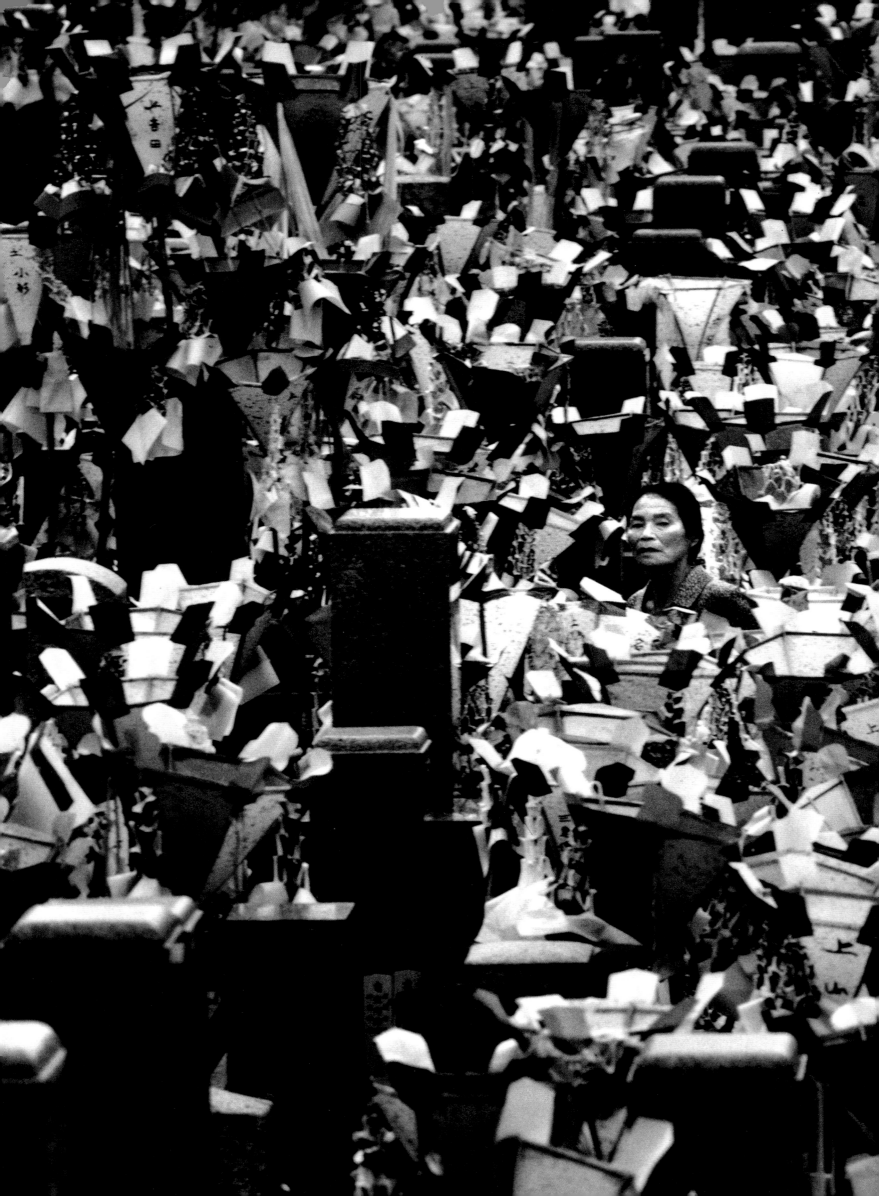

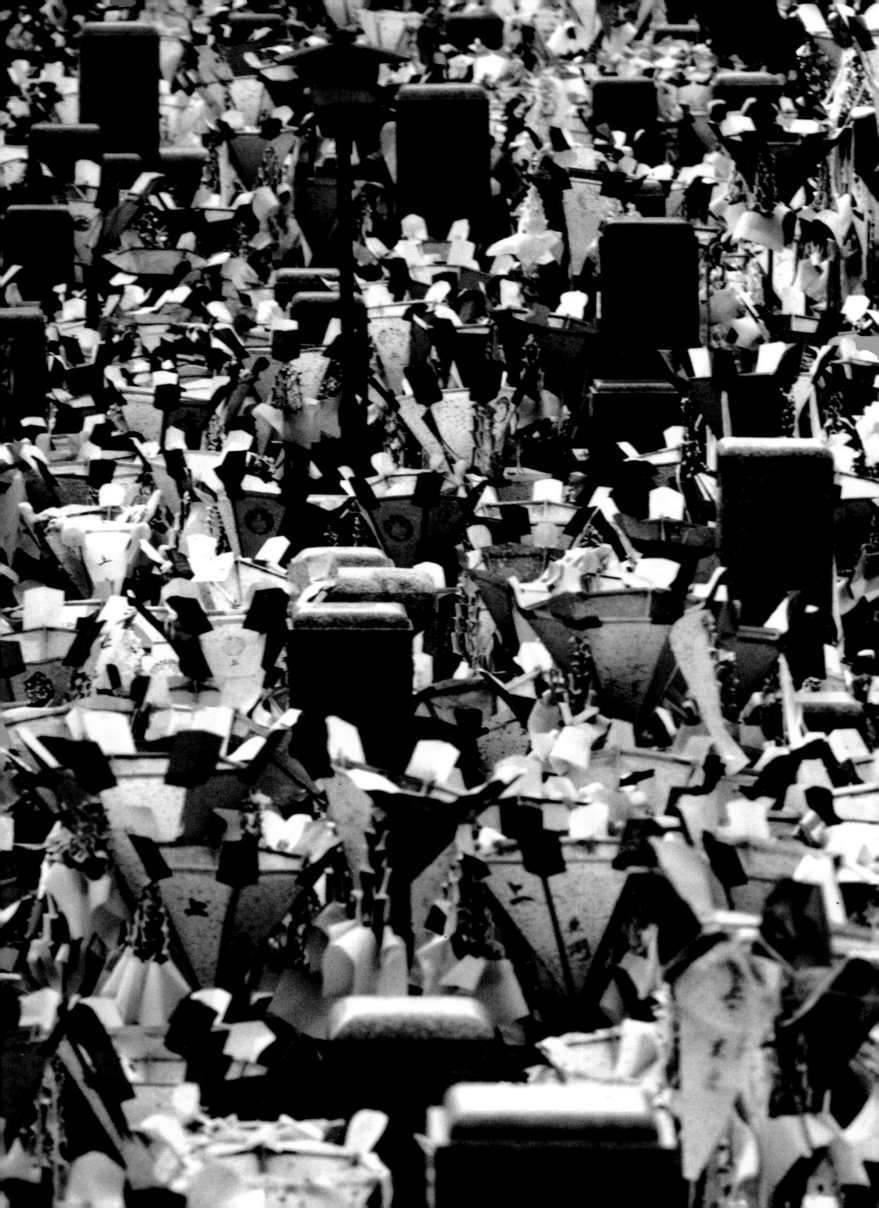

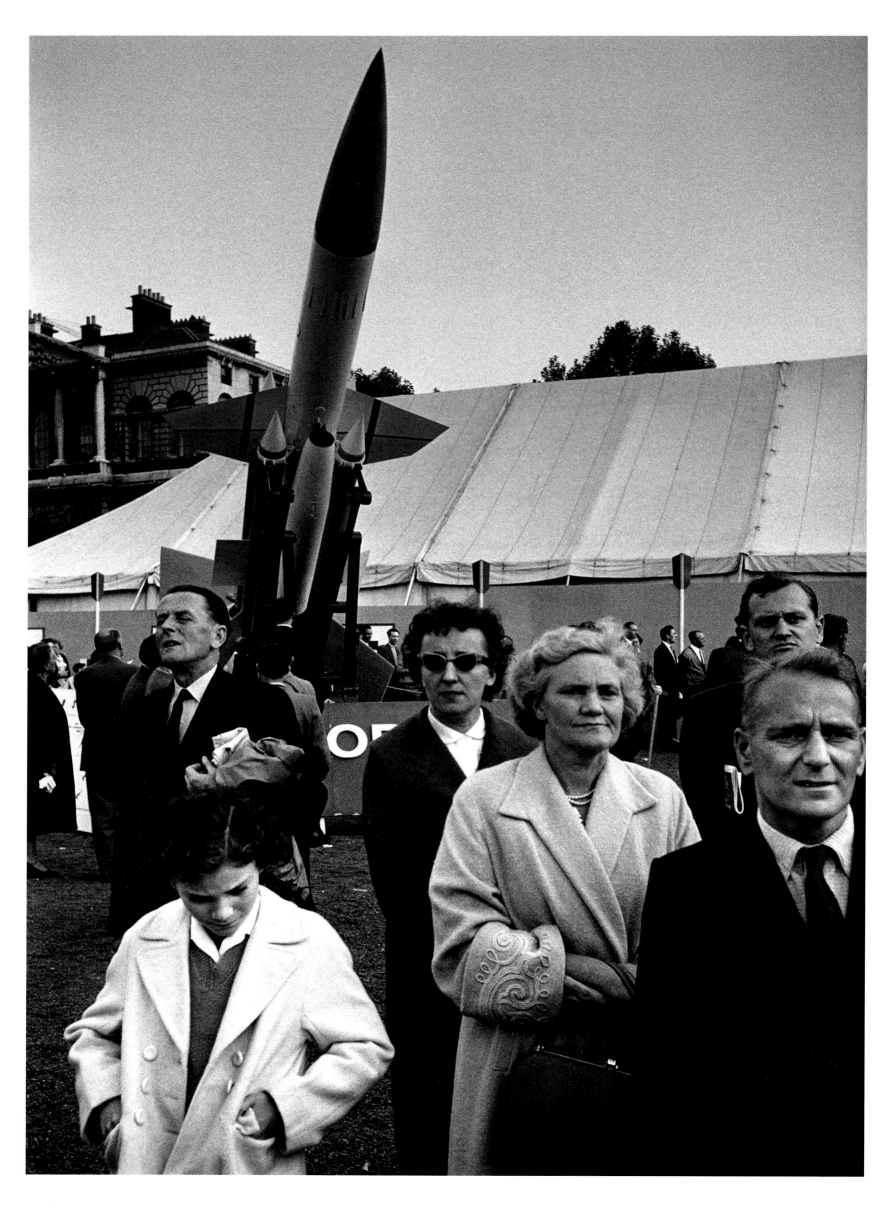

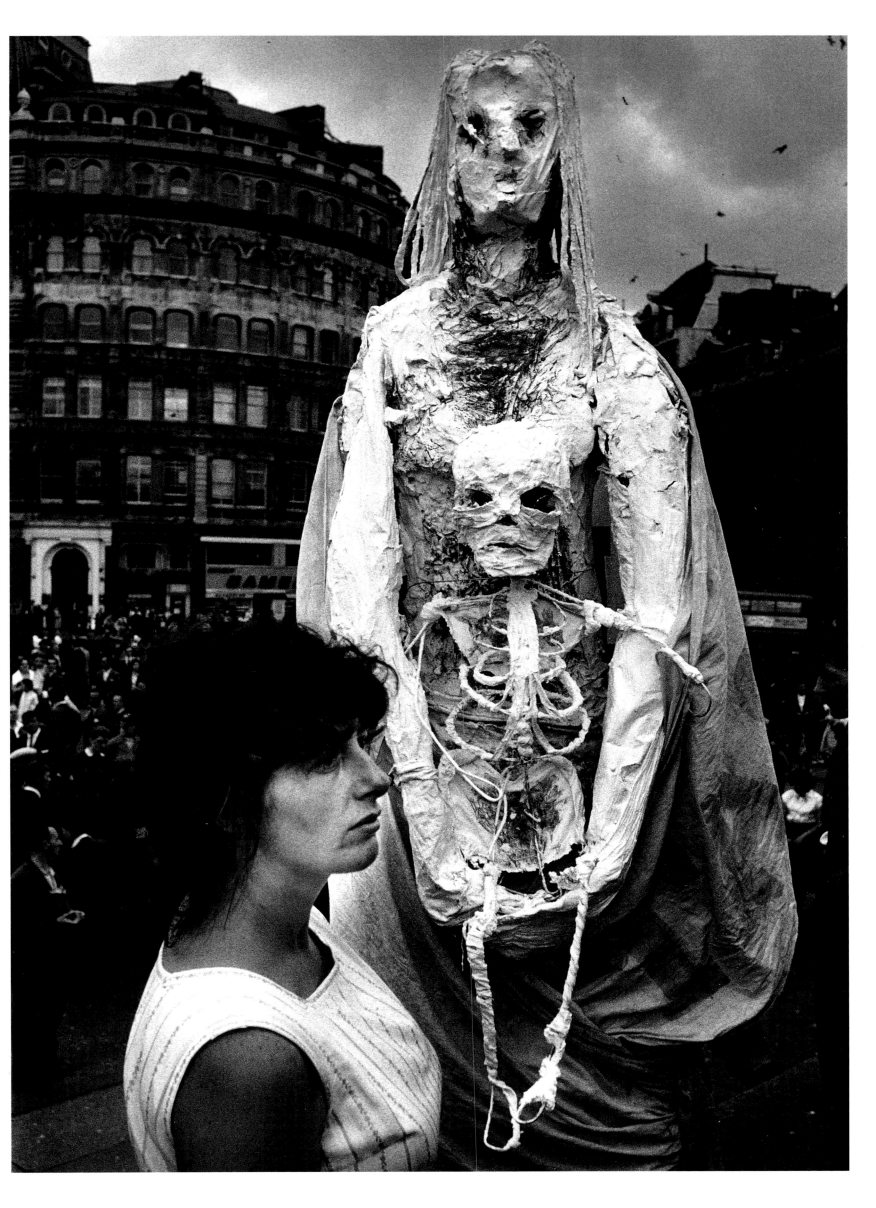

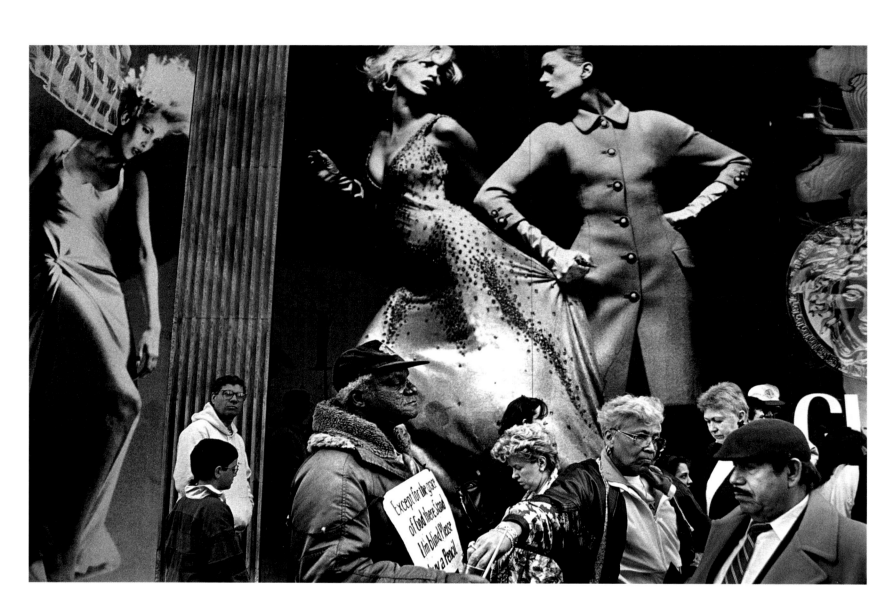

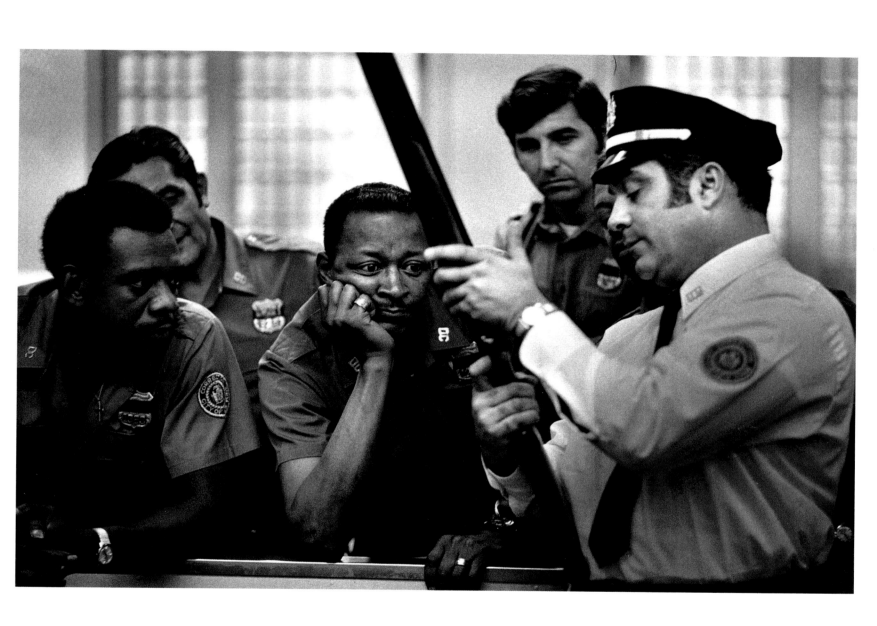

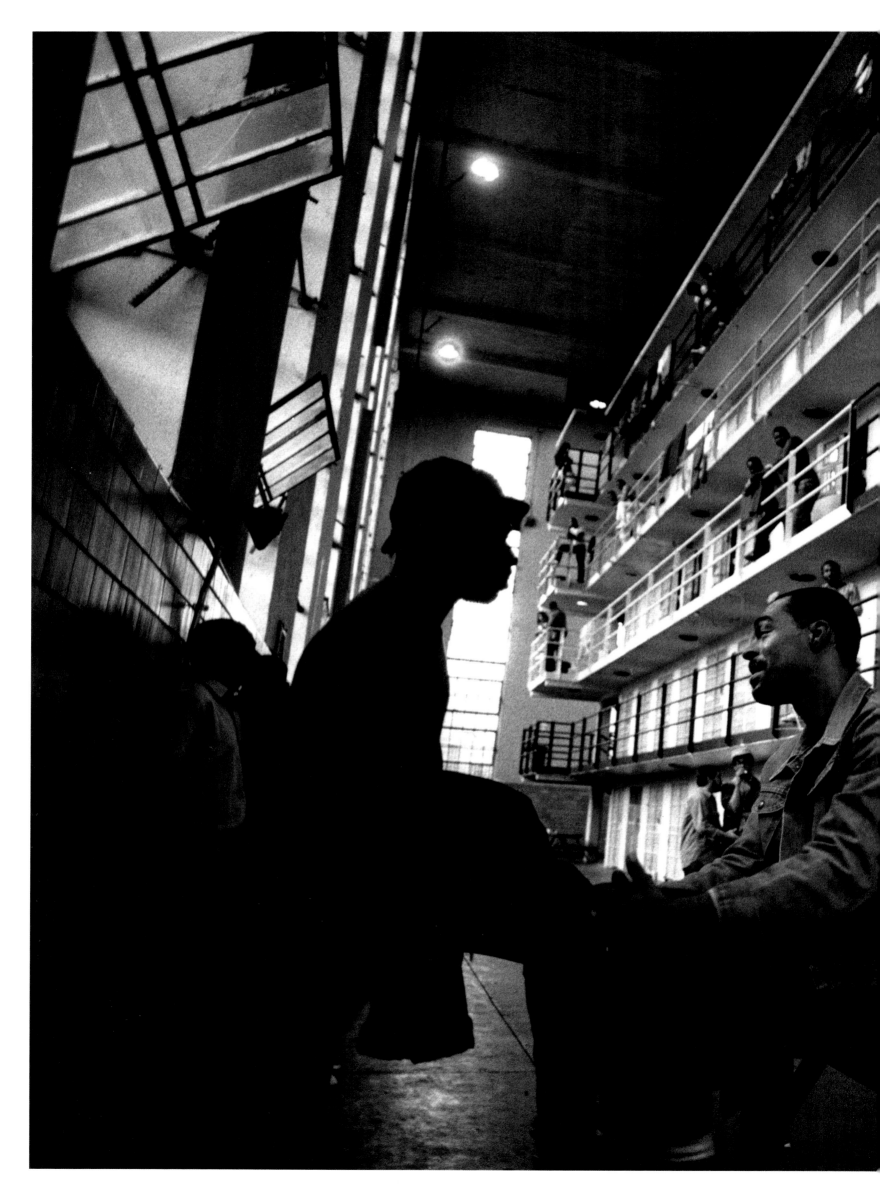

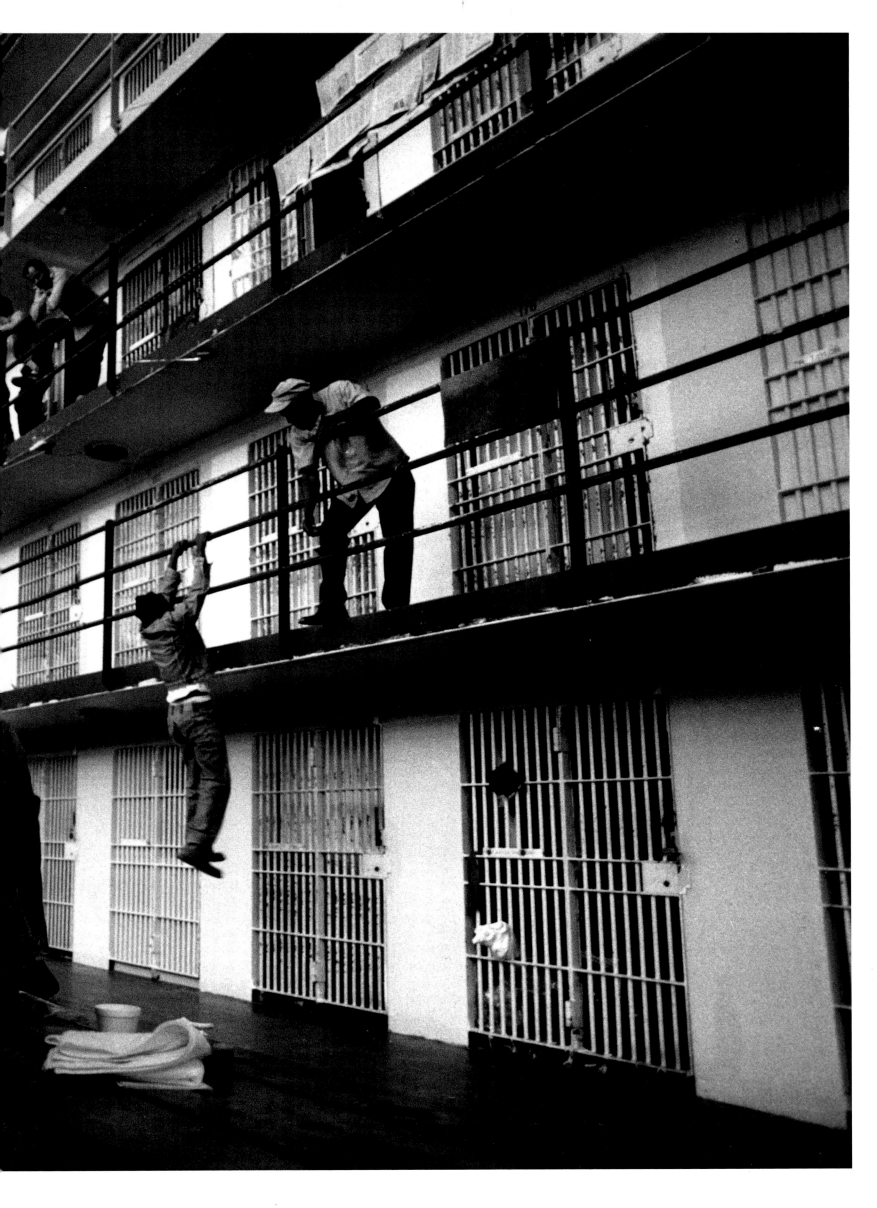

maelstrom

The war in Southeast Asia revealed the true nature of American foreign policy as it had never been seen before. For more than ten years the wealthiest and most powerful nation on earth tried everything short of nuclear weapons to defeat a nationalist revolutionary movement in a small nation of poor rice farmers. And they failed. Despite the slaughter, the people triumphed. America had the smart bombs but the Vietnamese had the smart minds. The battle was between technology and human beings, and the human beings won.

Being British, and a photographer, I had a privileged overview of the contest. I spent five years immersed in Vietnam trying to make sense of what was going on. All that was needed was a cool head, a sharp eye, and a modicum of humanity to qualify as a serious observer. My book *Vietnam Inc.* examined every aspect of the war and, I hope, helped illuminate the subject.

At times the Vietnam War, like all wars, had the drama of the Forces of Darkness murdering the Innocents. The task, of course, was to see beyond the obvious. All wars produce the familiar iconic images of horror, which do little to further anyone's understanding of a particular conflict. My purpose was to understand the nature of the war, and reveal the *truth* about it, with photographs providing the visual proof. The photographs are the *evidence*.

When all the revisionist historians, Cold War warriors, armchair peaceniks and confused handmaidens of authority have had their say, the reality remains—it was a genocidal war aimed at slaughtering civilians. When Lieutenant Calley was asked during the inquiry into the My Lai massacre whether he had thrown babies in the air to shoot them, he replied, "Yes sir, in the air." Nowadays, it is not considered polite to dwell on such matters.

More bombs were dropped on Vietnam than the total tonnage dropped during World War II, including the bombing of Hiroshima. The facts are overwhelming and so is the evidence—the photographs. The smell of gangrene, the sight of children with their lips and eyelids burned off by napalm, a mother's shame because she couldn't feed her baby (the shell fragments had sliced off her breasts and the leg of her three-day-old daughter.) It's possible that these memories might fade. The photographs will not.

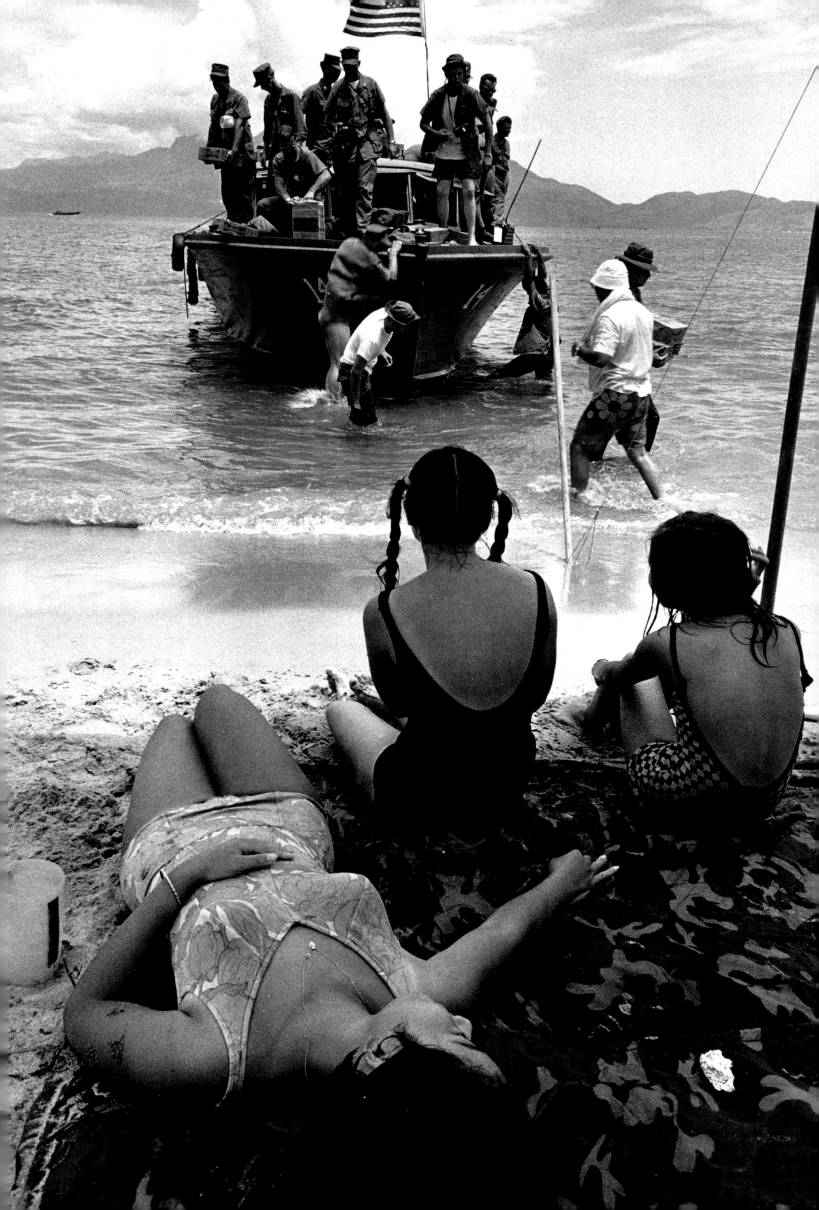

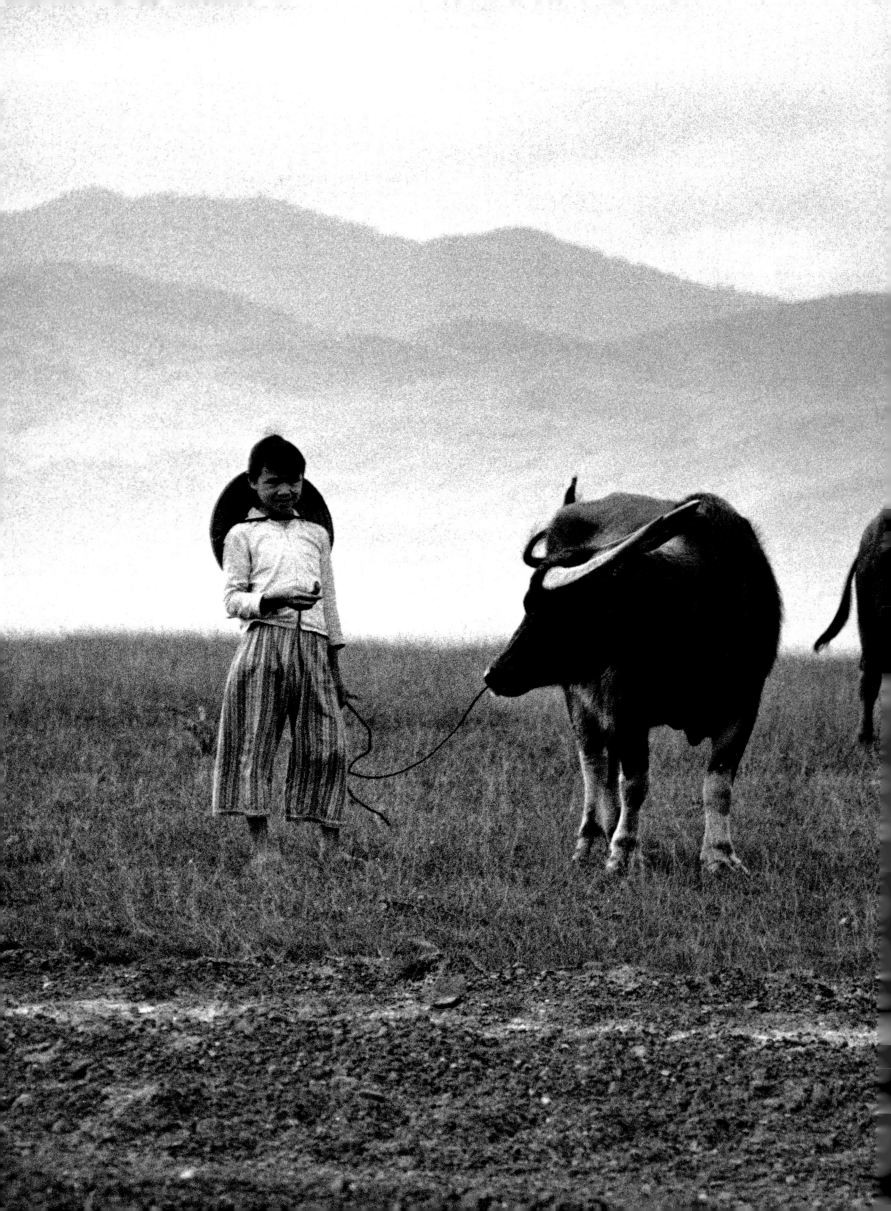

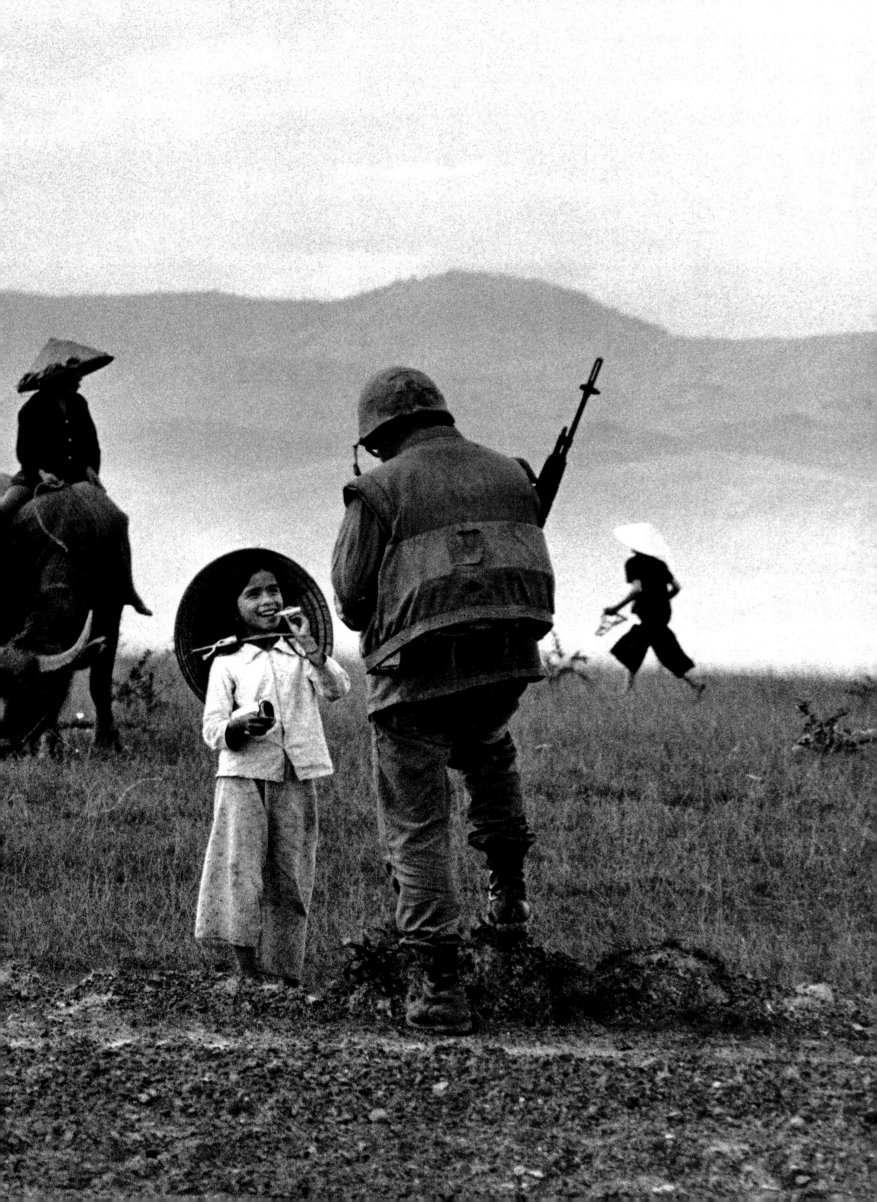

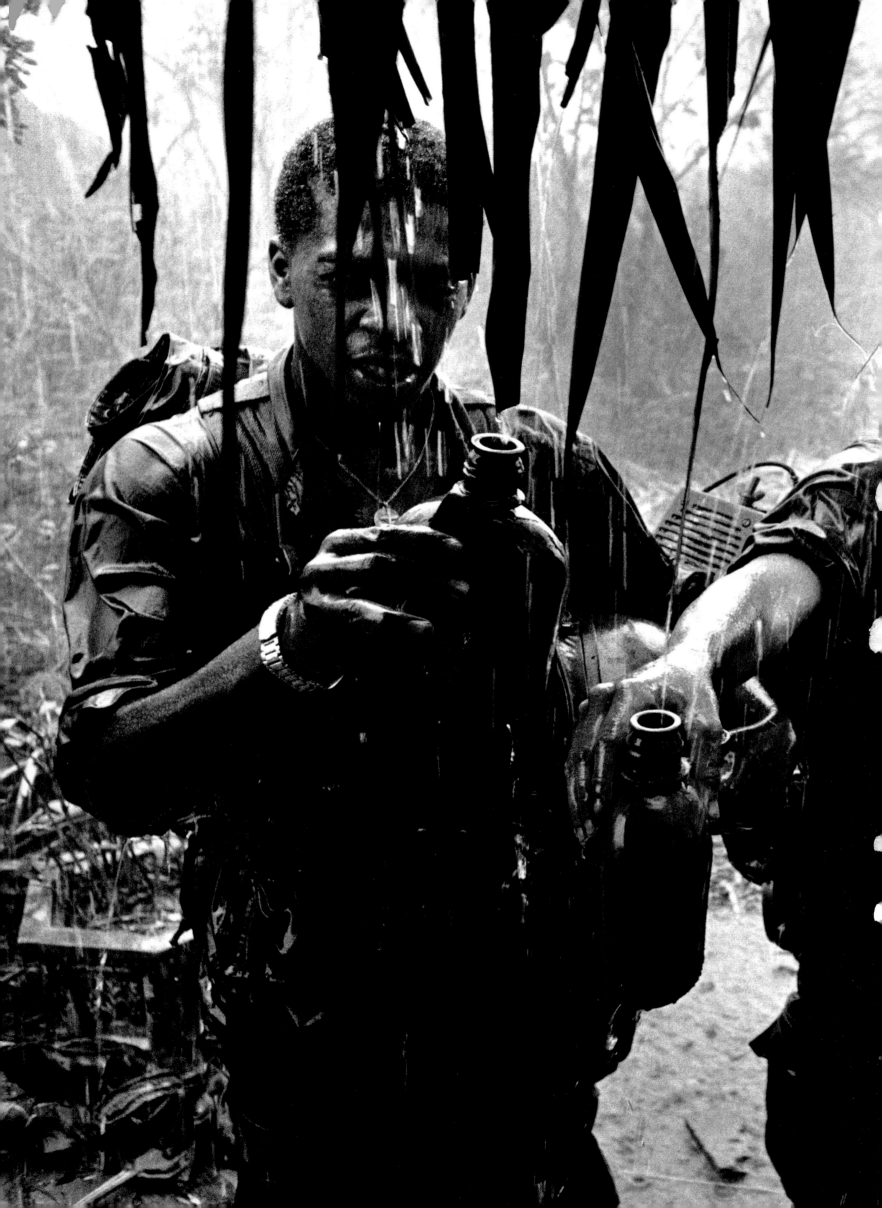

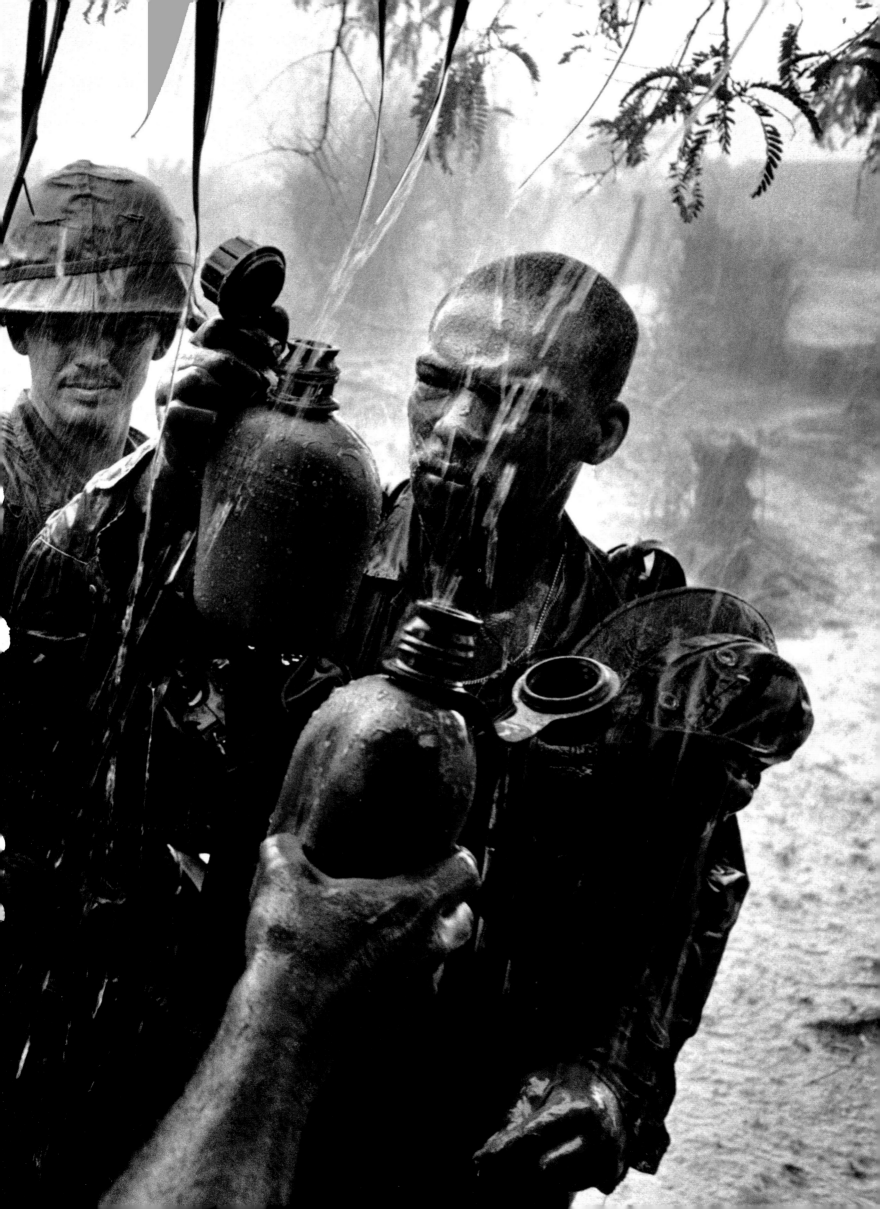

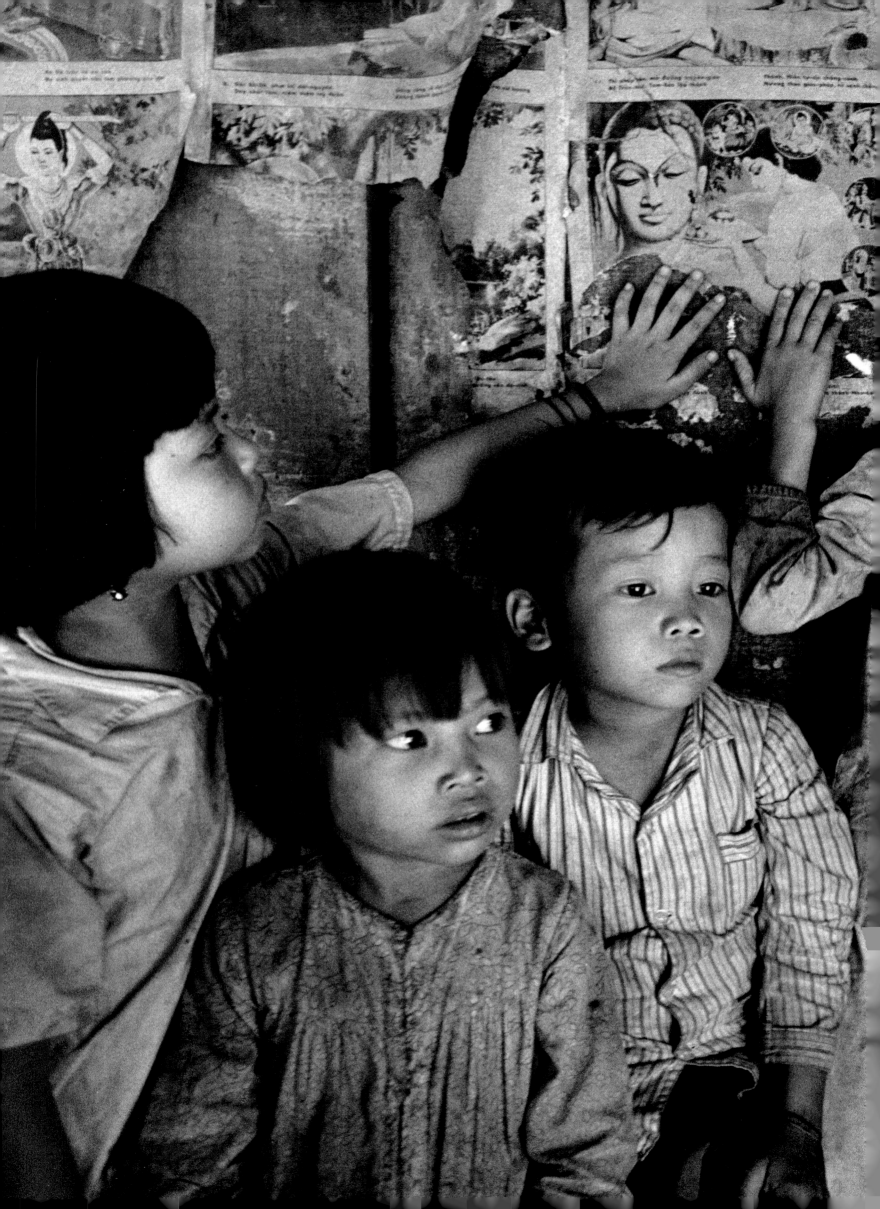

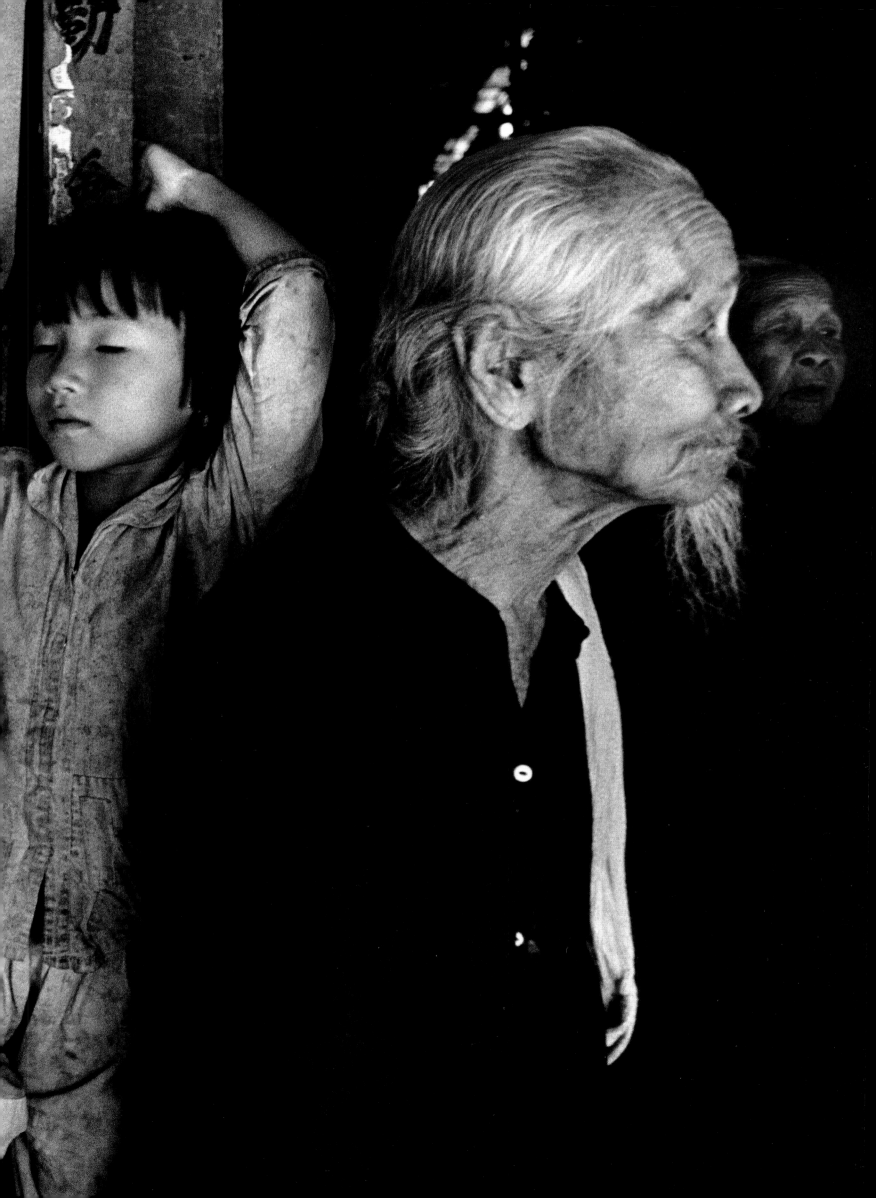

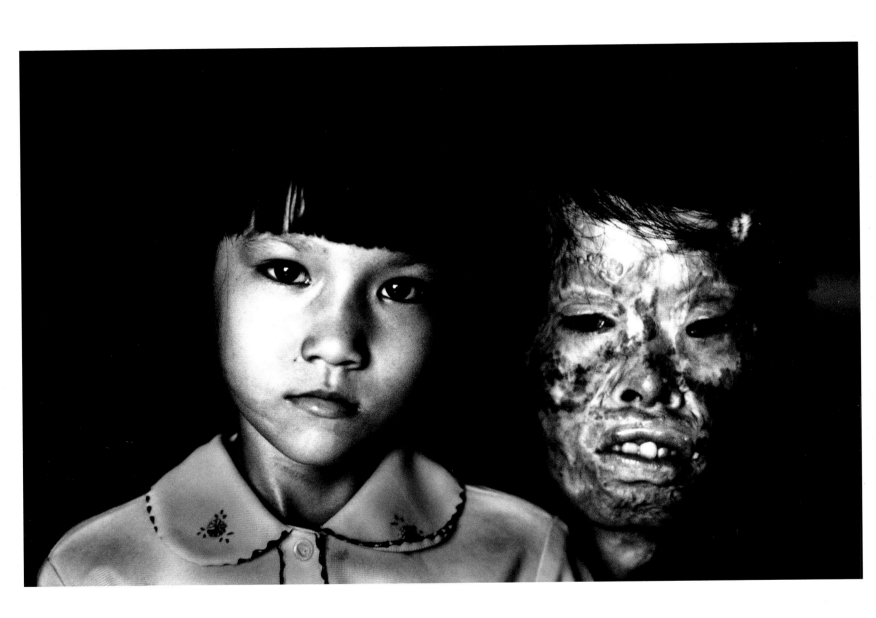

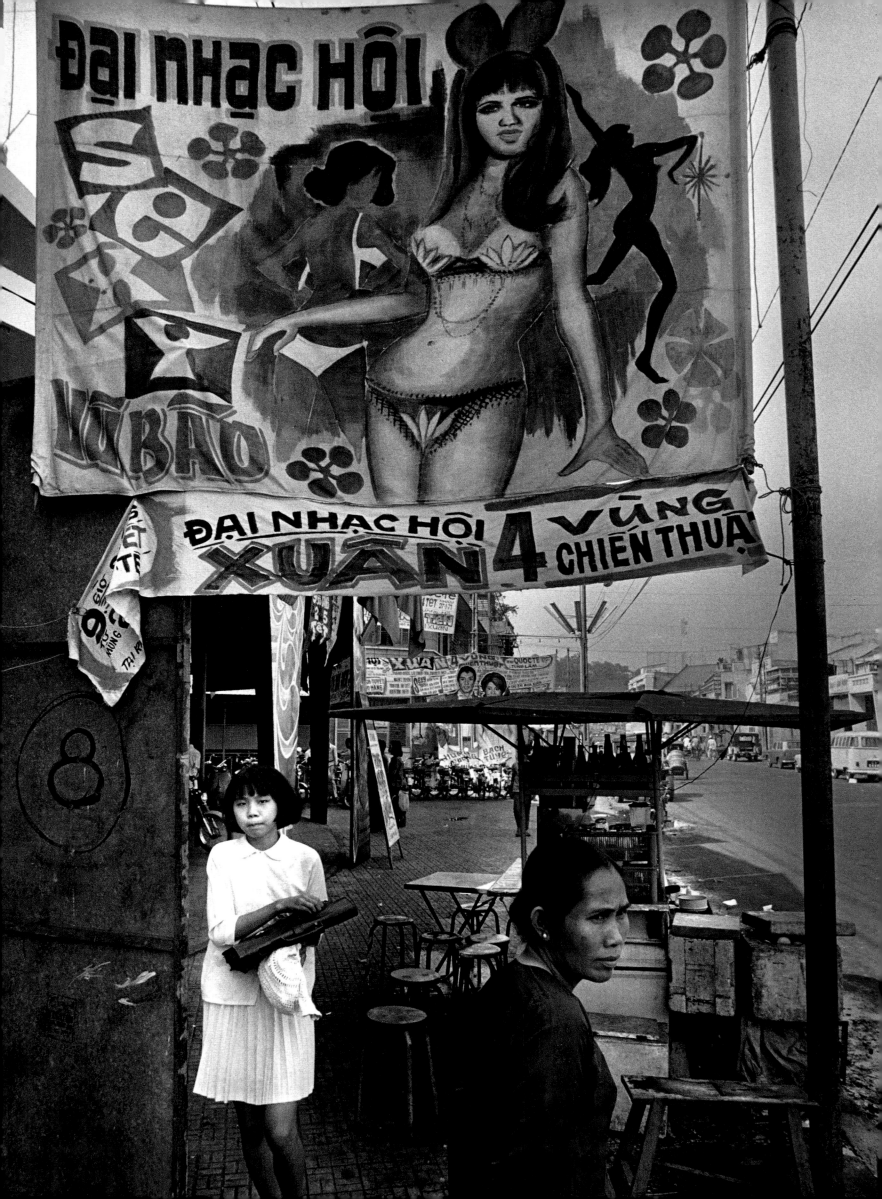

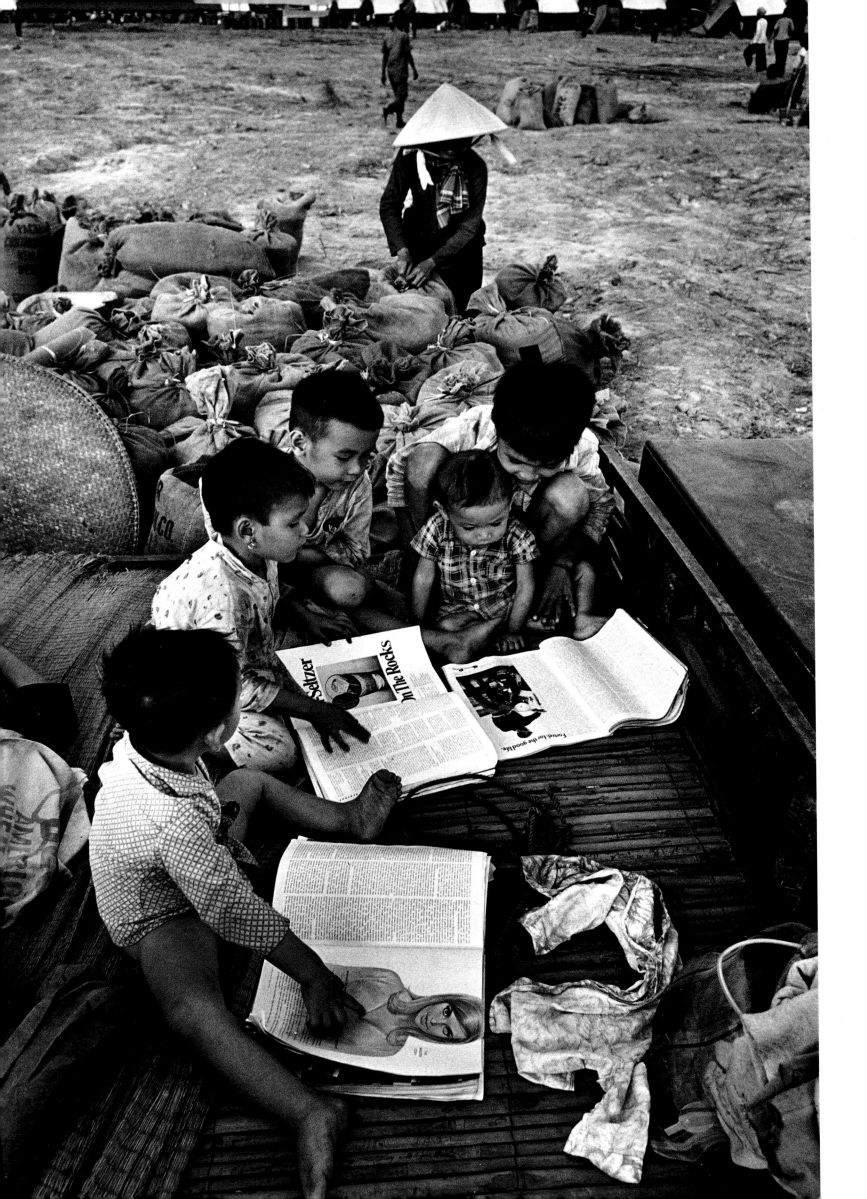

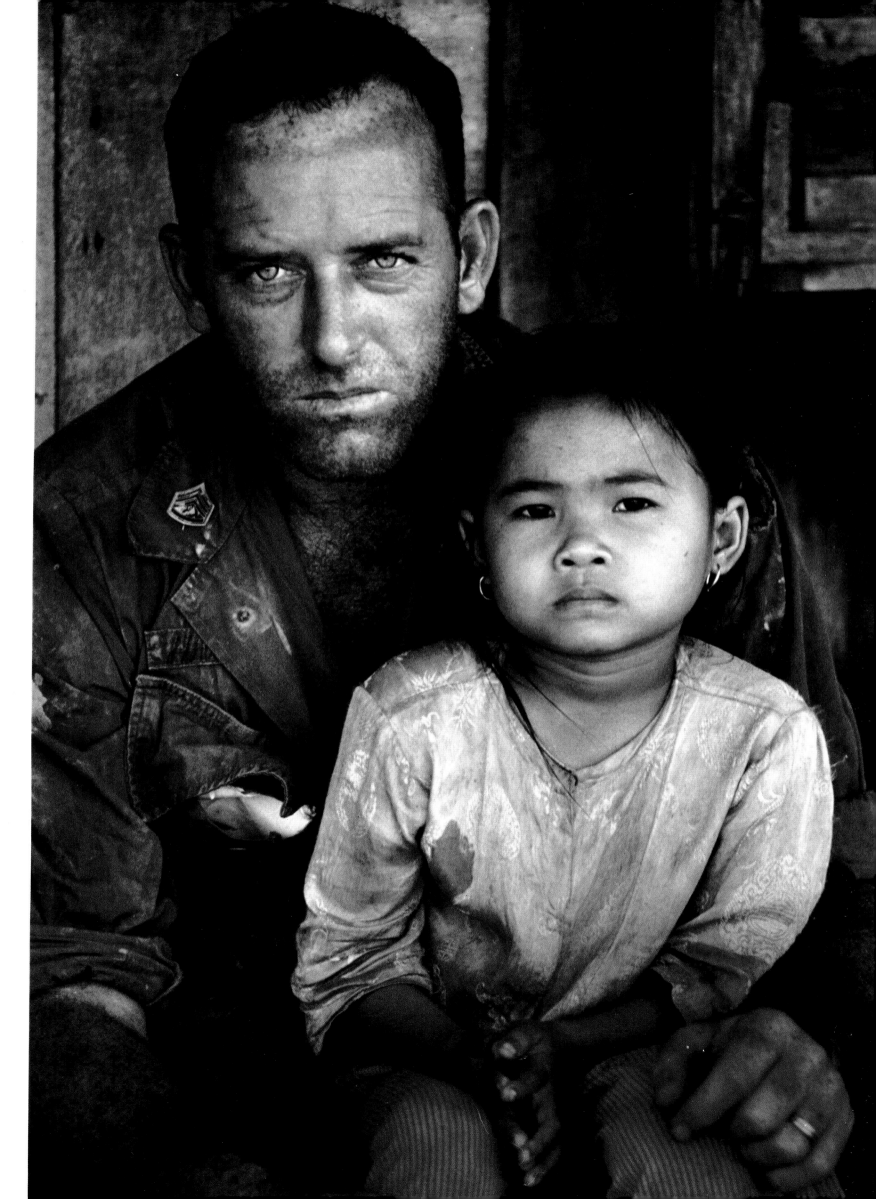

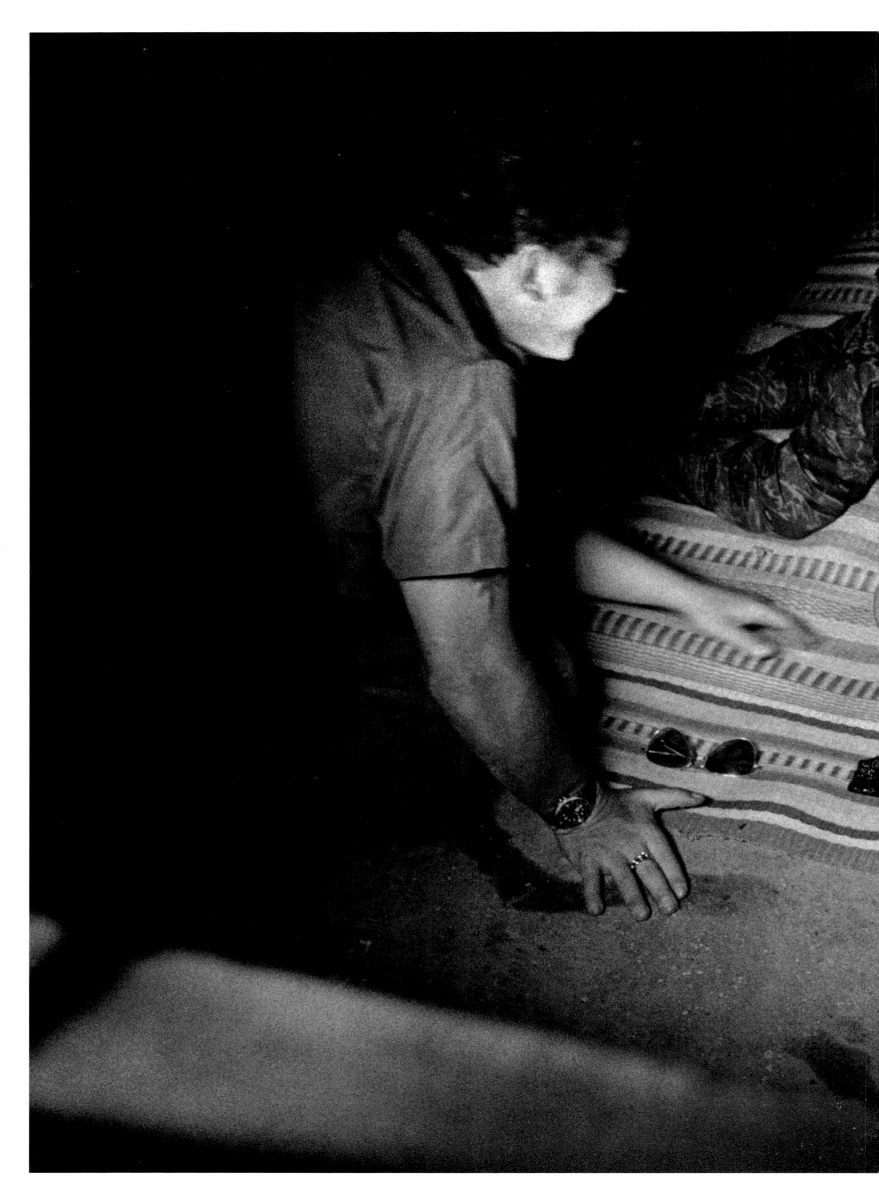

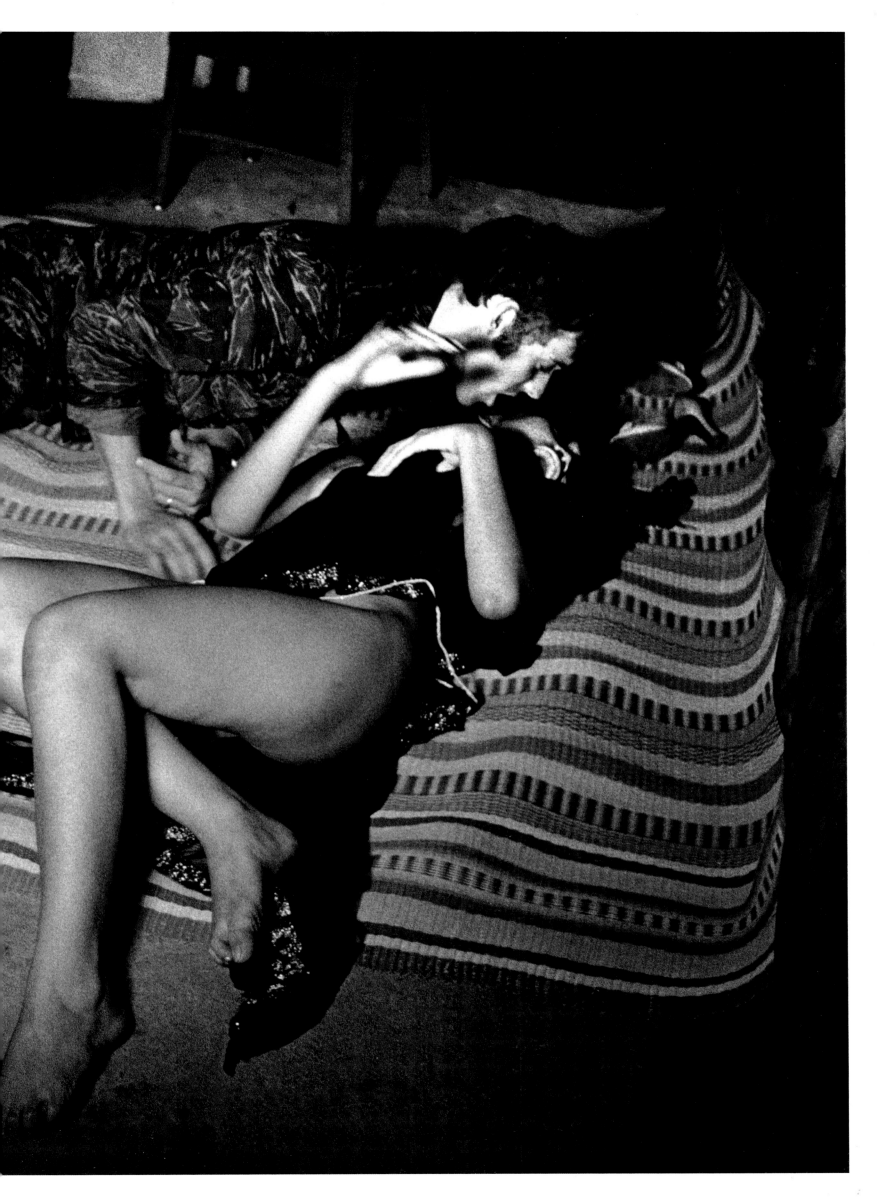

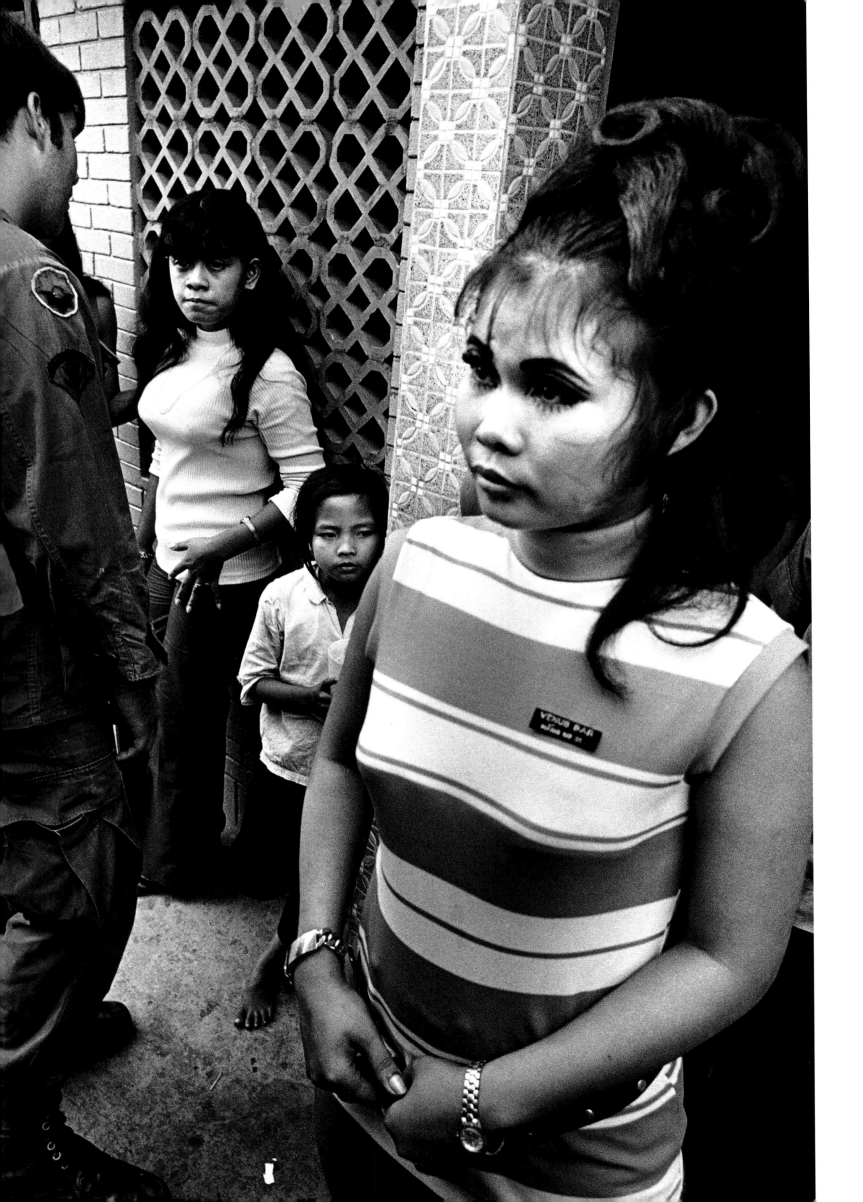

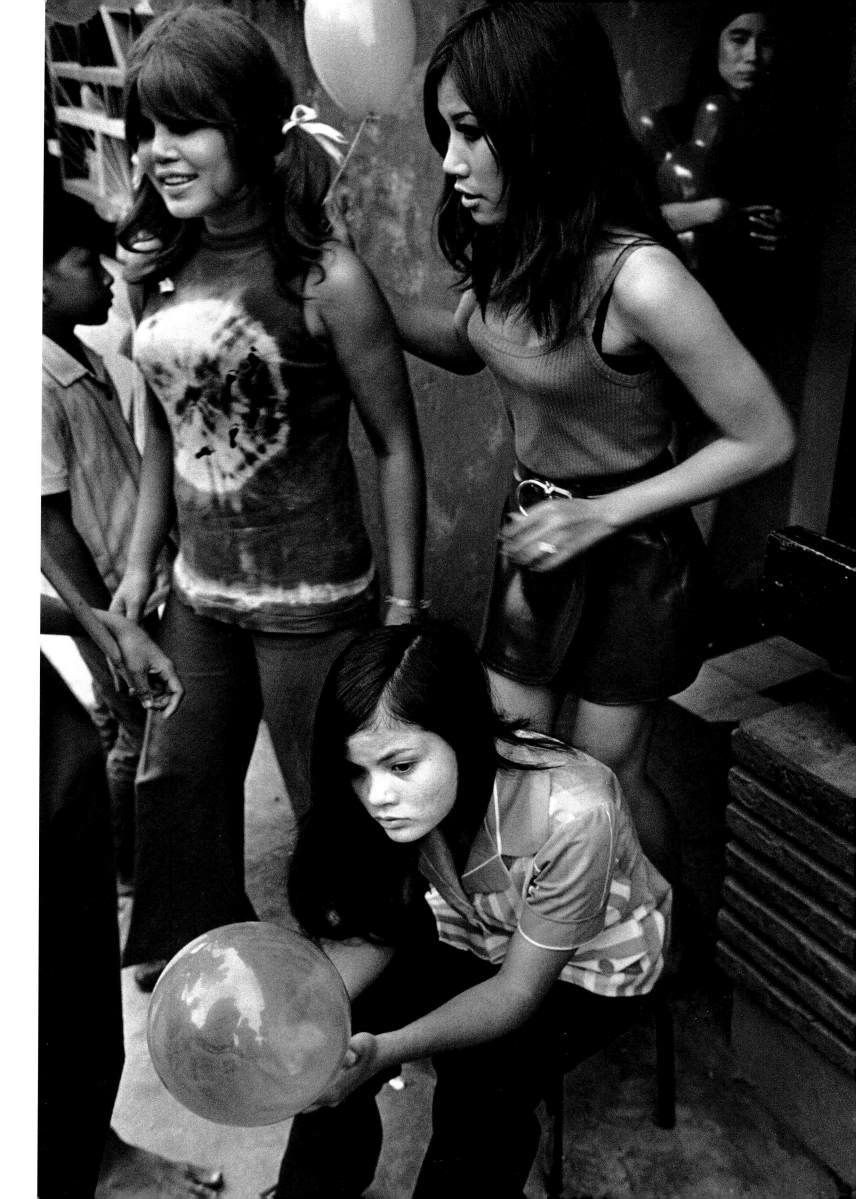

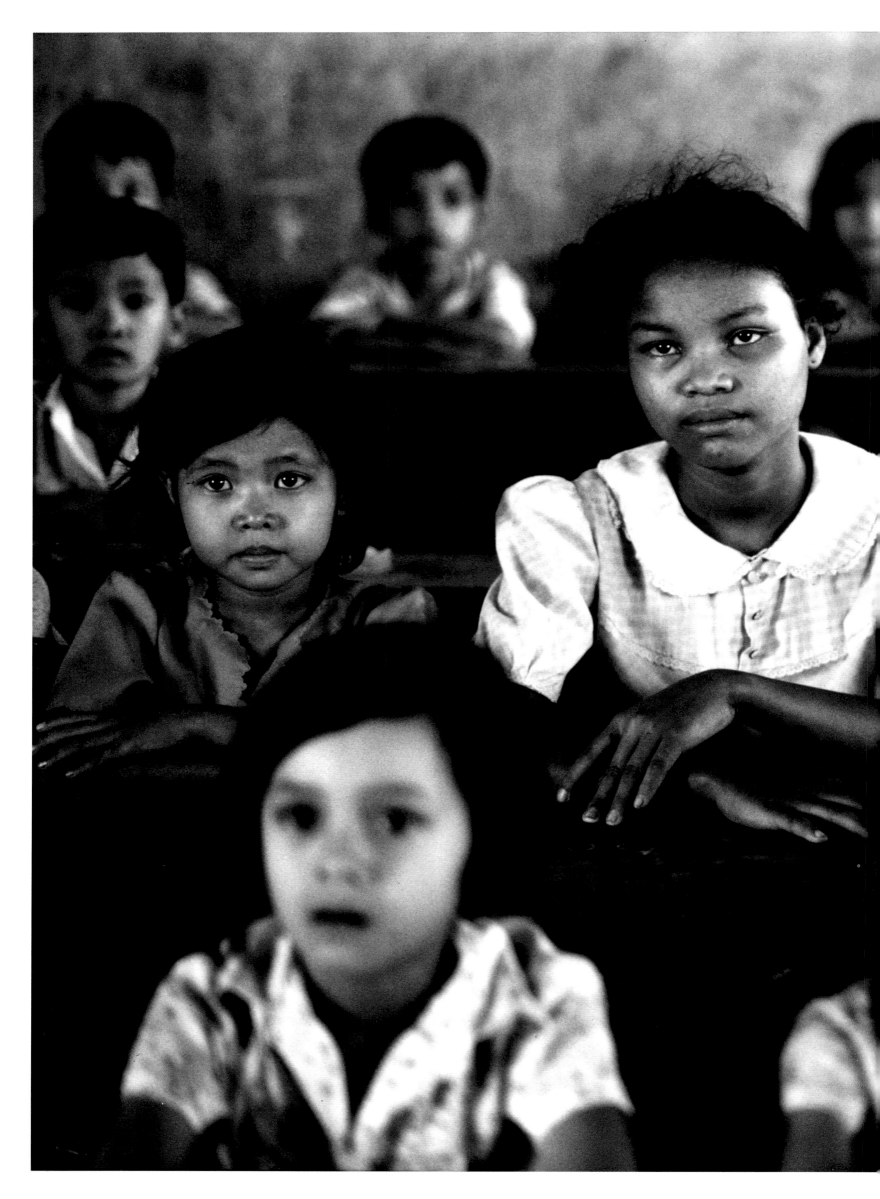

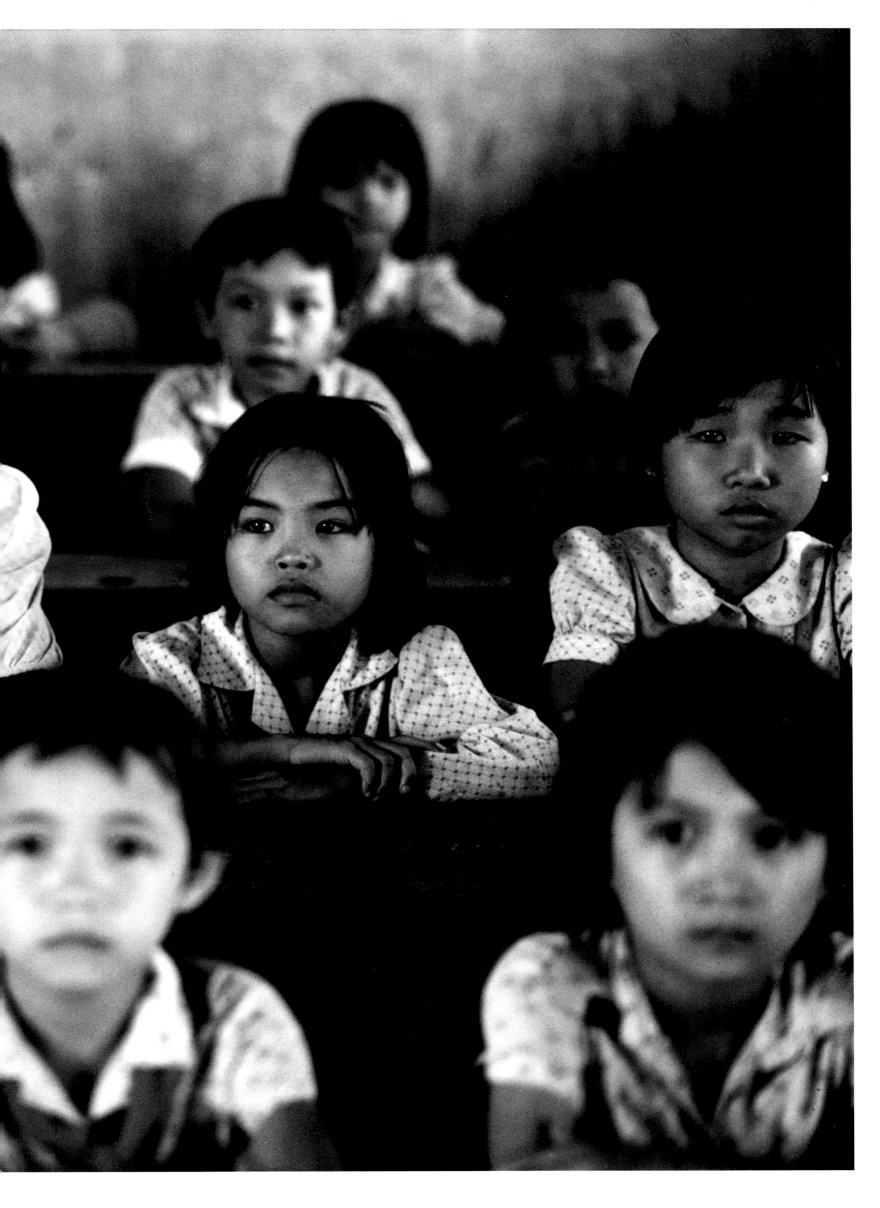

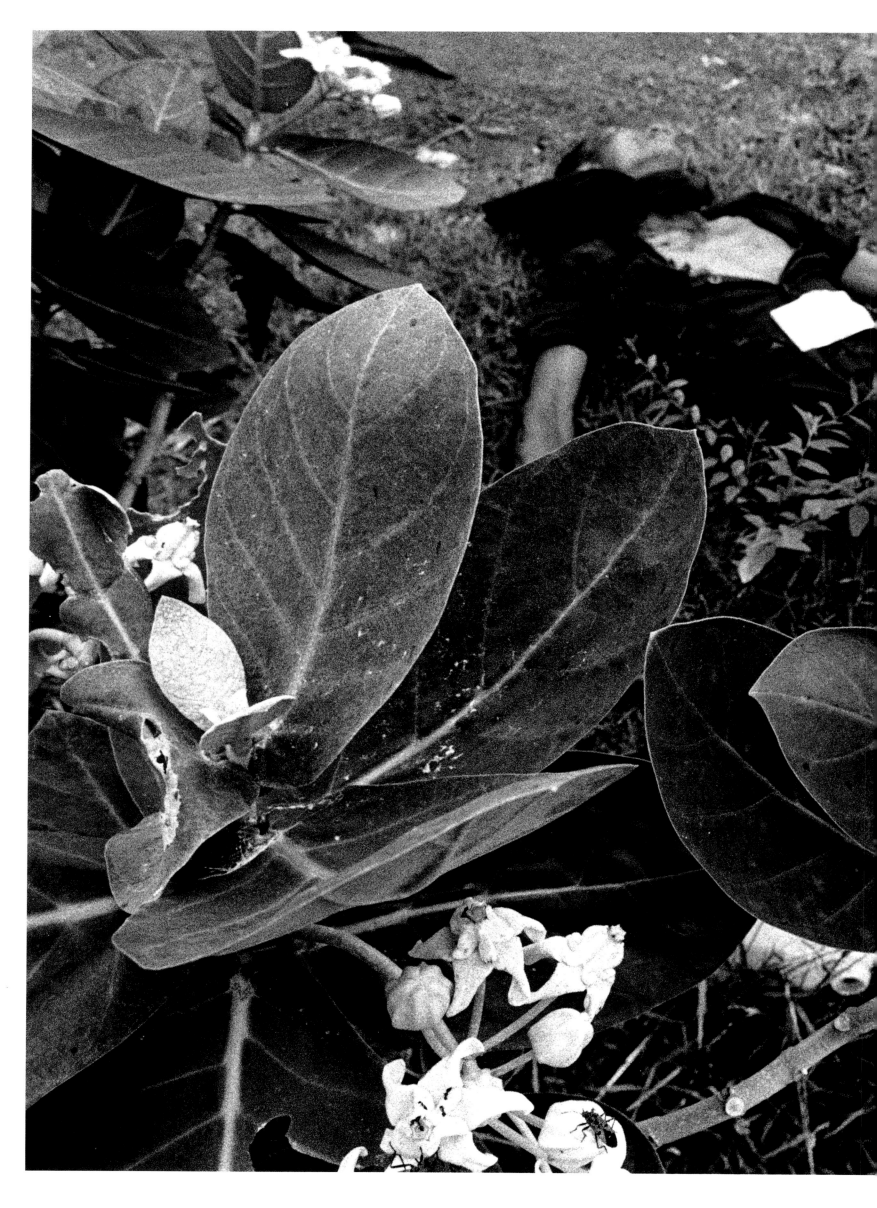

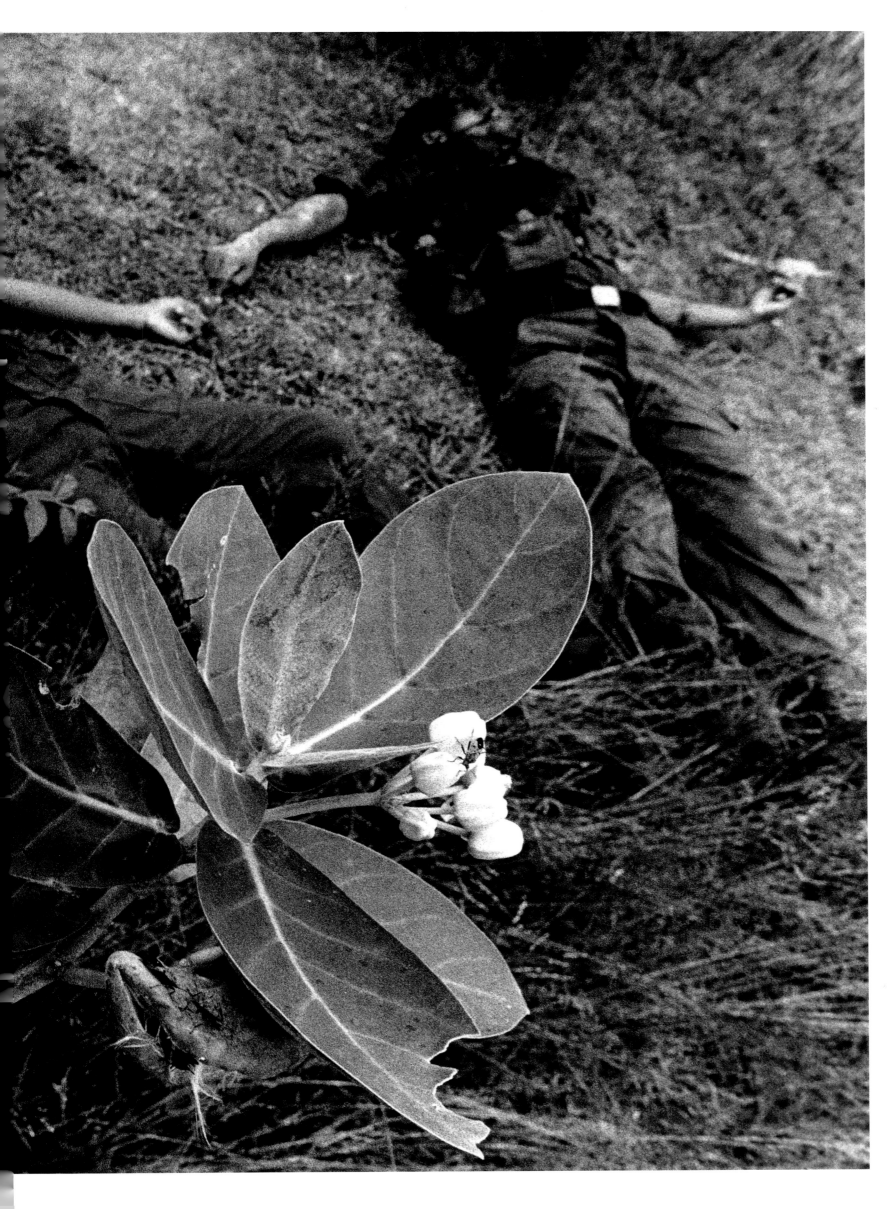

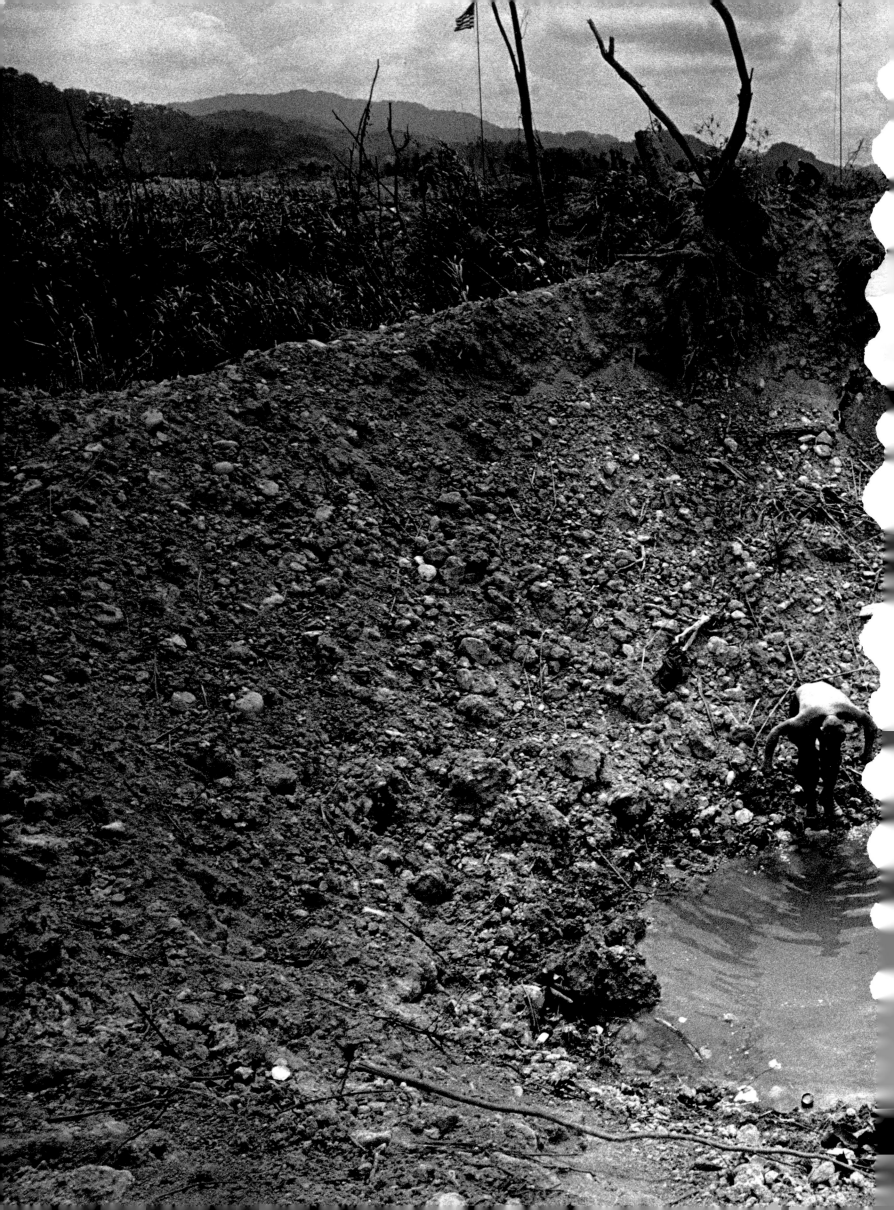

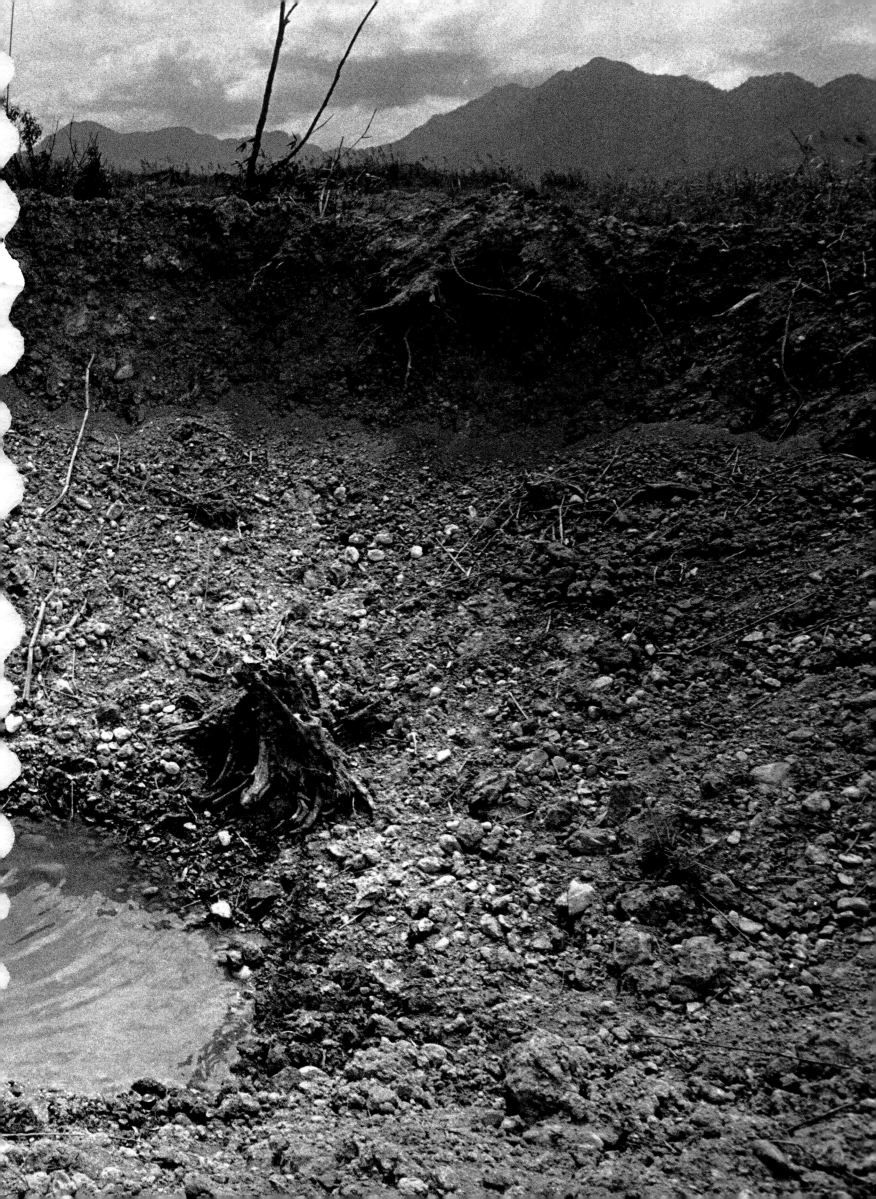

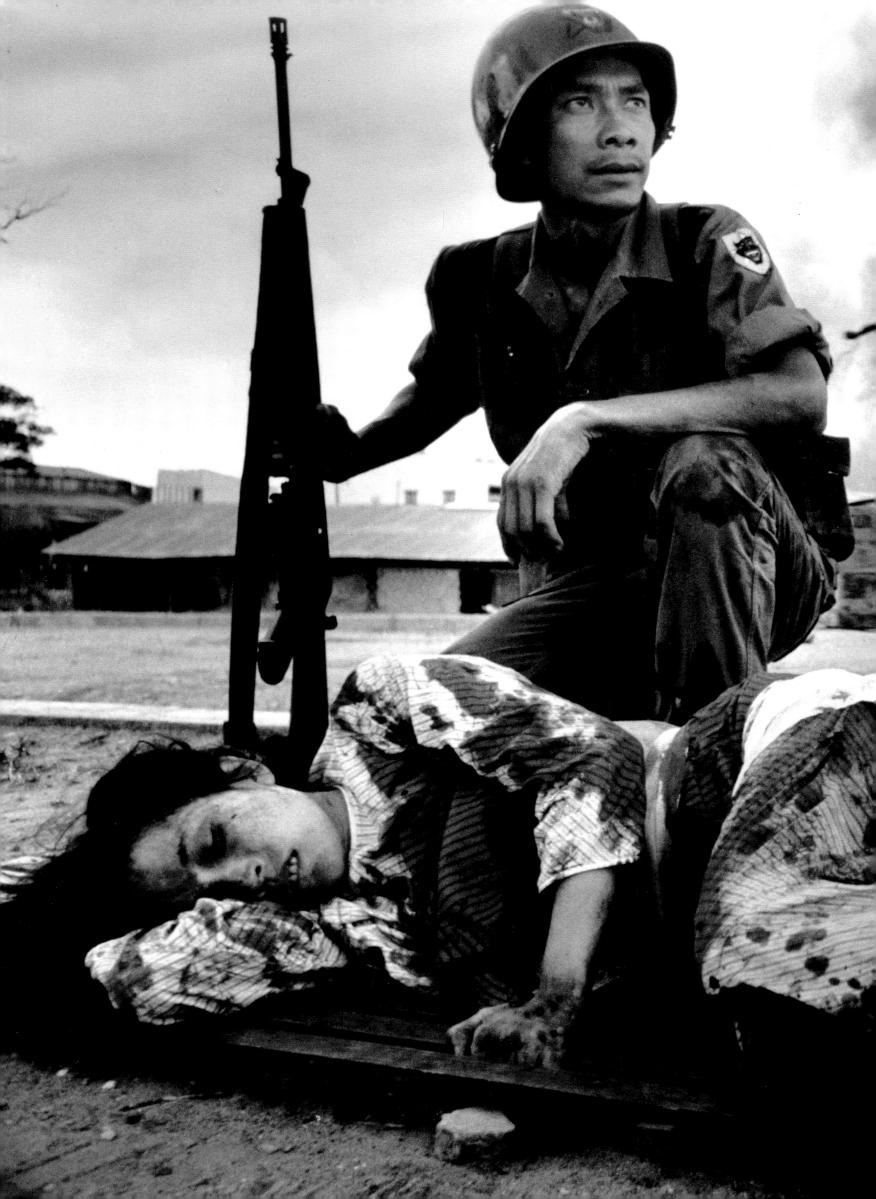

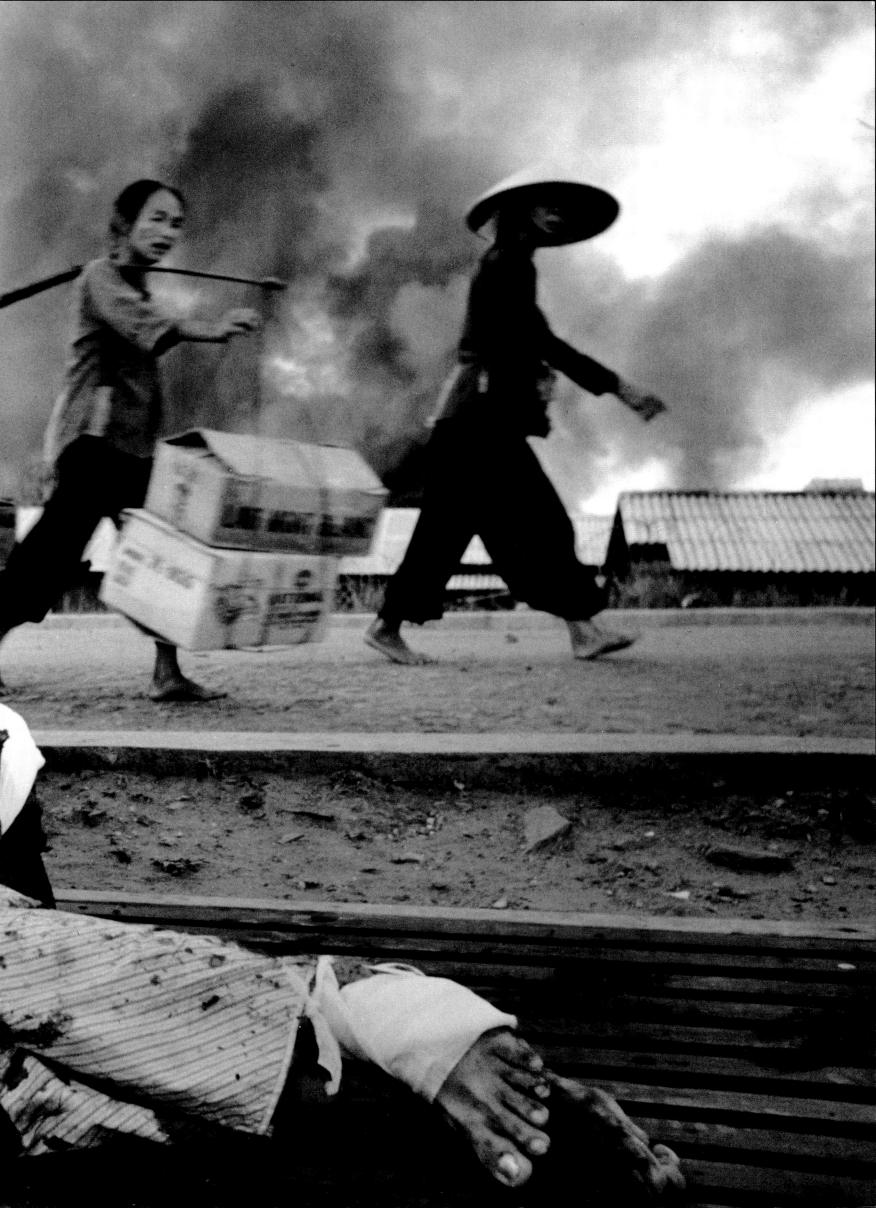

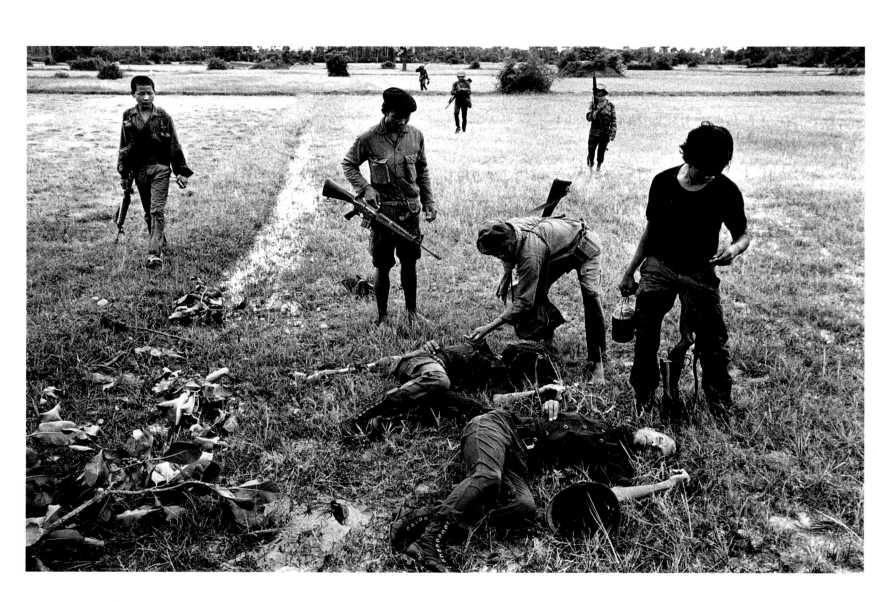

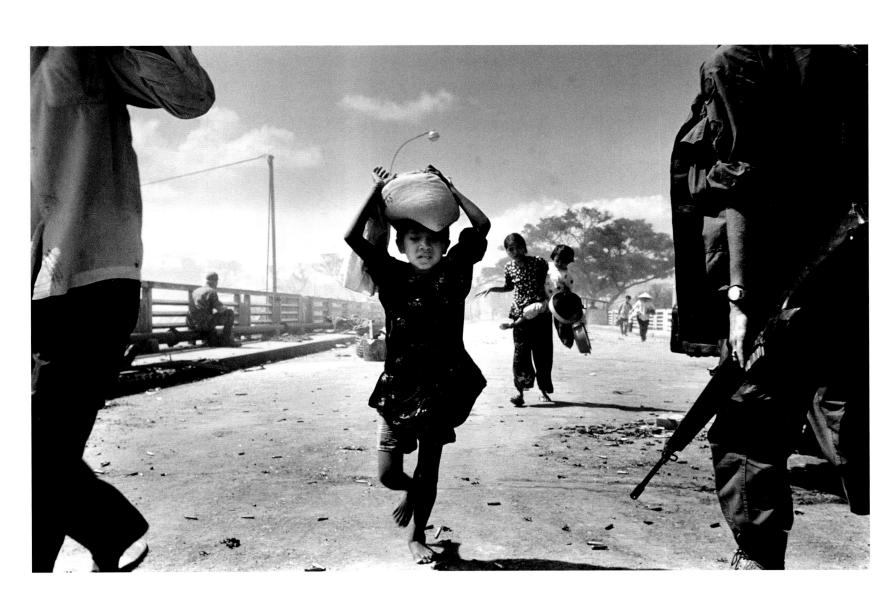

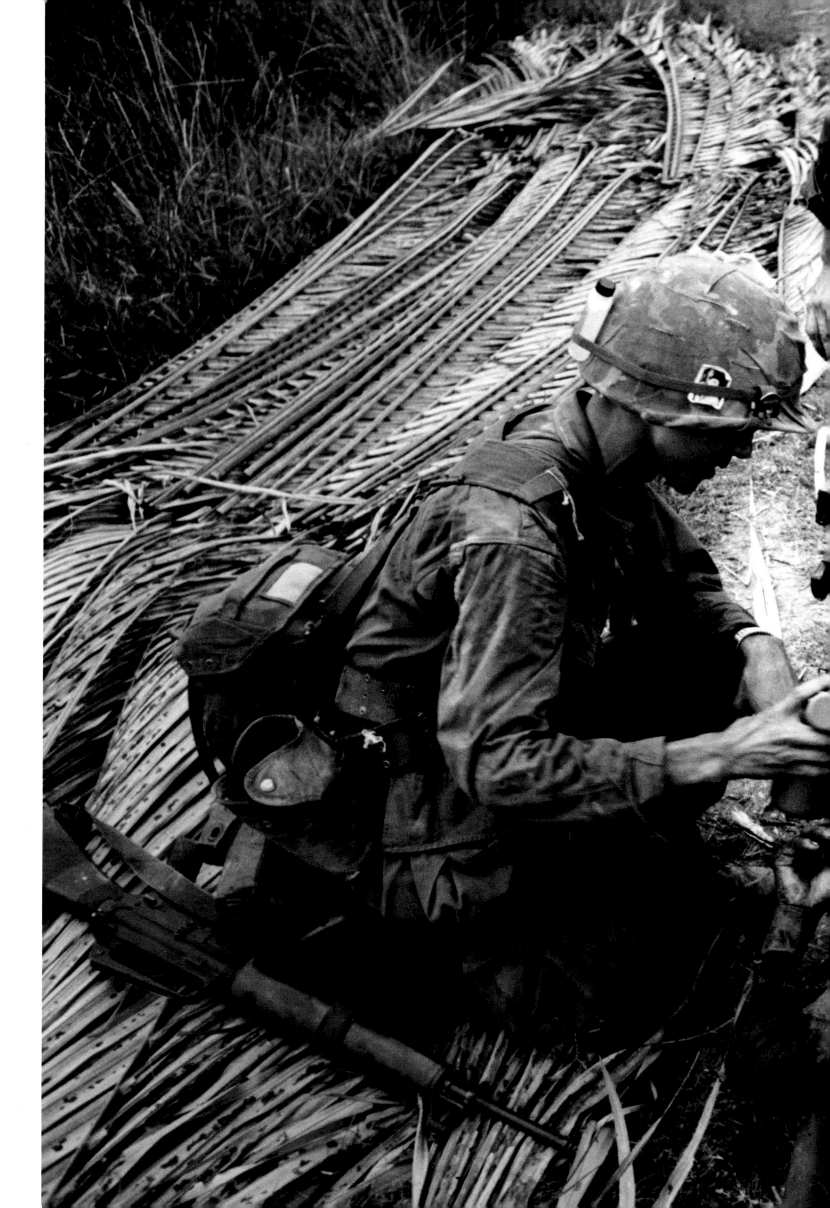

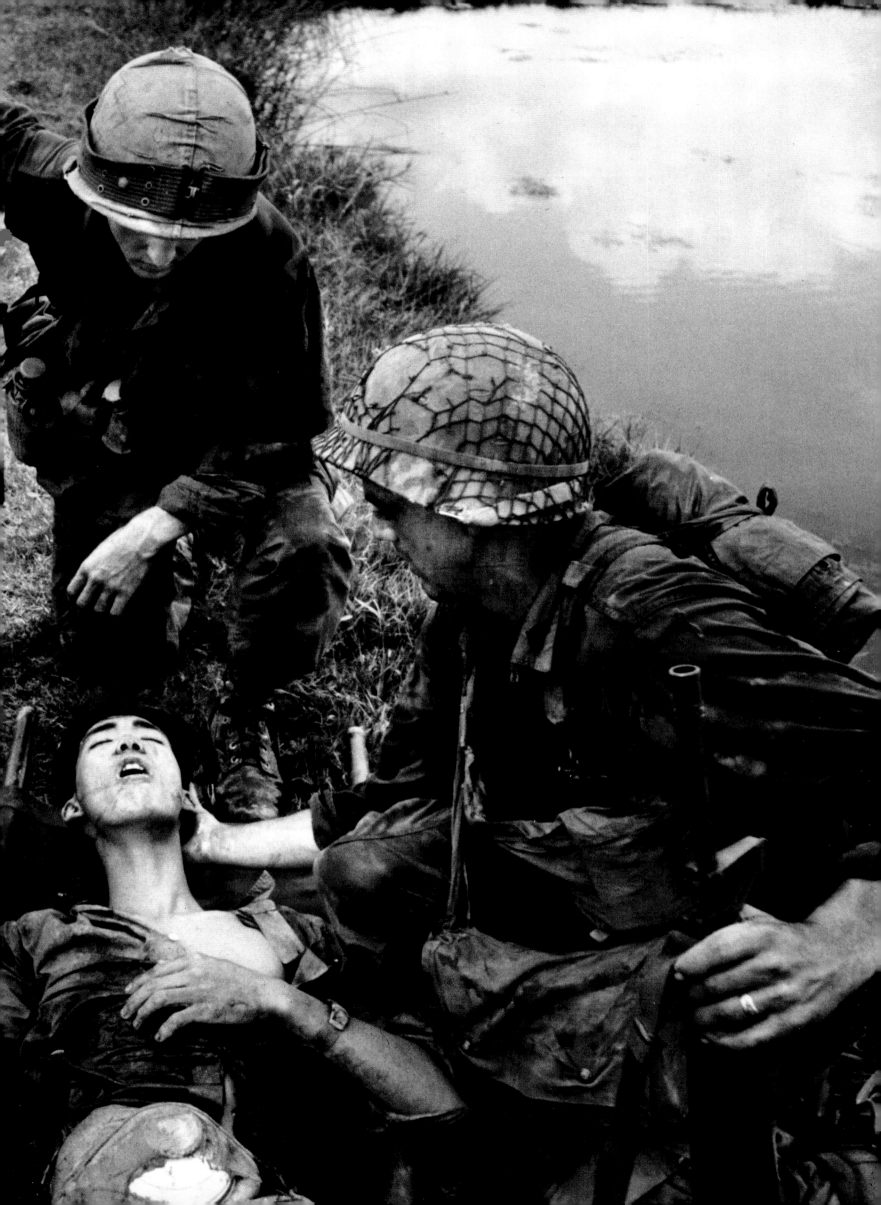

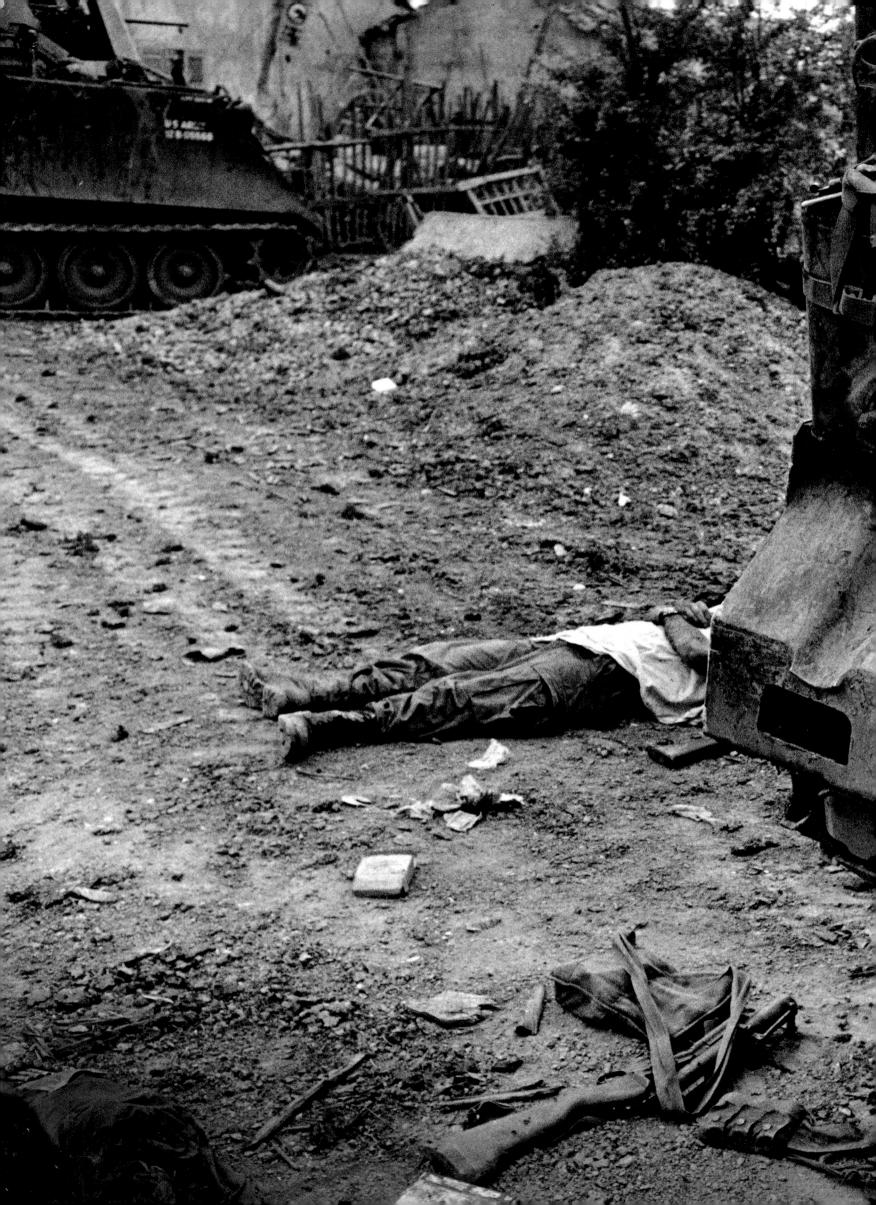

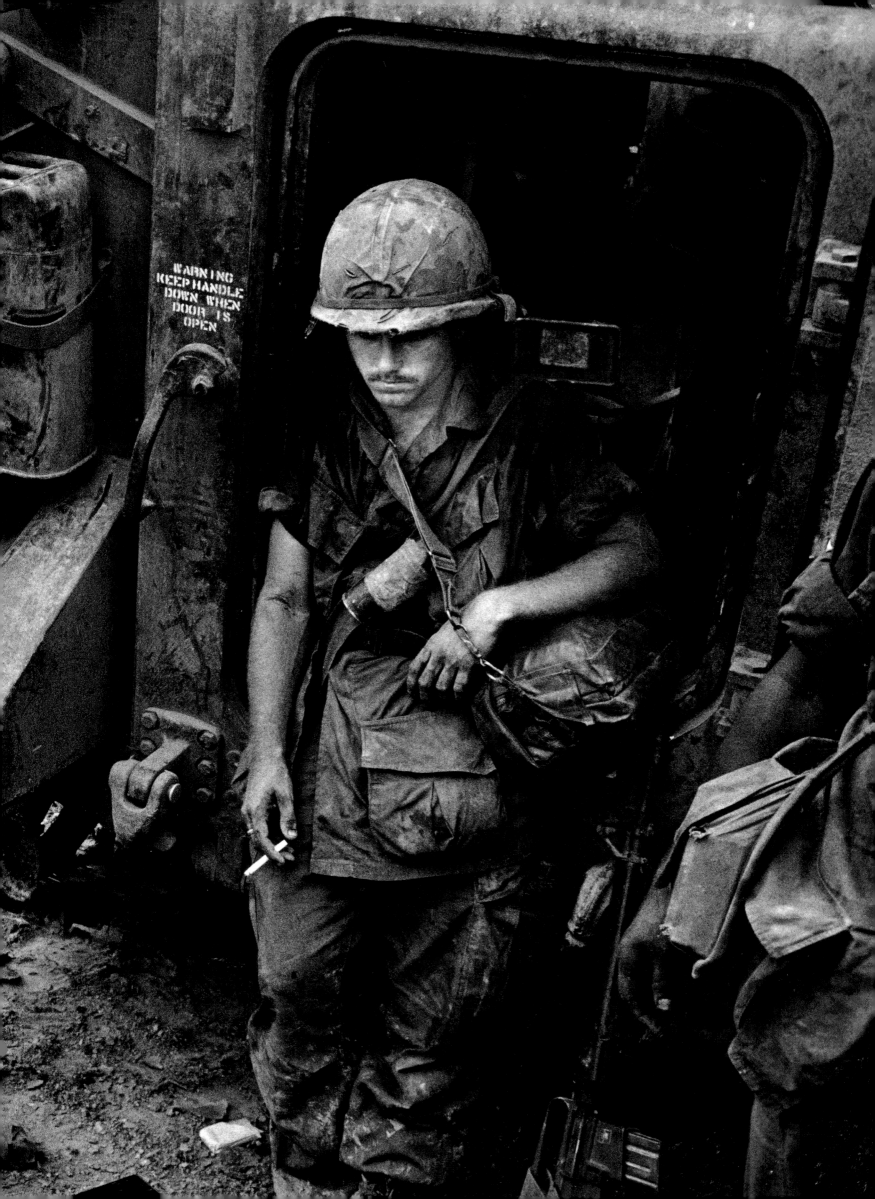

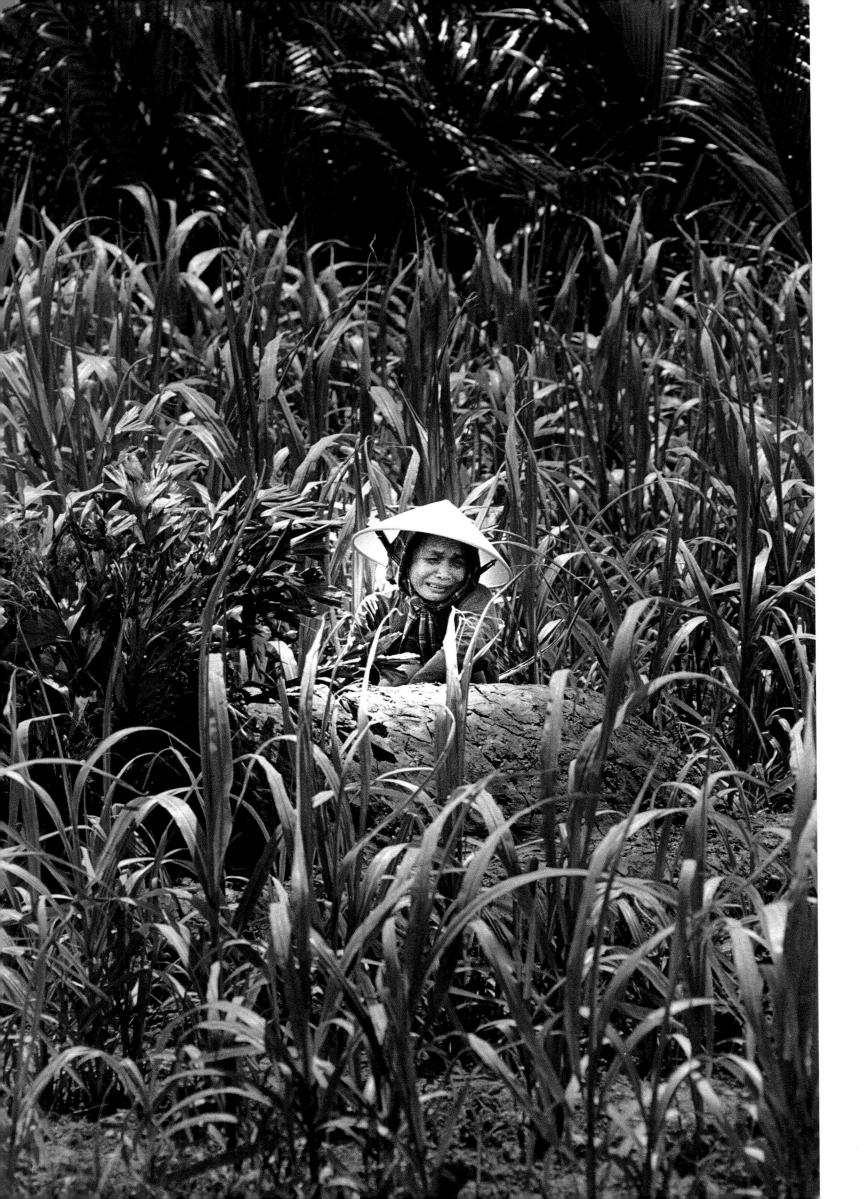

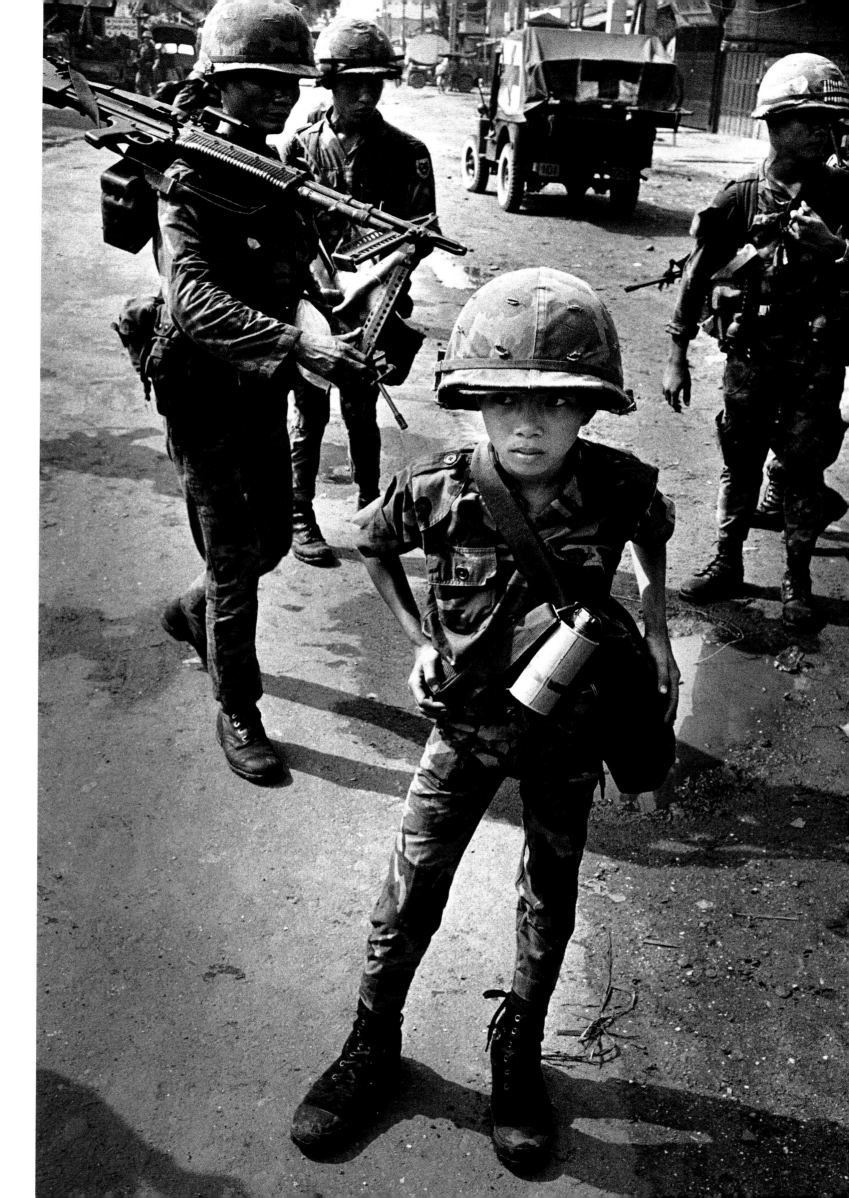

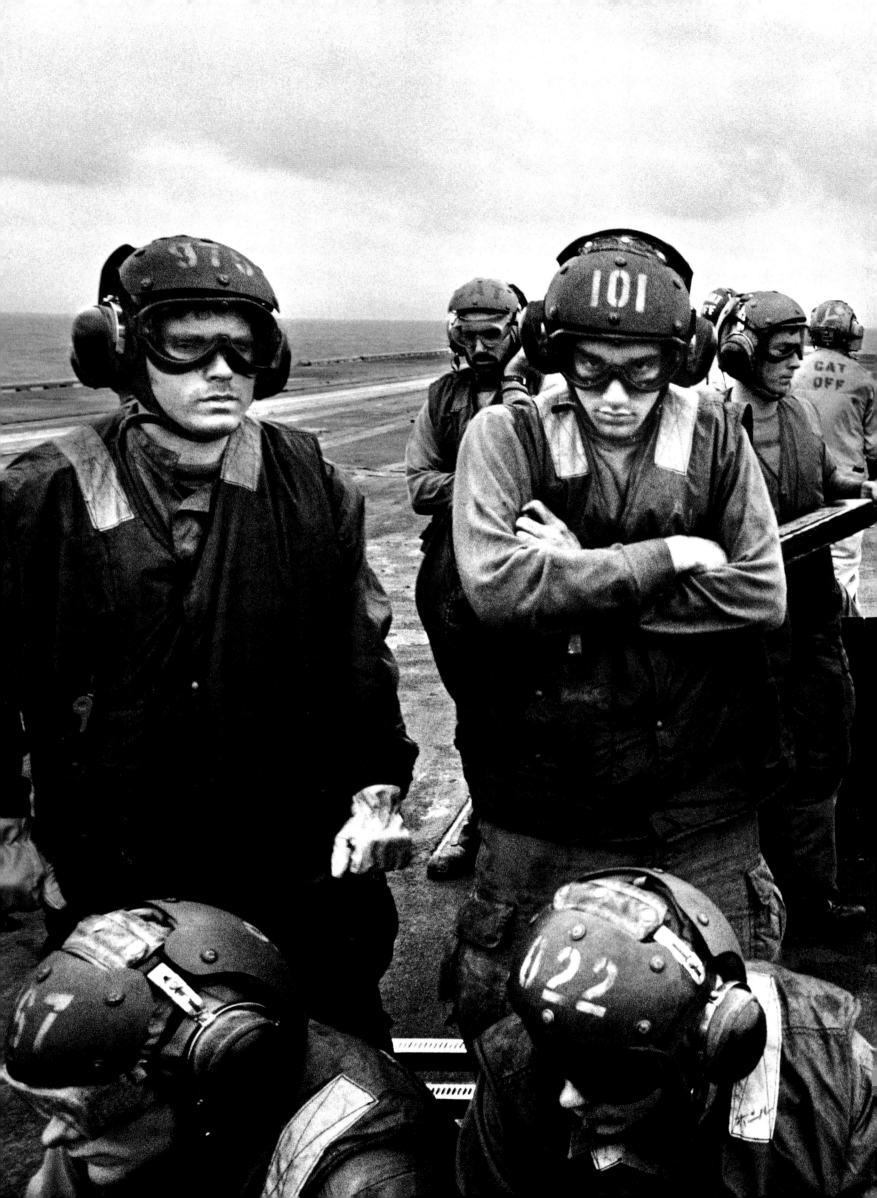

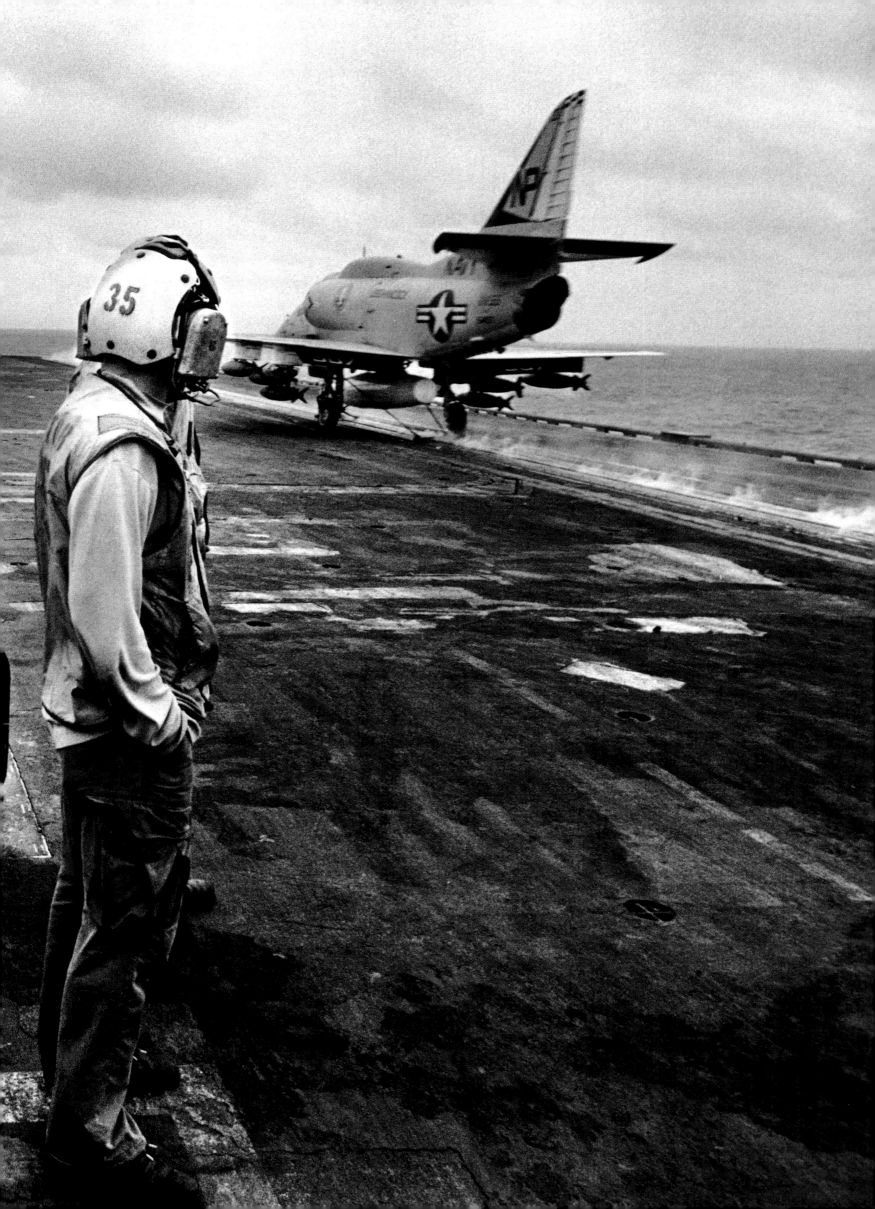

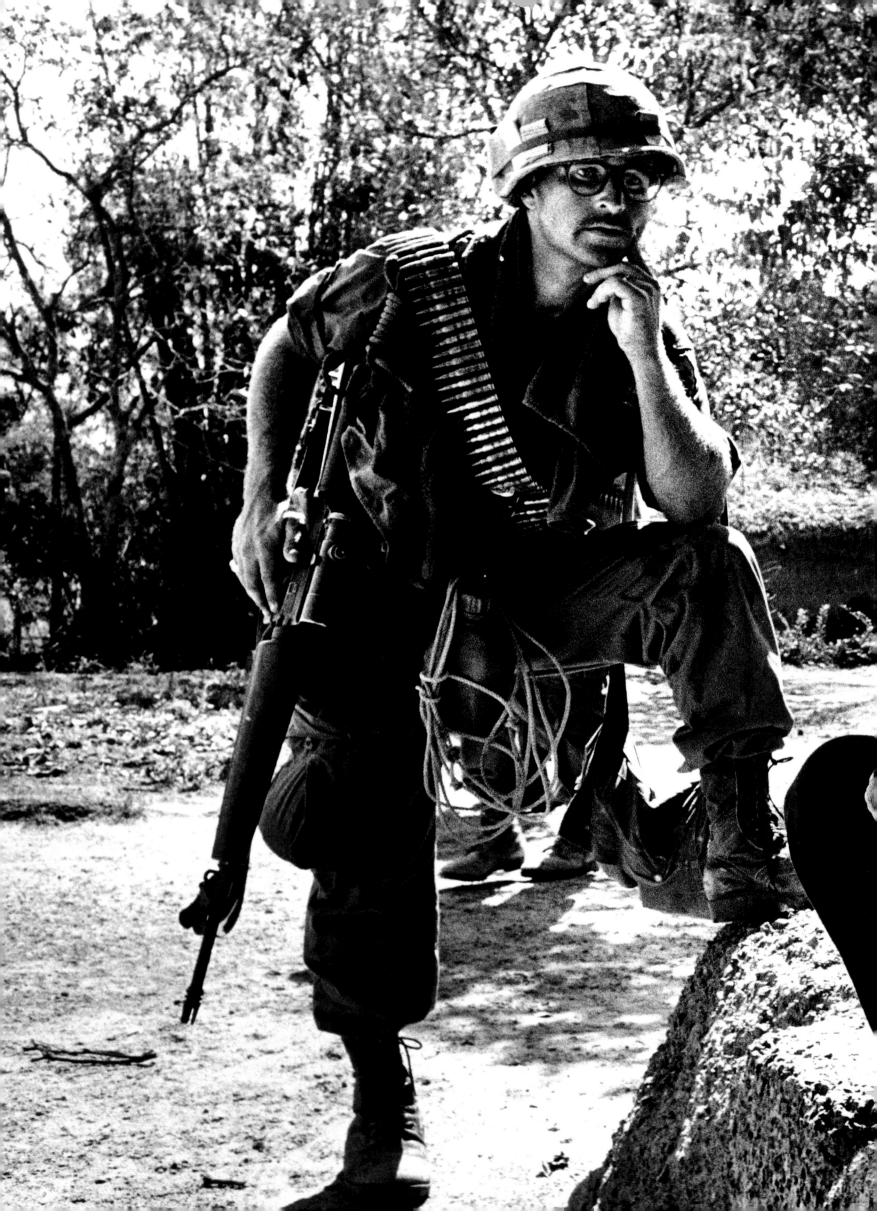

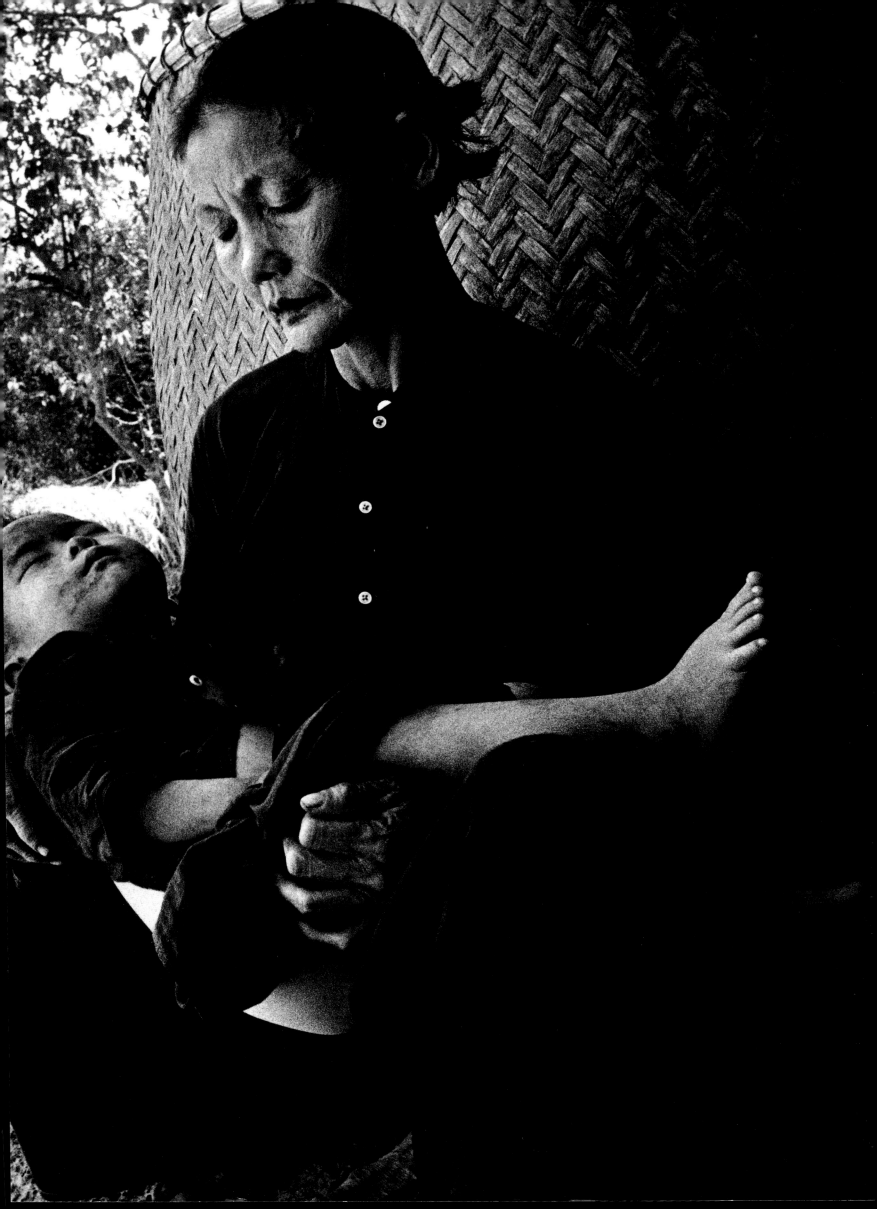

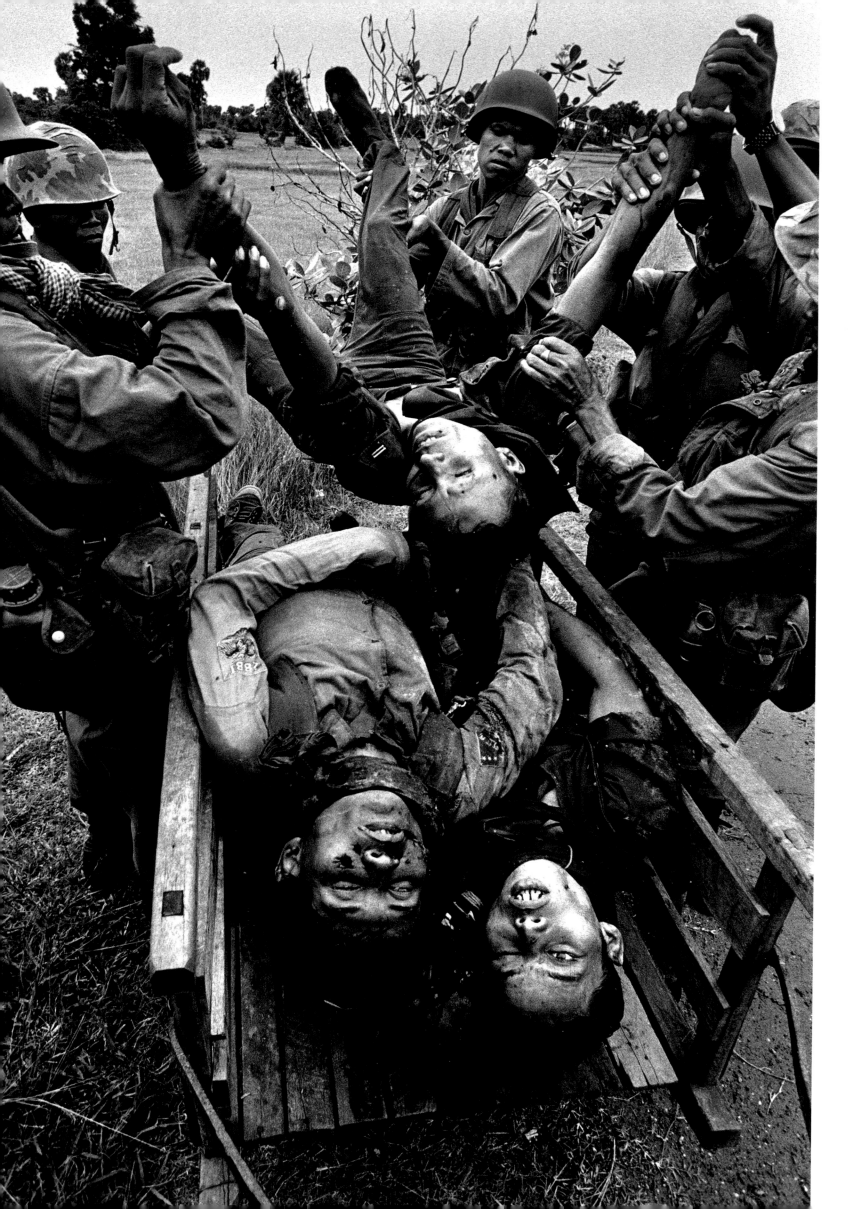

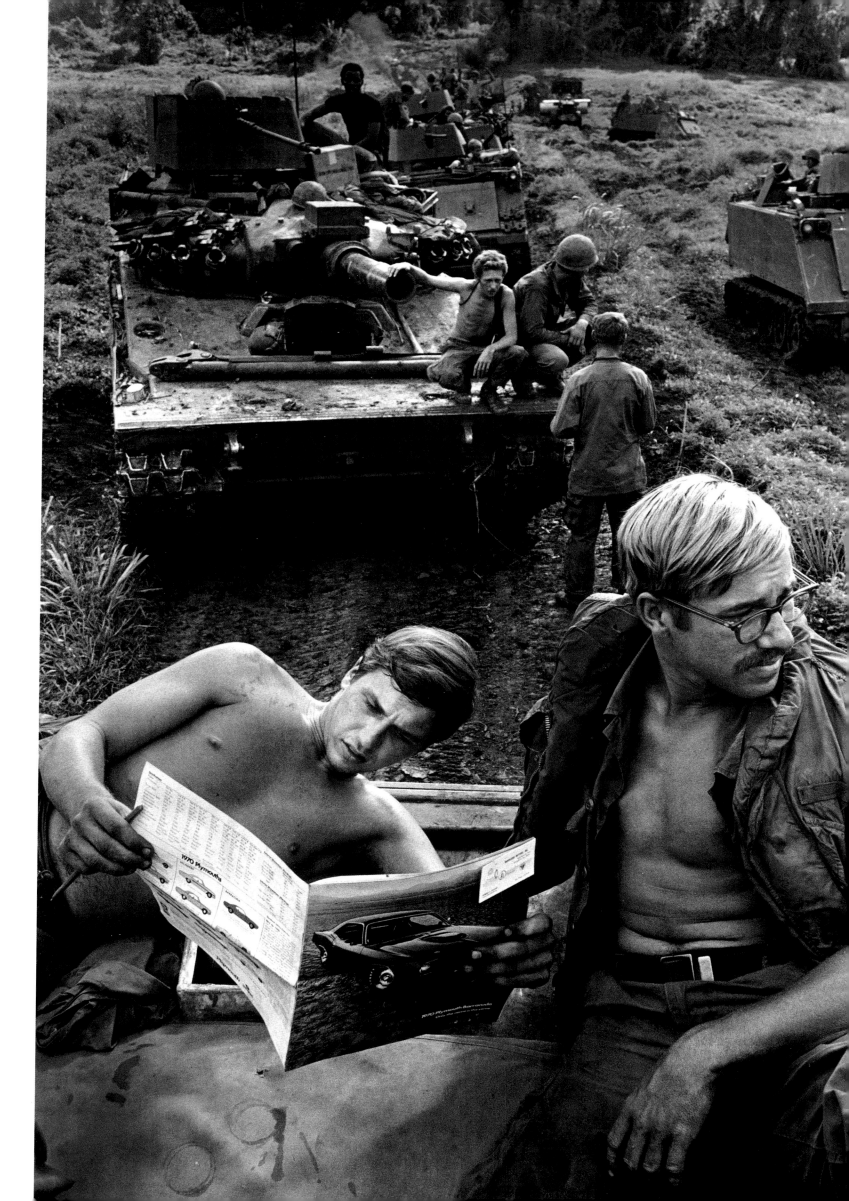

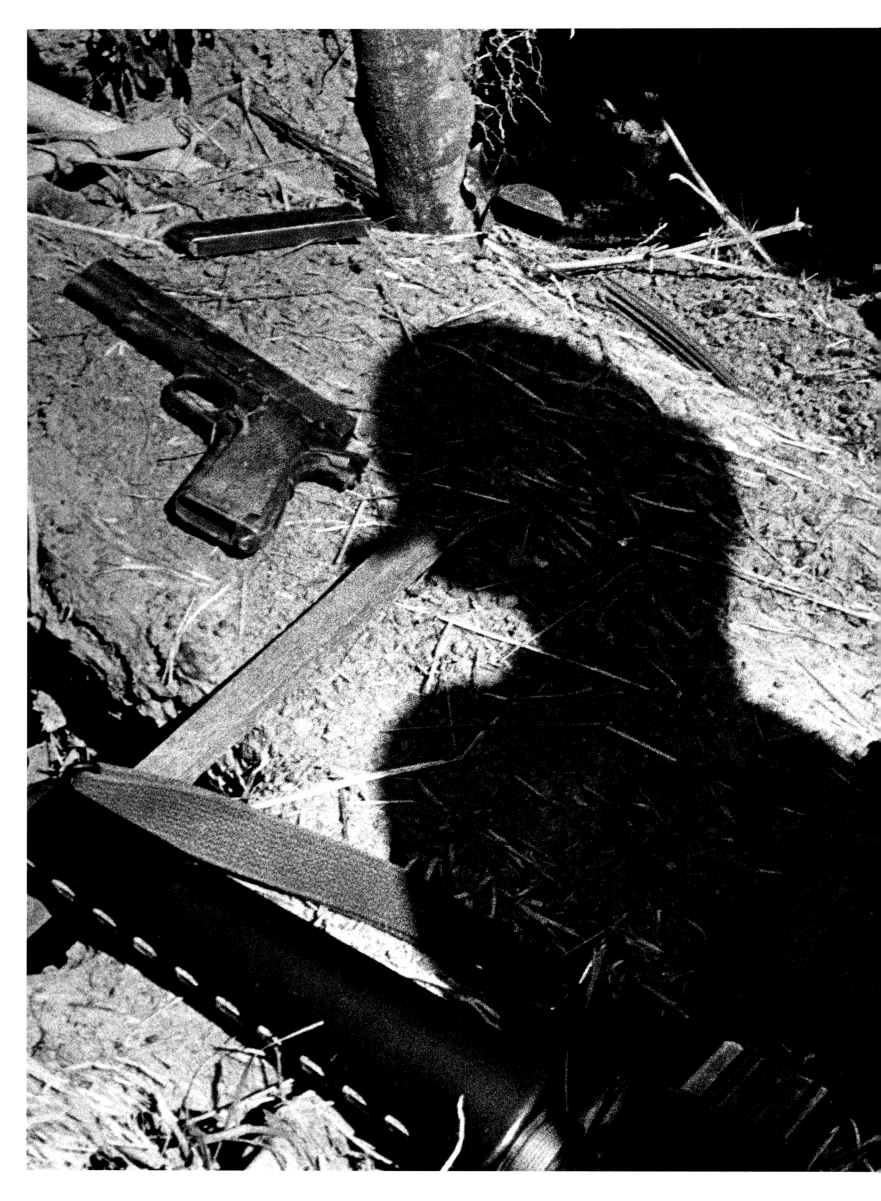

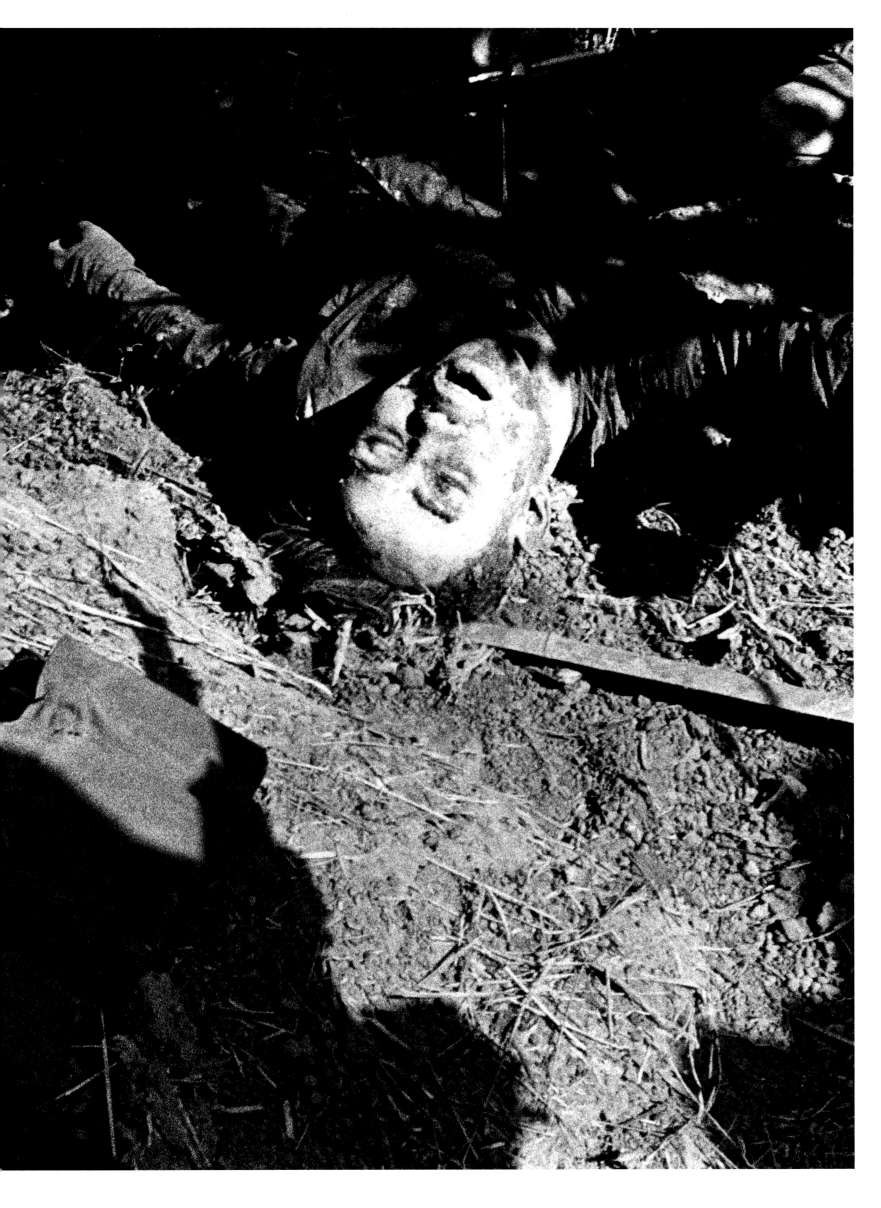

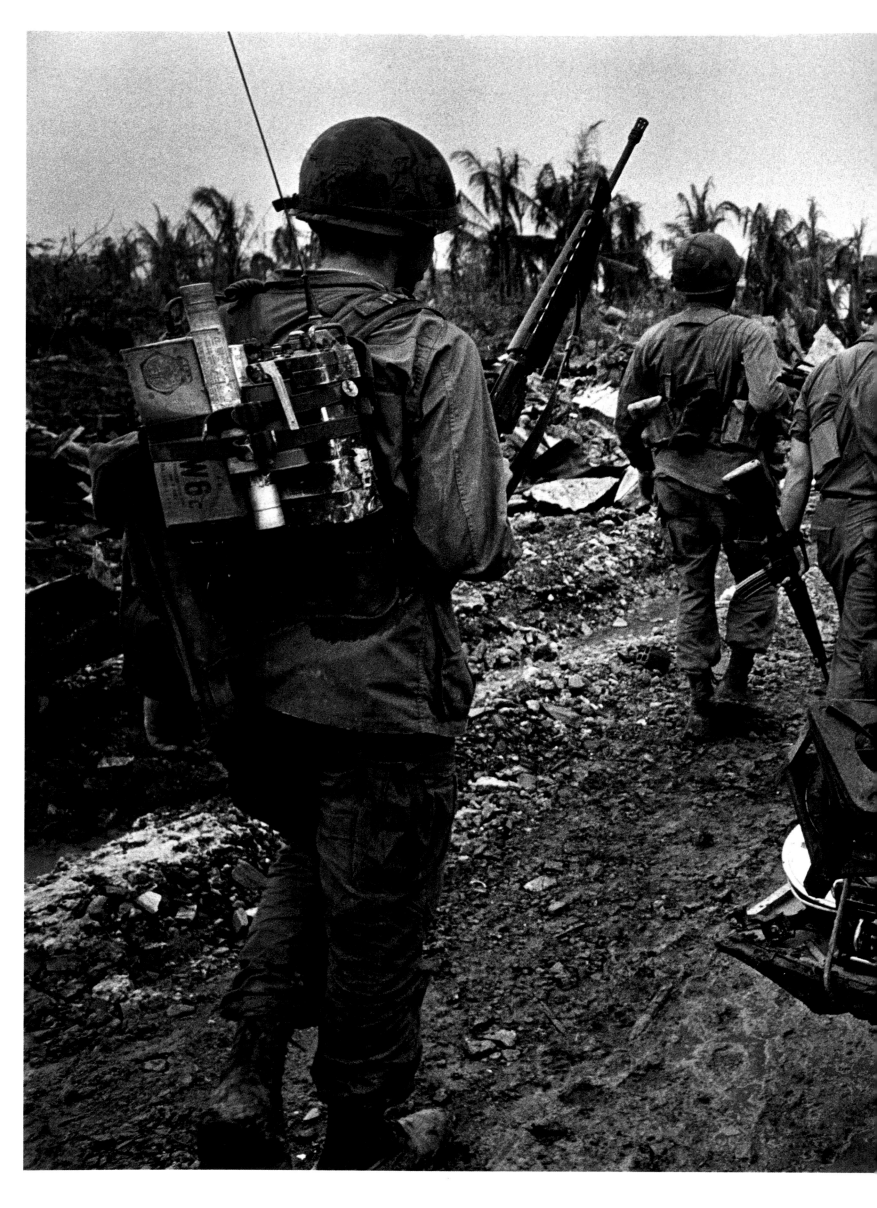

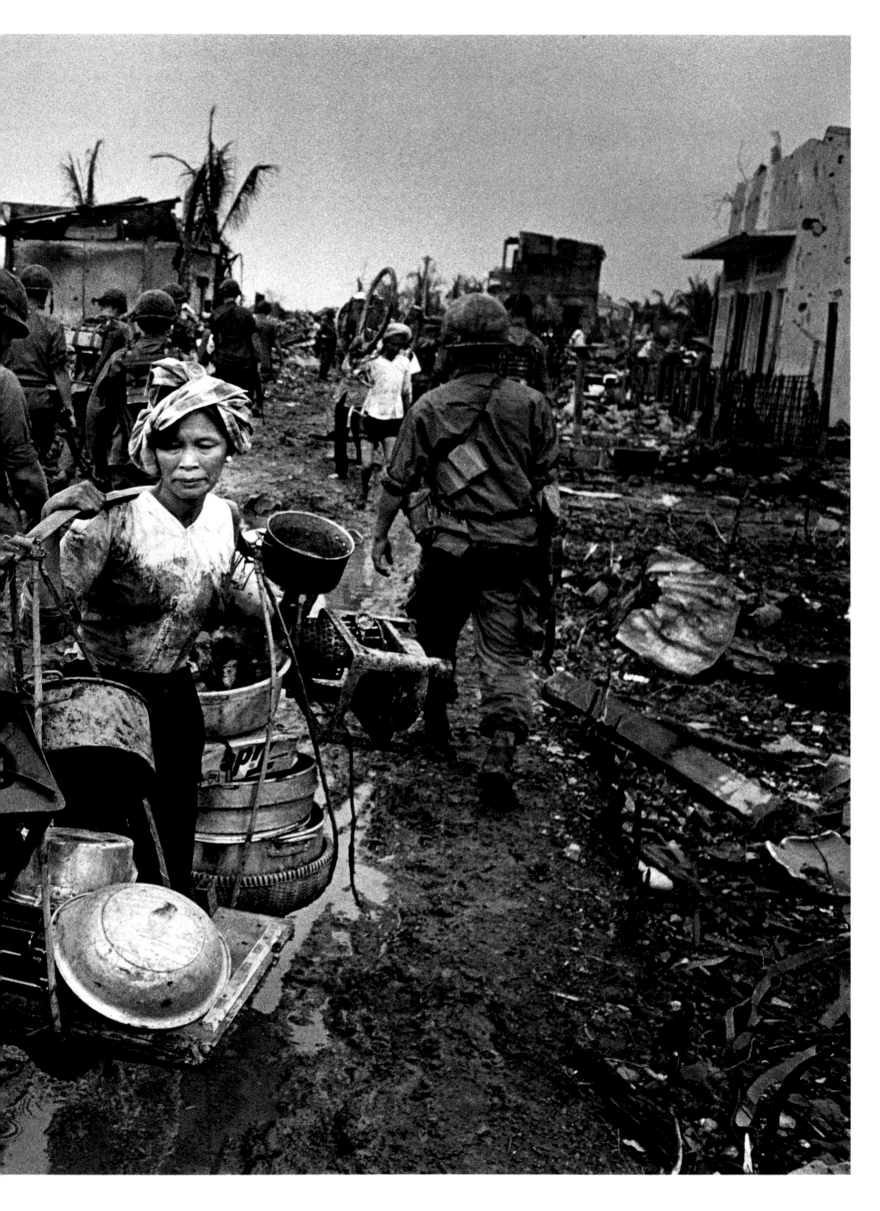

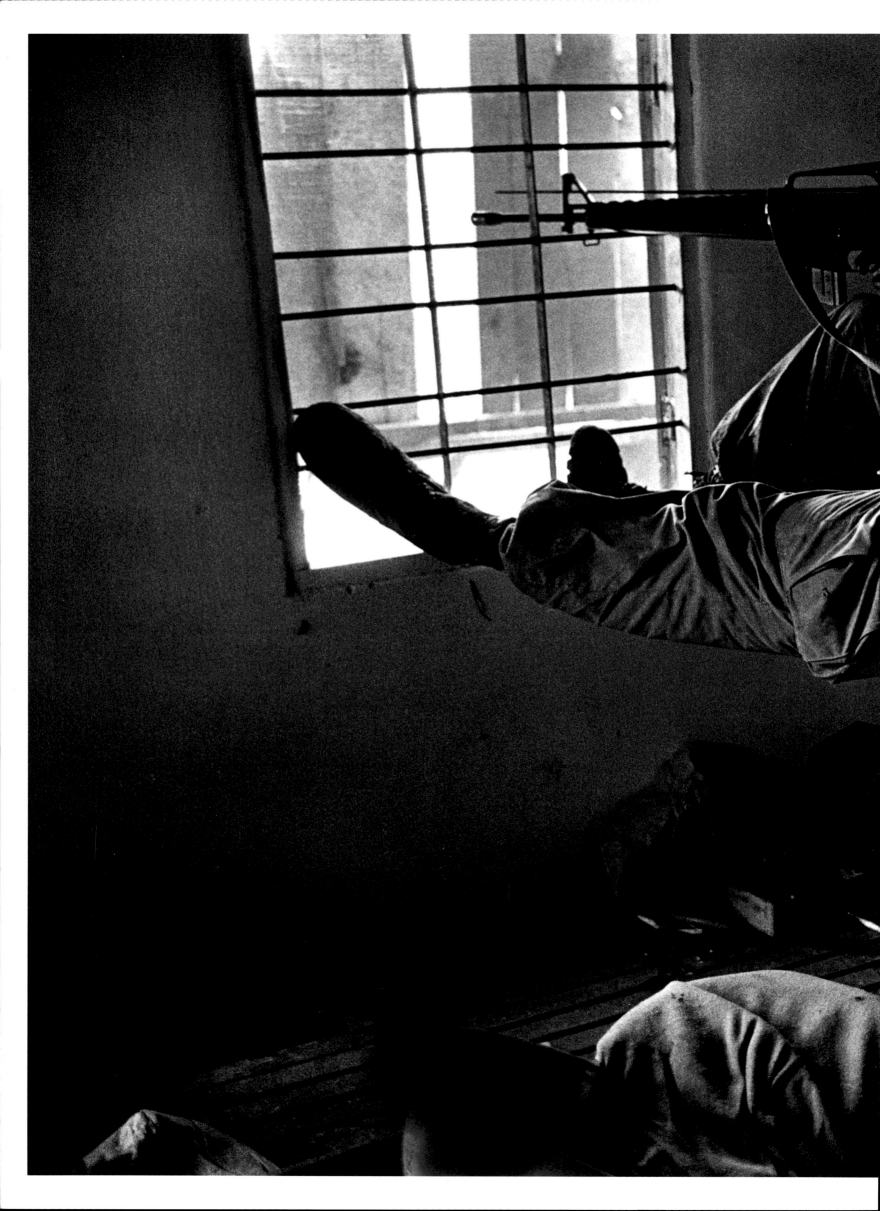

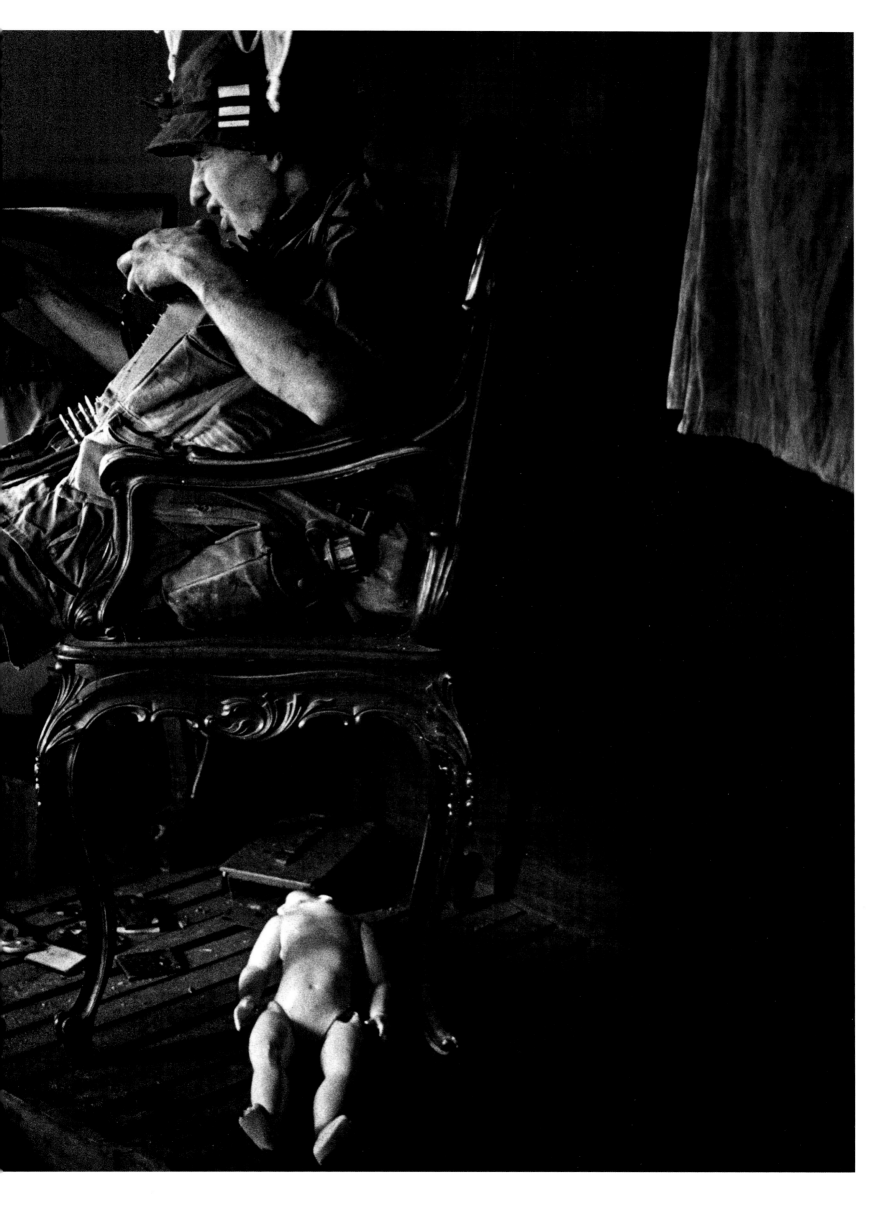

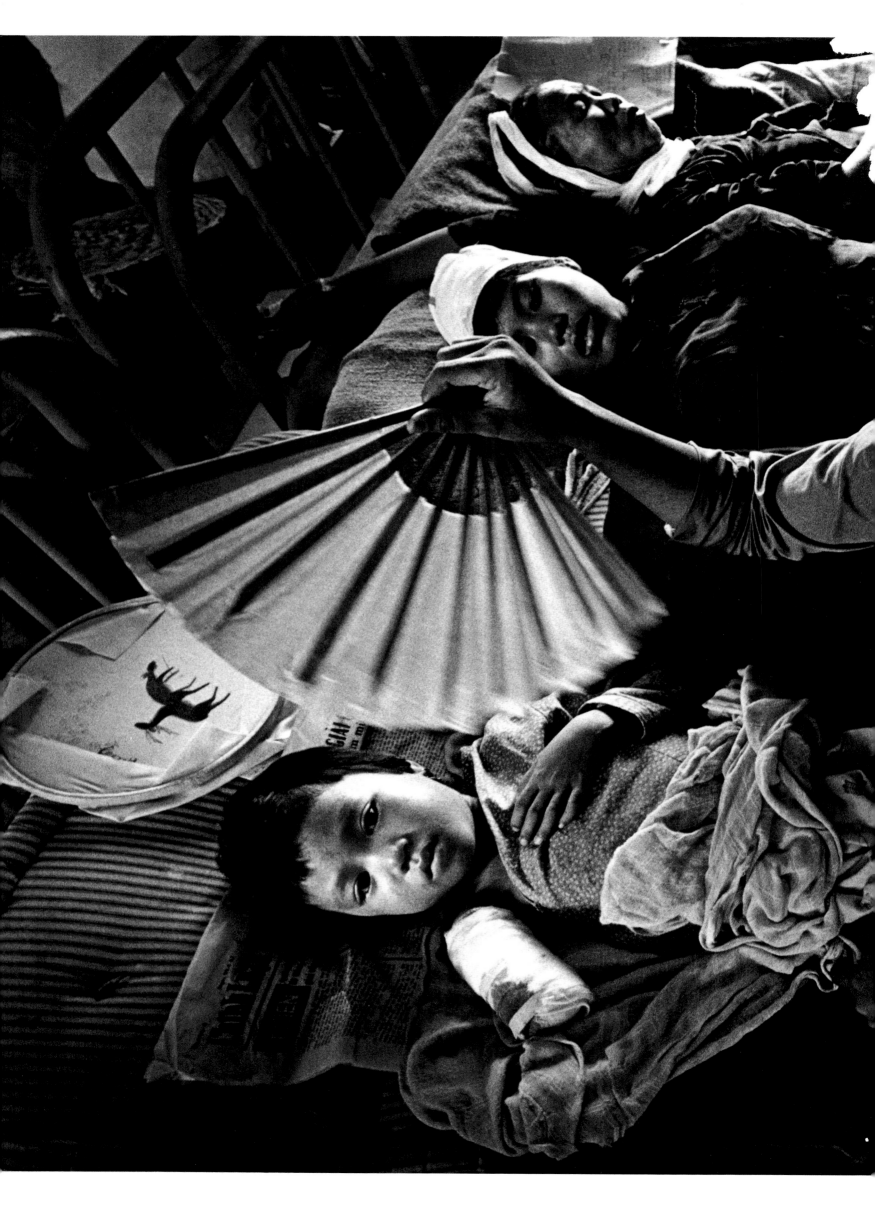

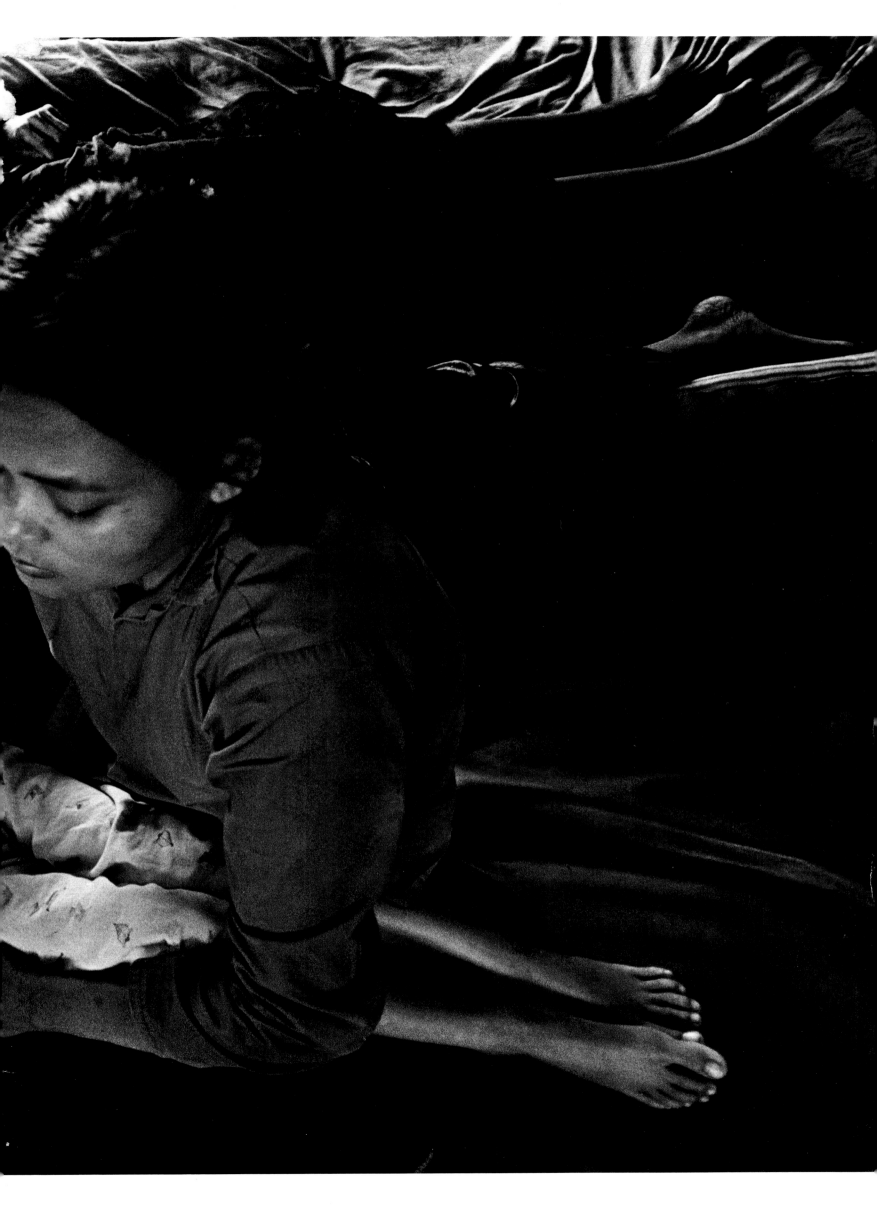

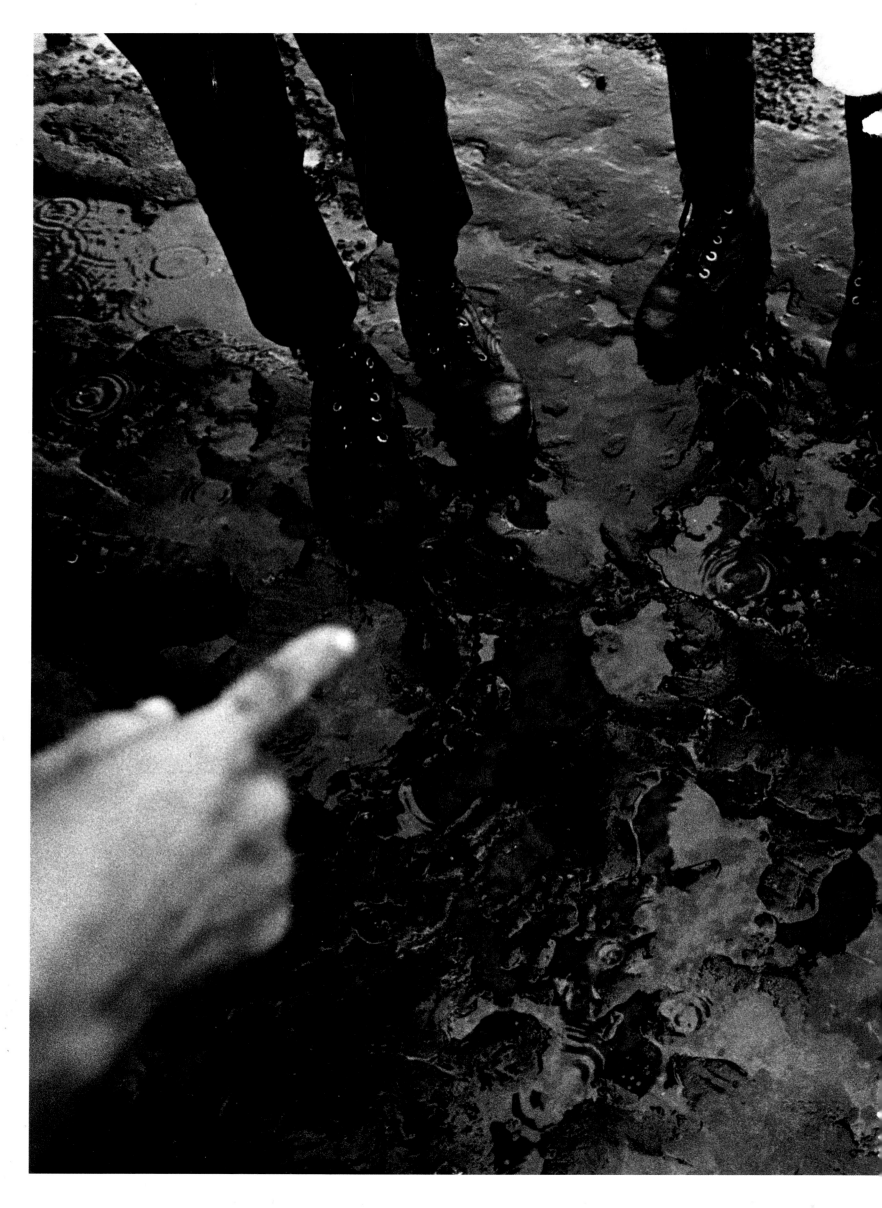

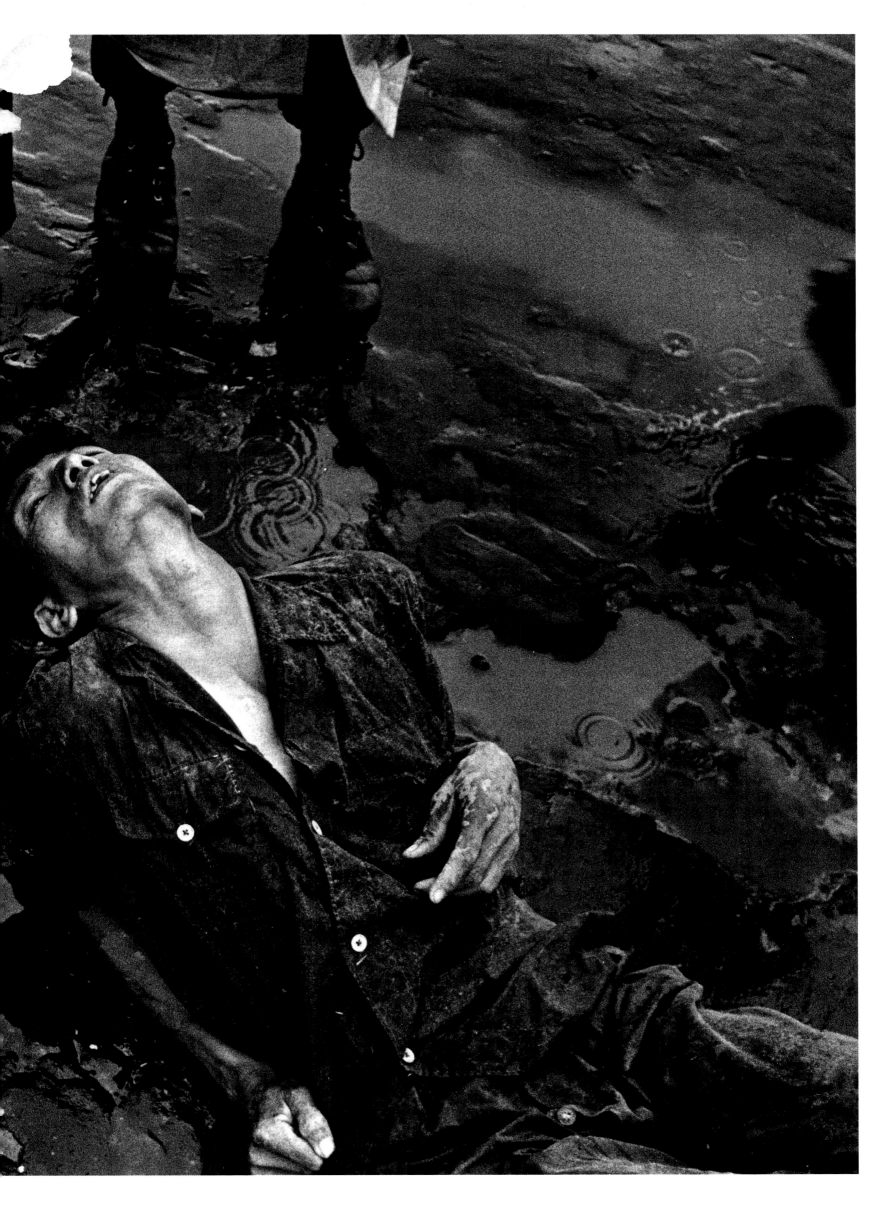

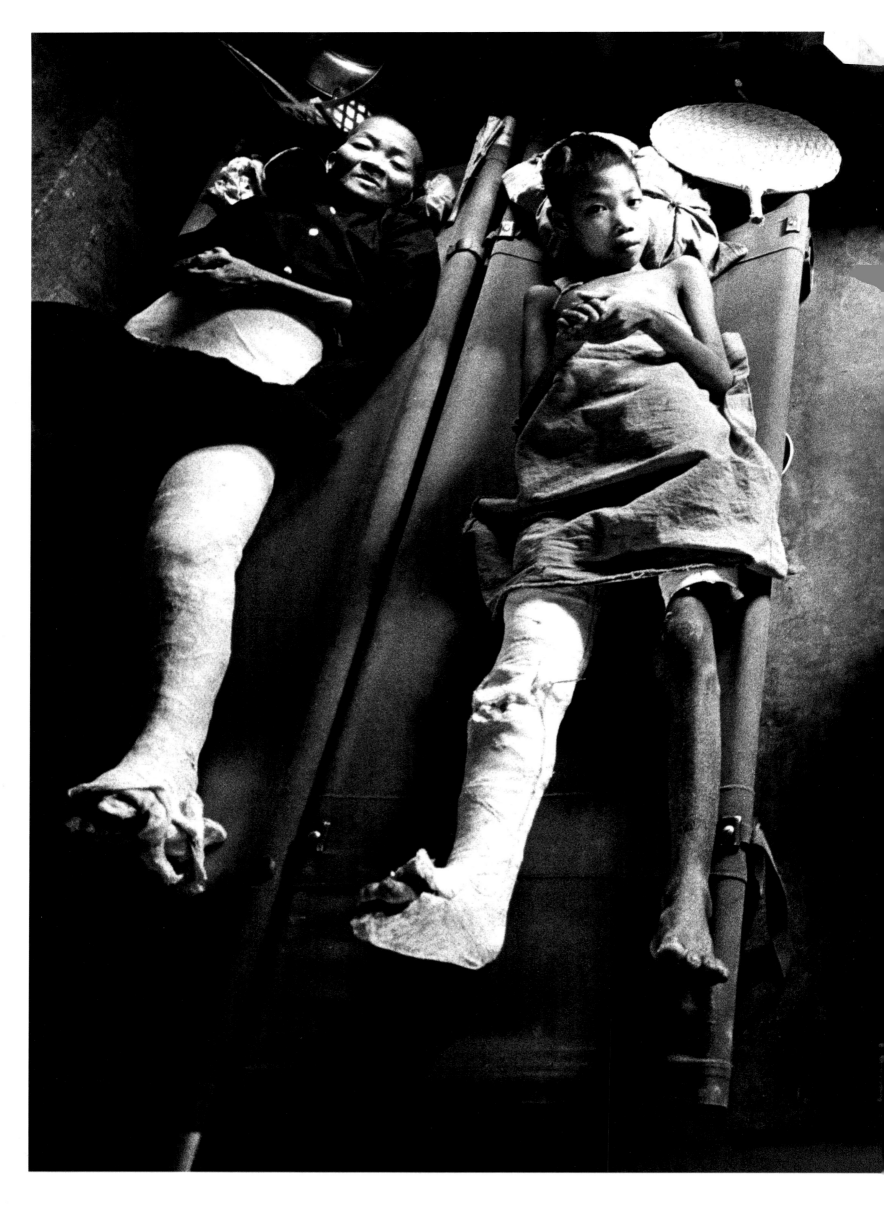

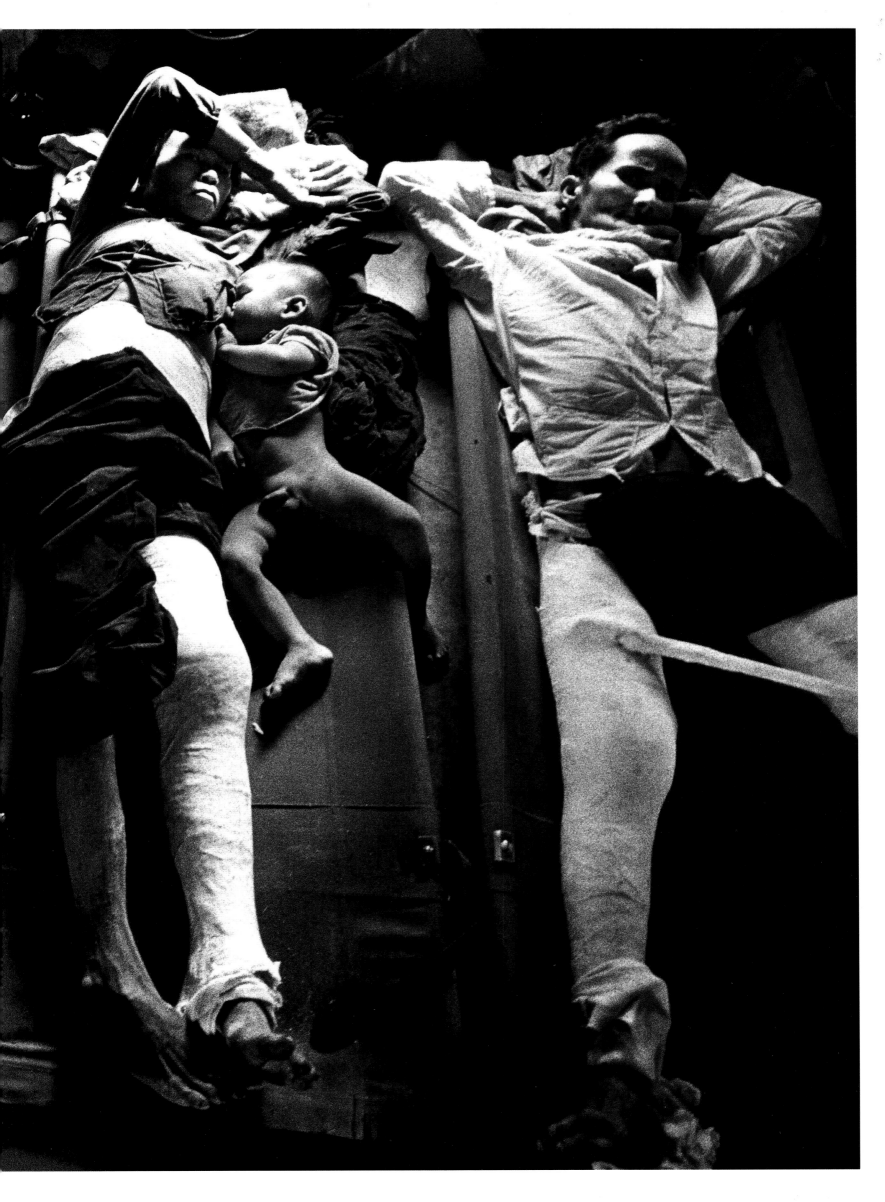

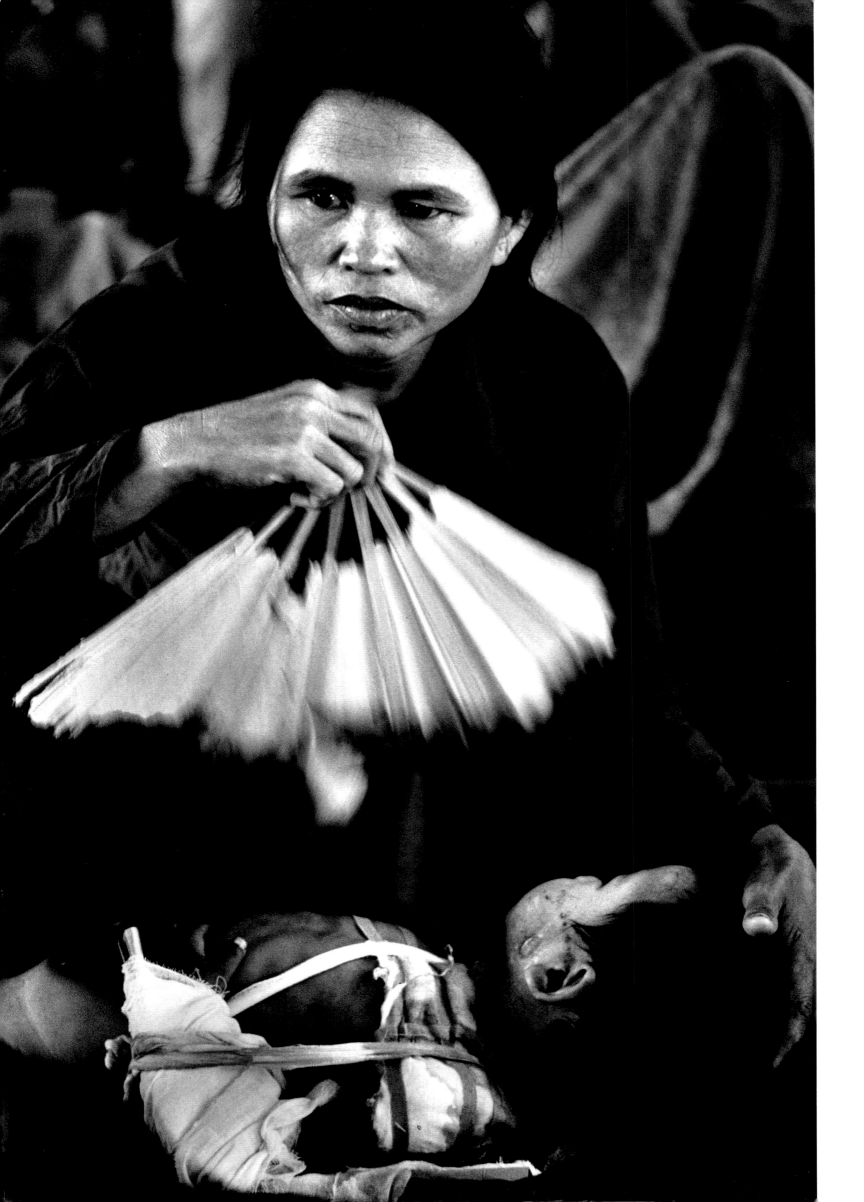

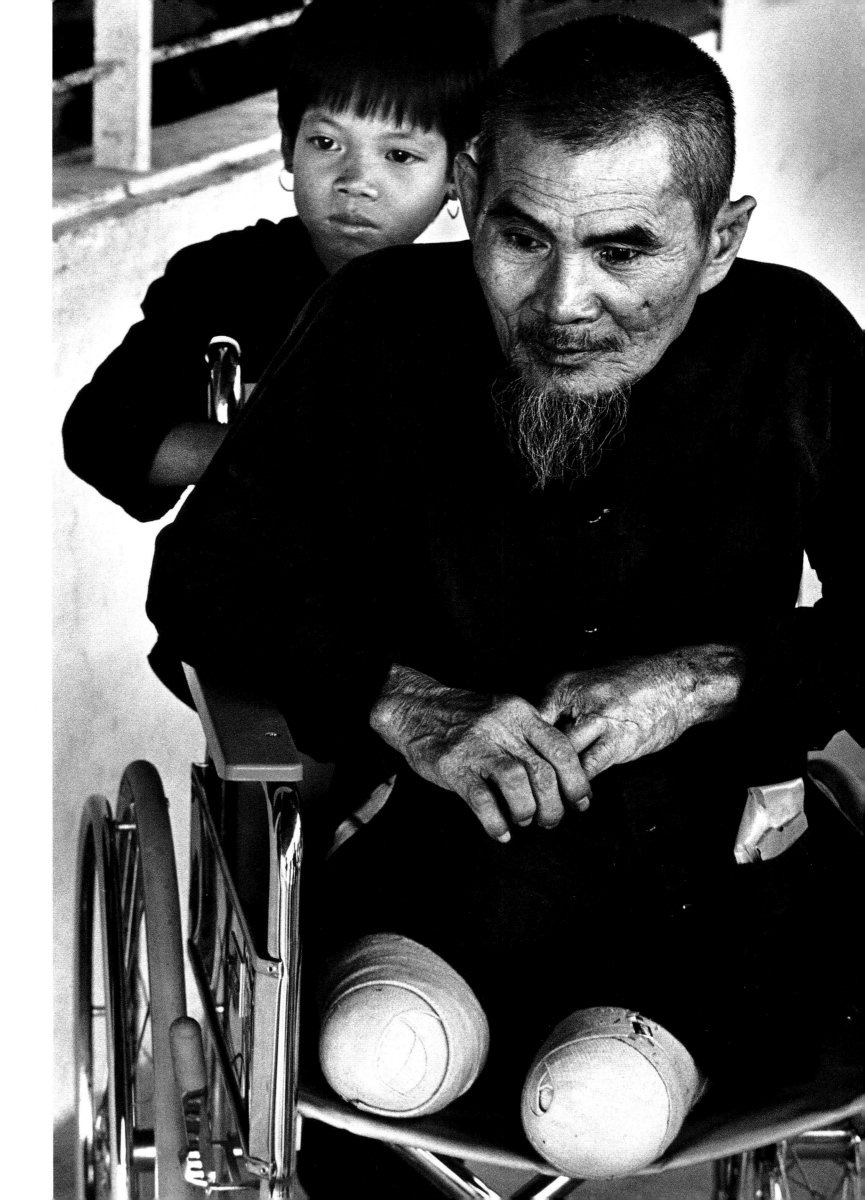

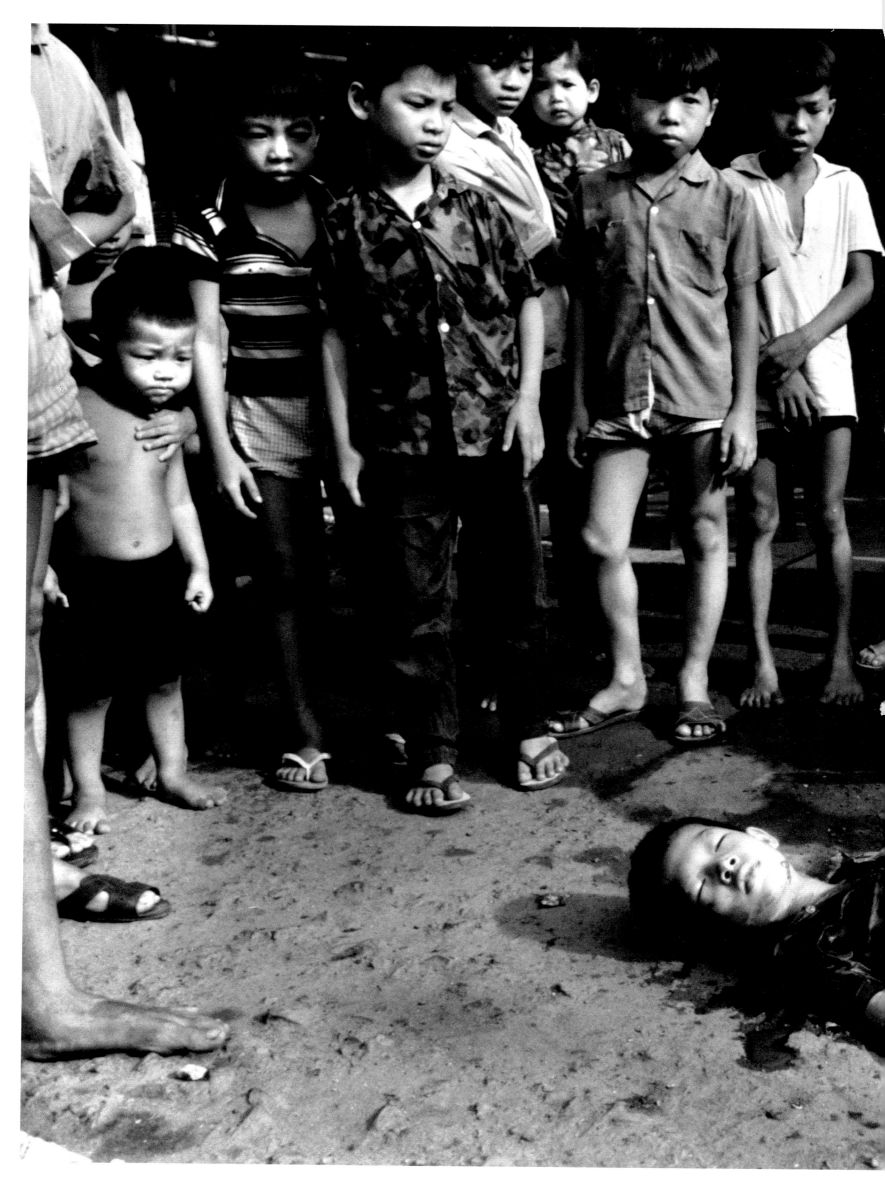

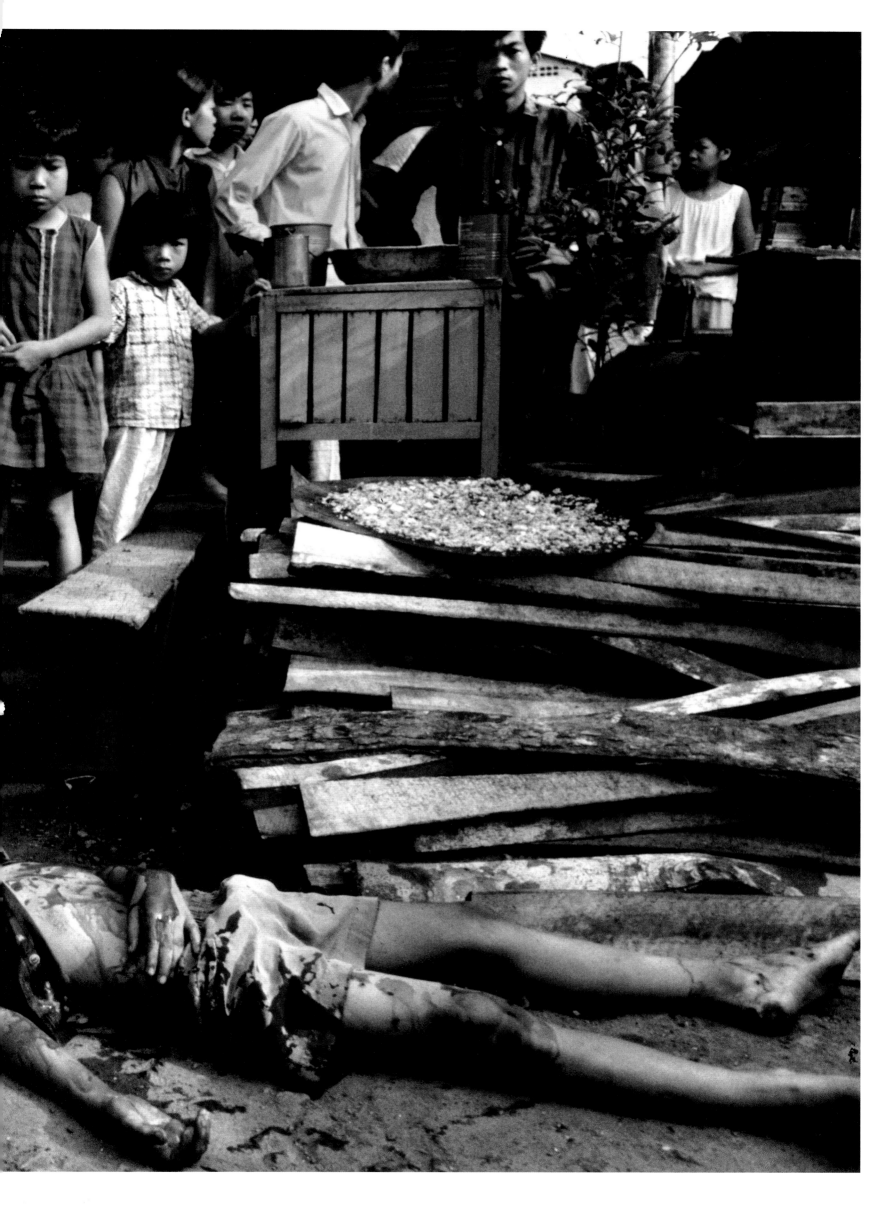

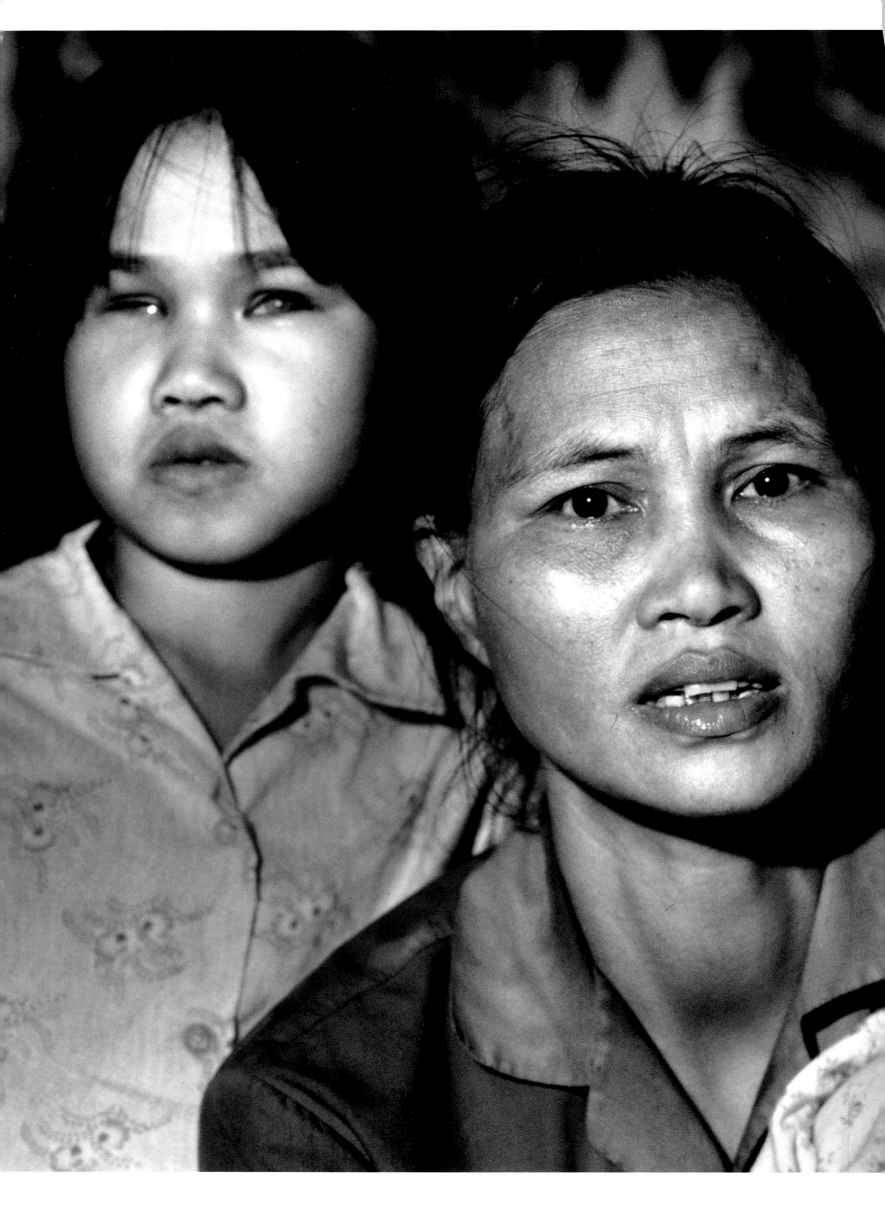

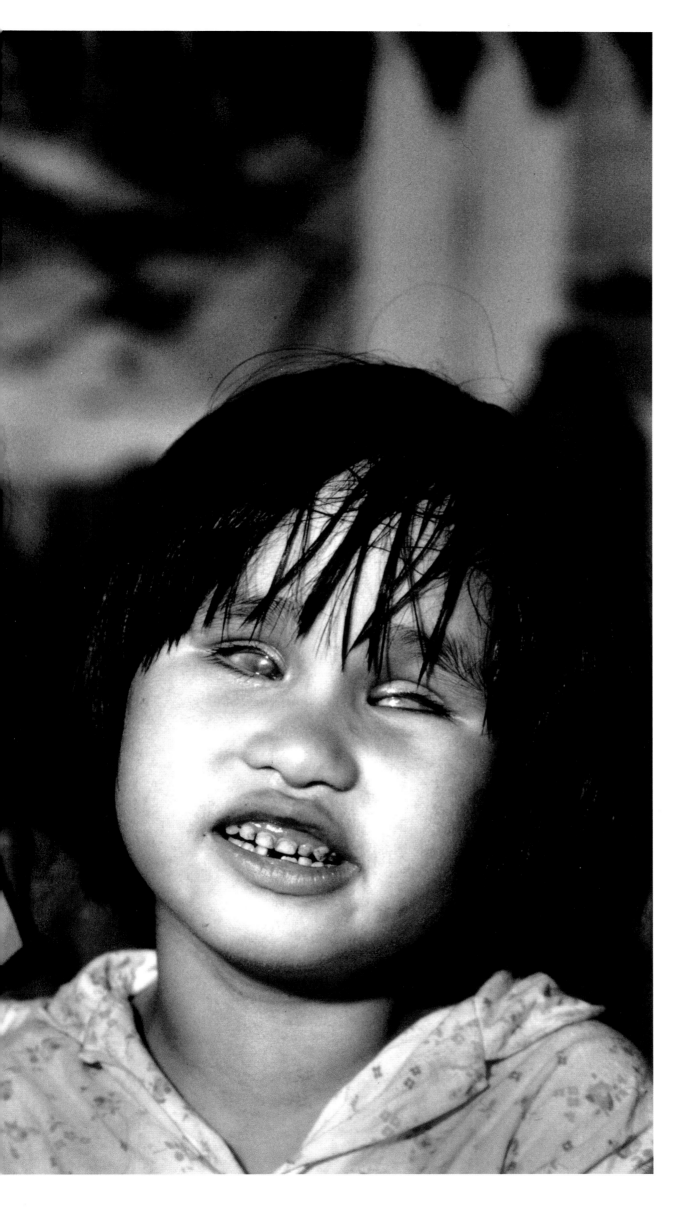

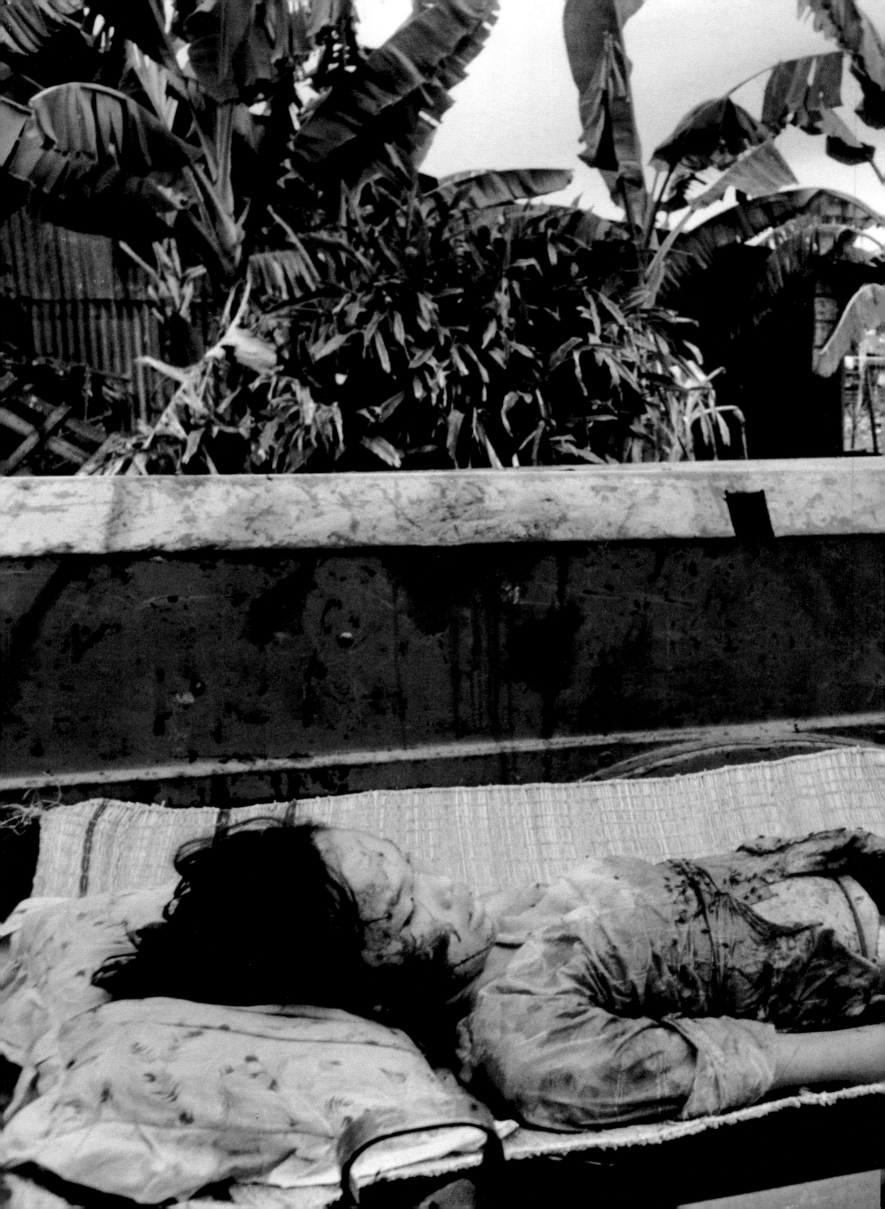

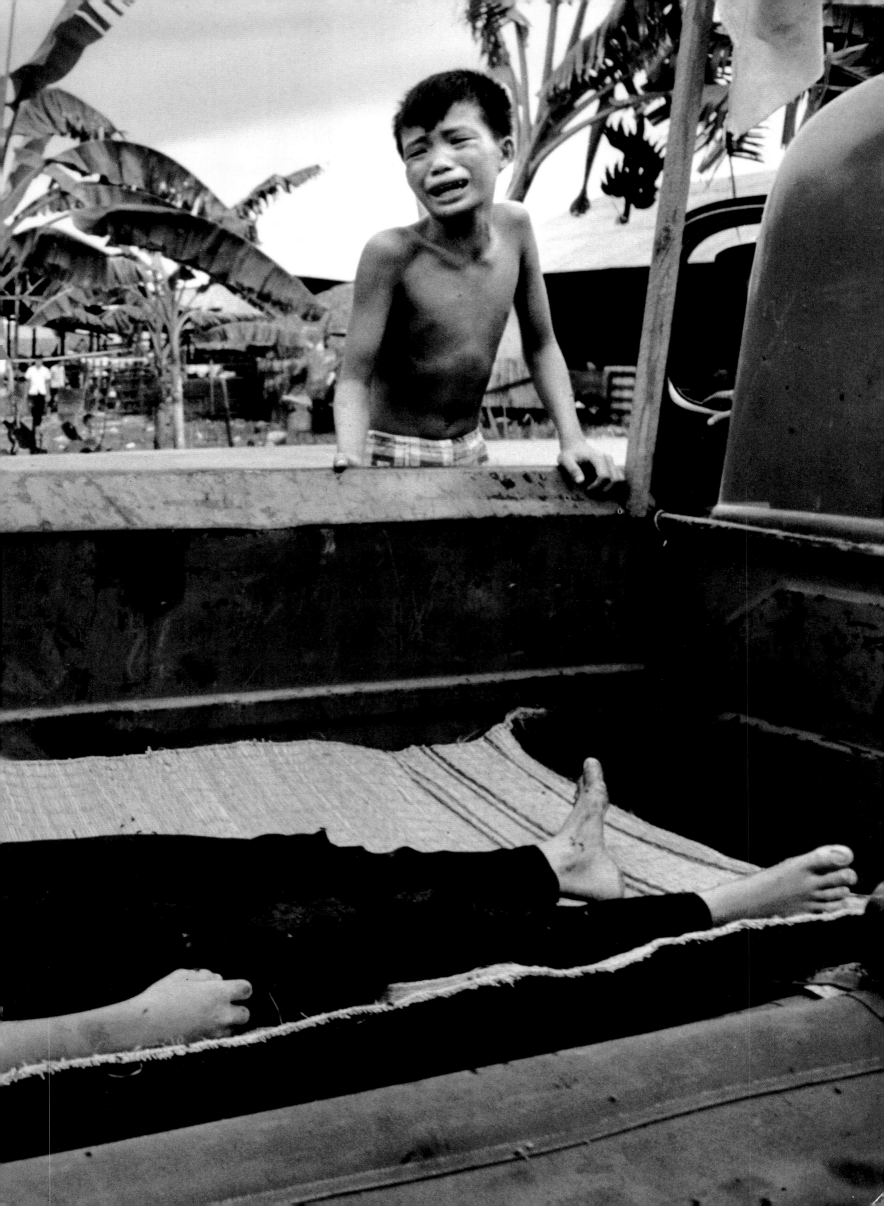

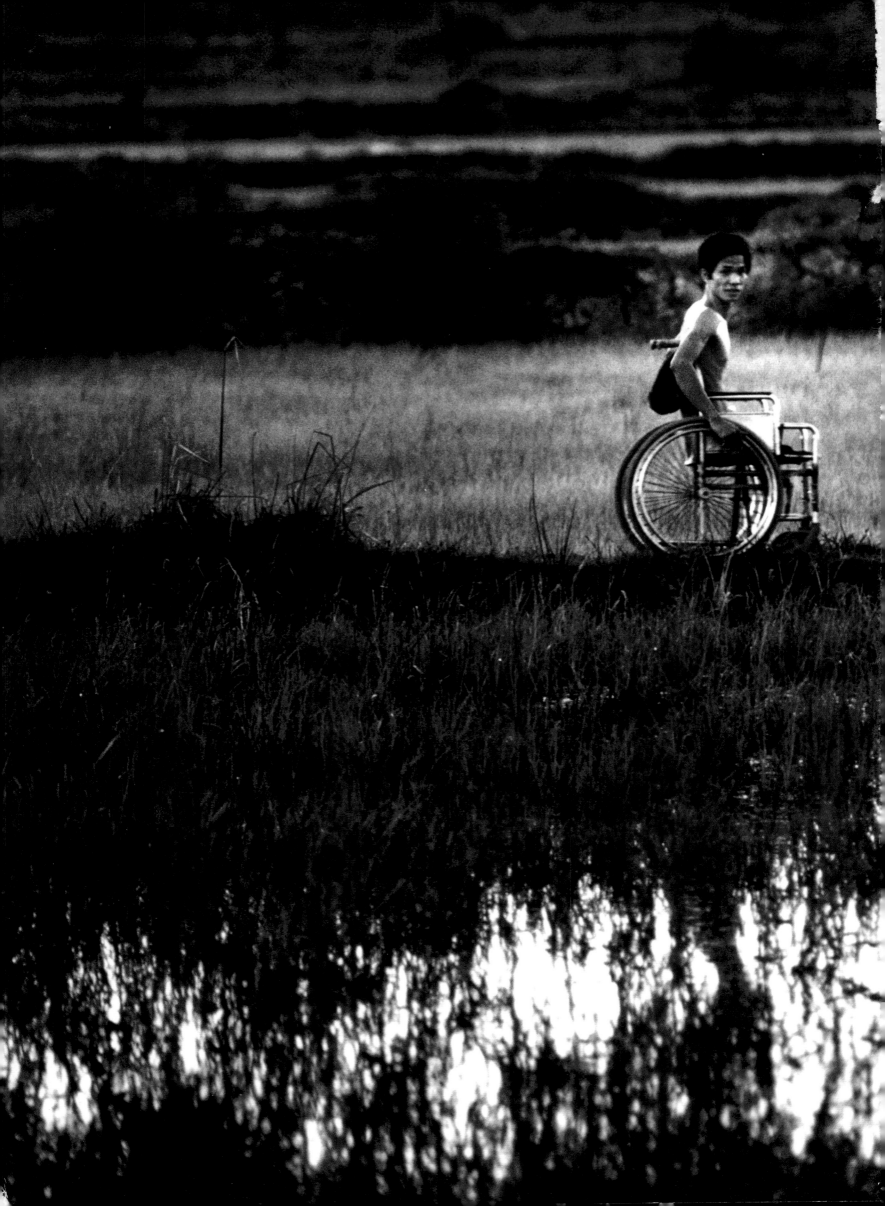

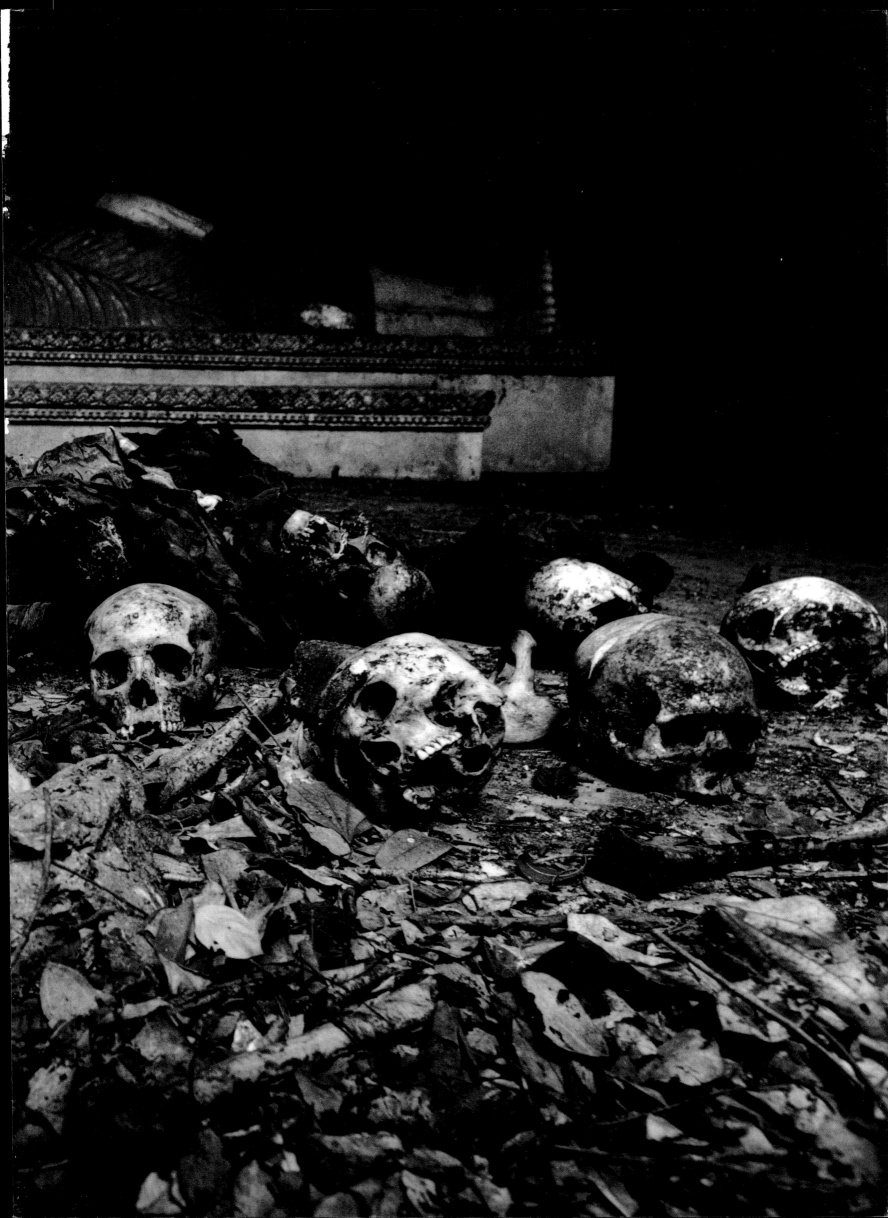

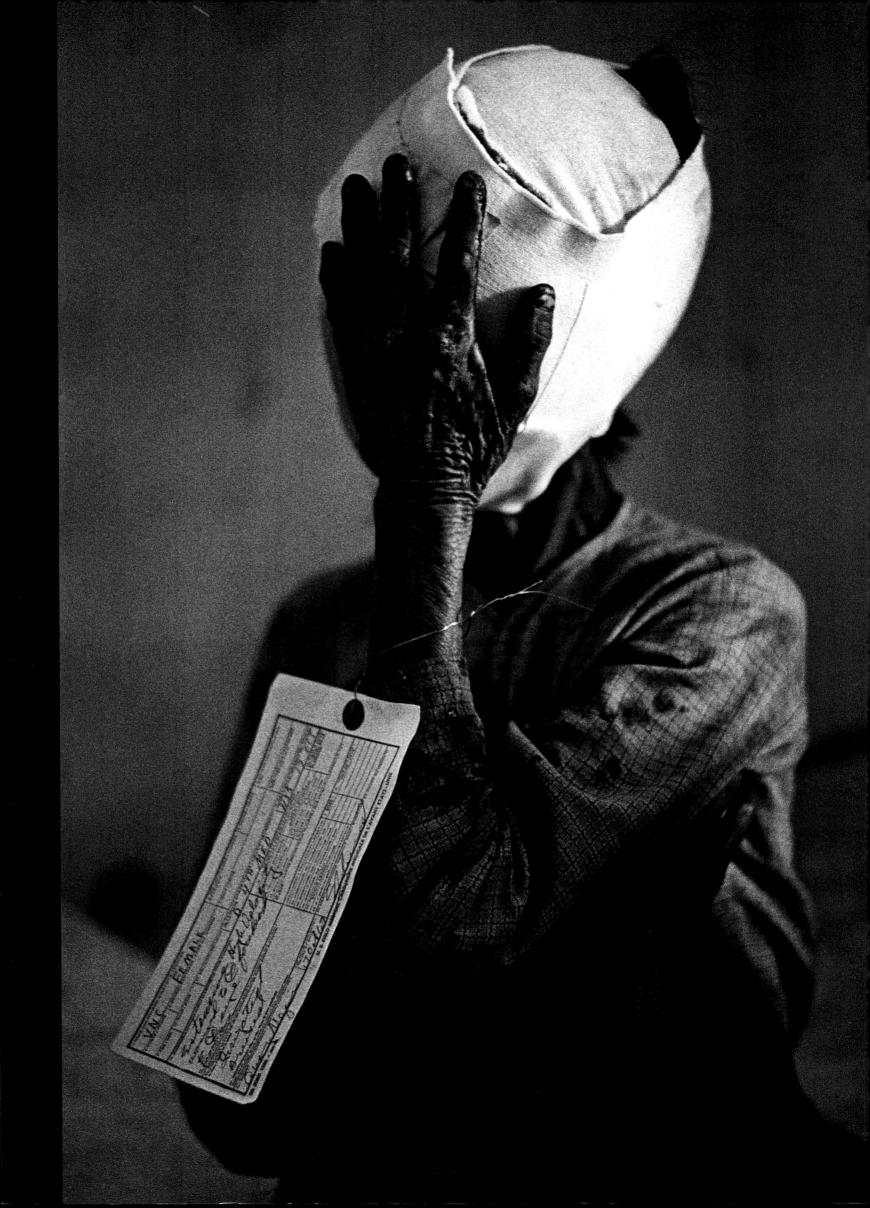

index

2 3

Boy destroying piano, Wales, 1961
This place, Pant-y-Waen, was once, in the 1930s, voted the Most Beautiful Village in South Wales. It has long since been obliterated by opencast mining. This young boy epitomizes our ambivalent love for both rugby and music. When I asked him what he was doing, he replied, "My mother gave it to me to mend."

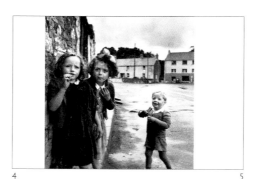

4 5

Children, Laugharne, Wales, 1952
In my youth a visit to the South Wales town of Laugharne was considered imperative. The longest monosyllabic place-name on the map, Laugharne was made famous by Dylan Thomas, who redubbed it with the wickedly dyslexic name of Llareggub. I met this sparkling girl years later—she was now the landlady of Thomas's local pub.

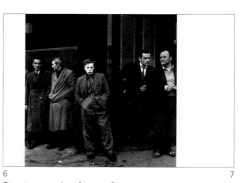

6 7

Street corner, London, 1958
There had been a hanging that morning in Pentonville prison in north London. A group gathered outside the still-unopened pub opposite the main gate. The executed man had lived nearby and these were some of his friends.

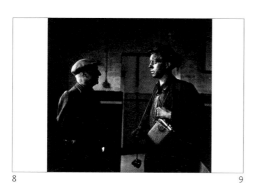

8 9

Coal miners, Wales, 1957
Miners at the Cwm colliery in South Wales. These kings of the working class sensed that their world would soon change. Miners always elicited extreme reactions from the ruling class, who saw them as an enemy to be destroyed. Today they are virtually all gone—for reasons unconnected with economics.

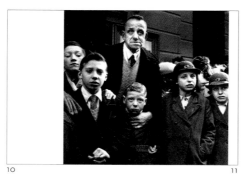

10 11

School outing, Liverpool, 1952
This group of school children and their teacher were waiting to board a bus. Liverpudlians have always expressed an intensity rarely seen on other faces. When Evelyn Waugh described people like this in his novels, he was accused of fantasy.

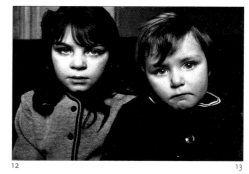

12 13

Children, England, 1961
This brother and sister reacted to being photographed in a way that reveals the inherently different levels of self-esteem observable in children. She was alive with the solipsism of youth, while he was still uncertain.

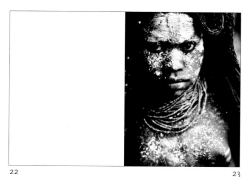

22 23

Young girl, New Guinea, 1973
This girl was covered in white clay as part of the traditional mourning ceremony for her dead grandfather. In parts of New Guinea, people wear no clothes (in the Western sense). For special occasions they paint their bodies with pigments and adorn themselves with feathers and shells.

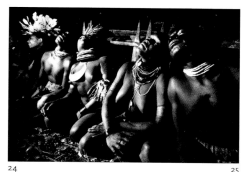

24 25

Courtship ceremony, New Guinea, 1973
I was allowed to attend this ceremony after it was established that I was not a missionary. To the accompaniment of rhythmic chanting, couples roll their heads against each others' with ever-increasing momentum. When the climax is reached, copulation usually occurs—but on this occasion my flash gun lengthened the foreplay until my batteries ran out.

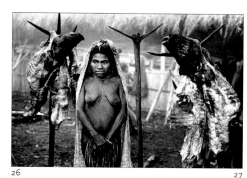

26 27

Pig-kill, New Guinea, 1973
The people who inhabit the highlands of New Guinea live for months on a diet of the starchy *cau-cau* root. Then, one morning, just as dawn is breaking, they massacre thousands of pigs and the whole community takes part in a three-day orgy of eating. After this, until the next protein fix (perhaps a year away), they return to their *cau-cau* roots.

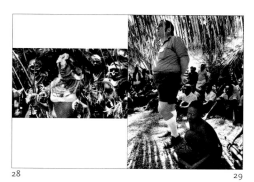

28 29

Ceremonial dance, New Guinea, 1973
Missionaries are obsessed with breasts. These storm-troopers of cultural imperialism impose brassieres on reluctant women (although some recipients do find them useful for carrying coconuts).
Missionary, New Guinea, 1973
Missionaries like to keep out of the sun—it helps them stand out from their darker flock.

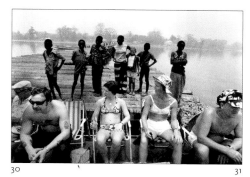

30 31

Tourists, Gambia, 1978
On the riverbank in Gambia near Juffure, home of the slave Kunte Kinte of *Roots* fame. Nowadays, Swedish visitors have made this poor West African country a favoured tourist destination, especially for older single women who find the local men amenable. In earlier times, slaves were gathered on the island in midriver before being shipped to the West Indies.

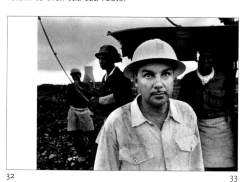

32 33

Copper smelter, Zambia, 1965
The country had just gained its independence. The copper belt in the north provided most of the country's export earnings and the expertise of whites was still needed. The bosses were now black. Not all whites adapted well to the new circumstances.

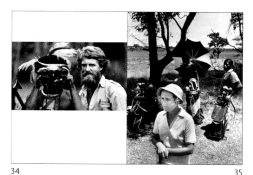

34 35

Western Highlands, New Guinea, 1973
A warrior is given the opportunity to see farther than ever before. His world is about to change forever.
Golfing, Rhodesia, 1965
Before the country became independent Zimbabwe, the whites, who ran everything, had a privileged existence. They offered specialized employment opportunities to generations of young black males—as golf caddies.

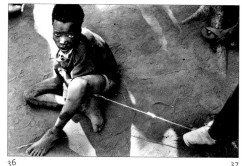

36 37

Demented boy, Sudan, 1988
The sons of the Dinka people of Southern Sudan look after the family cattle, often miles away from their villages. When government soldiers massacre the inhabitants, the boys are often the only survivors. Many walk hundreds of miles to reach refugee camps along the border. Some, like this boy, go insane from their experiences.

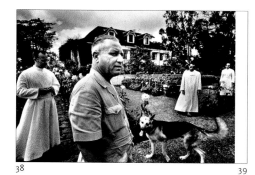

38 39

Plantation owner, Mauritius, 1966
A rare moment when the constituent symbols of colonialism come together in a frame. On a French sugar plantation the owner, with his dog, guide visiting priests around the garden of his mansion.

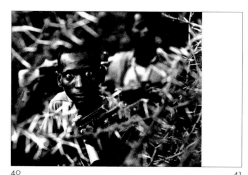

40 41

Guerrilla soldier, Somalia, 1980
A fighter with the West Somalia Liberation Front. To compensate for food shortages, the soldiers consumed large quantities of *chat*, a leaf containing an amphetamine-like substance. This gave rise to many symptoms incompatible with good soldiering, including providing the enemy with an easy target.

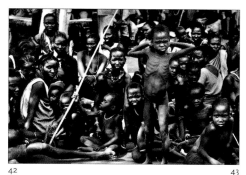

42 43

Refugees, Sudan border, 1988
Refugees are rarely seen as intact families: the men are absent, either dead or fighting in a rare war where Muslims are busy killing Christians. The people of southern Sudan came under the influence of Christian missionaries sent from Britain to save their "heathen souls." The Muslim government in the north is waging a war against them.

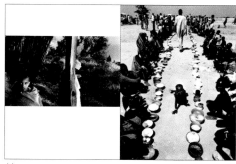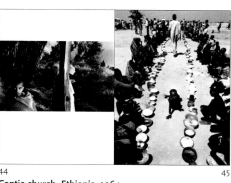

44 45

Coptic church, Ethiopia, 1964
On this island-church, everything female was banned, except I found a colorful mural of the Virgin Mary squeezing milk from her breast and placing it on the eyes of a blind man to restore his sight.
Feeding refugees, Sudan border, 1988
The imposition of order preoccupies the minds of those who run the refugee camps of the world.

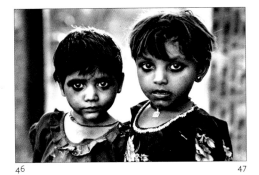
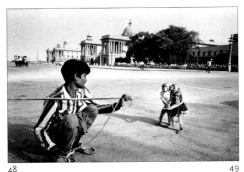

46
47
Young girls, India, 1987
The Bishnoi people of Rajasthan possess remarkable physical beauty; indeed, every aspect of their lives conforms to strict aesthetic standards.

48
49
Dancing monkeys, New Delhi, 1987
On Delhi's main thoroughfare, where generations of British paraded their colonial pomp and ceremony to convince the world of their invincibility, monkeys now perform for passersby.

50
51
Soldier with bulletproof shield, Northern Ireland, 1973
Since ancient times, the shield has presented a challenge to military designers—how to see the enemy without sacrificing protection. The latest development is one made of Plexiglas. Unfortunately, it affords a dimmed visibility after repeated blows.

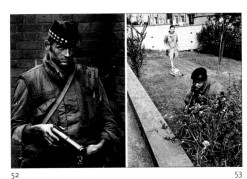
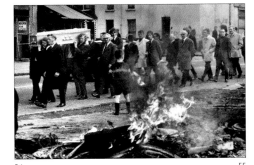
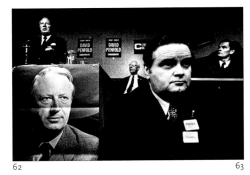

52
53
British soldier, Northern Ireland, 1972
This soldier was facing a hostile crowd of youngsters and, for a moment, his expression revealed his disdain.
Mowing the lawn, Northern Ireland, 1973
The incongruities of daily life in the urban war zone. For years, the people of Northern Ireland have lived in a strange and strained symbiosis with the occupying British army.

54
55
Funeral procession, Northern Ireland, 1972
As an Irish poet put it, "The tragedy of Northern Ireland is that it is now a society in which the dead console the living." The Northern Ireland Tourist Board, with mindless verve, ran an advertisement: "For generations, a wide range of shooting in Northern Ireland has provided all sections of the population with a pastime."

56
57
Life in Northern Ireland (56, top) 1973
The Occupation has denied many their childhood. **(56, bottom) 1973** Fighting men preoccupied with the distinction between guns and weapons are not new to armies. Here the dilemma seemed far from resolution. **(57, top and bottom) 1973** Protestants love parades, and Catholics live with British soldiers underfoot, though they hold them in fearless contempt.

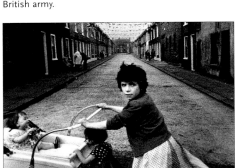
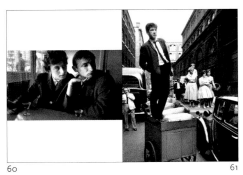
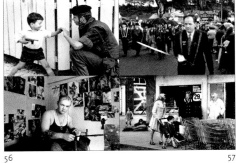

58
59
Children, Northern Ireland, 1965
In the narrow terraced streets built for the working people of Northern Ireland (every house except the last needs only three walls), the closely knit communities of differing religious persuasions are encouraged to battle one another.

60
61
Calais, France, 1961
Social changes in the 1960s had the positive effect of taking some pressure off men to behave always in a dominant manner.
Spectators, London, 1959
Meanwhile, back in London a youth strains to glimpse his pop-star idol emerging from church with his new bride.

62
63
Prime Minister Edward Heath, England, 1974
In the '74 elections, the Tory party was attempting to persuade the electorate to vote against their own interests.

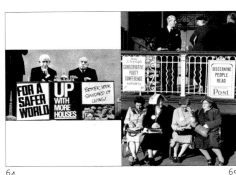
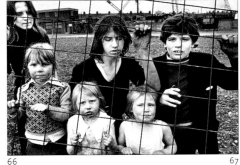
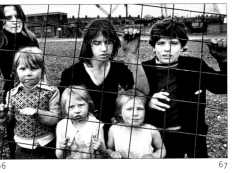

64
65
Tory election meeting, England, 1964
Before the Tory party put on a more acceptable face, these men gave a clearer testimony of the true character of their leaders.
Prime Minister Harold McMillan, England, 1956
The Prime Minister and his wife with some delegates at their party conference in North Wales.

66
67
Children, Middlesborough, England, 1976
These children were playing on a piece of spare ground where a factory once stood. They belong to the ever-increasing population of a wasteland where, for political reasons, education and opportunity are denied.

68
69
Nice, France, 1965
Sea air and sand embolden men in their hunt for a mate. Along the Côte d'Azur each summer, a spectacle is afforded by their lack of prowess in this task.
Parade, South of France, 1965
The confidence of youth is enhanced by wearing fashionable clothes. This allows them to deride those outside the dictates of advertisers.

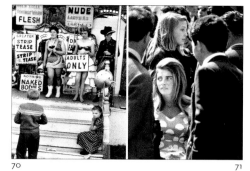

70

71

Striptease sideshow, England, 1957–58
The English have an ambivalent attitude toward sex (often expressed at an early age). Ignorance surrounding the subject has always been a prime instrument of control.
Young women, Zaragossa, Spain, 1963
Sunday afternoon and the main business was ogling women. There was a certain desperation evident in this activity.

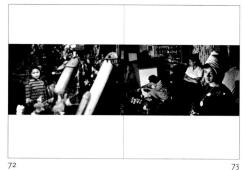

72

73

Fertility shrine, Thailand, 1977
A fertility shrine in Bangkok where young women pray to get pregnant.
Brothel, Addis Ababa, Ethiopia, 1964
The sign for a brothel was a red cross (there were many stories of injured tourists being rushed into them by their wives). At night, with the glow of illuminated crosses, the city seemed to be on fire.

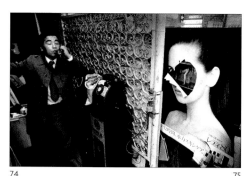

74

75

Shinjuku, Tokyo, 1980
Japanese society has designated roles for women, from which it is almost impossible to escape. A rumor that the head of the Women's Liberation movement had to resign because her husband forbade her to attend meetings was met with outrage in the West. However, it is not only women who suffer. Men also lead regimented lives that stifle creativity.

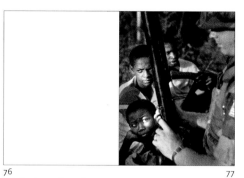

76

77

G.I. in Grenada, 1983
When 6,000 elite troops of the American armed forces invaded Grenada in 1983, they managed to overcome the token resistance put up by the handful of defenders. Nevertheless, they won 8,700 medals for their valor, and President Reagan declared that America was again "standing tall."

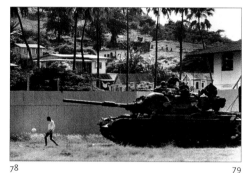

78

79

Invaded sports field, Grenada, 1983
Grenadians for generations had welcomed the only foreigners they encountered—tourists—so U.S. forces had the rare experience of being surrounded by polite and friendly locals. For many Americans, the Grenada invasion was seen as a morale booster after the defeat in Vietnam.

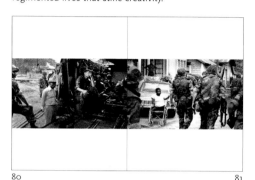

80

81

Captured civilian, Grenada, 1983
Grenada posed no military threat and had no resources worth plundering, but if the government's social programs had succeeded it could have become an intolerable example to other countries in the region.
U.S. troops on patrol, Grenada, 1983
America's message was clear—any move toward true democracy would be met with maximum force.

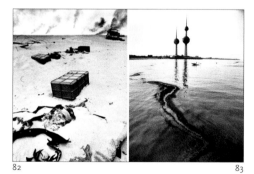

82

83

War dead, Kuwait, 1991
Dead soldiers lie in the sand while oil fires burn. Back in Washington, the oil-men running the government were pleased with their success in controlling the flow of essential oil to their economic competitor, Japan.
Water-skiing, Kuwait, 1991
Meanwhile, the rich of Kuwait continue to water-ski while trying their best to avoid oil slicks in the bay.

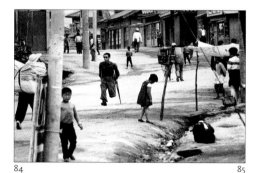

84

85

Street scene, South Korea, 1967
The Korean War had been over for fourteen years. Most of South Korea looked much as it had for centuries. This was the main street of Sokcho, a town in North Korea before the war began—now complemented with a reminder.

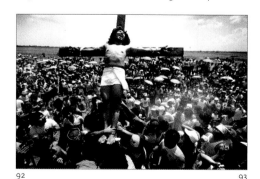

86

87

South Korean paramilitary, Seoul, 1987
South Korea's economic development has relied on the military. The country lacks energy and raw materials, so Korean workers have been forced by intimidation, arrest, and torture to work hard for low wages.
Cinema display, Thailand, 1977
All societies that have embraced consumerism owe a huge debt to the media for facilitating its acceptance.

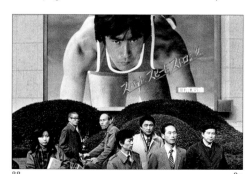

88

89

Advertising board, Tokyo, 1984
The streets of Japanese cities amaze visitors who marvel at their neat and orderly appearance. The efficiency of Japanese society relies on the personal acceptance of responsibility. This affords a great advantage to the authorities. However, even in Japan values are changing. The number of jay-walkers increases every decade.

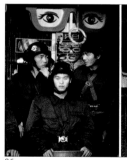

90

91

Priest with remains of martyrs, Macao, 1978
Early missionaries set out from Macao to "Christianize" China. They were not successful. The Chinese swiftly executed the ones that kept quiet; the rowdy they hung by their ankles in public urinals and urged men to aim down their nostrils until they choked to death. Their bodies were returned to Macao as a warning.

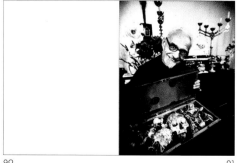

92

93

Easter Sunday, Philippines, 1981
Filipinos give new meaning to religious devotion. Every Easter, Bible stories are brought to life as young men are crucified using real nails (which, in the interests of hygiene, are first soaked in surgical spirit). In New York, this sort of thing can cost up to five hundred dollars an hour—and when a man crucified another on London's Hampstead Heath, they were both arrested.

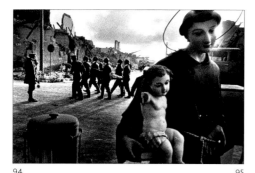

94 95

Earthquake victims, Sicily, 1968
As befits the Sicilian disposition, relics had been rescued. Earthquakes have long since been appropriated by religions and presented as the wrath of some god. After an earthquake in Spain, as heretics were publicly burned, it was declared that the sight of several persons being incinerated with great ceremony is an infallible recipe for earthquake-prevention.

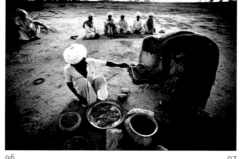

96 97

Rain-making ceremony, India, 1987
When a drought gripped western India in 1987, in desperation many turned to holy men to perform ceremonies to summon the god of rain. This meant they were not protesting about the cause—deforestation.

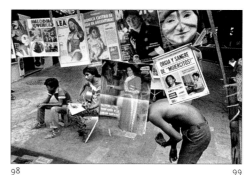

98 99

Acapulco, Mexico, 1982
On a fine spring morning these newspaper vendors were singing while reading their stock of magazines. Literacy, thanks to the paucity of TV sets, is still on the increase south of the border, whereas in North America it is declining rapidly.

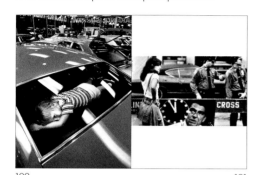

100 101

Car showroom, Atlanta, 1971
While her parents slammed car doors and tested radios, this girl tried out the ledge behind the back seat.
Democratic rally, New York, 1980
A live microphone had caught a sample of President Reagan's wit. The Democrats quite rightly seized on the remark to remind the American people of how eloquently he had confirmed his qualities as their leader.

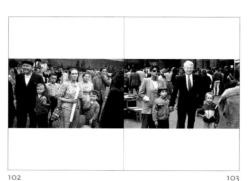

102 103

Red Square, Moscow, 1963
A family on an outing to visit the Kremlin. The standards they embodied would remain paramount in Russians for thirty more years.
Gorky Street, Moscow, 1991
By 1988, Soviet society was plagued with street crime, corruption, pimps, and prostitution. Russia was at last qualified to join the community of nations.

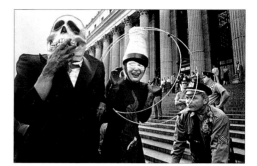

104 105

Antinuclear demonstration, New York, 1980
The British "Ban the Bomb" movement of the early sixties emerged revitalized in America after the Three Mile Island nuclear power station accident in 1979, and America's planned deployment of new medium-range missiles in Western Europe. A million people gathered in New York to protest, some appropriately costumed for the day.

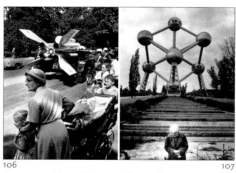

106 107

Nanny watching military parade, London, 1960
Armed forces are always eager to brandish their latest purchases, by which some members of the public are possibly reassured.
Public park, Belgium, 1962
There was a time when nuclear energy was seen as a miracle panacea. In this park near Brussels, people could lunch in one of the atoms of a model molecule.

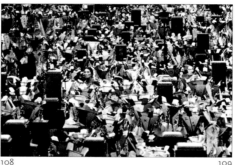

108 109

Public cemetery, Hiroshima, 1985
On an anniversary of the 1945 dropping of the first atomic bomb on a city, relatives decorate the graves of those who died. There were 130,000 casualties and 90 percent of Hiroshima was leveled.

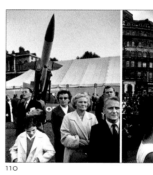

110 111

Military display, London, 1960
The threat of nuclear annihilation concentrated the public's mind on the larger issues of the arms race. The government responded with shows of hardware meant to reassure the public.
Antinuclear demonstration, London, 1960
The authorities encouraged demonstrations to "let off steam," lest pent-up frustrations get out of hand.

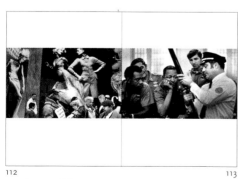

112 113

Begging on Fifth Avenue, New York, 1995
Published in *Newsweek: The poor in the land of plenty. Surrounded by the icons of success the blind man begs. He cannot see us. We are learning not to see him.*
Police training, New York, 1971
The people of America love guns and the police are no exception. Here, they are being instructed in the use of the shotgun for "crowd control."

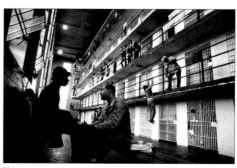

114 115

State prison, Virginia, 1986
The American justice system directs attention away from corporate crime. A deluge of trivia about murder and mayhem is provided, sending the message that everyone is wallowing in original sin and that deliverance can only come from a strong police force. The economically deprived, mostly blacks, who turn to crime are incarcerated in ever-increasing numbers.

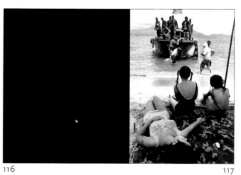

116 117

Marines landing on beach, Danang, 1970
This amphibious assault was to establish a beachhead for a barbecue. Vast quantities of meat and beer were consumed while local Vietnamese looked on. Such activities were promoted to engender morale among the troops and to expose the Vietnamese to what was considered the superior American way of life.

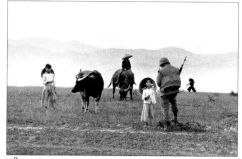
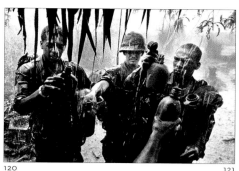
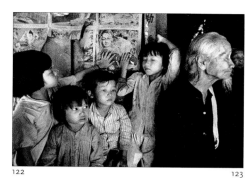

U.S. Marine sharing cigarettes, Vietnam, 1967
In an attempt to impose the American value system on the Vietnamese, the Marines conducted operations called, in Orwellian Newspeak, "county fairs." Villagers were taught how to wash their children, made to watch Disney films on hygiene, had their teeth pulled, were given real toilets with seats, and were introduced to filter tips.

G.I.'s filling water bottles, Vietnam, 1968
Pity the poor fighting man in Vietnam—the problem was always either too much water or too little. In the early days of the war, water was shipped in from California, the indigenous sort being considered somehow unsafe. Later it was made "palatable" with huge quantities of chlorine. Wiser men knew to fill up with the natural variety.

Couple with grandchildren, Vietnam, 1970
The parents of young children were rarely present in the villages of Vietnam. Americans often wondered where all the children came from. The fathers were often away fighting for one side or the other, and the mothers had jobs servicing the G.I.'s. Whether officially called *cleaning*, *laundering*, *shoe-shining*, or even *car-washing*, "servicing" usually meant prostitution.

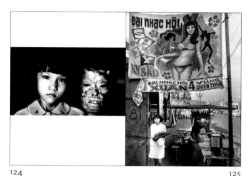
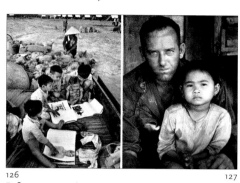
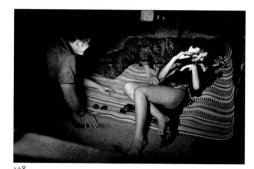

Napalm victim and daughter, Vietnam, 1980
This woman, badly disfigured during a napalm strike, adopted this girl as a baby. The child was orphaned when her family died in an American attack.
Street scene, Saigon, 1971
The wartime streets of Saigon soon showed signs of penetration by those values dear to American hearts—in this case, Mr. Hefner's "Herbivorous Woman."

Refugee camp, Vietnam, 1967
In this camp, the "Psy-Ops" officer discovered he'd forgotten to order "indigenous reading material" for the inmates, so he dished out *Playboy* magazine instead.
G.I. and child, Vietnam, 1967
Older soldiers who missed their families befriended dogs and children. The canines proved more congenial. More dogs than wives were taken back to the U.S.

G.I.'s with dancer, Vietnam, 1970
In a society where women are traditionally revered for their poise and purity, the wartime conditions effectively dehumanized them. This girl was dancing for a group of U.S. Navy personnel on a makeshift stage (the officer's reviewing stand) when she was joined by two unwelcomed spectators.

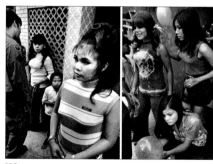
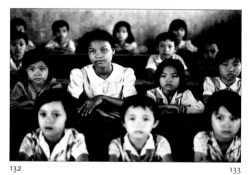

Bar-girls with G.I., Vietnam, both 1970
A beautiful daughter could be a bonanza for a poor family. She could earn more in one night than her father in a month. The average prostitute earned more than President Thieu's official salary. Their money helped support family members back in the countryside. After the war, many slipped back into the puritanical life of the village.

Amerasian girl, Vietnam, 1985
Like most people who measure human value by the paleness of skin, the Vietnamese do discriminate against the offspring of black fathers (although the extent of their prejudice is probably exaggerated.) This girl, in a school in the countryside, seemed well liked. Back in Saigon, Amerasians claimed persecution, hoping to get visas to emigrate to America.

Dead Khmer Rouge soldiers, Cambodia, 1973
In an asinine attempt to resolve the war in Vietnam, Nixon and Kissinger widened the conflict by invading Cambodia. Ostensibly this was to eliminate the Vietcong's headquarters. The scheme failed, but the resulting bombing, which killed over 750,000 Cambodians, caused many to take up arms against their new American-backed government.

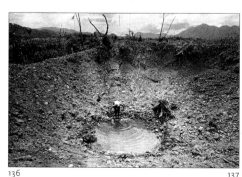
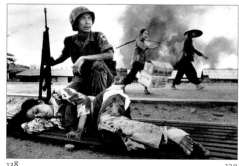
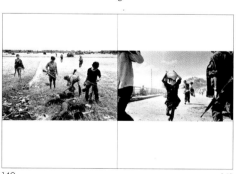

Bomb crater, A Shau Valley, Vietnam, 1968
This operation by the 1st Cavalry Division to cut the Ho Chi Minh trail failed like all the others but the U.S. military were shaken to find such sophisticated weapons stockpiled in the valley. Officers still talked of winning the war, of seeing "the light at the end of the tunnel." As it happened there was a light, that of a fast-approaching express train.

Woman injured by helicopter fire, Saigon, 1968
U.S. policy in Vietnam was based on the premise that peasants driven into the towns and cities by the carpet-bombing of the countryside would be safe. Furthermore, removed from their traditional value system they could be prepared for imposition of consumerism. This "restructuring" of society suffered a setback when, in 1968, death rained down on the urban enclaves.

Soldiers pilfering from the dead, Cambodia, 1973
After an ambush, soldiers returned to recover their dead. Pockets of the fallen were first checked for cash since Cambodian soldiers were rarely paid. This one found enough to buy his way out of the army.
Refugees under fire, Saigon, 1968
Confused urban warfare was such that Americans were shooting their staunchest supporters.

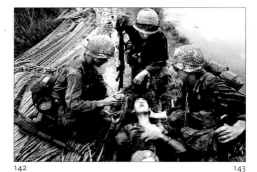

142

143

G.I.'s with wounded Vietcong, 1968
American G.I.'s often showed compassion toward the Vietcong. This sprang from a soldierly admiration for their dedication and bravery—qualities difficult to discern in the average government soldier. This VC had fought for three days with his intestines in a cooking bowl strapped onto his stomach.

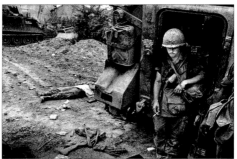

144

145

G.I. killed by "friendly fire," Vietnam, 1968
The problem with "close" artillery support was that it was often too close. On this occasion shells called in by these troops had landed among them. The officer's desperate messages to halt the bombardment were not received—he had taken refuge inside an armored personnel carrier where his frenzied transmissions could not penetrate the metal hull.

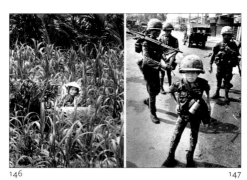

146

147

Mother at graveside, Vietnam, 1967
Vietnamese were the foreign "Other," as in General Westmoreland's telling comment, "The Oriental doesn't put the same high price on life as the Westerner—life is plentiful, life is cheap, in the Orient."
Ten-year-old South Vietnamese soldier, 1968
Called a "little tiger" for killing two "Vietcong women cadre"—his mother and teacher, it was rumored.

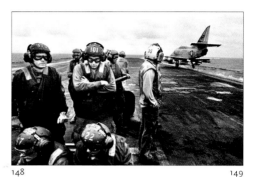

148

149

U.S. aircraft carrier, South China Sea, 1971
As part of the techno-war concept, the idea of an automated battlefield was widely touted. Aircraft carriers—floating airstrips, secure from attack—would respond to requests for bombing. The pilots never saw the faces of those they killed and maimed. It was considered important to protect men from sights that could produce emotional reactions.

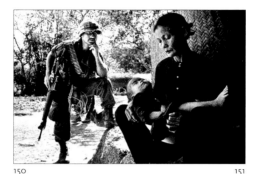

150

151

G.I. with villagers, Vietnam, 1967
This was a village a few miles from My Lai. It was a routine operation—troops were on a typical "search and destroy" mission. After finding and killing men in hiding, the women and children were rounded up. All bunkers where people could take shelter were then destroyed. Finally the troops withdrew and called in an artillery strike of the defenseless inhabitants.

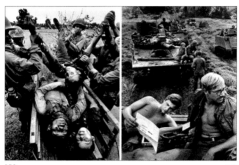

152

153

Government troops, Cambodia, 1973
Lon Nol troops were not inspired fighters and soon became adept at recovering the bodies of comrades.
G.I.'s choosing mail-order cars, Vietnam, 1970
Car salesmen used to follow soldiers into the field to make their sales ("so the boys will have a real reason for wanting to get home in one piece"). As the fighting intensified, they found it safer to send catalogs.

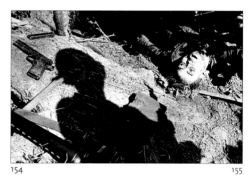

154

155

Dead Vietcong, Vietnam, 1967
This guerrilla fighter had just thrown a grenade, killing one member of the platoon and wounded two others. In the resulting fracas, he too was killed. The incident occurred in what had once been a quiet hamlet in central Vietnam, probably in the very field in front of his home where he'd spent his youth tilling the soil.

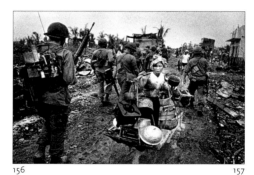

156

157

Refugee from U.S. bombing, Saigon, 1968
This was previously a "showcase" district of Saigon where Catholics who had fled from the North were relocated. It was reduced to rubble by U.S. firepower trying to "flush-out" Vietcong snipers, and the casualties were enormous. (Unlike people in the countryside, urban dwellers had never had the need to build bunkers.)

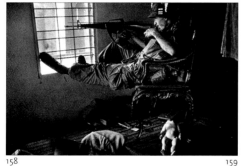

158

159

G.I. during urban fighting, Saigon, 1968
Soldiers of the U.S. 9th Division were sent to retake the suburbs of Saigon from the Vietcong. Sobered by the realization that many of their victims enjoyed a higher standard of living than their own back in America, they compensated with a spree of looting. Despite what his demeanor implies, this soldier was being shot at. Seconds later the house was demolished by a rocket.

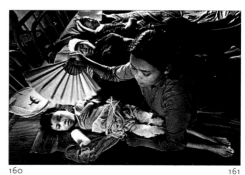

160

161

Civilian victims, Vietnam, 1967
In Quang Ngai Province everything that moved was a target. It had been strongly Communist for thirty years and in practice U.S. policy there was genocide. Each morning, a few lucky survivors of the previous night's carnage made it to the province hospital. The newly developed antipersonnel weapons caused a problem—their plastic darts did not show up on X-rays.

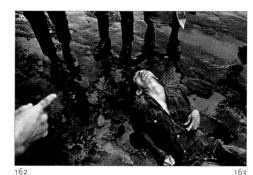

162

163

Captured Vietcong, Cambodia, 1970
Prisoners of war were afforded very different treatment by each side. Americans were treated reasonably (the ranting of the MIA movement in America aside), whereas captured Vietcong were tortured, raped, and killed. Some ended in the tiger-cages of the U.S.-administered Con Son prison, where conditions would have staggered a Spanish Inquisitor.

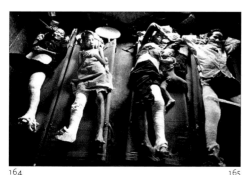

164

165

Wounded civilians, Vietnam, 1967
This group was not recovering from surgery so, to free up scarce beds, they were transferred to an outbuilding to die. The determination was made by the hospital's solitary Spanish surgeon. There was no way he could operate on everyone; he explained with tears in his eyes, "Every morning I have to play God—deciding who will die and who I will give a chance to live."

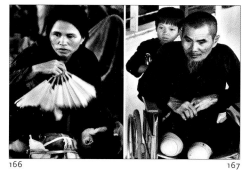 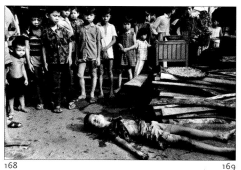 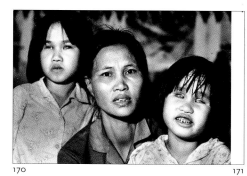

166 | 167

Mother with wounded child, Vietnam, 1967
The American policy of annihilating as many
Vietnamese as possible while claiming to be saving
them from the "horrors" of Communism could be
confirmed by visiting any hospital.
Girl with grandfather, Vietnam, 1970
No one was spared—the old, the young—once I even
saw the X-ray of a foetus with a bullet through its brain.

168 | 169

Boy killed by helicopter fire, Saigon, 1968
This boy was killed by U.S. helicopter gunfire while
on his way to church—a Catholic church—whose
members were avid supporters of the government,
who were in turn pro-American. The result was a
disillusioned urban population, reluctant to believe
in or support their discredited leaders.

170 | 171

Mother with blind daughters, Vietnam, 1980
This woman's husband had been a truck driver on the
Ho Chi Minh trail, who had been sprayed often with
Agent Orange. Americans practiced ecocide on the
land by spraying millions of acres with this defoliant,
containing dioxin, which damages human genes thus
causing grotesque birth defects for future generations.
Both daughters were born blind.

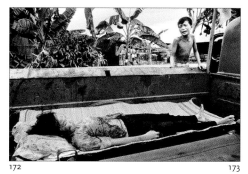 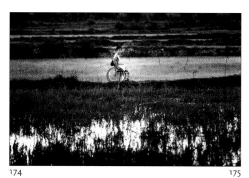 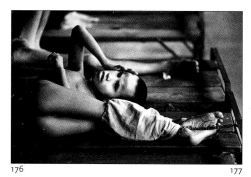

172 | 173

Boy with dead sister, Saigon, 1968
The Saigon fire department had the job of collecting
the dead from the city streets during the Tet offensive.
They had just placed this young girl, killed by U.S.
helicopter fire, in the back of their truck, where her
distraught brother found her. *The New York Times*
published this photograph, and implied there was no
proof that she was killed by American firepower.

174 | 175

Amputee in rice field, 1967
During the war the lack of doctors and specialized
surgical techniques led to the adoption of amputation
as a time-saving measure. In postwar Vietnam the
production of artificial limbs has become a major
industry. With the country's recent change in
economic direction, limbless beggars have become
a common sight.

176 | 177

Demented boy, Vietnam, 1970
As a young child, this boy had been in the arms of his
fleeing mother as she was hit by machine-gun fire
from a helicopter outside their home. He survived,
but went insane and spent his life chained up to his
hospital bed. When helicopters passed overhead he
went berserk trying to shut out their sound.

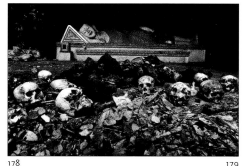 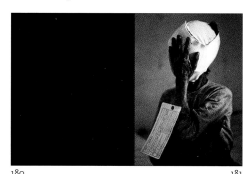

178 | 179

Human remains, Cambodia, 1980
This Buddha reclined in a cave below a temple
surrounded by the remains of many Cambodians.
Situated near the town of Sisophon in the northeast
of the country, the area had recently been occupied
by invading Vietnamese troops.

180 | 181

Civilian victim, Vietnam, 1967
This woman was tagged, probably by a sympathetic
corpsman, with the designation VNC (Vietnamese
civilian). This was unusual. Wounded civilians were
normally tagged VCS (Vietcong suspect) and all dead
peasants were posthumously elevated to the rank of
VCC (Vietcong confirmed).

ACKNOWLEDGMENTS

My indebtedness—to those who were there at the beginning:
William Llewelyn-Jones, Adrian Henri, Rhydwen Williams, Charles Cowen,
Charles Jones, Denis Hackett, and Norman Hall—to those who helped along the way:
Ian Berry, Charles Harbutt, Burk Uzzle, Bob Dannin, and Tom Keller—and to
those in the home stretch: the staff at Aperture, especially my editor Diana Stoll,
and to the book's art director Ruth Ansel, for her unparalleled flair for design.

Prints of *Street Scene, South Korea*, 1967 (pages 84–85) are available
in a limited edition of 150, signed and numbered by Philip Jones Griffiths
and accompanied by a signed copy of *Dark Odyssey*.

Copyright © 1996 by Aperture Foundation, Inc.
Photographs, commentary, and caption texts copyright © 1996 by Philip Jones Griffiths/Magnum Photos.
Introduction copyright © 1996 by Murray Sayle.

All rights reserved under International and Pan-American Copyright Conventions.
No part of this book may be reproduced in any
form whatsoever without written permission from the publisher.

Library of Congress Catalog Card Number: 96-83975
Hardcover ISBN: 0-89381-645-0
Paperback ISBN: 0-89381-689-2

Typesetting by Francesca Richer
Type production by Robert Vizzini
Printed and bound by Federico Motta, Milan, Italy

Initial photo editing by Susan Beardmore

The staff at Aperture for *Dark Odyssey* is:
Michael E. Hoffman, *Executive Director*
Diana C. Stoll, *Editor*
Ron Schick, *Executive Editor*
Stevan Baron, *Production Director*
Helen Marra, *Production Manager*
Michael Lorenzini, *Assistant Editor*
Nina Hess, Charleen Chan, and Marcy Gerstein, *Editorial Work-Scholars*
Meredith Hinshaw, *Production Work-Scholar*

Aperture Foundation publishes a periodical, books, and portfolios of fine
photography to communicate with serious photographers and
creative people everywhere. A complete catalog is available upon request.
Address: 20 East 23rd Street, New York, New York 10010.
Phone: (212) 598-4205. Fax: (212) 598-4015.

First edition
10 9 8 7 6 5 4 3 2 1

BOOK AND JACKET DESIGN BY RUTH ANSEL